DISTANT
RELATIONS

As to Ireland, they know little more
than they do of Mexico; further than
that it is a Country subject to the
King of England, full of Boggs,
inhabited by wild Irish Papists; who
are kept in Awe by mercenary Troops
sent from thence: And their general
Opinion is, that it were better for
England if this whole Island were
sunk into the sea: for, they have
a Tradition, that every Forty Years
there must be a Rebellion in Ireland.

Jonathan Swift
The Drapier's Letters, 1724

CHICANO
IRISH
MEXICAN
ART AND
CRITICAL
WRITING

DISTANT
RELATIONS
CERCANIAS DISTANTES / CLANN I GCÉIN

Introduction by Lucy R. Lippard

Edited by Trisha Ziff

Coordinated by Pilar Perez

SMART ART PRESS
Distributed by D.A.P., New York

This exhibition and publication have been funded by The International Initiatives Fund of the Arts Council of England ▪ Fideicomiso para La Cultura, México /USA –U.S/ Mexico Fund for Culture ▪ The Rockefeller Foundation, USA ▪ Fundación Cultural Bancomer, México ▪ National Endowment for the Arts ▪ California Arts Council ▪ An Roinn Gnóthaí Eachtracha – Irish Department of Foreign Affairs ▪ An Chomhairie Eaiaíon – The Arts Council (Ireland) ▪ Secretaría de Relaciones Exteriores, México ▪ British Council, Mexico ▪ Consejo Nacional para La Cultura y Las Artes, Mexico

The Ikon Gallery gratefully acknowledges financial assistance from the Arts Council of England, Birmingham City Council, and West Midlands Arts.

Camden Arts Centre wishes to thank the Arts Council of England for its support of this exhibition. The Centre is funded by London Borough of Camden and London Arts Board.

The Irish Museum of Modern Art is a national institution established by the Government of Ireland.

Santa Monica Museum of Art is pleased to acknowledge the financial support of the Institute of Museum Services, the National Endowment for the Arts, and the California Arts Council.

Museo Arte de Contemporáneo Alvar y Carmen T. de Carrillo Gil is funded by Consejo Nacional para La Cultura and Instituto Nacional de Bellas Artes.

Cover: Javier de la Garza, *In-finito* (detail), 1992, oil on paper/canvas, 59 x 78-3/4" (150 x 200 cm); courtesy of the collection of Sandra Azcárraga and Galería OMR, Mexico City

Back cover: John Kindness, *Ninja Turtle Harp*, 1991, ceramic mosaic, 24 x 9" (61 x 23 cm); collection of the artist

Library of Congress Cataloging-in-Publication Data
Ziff, Trisha
Distant Relations/Cercanías Distantes/Clann I gCéin
with contributions by Lucy Lippard. . . [et al.].
ISBN 0-9646426-1-1

Printed and bound in the United States

Available through D.A.P./Distributed Art Publishers
636 Broadway, 12th Floor, New York, N.Y. 10012
Tel: (212)473-5119 Fax: (212)673-2887

DISTANT RELATIONS

EDITOR:
Trisha Ziff

FOREWORD:
Elizabeth A. Macgregor
Jenni Lomax
Declan McGonagle
Thomas Rhoads
Sylvia Pandolfi Elliman

PREFACE:
Trisha Ziff

INTRODUCTION:
Lucy R. Lippard

ESSAYS BY:
Gerry Adams
Max Benavidez
Juan Arturo Brennan
Ellen Calmus
Eva Sperling Cockcroft
Fionnula Flanagan
Joan Fowler
Luke Gibbons
Guillermo Gomez-Peña
Mary J. Hickman
David Lloyd
Rubén Martínez
Cuauhtémoc Medina
Amalia Mesa-Bains
Garrett O'Connor
Elena Poniatowska
Richard Rodriguez
Bill Rolston
Juan Villoro

COMPACT DISC:
Roger Doyle
Manuel Rocha Iturbide

DISTANT RELATIONS

A Dialogue Among Chicano,
Irish & Mexican Artists

ARTISTS:

Willie Doherty

David Fox

Javier de la Garza

Silvia Gruner

Frances Hegarty

John Kindness

Alice Maher

Daniel J. Martinez

Amalia Mesa-Bains

Philip Napier

Rubén Ortiz Torres

John Valadez

Exhibition Schedule

Ikon Gallery
Birmingham, England
November 18, 1995– January 20, 1996

Camden Arts Centre
London, England
February 2 – March 10, 1996

Irish Museum of Modern Art
Dublin, Ireland
April 24 – June 30, 1996

Santa Monica Museum of Art
Santa Monica, California
September 6 – November 24, 1996

**Museo de Arte Contemporáneo
de Carrillo Gil**
Mexico City, Mexico
March 1 – May 15, 1997

CONTENTS:

DIRECTOR'S FOREWORD

Birmingham/London/Dublin

The past few years have seen an important shift within the art world. The exclusivity and cultural assumptions of the mainstream have been roundly challenged on a number of fronts. Fueled initially in Britain and North America by the sense of outrage from artists and critics of African, Caribbean, Latino, and Asian descent at their exclusion, the debate has now moved on to trying to define what is meant by internationalism for the visual arts in a postmodern culture. The spotlight has shifted from the traditional European/North American axis. How to present exhibitions which take account of artistic practice around the world has become a key concern for curators.

This situation naturally raises as many problems as it purports to solve. The spectacle of curators traveling the globe like anthropologists seeking to 'discover' new and exciting work gives rise to doubts about whether the shift of emphasis can go beyond a jaded art world's desire for rejuvenation through the appropriation of work from hitherto ignored parts of the world.

Nevertheless, this cultural shift is important. At the recent Venice Biennale, some of the most exciting work was to be found outside the main venue, the Giardini. "Transculture," curated by Fumio Nanjo, brought together fifteen artists from a number of countries including China, Brazil, Singapore and the United States as well as the Irish exhibition by Kathy Prendergast and Shane Cullen. Here, being on the margins at the Biennale had a distinct advantage, throwing the tired old format of the national pavilions into sharp relief.

The challenge must now be to move beyond a narrowly defined discussion about mainstream and periphery, inclusion and exclusion, and to recognise that, in the words of Uruguayan artist, critic and author Luis Camnitzer, ". . . the issue is not our access to the mainstream, but the mainstream's access to us. Only put this way can the mainstream act as a resonance box for our activities without eviscerating us."

This exhibition, "Distant Relations: A Dialogue Among Chicano, Irish and Mexican Artists," was first proposed to us four years ago. The

premise, bringing together the work of artists from two countries in different continents, opens up a new discussion about cultural difference. Ireland and Mexico, on the surface two very different countries, have much in common and the more the project progressed, the clearer it became that this was not an artificial curatorial imposition.

From the outset, it was important that the framework for the show should not be a straitjacket. The intention was never to illustrate a theory about identity, but to give artists the space to contribute in whatever way they felt was appropriate. A crucial aspect of the project was the enthusiasm with which all the artists agreed to participate as well as the different ways they responded. Some chose to travel to the other country, others did not. Ultimately, it was the possibility of new meanings arising from the interplay between the work and the responses of audiences in England, Ireland, the United States and Mexico which would create the essential dialogue.

We hope that by juxtaposing work by artists of Irish and Mexican descent, the exhibition will encourage our audiences to question stereotypical assumptions, and to explore with an open mind similarities and differences of response to cultural situations through the work of living artists.

The exhibition and anthology could only have come about as a result of the support of many people. First we must express our gratitude to the artists, whose patience and commitment to the project have been invaluable. We would also like to thank all the contributing authors to this fascinating anthology, and the composers for creating new works for the accompanying compact disc. Finally, we are indebted to the curator, Trisha Ziff, without whose tireless energy and ability to convince key people of the importance of this project, the exhibition and this publication could not have happened.

Elizabeth A. Macgregor – Director, Ikon Gallery, Birmingham, UK
Jenni Lomax – Director, Camden Arts Centre, London
Declan McGonagle – Director, Irish Museum of Modern Art, Dublin

Santa Monica

Located on the edge of the Pacific Rim, the city of Santa Monica possesses the charm of a sleepy seaside community and yet is situated at the geographical crossroads of a hugely complex multiethnic metropolis. It is estimated that eighty-five separate languages are spoken in the Los Angeles

County school system alone, and that by the year 2000 the non-Caucasian population will comprise two-thirds of the total population. The 1990 census reported that racial and ethnic minorities represented more than 59 percent of the county's 9 million people. As the demographics of Los Angeles County shift, and rapid changes continue to challenge our civic, social, and cultural institutions, the role, function, and responsibility of institutions like the Santa Monica Museum of Art are critical to the well-being of this community. It is for this reason that exhibitions like "Distant Relations" are of interest, for they provide a forum for dialogue between distant peoples.

Since its inception, the Santa Monica Museum of Art has sought to revitalize and redefine the relationship with the communities and artists that it serves. By presenting works by artists seldom seen in either the greater Los Angeles area or West Los Angeles, including work by artists whose beliefs or outlook may differ from those of the dominant American culture, the Santa Monica Museum of Art seeks to cultivate global dialogue among people of diverse backgrounds and aesthetic values. With the example of the "Distant Relations" exhibition, this leads invariably to a transcultural awareness, providing our audiences with insight into the parallel histories that flourish here, but very seldom emerge.

From its earliest conception four years ago, this exhibition has seen many twists and turns. For an exhibition as unorthodox in conception as "Distant Relations," perhaps this long gestation period was inevitable. A lesser or more feeble show would have simply faded away. It is therefore testimony to the resourcefulness, perseverance, and creativity of Trisha Ziff, the curator of the exhibition and editor of this accompanying anthology, that this exhibition has come to fruition. In bringing together the myriad strands of this exhibition—the participating artists and writers, the collectors and funders, and the participating institutions and governmental support, Trisha has truly orchestrated a wonderful exhibition. Let me thank as well Pilar Perez, without whose fundraising abilities the Santa Monica Museum exhibition simply would not have been possible. It is my fervent hope that this inspired and novel approach to curation serves as a model for other such transcultural explorations.

Thomas Rhoads – Director, Santa Monica Museum of Art

Mexico City

"Distant Relations" will come to Mexico in 1997. As I write this foreword, it does not seem possible to foresee with any clarity the context within which this exhibition will be viewed over a year from now, given the last year of tumult within the country.

In times of crisis and change we inevitably question the role of a Museum of Contemporary Art. Do we as a museum ignore the world beyond our museum walls? Or do we use the museum to address cultural issues that are pertinent to these times? During an economic crisis the arts suffer, and we at this time in Mexico are operating under severe limitations.

However, convinced of the absolute necessity to participate in the global discussion about art, culture, and identity, and the always open questions about what we do as museums, the Museo de Arte Contemporáneo Carrillo Gil decided to create a page on the World Wide Web—to avoid drying up and withering in isolation. Thus, when "Distant Relations" arrives in Mexico, the final stop on its tour, we can provide an international platform for a discussion of issues raised by the exhibition and catalogue that will not be limited by distance or budget.

"Distant Relations" is a dialogue between artists from cultures that have been subjected for generations, both directly and indirectly, to foreign domination and pressures. The intention of the exhibition is to provoke discussion on the issues we ruminate over constantly—art, culture, and identity.

Finally it is about people—creative people—the Irish in Ireland and in Britain; the Mexican in Mexico; and the Chicano in the United States.

We are looking forward to hosting the exhibition at the Museo de Arte Contemporáneo Carrillo Gil.

Sylvia Pandolfi Elliman – Director, Museo de Arte Contemporáneo
Carrillo Gil, Mexico City

ACKNOWLEDGMENTS

On behalf of everyone involved in the development of "Distant Relations," I would like to thank, firstly, all the participating artists, authors, and composers for their time and commitment. It is their thought-provoking ideas that have generated the energy for this cultural dialogue, and their vision that has enabled me to take this project from an idea and make it a reality. Over a four-year period, a great many people in Ireland, England, the United States, and Mexico have invested their time and enthusiasm; this exhibition and publication could not have been realised without their support.

It has been a long and complex process from my initial discussions with Elizabeth Macgregor, Director of the Ikon Gallery, to where we are today; without her commitment and belief in this project there would be no exhibition. Thomas Rhoads, Director of the Santa Monica Museum of Art, has also given me consistent advice and encouragement, and his staff at the museum have assisted in writing copious grant applications and have spent hours of their time discussing this project with me. I would also like to thank Jenni Lomax, Director of the Camden Arts Centre; Declan McGonagle, Director of the Irish Museum of Art; and Sylvia Pandolfi Elliman, Director of Museo de Arte Contemporáneo Carrillo Gil, for believing in this exhibition and lending the support of their institutions.

I am extremely grateful to Luke Gibbons in Ireland, who has been an invaluable source of ideas, and who extended himself way beyond the role of an advisor; Ambassador Hermilo Lopéz Bassols, who took this project under his wing and energetically helped us secure funding from Mexico, as well as making available the resources of his embassy to me on my many trips to Ireland; Pilar Perez, my friend and colleague here in Los Angeles, whose unflagging enthusiasm and commitment have made this publication a reality.

I would also like to acknowledge the advisors for this project who lent their names and support from the beginning: Paul Muldoon; Joan Fowler; Luke Gibbons; Janet Madden; Helena Maria Viramontes; Mike Davis; David Lloyd; Edward Leffingwell; and Lucy Lippard.

In Mexico, I have been fortunate enough to have had the support

of individual women who have been committed to making this exhibition and catalogue a reality, and have helped us despite the pressures of a major economic crisis: Marcela Ramirez, Cultural Officer of the British Council in Mexico; Marcela S. de Madariaga, Program Coordinator at the Fideicomiso para La Cultura, México/USA; Beatrice Margain, Director of Cultural Communications at Secretaría de Relaciones Exteriores, and her assistant Maria Eugenia Rabadan; and Alejandra de la Paz, Minister for Cultural Affairs at the Mexican Embassy, London. I would also like to thank Rafael Tovar y de Teresa, President of the Consejo Nacional para La Cultura y Las Artes, for his commitment to bringing this exhibition to Mexico.

Over the last four years, many of us involved with "Distant Relations/Cercanías Distantes/Clann i gCéin" travelled between Mexico, Ireland, California, and England for our research. We especially wish to thank Yolanda Andrade; the Lopéz Bassols family; Joelle Gartner; Tom Hartley; Gerard Kelly; Brid Keenan and Paedar Wheelan; Locky Morris and Stephen Gargan; Jo and Aleen Mulhern; Rita O'Hare; John and Danae Kindness; Sylvia Stevens; Elizabeth Macgregor and Peter Jenkinson; and Mariana Yampolsky and Arjen van der Sluis, for opening their homes to us all and for spending their time helping us understand more about each other's respective cultures.

For loaning works of art from their own collections for the duration of the touring of this exhibition, I would like to thank the following collectors: Susan Hill in Venice, California; Sra. Sandra Azcárraga, and Pedro Torres in Mexico City. We are also grateful to Patricia Ortiz Monasterio and Ms. Edith Fay of the Galería OMR for their energies in making the Mexican loans possible, and to the Arts Council of N. Ireland for loaning *Ballad no. 1* by Philip Napier. We would also like to thank Graham Cope and Bright Tech Developments Ltd., Dorset, England, for donating an electronic display system to artist Philip Napier.

I would like to acknowledge the work of the curators and staff involved in bringing "Distant Relations" to the various venues: Noriko Gamblin, Michael Phillips, Scott Boberg, and Alissa Levin at the Santa Monica Museum of Art; Brenda McParland at the Irish Museum of Modern Art; Isabelle King and Gordon Agar at the Camden Arts Centre; Claire Doherty and Helen Juffs at the Ikon Gallery; Edouardo Ganado Kim,

Alejandro Beltrán, Patricia Felguérez, Jorge Reynoso, Juan Cortés, Esther Fernández, Mario Bocanegra, and Antonio Hernández at the Museo de Arte Contemporáneo de Carrillo Gil.

My special thanks to Michele Perez for designing this book. Thanks to Tony Scully, Mary Ferguson, Brendan Leech, Garrett O'Connor, and Fionnula Flanagan for their assistance editing and proofreading; Ellen Calmus and Juan Arturo Brennan for working on the translations; Joe Nuñez from Typecraft for his advice and patience during the production of this book; Tom Patchett for committing to publishing this catalogue/anthology without any hesitation; and to Jody Zellen and Antonette DeVito for their support at Smart Art Press.

I would also like to thank Mike Abrahams; Annette Ballester; Jocelyn Benzakin; Enrique Berruga; CURARE (Espacio Crítico para Las Artes); Ambassador Erwan Fouére; Richard McAughley; Michael McMullen; Charles Melcher; Patricia Mendoza; Siobhan O'Hanlon; Noreen O'Hare; Victor Flores Olea; Jonathan Reff; Laurie Sparham; and Sue Steward for contributing their time and support.

Finally, I would like to thank my partner Pedro Meyer for his understanding and constant belief in this project. To our son, Julito, who learnt to sleep through the night as soon as he was able, allowing me to complete this publication on time. This project is about the meeting of two distinct cultures, and so I dedicate my work on "Distant Relations" to Julio Ernesto Patrick and Pedro, my closest relations.

Trisha Ziff
Los Angeles – July 1995

DISTANT RELATIONS

Lucy R. Lippard

There are some apparently simple reasons why Chicano, Mexican, and Irish artists should be shown together, and they are undoubtedly those that inspired curator Trisha Ziff to make this provocative juxtaposition: the combination of indigenous and Roman Catholic spirituality; a preoccupation with death and rebirth; a poor but vital rural culture that has changed and is changing; resistance politics fueled by occupation of traditional homelands; the memory of inconclusive revolutions; the endless "Troubles" in Northern Ireland and the escalating Zapatista rebellion in Chiapas; and anti-Irish/Mexican prejudice and economic violence in England/U.S., epitomized by the war against immigrants in California that is spreading across the Southwest. But the real common ground is the retention of a mixed, still-powerful, and often romanticized identity that is layered beneath the surfaces of modernity and internationalism—an identity manipulated as often in popular as in "high" culture. This set of factors cannot be oversimplified as a "postmodern" phenomenon, but it lends itself gracefully to the border-blurring analyses that fuel the postmodernist pastiche, even as it casts doubt on the social efficacy of such theory.

Class is the great underlying force of this common ground, but few artists deal imaginatively with the issue. The ongoing internal and generational reinventions of national identities in conflict with ongoing external cultural and political pressures are what makes the "hybrid state" personified by the two Irelands and the two Mexicos so compelling for both insiders and outsiders. The two Irelands are self-explanatory. The two Mexicos were also once one. The mythical Mother Ireland is paralleled by the mythical Aztlán, and a deep longing for these respective homelands is one of the connecting threads. The land itself continues to represent an indigenous past while industrialization represents the neocolonial present. In both cases the north has been separated from the south, and has become in the process the site of contested loyalties, language, and art.

Although place is not the overt theme of much of these artists'

work, it surfaces within the exhibition's framework of national borders and border-crossing. Chicana/o artists in the U.S. are at home. For all its urbanity, *Chicanismo*—a culture in itself—is landbased, even as the land's name has changed from Aztlán to New Spain to Mexico to the U.S. One of the precepts of *El Movimiento* from the 1960s on has been blood connection with the native populations. The artists' ties to Mexico vary in depth and precision, and are sometimes ambivalent. Shaped by internal exile, a part of and apart from 20th-century Mexico, Chicano culture can be a mystery to Mexicans, even though many Mexicans have had the experience of being simultaneously Mexicans and Chicano. (Border *Brujo* Guillermo Gomez-Peña has been the most original spokesperson for this third-stream identity (*Mexichicanidad*, both or neither).) Progressive Central and Latin American immigrants also identify as Chicanos; the popular song "Salsa Chicana" welcomes Puerto Ricans, too. The permutations can be dizzying, recalling the absurdly elaborate lists of "castes" in colonial Mexico, when each possible *mestizaje* had a separate name.

Max Benavidez speaks for "a migrant consciousness that constantly crosses the intersections of opposed cultural fields." Mexican artist Rubén Ortiz Tórres says his work describes the confrontation and contradiction of a religious, magical world and a world driven by progress. It is at these shared crossroads that the increasingly sophisticated and "postmodern" Chicana/o artists, in increasing contact with their Mexican colleagues, have come into their own.

Irish artists in England, on the other hand, are either exiled or coming home, depending on their ancestry, their class, and their politics. Do Irish artists whose families have been in England for five or more generations (as many Mexican American families have been in the U.S.) perceive themselves as Irish? "The nationalist myth elevates to a birthright the fantasy of being rooted," writes Mary Hickman, remarking how much more complicated the situation becomes when emigrants move to "the former colonising power." Luke Gibbons notes that the "need to define themselves as white presented itself as an urgent imperative to the degraded Irish arriving in North America after the Famine," a need that sometimes resulted in "redneck" and "cracker" racism, despite intermarriage with both African and Native Americans. (The same might be said for those

often upscale "Hispanics" who deny any Indian ancestry.)

The missing link here is the Irish American. As the economic magnet that attracted the Irish in the 19th century and Mexicans in the 20th century, the U.S. is the place where they come together (as was Mexico itself at one point in history). Although the two diasporas have dissimilar histories, the addition of artists of Irish ancestry who have active and/or activist relations with Ireland (Peter Courfain, for instance) or Irish artists who have long lived in the U.S. and have acted as bridges (Patrick Ireland and Anna O'Sullivan, for instance) would extend the spiral.

A border has no identity of its own, but is a hybrid in itself, defined by what it brings together (what is bound by the boundaries) and what it keeps apart. The U.S./Canadian border has a very different character from the U.S./Mexican border, racism and economics being major components along with culture. The Irish/Northern Irish border has long been a war zone of another caliber, and the underwater Irish/British border is both historical and subliminal.

In the North American art world, over the past decade of rising intercultural consciousness, the very word "border" has become a cliché, but Rubén Martínez's voice from the frontlines of border-crossing, back and forth between L.A. and D.F. and El Salvador, restores some of its significance: "Everything and everyone is crossing the line that stretches for 2,000 miles between Mexico and the United States. AT&T and the Indian teenager from Oaxaca, Mexican-produced automobile parts and MTV *en español*" (and, one might add, Frida and Lupita, Popo and Ixta, Pop art, Ninja Turtles, and that other Madonna). While Ireland is an island, and its history reflects that geographical fact, Mexico has always been a bridge between continents, culturally Southern/Indian American ("*nuestra America*" as José Martí put it) and geographically North American. Drawing a direct Irish parallel doesn't work. As Gerry Adams writes, "this term 'two traditions' or 'two cultures,' is incorrectly and often deliberately used to describe what are in fact two different and conflicting political allegiances Loyalist leaders who express hostility to the Irish language are denying their own past." If Irish art is fundamentally European (Celtic culture having been a formative factor in several of today's nations), Mexican art remains poised in a potentially central place that sometimes

resembles a limbo. "Seen in the best light," writes Rubén Martínez, "Mexico is embracing the otherness that it had rejected for so long, both the other of the North (the United States, with its culture of individualism and tradition of democratic debate) and the other of the South (the Indian's mystical and communitarian millenary culture)."

The borderless world is a longstanding vision all the more yearned for in this millenial moment of lethal nationalism and archaic feuds. (Paradoxically, "Distant Relations" an exhibition of nationally defined art, suggests transculturation as a goal.) Ambivalence is the only sensible approach to nationalist identity in a century when nationalism has done immense harm but has also provided the glue for much-needed and eventually imperfect revolutions. These in turn illustrate one of postmodernism's most significant insights—the ways in which all communities and nations are at least in part invented or "imagined."

Many of the writers and artists included here insist on the role of memory as a component of resistance against a dominant culture bent on absorbing all difference. This is an interesting phenomenon in which both politics and religion have drawn attention to a past that people in general are ready to forget as they get on with their daily lives. Memory, of course, is as manipulable as history itself, but where history tends to be associated with imposition from the outside—by the state, teachers, religious institutions—memory is associated with the stories of a personal/communal past. Within the life of each person (especially those who are land-based), histories vie with stories, teachers vie with grandmothers, received information vies with lived experience. Artists from everywhere often bank on the hope that memory can subvert and sometimes change history.

If history is associated with text, memory is associated with image, with a full panoply of the senses. This is where art comes in. Art and politics are both acts, acts of faith, although conventional wisdom sets them against each other: "high" art is opposed to "low" art, much-schooled to self-taught, "private" to "public," "universal" to "local." Whereas some artists work blissfully unaware of all these conflicting forces, and many prefer to ignore them and go with the art market flow, the most vital work results from attempts to juggle them, and in so doing to develop a hybrid practice in which dissonance and harmony get equal time.

The conscious artist is both subject and object of her/his own work. Mexican Silvia Gruner says her title *Don't Fuck With The Past, You Might Get Pregnant* is like "something your mother would tell you! . . . I inhabit a space that is an archeological site—it informs my reality." At the same time, the information is only partial: "My work is always a fragmented place; it's a place that basically is filled with *tepalcates*, these little pieces of clay that can be found everywhere," but cannot be reconstructed.

On the Irish side, Willie Doherty also refuses any illusion of totality. He says his photographs "do not propose any evidence of truth. . . . Their job is to be there. They occupy space in an uncertain present, a past which is in the process of being denied and a future without history." In contrast, Chicana Amalia Mesa-Bains's installation, *The Circle of the Ancestors*, is affirmatively reconstructive. Chairs sitting in for eight historic women, eight historic moments, representing the collective strength to be gained from intimacy, face a spiral (also a major Celtic symbol) of candles on the floor, the configuration of "a spiritual and cultural geography as Mexicana/Chicana women."

Frances Hegarty's videowork, *Turas*, seems to fall somewhere between these two positions: ". . . linguistic and symbolic ciphers in landscape are used to trace an eroded Irish language and culture. The central signifier is the river," its "epic narrative function" countered by the internal landscape where "the Mothertongue reasserts itself." And in turn this river is paralleled by Alice Maher's *Folt*, a river of hair, different strands braided together by a marvelously visual and multivalent Irish word that means "abundance, tresses, weeds, forests of hair."

Guadalupe provides another syncretic river image: in the Moorish Arabic dialects used on the Iberian peninsula and carried to the new world, it means "banked river" or "river running through a ravine." For Mexicans and Chicanos, the Virgin of Guadalupe, La Lupita—star of altarpieces, *almanaques*, murals, candles, demonstration banners, tattoos, and jewelry—has served both as a conservative icon and a revolutionary inspiration. For Chicanas in particular she is the latter, the Indian virgin, daughter of Tonantzin. (The Irish Saint Bridget or Bride has a similar cross-religious genealogy.) Icons like Guadalupe and La Malinché, Mother Ireland and Queen Mab, Chaac Mool, Quetzalcóatl, and Cuchulainn—or Ché Guevara

and Bobby Sands, Frida Kahlo, and Bernadette Devlin—are mnemonic shorthand, offering mixed signals despite their homogenization, apparently inexhaustible despite their aesthetic overuse and commercial abuse.

Any image, any myth is vulnerable to reinterpretation, the shifting meanings on the postmodern seesaw. The notion of substitution as a visual and political strategy is raised in David Fox's lovely story about a Republican in whose home hangs a Constable (is there a pun there?) by day, and an IRA image by night. Both would classify as kitsch, under the circumstances, and raise the specter of secret art shows or secret content in outwardly bland art, a revolutionary ploy often used in repressive situations. Native American artists have proved particularly adept at a related strategy, the subversion of stereotypes treasured by the dominant culture.

When the same mythologies are drawn upon by different factions (or by different aesthetic intelligences), a kaleidoscopic image appears. James Turpin points out (in *Circa*, Fall 1994) the ways the ancient warrior legend of Cuchulainn, resurrected as a product of the Irish cultural revival, has been drawn upon by diverse interests in Ireland, appearing, like Guadalupe, in airline ads and sporting trophies as well as a memorial to the 1916 Rising and in loyalist murals. The persistence and survival of such empowering popular images has been an object lesson for artists, who have appropriated their vitality in both condescending and respectful ways. It also suggests a very contemporary (and possibly evasive) way of seeing —through a television-like barrage of interchangeable meanings. Politics is all too often hidden behind ambiguity, which is in turn validated by theory that throws the baby out with the bath water by using the notion of "hybridity" as just another way of wiping out newly empowered identities.

Popular culture is a significant source for many of these artists, incorporating photography, artisanry, and so-called kitsch. In Ireland (and perhaps in Chiapas, where Subcomandante Marcos writes his communiqués from the mountains to the world on a laptop computer plugged into the cigarette lighter of a beat-up truck), the new myths created by the media are as important as the ancient myths. Joan Fowler observes that in Ireland, "the scenario after twenty-five years was that the ultimate sign of the conflict, violent death, had been reduced to theatrical funerals specifically stage-managed for the media and its distribution system."

Much current progressive art is also overtly theatrical in its need to communicate, such as Daniel J. Martinez's spectacular interventions into the world of spectacle (his Whitney Museum "tags") and "the urban drama" (his parade piece for the Chicago "Culture in Action" project, where he "orchestrated chaos" in collaboration with 500 local people and composer VinZula Kara). Philip Napier's multimedia installation *Ballad no. 1*, with its palimpsest of references to past and present, *banshees* and hunger strikes, characterizes the importance of photography and its avant-garde mutations to the Irish and Irish-in-Britain artists in this show. For Irish artists, the camera becomes witness and surveillant, a contradictory double symbol of internal liberation and external oppression.

Although Mexican photography is also a flourishing field, the Mexican Chicano/a artists in this exhibition tend to be drawn more to the popular arts. John Valadez's big and often brutal paintings of *barrio* street life and people, for instance, pack much more of a grass-roots wallop than the photographs or journalism they depart from. ("I'm doing urban Mexican art," he writes. "In L.A. it means/don't blink/underclass/clean dishes/cholo logic . . .") John Kindness is the satirical populist among the Irish contingent; religious wars and class wars and objects dissed and dismissed by high culture are grist to his allegorical mill. His *Belfast Frescoes* are an attempt to restore respect for ordinary life and labor in the North before the latest phase of the Troubles began.

David Lloyd sees kitsch and folklore/folk art as two different responses to the longing for authenticity, to the search for sameness that provides community: "Nowhere are the deracinating and alienating effects of capitalism felt more powerfully than in communities whose histories are determined by domination, displacement and immigration, for whom ruins are the entirely just and not merely figurative indices of living dislocation." The "neo-Mexicanists," however, recycle the popular signs of *Mexicanidad* in a tone radically different from the ways most Chicano/a artists use similar imagery. The deliberately vulgar and in-your-face class defiance of Chicano *rasquache*, about which Tomás Ybarra-Frausto has written so elegantly, is appropriated by the well-educated, well-traveled internationalist Mexican Julio Galan, for instance. Channeling an earnest communal tradition into a narcissistic expression, he uses the mannered formalism of

vernacular art, and its class origins, to convey a rebellious and incongruous homoeroticism within an internationalist art historical framework.

Olivier Debroise points out that Javier de la Garza subverts identity assumptions by exposing the essentially "libidinous force behind the ideological constructions of propaganda art . . . (repositioning) patriotic and religious symbols"—those of the tourist industry, of folk traditions, and of the muralist tradition idolized by the Chicano movement. By doing so, writes Debroise (in the catalogue of a one-man show at Cavin-Morris, New York, 1992), de la Garza "shows how Mexican culture was invented, how it has symbolized itself, over and over, and now once again, with these new altars to our daily idolatry."

While the tug of ancient mythologies—Celtic, Mayan, Toltec, Aztec—no matter how distorted by distance and commercialism or intentionally demythologized and satirized by artists—is one profound connection between Mexican/Chicano and Irish art, neither the political nor the spiritual are overt elements of much of the art in this show. In 1984, when I spent some time in Ireland selecting an exhibition, I had to revise my expectations of Irish political art; I found that artists, like everyone else, were just plain tired of the Troubles. No visual strategy seemed to affect the tedious destruction. Similarly, I had to disconnect my own fascination with Irish prehistory, and take the word of Chris Coppock, who wrote (in *Circa* no. 14, Jan.-Feb. 1984), "the future of Irish art lies in the abandonment of myths—and that includes modernist ones." Both romanticism and formalism have at times inclined toward fascism.

I have a few Irish forebears, but more of them are English. Working in a Mexican village in the late 1950s was my first intercultural experience, my first glimpse of the Third World and syncretic culture. Now I live near the northern border of Aztlán. So what? Almost anyone could weave herself into this narrative. We're all implicated. As I complete this essay, various doors open and slam closed: the "framework" for a new constitution is proposed in Ireland, the president of Mexico has pulled back (at least temporarily) from a military confrontation with the EZLN (Zapatistas), and a federal "English Only" bill is introduced in the U.S. Congress to keep company with California's racist Proposition 187. How will artists respond? Will artists respond? What will be lost if they don't?

Different ghosts haunt European and American histories, and memories are oceans apart. In fact, despite the global art market, the culture-specific contemporary arts emerging from Ireland, Mexico, and the U.S. are so unlike each other that what may finally be most interesting about this exhibition is the dissolution of the original idea. Bringing groups of artists together because of similarities becomes most compelling when centrifugal dissimilarities break them apart again. Perhaps art about borders is a prelude to reconciliations, to the erasure of borders.

Perhaps in some as yet only dimly imaginable future, it won't matter if I'm in the North or the South. Perhaps one day "south" and "north" and "east" and "west" will be archaic references to a primitive, bordered world where nationalism and economic tension pitched the planet into chaos.
—Rubén Martínez

. . . the escape from cultural enclosure and openness towards the other might take the form of "lateral" journeys in which subaltern cultures short-circuit the western axis and speak directly across the colonial divide.
—Luke Gibbons

IDENTITY/HYBRIDITY:
IDEAS BEHIND THIS PROJECT

Trisha Ziff

We live in a confusing world of criss-crossed economies, intersecting systems of meaning and fragmented identities. Suddenly, the comforting modern imagery of nation states and national languages of coherent communities and consistent subjectivities, of dominant centers and distant margins no longer seems adequate. . . . we have all moved irrevocably into a new kind of social space, one which our modern sensibilities leave us unable to comprehend.[1]

Introduction:

It is four years since this project began to evolve, and as it begins to take shape just a few months before the exhibition opens at the Ikon Gallery in Birmingham, I am also entering the last few days of a long-awaited pregnancy. I know I am going to have a boy—we, that is my partner Pedro and myself, have decided to call him Julio Ernesto Patrick. His father is Mexican, his mother English, and he will probably grow up in California. Like many children today, his identity will reflect the complexity of the world he arrives into. How will he describe himself?

My son will be born into a new era, far less clear than the postwar world I arrived in forty years ago. Identity can no longer be defined by geographic borders—they mean less and less—and yet despite this, nationalism remains a powerful focus. Perhaps it is the erosion of what distinguishes us that makes our desire to place ourselves even more intense. Information, emigration, communication, and new technologies are redefining our worlds at an ever-increasing speed, and although we remain products of our histories, defined by class, colour, religion, and language, we are also caught up in these new nets and webs of change. Our cultures meet, cross, interact, influence. What emerges are new hybrid forms, from language to ritual, "high" and "low" art forms: kitsch, *rasquache*,[2] Irishness, and *Mexicanidad*. The Mexican/Irish relationship explored in this project

1 Roger Rouse, "Mexican Migration and the Social Space of Postmodernism," *Diaspora* 1, no. 1 (1991).

2 *Rasquache* is a Chicano term equivalent to kitsch that has been defined by Tomás Ybarra-Frausto as "an underdog perspective . . . it presupposes a world view of the have not, but it is a quality exemplified in objects and places and social comportment." It also refers to "bad taste" and a self-conscious recouping of a perception of inferiority. See Amalia Mesa-Bains, "*Domesticana*: The Sensibility of Chicana *Rasquache*," p. 156.

is not unique, but a specific example of the "border-blurring analyses that fuel the postmodernist pastiche," described by Lucy Lippard in her introduction, "Distant Relations."[3]

The idea for this publication evolved over the last two years. Our intention has been to create an anthology of critical writing reflecting parallel issues to those addressed by the participating artists. Lucy Lippard synthesises the ideas behind this project in her introduction, and authors Cuauhtémoc Medina, Joan Fowler, and Max Benavidez have written specifically about the artists. Other essays included provide a framework, extending the themes and issues of colonialism in which this exhibition is sited into a broader context.

In editing this anthology we were confronted by the issue of which version of the English language we should use: European English (the English written by the authors from Ireland and England), or American English (used by the Chicano and Mexican writers), a choice made more complex by authors Garrett O'Connor and David Lloyd and myself who now write in a hybrid style of both. The histories of our own lives are reflected through the placement of our dots and commas, z's or s's. Certain spellings and punctuation that the reader will come across are not proofing oversights; they reflect evolving forms of the English language as it has changed from "home" to "colony" to "diaspora."

The artists, authors, and composers participating in this project come from different sides of the world: Ireland and Mexico; England and the United States. What they share in common is how their work has been marked by the experience of colonialism, whether as members of a dominant culture, whether they emigrated and became part of a minority culture far from home, or whether they were born in a country where the dominant culture was not theirs. All the contributions to this project are marked by the colonial experience. It is precisely this experience that places these contributors outside the mainstream; it is their knowing the edge, the border, the periphery, the sense of exile from the dominant point of view that drew me to their work. These experiences emerge through the essays reproduced in this anthology, the artwork in the accompanying exhibition, the sounds and music recorded on the enclosed CD. Some of the texts and work reflect personal experiences and intuitive responses; others are more

3 Lucy Lippard, "Distant Relations," see page 15.

theoretical or analytical in both their form and content. This project is about identity, culture, and colonialism, a dialogue relevant to the Irish and Mexican experience.

Why Ireland and Mexico?

In her introduction to this book, Lucy Lippard eloquently explores the common ground between Ireland and Mexico, looking at the cultural, colonial, and historical parallels. Since this project was initiated four years ago, this common ground has shifted dramatically, yet the parallels remain in place (although moving in opposite directions): peace talks in Ireland, rebellion in Mexico, economic development in the south of Ireland, post-NAFTA economic chaos in Mexico. These events have affected both the form and content of this project, at moments throwing its very existence into jeopardy, and demanding of the artists and authors alike a need to address these changes within their work.

Unapproved Roads[4] and Superhighways:

Five years ago, while driving through the back roads of the Mixteca Alta region of Oaxaca in the south of Mexico, my thoughts were constantly interrupted with images from earlier travels through the wilds of Donegal and Bloody Foreland in the northwest of Ireland. Listening to the spoken pre-Hispanic Mixtec language transported me back to the Gaeltachts in the west of Ireland, shrinking communities of traditional Irish-language speakers. Colonial languages (both Spanish and English), have replaced Irish, Zapotec, Mixtec, Tzotziles, and Tzeltales, and many other Indigenous idioms. They have become endangered languages, which will eventually disappear without conscious efforts to preserve them. Gerry Adams in his essay *"S é an rud é, cultúr, ná an méid a dhéanann sé (Culture Is What Culture Does)"* describes the contemporary Irish language movement as part of "the reconquest of Ireland"; he sees the rekindling of interest in the language as inseparable from the nationalist desire for reunification, North and South. Elena Poniatowska, in her text "Subcomandante Marcos and Culture" writes about the Zapatistas' demand that all fifty-seven Indigenous languages be made official Mexican languages. The government, while vigourously celebrating its Indigenous heritage, deprives

4 Luke Gibbons,
"Unapproved Roads:
Post-Colonialism and
Irish Identity," see p. 56.

many groups of Indigenous peoples within Mexico of their basic rights to land, education, and health care. Cuauhtémoc Medina, in his text "Irony, Barbary, and Sacrilege," writes:

The government of the world's oldest revolution attempted to alleviate the absence of an image of the future by trying to reaffirm the thesis of the continuity of the culture's past without conflicts or divisions, since, from the perspective of power, Mexico is an entity where massacre and pillage are hidden behind an image of docility.

The Ejercito Zapatista Liberacion Nacional (EZLN) in Chiapas in southern Mexico is clearly aware of the differences that separate them from modernity. As the first liberation movement to emerge in this post-Cold War era, they have managed to capture the attention of the world. Their world, on the other hand, is isolated, remote; nothing much has improved in the last 500 years for the Indigenous peoples of Chiapas. Yet, despite their lack of access to electricity, formal education, health care, basic resources, they are linked to the rest of the world via the Internet; a modem has become their most effective weapon. As they walk from one village to another passing on information, and maintaining control of Zapatista-held areas, they keep the rest of us informed via the superhighway.

Along the back roads of rural Ireland, two architectures dominate: tumbledown ruins of stone "famine cottages" stand within view of modern ranch, country, and western-style bay-windowed farmhouses built with funds from European grants designed to ebb the flow of people deserting the farms for the cities. Replete with satellite dishes, their inhabitants receive CNN and reruns of old American sitcoms. In Oaxaca, Mexico, on the other side of the world, crumbling adobe homes mark abandoned *pueblos* where the young and able-bodied have left, first to the city, then to the capital, and then northwards to the United States: migration, then emigration. Many return to build new homes for those who stayed behind and for their own old age.

Breeze block replaces adobe; those who can afford it install electricity, water, and even satellite dishes, where they watch the same news reports and sitcoms as in Ireland. Power Rangers, Ninja Turtles, Lion Kings, and Pocahontases are transformed into piñatas in Mexican markets, defying international copyright, to become the characters of the

latest children's street games.

This exhibition of Irish, Mexican, and Chicano art was conceived as a dialogue to explore the parallels of these cultures in the context of their colonial experiences, rather than as a survey exhibition. The twelve participating artists were chosen primarily because the ideas that drive their practices complement one another and echo parallel themes. There are many fine contemporary artists working in Ireland, Mexico, the United States, and England, whose absence from this show is only a reflection of the limitations placed on any exhibition.

After much discussion in the early stages of the development of this project, I chose to limit the group of artists to four geographic centres: Ireland, Mexico, California (Chicano), and England (Irish diaspora). The obvious omission was the exclusion of Irish American artists. The clear parallel I found was between Chicano artists of Mexican descent and Irish artists in Britain. Both groups of artists clearly identify themselves with their cultural histories and see themselves as working outside of the mainstream: participation without assimilation. Their work and concerns are primarily informed through their experience of colonisation, exile, memory, and myth. The majority of Irish American artists have through time become absorbed into mainstream American culture, and while individual artists like Mark Alice Durant, Patrick Ireland, and Michael Tracy reveal through their work a conscious relationship to their Irish heritage, their experience as Irish Americans today does not place them outside the dominant culture in the way in which Chicana/o artists have systematically been excluded or Irish artists in Britain have been marginalised. Irish people in Britain and Chicanos/Latinos in the United States share a common experience of discrimination, politically, economically, culturally, and linguistically.

Proposition 187, a California statute introduced in 1994, was designed to undermine and destabilise the Latino community. Rubén Martínez, in his text "The Tense Embrace of the 'Other'," describes how Proposition 187 "clearly targets one ethnic group . . . and sets in motion forces that have already begun to affect not only those 'illegals' that the law singles out, but anyone with a brown skin or with a slightly accented English."

The border between the United States and Mexico is not a natural border, but a political and economic space where the first and third worlds

meet. Separated by a thin no-man's-land, heavily patrolled by police, helicopters, and constantly updated border architecture, it looks more like Berlin than Southern California, more like South Armagh, bandit country, just on a larger scale. Depending on the political or economic climate on the U.S. side, the border becomes more rigidly defined or withers away into mere formality.

The majority of Mexican people are driven north because the economy at home is not able to sustain their basic needs. In the United States there is a possibility of work, and at times the opportunity to save and send money home. For young people, crossing the border is also a rite of passage, an adventure. Those who return bring back the spoils of their personal conquests: electrical goods, videos, and new ideas. Traditions back home are influenced by these new experiences, and the past syncretism with Spanish culture shifts; new hybrids emerge, a blend of Indigenous, Spanish, and North American, which influence every aspect of daily life.

This works both ways; as author Juan Villoro writes, "East L.A. is the second largest Mexican city and guacamole is the second favorite snack for Superbowl Sunday." The long and meandering U.S./Mexico border extends northwards into the city. Los Angeles is no different than Belfast in this respect, a city divided, separated by motorways (freeways). "There are those—mostly older, white Americans—who would seal off the border with Mexico and the rest of Latin America," writes Rubén Martínez, "because they fear being overwhelmed by the immigrants."

In Britain, the Prevention of Terrorism Act (PTA), an act of parliament introduced over twenty years ago and ratified each year, discriminates against all Irish people entering Britain, and has created a climate of intense suspicion towards anyone with an Irish accent. The institutionalised racism of the PTA has (in identical ways to Prop. 187) attacked the Irish in England, who from an Anglo perspective are perceived as a suspect community.[5] The PTA allows for people to be arrested and held for up to eight days without being charged. In reality this law is used to harass young Irish people, predominantly at ports of entry. Mary Hickman writes in her essay "Differences, Boundaries, Community: The Irish in Britain," "The way in which the PTA was implemented fueled anti-Irish racism, with the oft-repeated injunctions of the police after various incidents to 'Keep an eye

5 By the end of 1991, 7,052 Irish were detained under the Prevention of Terrorism Act; of these, 6,097, or 86 percent, were released without being charged. For more in-depth information, see Paddy Hillyard, *Suspect Community: People's Experience of the Prevention of Terrorism Acts in Britain* (London: Pluto Press, 1993).

on Irish neighbours and watch out for Irish accents'."[6]

The psychological effects of such discrimination, coupled with transported residues of colonial oppression, have created complex problems of denial and shame in diasporic communities. The residual effects continue generations after independence.

Dr. Garrett O'Connor, writing for this anthology in his text on "Malignant Shame," describes impressions from his own childhood:

At school, the Irish history I was taught included robbery of our lands by plantations of English colonists, deliberate impoverishment of Irish Catholics through the Penal Laws, and near-elimination of the Irish peasantry by planned neglect and forced emigration during the Famine. Despite this knowledge, I had by the age of eight developed a conviction that England was a source of higher (and better) authority on nearly all matters except Catholicism. In my early teens I came to believe that everything Irish (including myself) was in some way defective or second rate in comparison to England.

The Artists:

The satirical visions of Mexican artist **Rubén Ortiz Torres** and Irish artist **John Kindness** share a common visual language. Ortiz's *Baseball Cap Series* and Kindness's *Ninja Turtle Harp* are ironic and contradictory icons of popular culture reinvented within a framework of history and nationalism creating bizarre self-conscious hybrids. Ortiz's baseball caps are transformed from fashion accessories into fine art objects; symbols and letters, signifiers of allegiance, are converted into sociopolitical commentary; **LA** becomes ChiLAngo;[7] an **X** in reference to Malcolm X becomes MeXico. The symbol of the "Fighting Irish" becomes a memorial cap to the San Patricio Brigade. Commenting on his work, Ortiz has said:

In Los Angeles different sports teams emblems have been reappropriated by different local communities and gangs. Bloods wear red like the Chicago Bulls, and the Crips wear blue from the sportswear of the Georgetown Hoyas. Chicanos like to sport Cleveland Browns paraphernalia, giving expression to pride in brown color, while L.A. Kings caps are now associated with Rodney King and Martin Luther King Jr. . . . by altering, recodifying, and recontextualizing signs already

6 Dr. Mary J. Hickman, "Differences, Boundaries, Community: The Irish in Britain," see p. 44.

7 *Chilango* — slang, a person from Mexico City.

given in baseball caps, I want to comment on the relation between aesthetics and history, mass media, culture, fashion, politics, etc. . . . [8]

John Kindness has previously stated, "I am always bemoaning the fact that there is so little art being made about daily life. Something in the art world despises the details of living on the edge of the capitalist abyss. For this reason political humour in art is a scarcity, since one has to know life to dissect it." [9] Kindness's work might be termed *Irish Rasquachismo*: Ninja Turtles, fragments of merchandising, symbols of American culture are fused with the symbol of Ireland—the harp—resulting in a sculpture that humorously juxtaposes the so-called "purity" of national culture against the perceived negative influences of the invasion of American culture. The warring ninjas fighting amongst themselves as they clamber up the front of the harp are a less than subtle reference to the "troubles" in the North.

Mexican artists **Silvia Gruner** and **Javier de la Garza** are also preoccupied with nationalism. Like Kindness, they use icons entrenched in the nation's psyche to comment on issues of cultural identity. They recycle objects of Mexico's archeological heritage, from the splendid Olmec heads and Chaac Mools depicted in de la Garza's paintings to the shards of pottery collected by Gruner, who binds them together to create new fictional goddesses, investing them with new meanings and fabricated mythologies.

In de la Garza's paintings, these objects become Warholesque symbols of popular culture, self-conscious surrogates that appear lost in their new environment. As art historian Olivier Debroise noted in a 1992 catalogue text for the artist, "Javier de la Garza's work is situated on a razor's edge, on a border between what is technically kitsch (or neo-Mexicanist) and what can be read as bitter criticism of the Mexican cultural scene which revolves around these signs of identity." [10] De la Garza's paintings play with the ambiguous positioning of Mexico as it fluctuates from representing itself through its past and heritage, and presenting itself as modern. The confusion cries out in his painting *HELP!*, which although painted in 1992, takes on a prophetic quality in 1995 as Mexico lurches from one crisis to another in its post–NAFTA chaos.

Objects that are sacred in one culture become kitsch objects of mass appeal in another. The Virgin of Guadalupe and Frida Kahlo are transformed in the United States, becoming objects of mass consumption:

8 Armando Rascón, *Xicano Progeny, Investigative Agents, Executive Council, and other Representatives from the Sovereign State of Aztlán* (San Francisco: The Mexican Museum, 1995), p. 17.

9 Lucy Lippard, "Critical Kindness," in *Treasures of New York* (Dublin, Ireland: Arts Council of Northern Ireland, Kerlin Gallery, 1990).

10 Olivier Debroise, "Javier de la Garza: fusiones," in *Javier de la Garza* (Mexico City: Galería OMR, 1992).

stencilled onto denim jackets and sold as earrings, the merchandising of these images resembles the latest Disney film. The potato, a cultural symbol of the Great Famine of 1845, Ireland's holocaust, is recreated in the United States as a chocolate "spud" packaged with leprechauns and sold for St. Patrick's Day, like an early Easter egg. Everything is recoupable; nothing is sacred.

David Lloyd, in his essay "The Recovery of Kitsch," writes: *An irrepressible conundrum mocks national cultures, all the more so when, overshadowed by more powerful neighbours, culture is all the nation has to distinguish it. That conundrum is the apparently inevitable declension of the icons of authentic national culture into kitsch. The images proliferate: round towers and wolfhounds, harps and shamrocks, la Virgen de Guadalupe and pyramids in Yucatán, Aztec masks and feathered serpents. And they have their histories, disinterred and shaped in the projects of cultural nationalism to symbolize the primordial origins of the spirit of the nation, la raza. But long before their visible commodification as signals of safe exoticism deployed by our tourist boards, breweries, or airlines, the logic of their standardization and circulation was embedded in the nationalist project.*

Artist and author **Amalia Mesa-Bains,** in her essay *"Domesticana:* The Sensibility of Chicana *Rasquache,"* sees the appropriation of everyday objects as a self-conscious act: "The political positioning of *Chicanos* emerging from a working-class sensibility called for just such a defiant stance. Raised in *barrios,* many *Chicano* artists have lived through and from a *rasquache* consciousness."

Mesa-Bains has been both a producer and protagonist of Chicano/a work for many years. Using traditional art forms practiced predominantly by women, she describes herself as having "created a hybrid form of ephemeral installation." Her work has an urban sensibility, loaded with ephemera from markets and swap meets. She consciously uses objects associated with women's personal space in her installations—knick-knacks, jewelry, photographs, beads, boxes, religious prayer cards—that evoke the familiarity of a mother's bedroom or a family kitchen. For this exhibition these altars have been transformed from a shrine and take the form of a circle of chairs, entitled *The Circle of the Ancestors.* Each chair is symbolic of a different woman, historical and personal, real and mythical,

heroines and anonymous women within Chicana culture. Describing the piece, Mesa-Bains says this series "extends this *Domesticana* into the importance of women's role in the life of the family, in the history of resistance, and in the tradition of labor connected to the Mexicano/Chicano cultures."

Ritual and counter-ritual are themes that echo throughout the work of the women artists. Through her use of candles and chairs (both are objects that function as symbols of absent people), Amalia Mesa-Bains creates a memorial, embedded in the traditions of her own Chicana culture. While Mexican artist Silvia Gruner—in her sequence of still images taken from video—is engaged in the process of rupturing history, she also appears to deconstruct ritual. Her physical intervention with the objects functions as the antithesis of Mesa-Bains's work—the destruction of her created object, the fictional fertility goddess. Alice Maher, in her work *Folt*, alludes to myth and ritual in her sequence of drawings of hairstyles that take the viewer again into the private space of women—the bedroom or bathroom —to conjure up fantasies of combing, braiding, and pinning hair. At the same time we are reminded of the mythical role of women's hair in western culture: Medusa, Rapunzel, and the seduction and destruction from the male gaze. In *Turas* (Journey) by Frances Hegarty, the ritual return is present throughout the piece—reflected through the gathering of water from the Foyle river and the repetition of the Irish language.

The work of all these women artists is informed by their own histories and experiences, and while this exhibition addresses broader issues of cultural identity, these artists do not separate issues of cultural identity from gender or personal history. This is not the case for the majority of the male artists in this exhibition, whose work functions in the public arena more than it reflects their own histories. It is interesting to observe that, despite the very different visual languages adopted in their practices, all these women artists see gender as being integral to their expression.

John Valadez is based in Los Angeles, California. He is a painter, and for him the ritual of painting is crucial to his practice. He is primarily involved in making public art works that take the form of complexly constructed murals depicting the history of the Mexican American community in the USA, and the political and cultural development of the Chicano movement. This work is painstakingly slow, and the commissions take three

or four years to complete. His personal work is on a smaller scale, and allows him to take more risks. In recent years, his pastel and oil paintings have intimately explored ideas concerning his identity and sexuality, reflecting on both the power and shame of the Latino male. The shame he describes is an internalised racism, as a Mexican born in California, of not speaking Spanish, of a sense of inferiority foisted on him from the mainstream community. Max Benavidez, in his text "Chicano Montage," describes Valadez as angry; Valadez describes himself and his work as a product of "schizo-ethnicity."

Daniel J. Martinez belongs to a new generation of Chicano cultural activists. He works with a multitude of different media in his site-specific installations, employing video, photography, sound, and found materials. He argues that political action and making art are intrinsically linked. His work leaves a trail of thought-provoking debate and action behind him as he moves from one project to the next: he is "a cultural provocateur."

Martinez grew up in postwar Los Angeles, a time when the pressure to assimilate—the melting pot theory—was at its most intense. Cut off from his own Mexican heritage and language, he experienced a sense of loss similar to Frances Hegarty's experience in England. Martinez has always felt that it is important to employ new methods to communicate his ideas. Influenced by the Situationalists, he rejects stereotypical Chicano art forms from his practice, fearing that they might entrench the view of Mexican Americans as quaint, exotic, and folkloric.

Martinez operates on two distinct scales. He creates large site-specific pieces, such as his temporary installation at Cornell University, *The Castle Is Burning* (1994), where a high wall separated one half of the university's quadrangle from the other. (The work became a catalyst for existing campus grievances and was reported on in the *New York Times* when it was attacked by right-wing students; this, in turn led to a student sit-in in support of the piece, an action that culminated in the establishment of a Chicano Studies program.) His smaller scale works have been equally controversial; for the 1993 Whitney Biennial, Martinez produced new admission buttons for the show. On each button was printed a word, from the statement "I can't imagine ever wanting to be white," a sentiment that directly reflects his own coming to terms with his family history of assimilation.

Event for (class) compression or what defense can one mount against an avalanche is a site-specific installation of sound and video that Martinez will adapt at each venue of the exhibition tour. Through these changing installations, Martinez will explore at various times issues of class, labour, racism, education, and imperialism, as well as the northern Irish and Chicano urban experience. *Event* also deals with the physical separation of communities, a reality as much in the artist's native city of Los Angeles as in Belfast, where walls, borders, freeways, and cul-de-sacs act as barriers between people of different race, class, and ideological allegiance. At the Ikon Gallery in Birmingham, the first venue, images will be projected through gaps in a brick wall, becoming fragmented and distorted projections. These images echo a symbolic pattern of the history of British disinformation in relation to the war in Ireland.

Throughout this project, the issue of language is a recurring theme. Adopting the language of the coloniser, or severing oneself from one's linguistic history in the diaspora occurs for complex and differing reasons, both imposed and self-imposed. Adams describes the decline of the Irish language in the nineteenth century "during which the emerging middle class strongly rejected the Irish language and customs. They embraced the 'new order' and rejected the 'old values'. To succeed meant speaking English. To be Irish was to be ignorant." The Mexican-American experience in the United States is not dissimilar. Where racism and discrimination are prevalent, one way of dealing with this is to repress one's own history and identity. The pressure to assimilate is part of the American experience. Writing about his childhood in Sacramento in the 1950s and 1960s, Richard Rodriguez, in his essay "Irish Catholic," describes his friendship with an American boy, Larry:

Larry scorns me for not taking chances. I refuse to hitchhike. I refuse to smoke cigarettes. I refuse Spanish. And yet, I think, Larry senses Mexico in me; I am his way of escaping Sacramento. But if I am his Negro, he is mine too. His casual relationship to money, his house with a swimming pool, these I take as ethnic traits. What dooms our friendship is that we stare past one another. What he sees in me is innocence, an inferiority complex, Mexico. He is all casualness about the things I intend to have. I want what he claims to discard.

Fionnula Flanagan, in her text "Culture Shock," describes her response as a young Irish actress looking for "digs" in London when she sees a sign in the window of a boardinghouse that reads, "No Coloureds or Irish." *The air is all of a sudden chilled, still. In the eye of that stillness there is no sound. Only the sign. Watching my confusion. To see what I in my Irish foolishness will do. Next. Must tell someone. Who? Panic. Someone. There must be someone to . . . Why is my heart going so fast? Scalding. Tell them. Can't think of. What? Who? Your credentials girl and be quick about it! My-mother's-sister-served-as-a-nurse-in-the-Royal-Alexandras! My-father's-father-fought-in-India!*

Her immediate response is less one of anger but more the need to prove her equality, a sense of inadequacy, inferiority. It is out of these experiences, these "culture shocks," that cultural shame develops. The pressure to give up one's own identity (language and culture) and participate in the dominant culture is enormous.

It is within this context that artist **Frances Hegarty** has made her video installation, *Turas* (Journey). Frances Hegarty was born in Donegal, a native Irish speaker who moved to the north of Britain as a child in the 1950s. This video piece reflects a literal as well as personal journey from the port of Derry on the Foyle estuary back to the source of the river in Donegal. In the nineteenth century, the port of Derry was a major point for emigration, and is the starting point of her journey "home." This work is in part autobiographical and in part reflects a collective memory, moving beyond Hegarty's own personal experience to address broader issues of loss of identity, loss of home, and loss of the mother tongue. The work is cathartic but not sentimental in that it returns the artist to her native land, and she is able to begin to re-establish her identity as an Irish woman. She writes: *I felt shame at the limited access I had to my own history, and the subtleties of the stories, songs and literature that my friends wanted me to "hand on" or document. It also confirmed growing awareness that in order to reclaim what I knew and gain access to my culture and its literature, I would have to reclaim/relearn my mother tongue.*

Writing about her sense of Irishness, **Alice Maher** says: "Sometimes the 'Irish' costume that I wear doesn't fit me too well: either it's too big for me or I'm too big for it. I learned Irish dance as a child. I love

dancing but I don't love wearing stiff artificial garments as a badge of my Irishness. I was born here, I live and work here. My thoughts and works have been influenced by many cultures including my own. . . ."

Alice Maher's work *Folt* is informed by the memories and sensibilities of her rural childhood, which is reflected throughout all her work. *Folt* is an Irish word; it translates as "abundance, tresses, forests of hair." A series of six cases contains drawings, "diagrams" of hairstyles, childlike in their simplicity; they invoke fantasies of little girl's dreams of sophistication —"when I grow up." The female child is a constant theme in Maher's work, whether as an actual presence or symbolic, as in her recent piece, *Familiar* (1994), or *Bee Dress* (1994). Concerning *Folt*, Maher writes, ". . . for adults, childhood is certainly an example of 'another' state and many of the figures in my work are of girl children. In childhood one is truly in a state of flux when anything is possible. Even though big people control the actual world, the child's world is bigger and more real with limitless possibilities."

Folt evokes the hidden world of women where creativity for women was confined to the home, a place of expression and a prison. Accompanying the series of drawings is one case that contains one long braid of human hair pressed against the front of the glass case. The hair, writhing like a frenzied animal trying to free itself, appears to rebel against its own claustrophobia. In contrast to the drawings, this disembodied hair evokes snake-like connotations of Medusa. Here, the hair is wild and real: as Maher writes, "Hair is a culturally loaded material; when it's on our heads it's one thing, but when it's separated from our bodies it becomes a repellent detritus."

. . . The many different meanings ascribed to hair, particularly women's hair, as a culturally significant material are a central part of numerous themes in Western folklore, mythology and consciousness. It is this multiplicity of theme and meaning which is addressed in Folt. *The images are intended to form a catalogue of identities, values, personae, imaginations and choices that girls and women adopt in order to operate within our culture. They could also be seen as a tribute to inventiveness.*

Mexican artist Silvia Gruner has also incorporated human hair into her work, but it reflects different cultural connotations than those mentioned by Alice Maher concerning her work (Rapunzel and Medusa, which are culturally specific to Western folklore). In Gruner's work the

disembodied hair is symbolic of the pre-Hispanic ritual of body sacrifice. In contemporary Mexico, when rural women migrate to the city, many of them cut off their braids and place them on altars in churches, as an offering to the saints. It is an act of contrition and castration as well as a symbolic severing with the past; short hair then becomes a symbolic embrace of modernity. These braids, often grown from childhood, are interwoven with ribbons; thick at the top, they trail into thin, baby-like hair at the tip, tracing the history of personal time.

The series of photographs by Silvia Gruner, *Don't Fuck With The Past, You Might Get Pregnant*, depicts a constructed (fantasy) ritual, created by Gruner. Sexuality, myth, and history are intertwined in these strange constructed idols. "The isolated, anxious gestures of these images are a metaphor for the tentative pursuit one would like to make of identity and history once the official narrative has expired," reflects Cuauhtémoc Medina in his essay "Irony, Barbary, Sacrilege." "It is not in vain: the ancient mythologies tear at us subversively as incest." By presenting us with still images from the video, the viewer is distanced from the artist's inter-vention, and like the objects, the *tepalcates* (fragments), we are left with traces of an event; unable to fully comprehend the meaning of the ritual, we create our own mythologies and construct our own versions of history.

Don't Fuck With The Past, You Might Get Pregnant is an angry title, a warning. Behave! Absorb the official version of your history (be it government or familial history): don't explore your own identity, the title warns, or you might get pregnant, you might be changed, you might grow. Presented as a wall of photographs, resembling a bank of television screens, these ancient objects are thrust into the present: a rebirth. Removed from the context of their own history, they appear lost, swimming hopelessly in their modernity.

Gruner's work forms an interesting counterpoint to Willie Doherty's seemingly empty landscapes. Their work, although emerging from vastly different realities, addresses a similar concern with the way in which history and information are presented within cultural boundaries. Gruner writes: *We are taught in Mexico to look into the past in a very contrived way, and it's a way that assumes many assumptions, not only about a notion of a "glorious past," our archeology, our big culture, the treasures of the*

last thirty centuries, etc., but we are also taught to look at all these things in a very conservative way, as if they were outside of ourselves. This was the way I was taught to look at Mexican culture.

Willie Doherty has been making photography-based works in Derry for over fifteen years. His work is rooted in Ireland's contemporary history of the "troubles," although many of his images convey a timeless quality. In contrast to most photographic images of the "troubles," which might be described as "reportage," Doherty's photographs appear to owe more to a landscape tradition. A documentary photographer whose images are without news value, his photographs are self-consciously understated and often visually anonymous; by superimposing a text onto these landscapes, he changes the way in which the viewer reads the image. He writes: *I am writing from a place with two names. Derry and Londonderry. The same place. Here things are never what they seem and always have more than one name. To understand this duality is to begin to understand how this place functions and lives are lived here. Failure to recognise this duality is to miss the essential dynamic of what has been called a microcosm of the Northern Irish problem.*[11]

The current cease-fire in the North of Ireland, while creating the potential for change, has at this time only facilitated cosmetic changes; some military checkpoints have been removed, closed country roads reopened, and berets have replaced the helmets of the occupying forces. However, the power structures imposed by the British—the troops, the prisons, the armed police force—remain in place. A policy of normalisation initiated in the 1980s is responsible for the current strategy of sanitisation and political gentrification. In the name of progress, recent history is being rendered invisible in the landscape. Doherty's photographs scratch away this veneer.

Doherty's work has always been concerned with the subconscious, the hidden landscape hovering below the surface, the invisible. In the current climate of attempted denial and amnesia of the last twenty-five years, his images take on a new resonance; open-ended, they ask more questions than they reveal answers. Doherty's work continues to move against the dominant flow, his images locate the "psychological relics" of colonialism rather than erase them. Garrett O'Connor, in his text "Recognising and Healing Malignant Shame," is aware of these patterns of post-colonial thinking:

11 Willie Doherty, "Two Names . . . Two Places. . . Two Minds," *Camera Austria*, no. 37: 11-17.

Even though the current peace process in Northern Ireland may soon result in the departure of British troops from the six counties, the occupation of the Irish mind by psychological relics of colonialism, including malignant shame and the capacity for self-deceit contained in the national tendency to say one thing and do another, will continue indefinitely.

Doherty writes of his own work, "Their job is to be there. They occupy space in an uncertain present, a past which is in the process of being denied and a future without history."

Philip Napier is from Belfast, and like Doherty, his work is informed by the current situation; he, too, has lived most of his life in a climate of war. Napier creates his works from the relics of colonialism, be they real or imagined. Like Doherty, he is concerned with the current climate of "amnesia," a term both artists have used in their descriptions of the present situation. He writes, "the interesting thing about living in Ireland is that nothing is perceived as neutral. This is as much a psychological state as it is a built, physical environment." *Apparatus V*, an installation piece commissioned for this exhibition, will continue to explore the ideas in his recent work using computerised "bus signage" and audio equipment; the work will explore iconography of place names in the context of history, past and present.

In *Black Top*, a site-specific work, Napier covered the floor of a Belfast gallery with a tar road surface, a symbolic gesture generating layers of invisible references to labour, history, and the current situation in the North. The act of changing the usage of a space from a public art gallery to a car park is more likely to be the decision of a local government bureaucrat than of an artist; however, in creating this piece Napier drew attention to the way in which buildings change their function, especially in a landscape of bombed-out, burned-out, and abandoned buildings that have accrued over the last twenty-five years. The "official" emphasis on urban renewal as part of the government policy of normalisation and the desire to eradicate traces of the troubles is changing the architecture of the city of Belfast. Today, the city centre begins to looks like any other "English" city, a repository of chain stores and fast food restaurants. In a move to establish normality, the city is becoming anonymous.

The physical laying of the tar on the gallery floor can be interpreted

as a homage to the faceless Irish workers, the "navvies" who built miles of motorways in England and in the North of Ireland for the British government. I have always been conscious of the contrast between the heavily utilised roads in England and the empty motorways in the North of Ireland; one built for traffic, the other for strategic reasons, to shift troops quickly from one location to another. The funding of road building by the British dates back to the time of the Famine in Ireland. As Napier writes, "There remain Famine roads which simply end where the labour died on its feet." Included in this exhibition is his piece *Ballad no. 1,* where echoes of the Famine are relived through the rasping sounds of a bellows-driven image of Bobby Sands. Luke Gibbons describes this piece in his text "Unapproved Roads: Post-Colonialism and Irish Identity:" "By linking the famished body with mourning and collective memory, the off-key image becomes, in effect, a living monument for the Famine and the dark shadow which it cast on the lung of the Irish body politic."

David Fox, an Irish artist and filmmaker living in Britain, takes up the theme of "apparent" change that is taking place in Ireland. He prefers to use the term "smokescreen" in talking about the current situation in the North of Ireland, which for him implies a conscious act, created to prevent people from seeing things as they really are. Amnesia, he argues, describes more the act of forgetting than a willful act of being prevented from seeing.

This series of paintings on aluminum is entitled *Tricolour: Watching Paint Dry.* The work consists of reflected images. Despite the chaos and disjuncture, despite the apparent shift of boundaries, Fox argues that while on the surface the narrative has changed, it has always been an invention; in essence, the power structure remains in place. He writes: *Military conquest, Penal Laws, Partition and "Low Intensity Operations" are easy to see even through the smokescreen. . . . In Ireland we're in a state of suspended animation. So perhaps painting is reasonable in these circumstances. The surface of these paintings is hard and reflective: empty spaces, divided in three, a few empty landscapes, a street, a tele- graph pole, an interrupted message, parts of a flag, a broken electronic image, a few hastily compiled words form a subtext: Free All POW's . . . "What should I wear?," "I hope Gerry knows what he's doing . . ."*

Compact Disc:

At the back of this publication is a compact disc containing new works by two contemporary composers, **Manuel Rocha Iturbide** from Mexico, and **Roger Doyle** from Ireland. Both composers were invited to make work using the sounds of their own and each other's cultures. Manuel Rocha travelled to Ireland and recorded music, sounds, voices, and the spoken Irish language. These recordings have become the basis for his work. Roger Doyle did not have the opportunity to travel to Mexico; instead he created a work based primarily on his own culture, and has woven flute and voice to form a musical dialogue with Uilleann pipes, bringing together sounds from Ireland and Mexico.

Conclusions:

The works chosen for this exhibition reflect off one another, creating a dialogue of themes and tensions that resonate throughout. Inevitably, different responses and ideas will be generated as the exhibition moves from one location to another, one country to another, one culture to another. "Distant Relations/Cercanías Distantes/Clann i gCéin" brings together two diverse cultures that share historic and contemporary tangents where ideas meet and cross as they clamber out of their colonial pasts, then carry on their independent ways.

Irish and Mexican art and the art of the diasporas are as different as they are informed by their parallel histories. This exhibition is not intended as a neat and tidy package of similarities. The intention is not to create an in-depth understanding of contemporary Irish, Mexican, or Chicano art—but rather to create a platform for discussion of these ideas, and to create a dialogue. These relationships are fragile, and as this last year indicates, both Ireland and Mexico are changing at such a rapid pace that perhaps what they share most in common is the experience of chaotic change. For now, the art presented in this exhibition occupies the same physical space. When this exhibition tour ends, some of the work will move on to future destinations. Others will cease to exist.

On the Mexico-Ireland front, here is a story that was once told to me by the Derry writer, trade unionist, and civil rights activist Eamonn McCann.

Derry, 1968: At the height of the Civil Rights campaign, demonstrators were listening to various speakers who were referring to students in Paris and Prague, when some young freckle-faced boy spoke up from the back of the crowd. Shouldn't they also be sending solidarity greetings to the Mexican students, and have a minute's silence in memory of those who had been recently massacred before the Olympic Games? McCann, one of the speakers at the rally, recalled that he saw the young man twice after that. Once at a political meeting in the early 1970s, he remembered him as shy, though articulate and politically astute. The last time was after he had died on hunger strike on August 20th, 1981, and his emaciated body was brought back to a relative's home in Derry for the funeral. His name was Micky Devine. In September 1981, in a packed hall at the University in Mexico City, students stood up for a minute's silence in memory of Micky Devine and his nine comrades.

Joelle Gartner, Ireland

DIFFERENCES, BOUNDARIES, COMMUNITY: THE IRISH IN BRITAIN

Dr. Mary J. Hickman

The issue of community is an important one for a minority population in Britain because of its relationship to issues of the nation, identity, ethnicity, migration and racism. However, to date, discussions about the Irish community either involve assertions that such an entity exists, or counterarguments suggesting that the degree of differentiation and dispersal of the Irish population negates the idea that we form a community. It is, however, important to refute the idea that differentiation necessarily negates community. At the same time, I would agree with the detractors of community that it is necessary to do more than just assert that the phenomenon exists. It is necessary to create a framework for understanding the basis of community and within that context establish what is meant by an Irish community.

Benedict Anderson describes nations as 'imagined communities'.[1] All communities, he insists, which are larger than primordial villages of face-to-face contact, are imagined. Until recently, the nation represented the largest community that most individuals imagined themselves as belonging to. All communities are distinguished not so much by falsity or genuineness but by the style in which they are imagined. The politics of forming a nation is the process by which the identity of a 'people' or 'community' is forged. The 'people' and its biography are mythical. Most nations, all products of the modern period, are based on imagined histories which posit back a unity, sometimes to antiquity, of its people.

The nationalist myth elevates to a birthright the fantasy of being rooted. For all those who are displaced by migration (frequently forced and structural), or who are refugees, the search for roots becomes inevitable, and often, depending on the context, this can be a poignant and difficult search to accomodate.[2] In this sense then, we can say that the notion of the Irish community in Britain is a myth—it is a myth in just the same way that all nations, or ethnicities, as imagined communities, are

1 Benedict Anderson, *Imagined Communities* (London: Verso, 1991), p. 56.

2 Stephan Feuchtwang, "Where You Belong," in *Where You Belong*, ed. A. Cambridge and S. Feuchtwang (Aldershot: Avebury Press, 1992).

based on myth and all migrant groups live the contradictions of maintaining or not maintaining that myth in the diaspora. Thus, Irishness is both a world and a set of representations, carried around in the heads of actual people, and can be displayed across a number of texts and visual representations.[3]

All migrant groups from former colonies or, generally, from the 'South' coming to the 'North' (in the Brandt Report's sense of those terms) have to engage with and resolve problems of difference. They migrate bearing the traces of particular cultures, traditions, languages, systems of belief, histories that have shaped them, and are obliged to come to terms with and make something new of the cultures and economic location they come to inhabit, without simply assimilating.[4] When the country they migrate to is the former colonising power, how much more acute and sensitive the situation is. Any comparison of the Irish in Britain with the Irish in the USA and Australia in the 19th century will bear this out. The contrast in terms of control of the Catholic Church and open participation in the political system is striking. It is not that the Irish did not face opposition in those two societies, but the response by the Irish was different.

It has been a main function of national cultures to represent what is in fact the ethnic mix of modern nationality as the primordial unity of 'one people'. This has been achieved by centralised nation-states with their incorporating cultures and national identities, implanted and secured by strong cultural institutions, which tend to subsume all differences and diversity into themselves.[5] The Irish first came in very large numbers to Britain during the period which was most critical for the successful securing of a national identity and culture in Britain (and by that means a class alliance): i.e., the 19th century. In that period the Irish were both the most sizeable and most visible minority element in the population. In migrant communities in Britain, 'Irishness' as an essentialist notion has shaped itself against other forms of political and cultural identity, especially Englishness. The consequences have been profound for the subsequent history and experience of the Irish in Britain.

The strategy of the British State and the Catholic Church has been incorporation; for example, through the education system. By incorporation I mean the active attempts by the State to regulate the expression and development of separate and distinctive identities by potentially oppositional

..............................

3 Jonathan Harris, "Passages: Transportations," in *Ware/Another Country: Irish Exile and Dispossession*, ed. C. O'Leary (Huddersfield: Huddersfield Art Gallery, 1991).

4 Stuart Hall, "Old and New Identities, Old and New Ethnicities," in *Culture, Globalisation and World System*, ed. A. D. King (London: Macmillan, 1991).

5 Stuart Hall, "Our Mongrel Selves," *New Statesman and Society*, 19 June, 1992.

groups in order to create a single nation-state. The incorporation of the Irish Catholic working class in Britain was based on strategies of denationalisation, and was not the consequence of an inevitable process of assimilation or integration. In Catholic schools, the priority placed on religious instruction, the effort which went into religious instruction, and the manner in which

3rd London Irish Women's Conference, Irish Women: Our Lives, Our Identity, 1987. Photo by Joanne O'Brien /Format

the religious pervaded all the rituals of school life were all part of a strategy for reinforcing the religious identity of the pupils at the expense of their national identity. There was a corresponding silence in the curriculum content of Catholic schools about Ireland.[6]

It is not surprising, therefore, that a contemporary account suggests the pressure experienced by the second generation to marginalise Irish identity. Tom Barclay, in his memoirs of a bottlewasher, recounts his childhood in Leicester in the 1850s and 1860s. After describing his mother's recitation of old bardic legends and laments, he continues:

But what had I to do with all that? I was becoming English. I did not hate things Irish, but I began to feel that they must be put away; they were inferior to things English. . . . Outside the house everything was English: my catechism, lessons, prayers, songs, tales, games. . . . Presently I began to feel ashamed of the jeers and mockery and criticism.[7]

'Becoming English' was not based on an inevitable process of cultural assimilation but on acquiring a perception of the inferiority of Irishness compared with Englishness. The cultural pressures to become English and reject Irishness that Barclay cites primarily emanated from the Catholic Church. His world outside the home was defined by the Church and the school, and the latter contained textbooks which glorified England and were silent about Ireland. In another example, Bart Kennedy describes his Catholic schooling as being "taught a great deal about the glory of God and the glory of England, and very little about the art of

6 Mary J. Hickman, *Religion, Class and Identity* (Aldershot: Avebury Press, 1995).

7 Lynn Hollen-Lees, *Exiles of Erin: Irish Immigrants in Victorian London* (Manchester: Manchester University Press, 1979), p. 190.

reading and writing. . . . It was a great privilege to be born in England, the teacher said".[8]

A low public profile for the Irish became characteristic in Britain as a result of these incorporatist strategies. One person I interviewed, when asked what the term Irish community meant to him, said, 'hidden people'. This low public profile is the main achievement of the state and institutional response to the Irish presence in 19th century Britain. For example, Catherine Ridgeway, discussing her early years living in England in the late 1920s and early 1930s, commented:

During that period I didn't mix much with Irish people. Mostly English. I think my uncle and aunt put me off. They said, "Don't get involved in Irish clubs or anything like that", because there was still the political background all the time. As the years went on and I was learning more about the political situation, I still didn't get involved, because you always had at the back of your mind that if anything crops up and you are involved, you might be deported or something like this.[9]

This quotation, and there are many others to support it, demonstrates that the low public profile is not just a product of events in Northern Ireland since 1968. The Irish in Britain have been positioned as a potential political and social threat since the Act of Union in 1801 brought Ireland into the United Kingdom.

It was the expulsion of a specific sector of the Irish peasantry, almost exclusively Catholics, that became represented as the problem of Irish migration in Britain. This occurred despite the fact that for over two hundred years a range of social classes have migrated from Ireland to Britain, including both Protestants and Catholics. This process of construction of the Irish 'minority', however, does not solely rest on the fact that historically the structural location of the majority of Irish Catholic migrants has been as part of the casual, unskilled and semi-skilled working class. As important in understanding the 'place' of the problematised 'Irish' is the discursive effects of Anglo-Irish colonial relations and their articulation with the religious signification of British nationalism.

In that context it is unsurprising that references to the Irish community in Britain in 19th- and 20th-century discourses usually refer to working-class Irish Catholics, part of whose response has been to construct

8 Steven Fielding, *Class and Ethnicity: Irish Catholics in England 1880-1939* (Buckingham: Open University Press, 1993).

9 Mary Lennon, Marie McAdam, and Joanne O'Brien, *Across the Water: Irish Women's Lives in Britain* (London: Virago, 1988). p. 50.

a community life based on the very features that encapsulated the threat they represented: religion, national politics and class organisation. Obviously, at different times and in different contexts these elements of 'community' are articulated together differently.

The incorporation of the 19th-century Irish immigrants was never completely successful because, although the state and its agencies managed to regulate the expression of Irish identity, it was not able to eradicate it from all those of Irish descent. Identity is an arena of contestation, and the result for many was a complex identity with different elements to the fore in different contexts. Both these points are illustrated by Anne Higgins, who was born in Manchester in the 1930s. This is how she described her childhood: *We were under a kind of siege being Irish Catholics in Manchester in the thirties and forties. We lived initially in a very poor inner-city district where there were many other Irish families. The parish school we went to had mainly Irish teachers and pupils, we knew Irish Catholic families in the street, we met Irish people at the church, and we didn't have to associate with English people if we didn't want to. In point of fact, my mother made friends easily and a next-door neighbour who was a staunch English Protestant became her best friend in no time, but we mixed mainly with other Irish people.*[10]

Reflecting on her own identity at the time of being interviewed in the 1980s, she said: "My religion, political beliefs and national identity were all inter-related when I was a child. I've had to rethink my position on all of these over the years but I'm glad I have been able to carry with me, much of what was important to me as a child."[11]

Anne Higgins speaks for many in this statement. Identity is not fixed, it changes over time and in different circumstances. But the elements she refers to—national identity (Irish), religion (Catholic) and political beliefs (support for the Labour party)—hardly deviate from what clearly emerge as the chief characteristics of the readers of the *Irish Post*, the biggest-selling newspaper for the Irish in Britain, in its recent survey.[12]

The proclaimed Irish identity, Catholicism and to a lesser extent support for the Labour party of the mid-20th-century migrants are rooted in the material basis of the 1950s migration and settlement in Britain. The experience of the emigrants of that period can be understood in terms of the

10 Ibid., p. 146.

11 Ibid., p. 155.

12 "Survey of the Readership," published weekly between 5th December 1992 and 16th January 1993, *Irish Post*, London.

*Irish Dancing
Competition,
London, 1982.
Photo by Joanne
O'Brien/Format*

co-existence and intersection of their class position (both in Ireland and in Britain) with their ethnicity (as asserted by them, be it in the Counties associations of the 1950s or the welfare or cultural organisations of the 1980s, and as assigned to them by their continuing problematisation as a social and political threat). The imagined community of being Irish in Britain, as so far discussed, is one that has been constituted by the sense of a forced migration and the differences and boundaries which were immanent in the problematisation of Irish immigrants. The making of a sense of community for this generation of migrants at some level has been secured through a common experience of loss.[13] This is the concrete reality of a distinct (although not homogeneous) community.

It is important to emphasise another aspect of community or cultural identity, one which recognises that as well as many points of similarity, there are also critical points of deep and significant difference which constitute 'what we really are' or 'what we have become'. Cultural identities, far from being eternally fixed in some essentialised past, are subject to the continuous 'play' of culture and power. Every regime of representation is a regime of power, and the dominant regimes of colonial experience had the power to make us see and experience ourselves as 'Other'. This inner expropriation of cultural identity can cripple and distort if it is not resisted. Cultural identities, therefore, are points of identification which are made within discourses of history and culture, and therefore are not essences but positionings.[14]

In Britain, the experience of anti-Irish disadvantage and discrimination has exerted its own influence over the development of Irish identity. Thus the particular articulation of religion, class and national identity that historically has constituted the communal identity of being Irish in Britain can be understood as, in part, an aspect of this resistance of colonial regimes

13 Fiona Barber,
"No Great and
Recognisable Events:
The Representation of
Emigration, Gender
and Class," in
Ware/Another Country;

14 Stuart Hall, "Cultural
Identity and Diaspora,"
in *Identity: Community,
Culture, Difference,*
ed. J. Rutherford
(London: Lawrence
& Wishart, 1990).

of representation. Irish identity was also formed in resistance to a racist British nationalism, for which Irish migrants were a specific Other. In other words, individuals and collectivities that are prey to racism (its 'objects') find themselves constrained to see themselves as a community.[15]

For example, during the past twenty years stereotypes and problematising discourses about the Irish have led to the toleration of the civil liberties abuses, which amount to a form of 'state racism', sustained by Irish people in Britain through the operation of the Prevention of Terrorism Act (PTA). In 1974, after the IRA carried out the Birmingham Pub bombings in England, the Prevention of Terrorism Act was rushed through Parliament. It gave the Secretary of State considerable new powers to control the movement of people between Ireland and Great Britain. The Act provided extensive powers to establish a comprehensive system of port controls, and a process of internal exile which gives the Secretary of State the power to remove people who are already living in Great Britain to either Northern Ireland or the Republic of Ireland.

Although the legislation was extended in 1984 to cover international terrorism, the port powers were devised, and have principally been applied, to control Irish people travelling between Britain and Ireland.[16] The Prevention of Terrorism Act is:

. . . a discriminatory piece of law in that it is directed primarily at one section of the travelling public. In effect it means that Irish people in general have a more restrictive set of rights than other travellers. In this sense, the Irish community as a whole is a 'suspect community'.[17]

The evidence suggests that the use of the powers is targeted at two particular groups: principally, young men living in Ireland and Irish people living in Britain. The introduction of the Prevention of Terrorism Act created a dual system of criminal justice in Britain. Of the 7,052 who had been detained under the Act by the end of 1991, 6,097, or 86 per cent, have been released without any action being taken against them.[18] People are suspects primarily because they are Irish. The usefulness of the PTA has always hinged on the fact that it can suppress political activity, build up information on Irish people and intimidate the whole Irish community.

A nun who was very active in the campaigns to get people like the Guildford Four (four people wrongfully imprisoned for an IRA bombing at

15 Etienne Balibar, "Is There a Neo-racism?," in *Race, Nation, Class*, ed. E. Balibar and I. Wallerstein (London: Verso, 1991).

16 Paddy Hillyard, *Suspect Community: People's Experience of the Prevention of Terrorism Acts in Britain* (London: Pluto Press, 1993).

17 Ibid., p. 13.

18 Ibid.

Guildford in England) and the Birmingham Six (six people wrongfully imprisoned for the 1974 Birmingham pub bombings) released has recorded the following account of the pressures on Irish people, especially in the 1970s and early 1980s:

There were widespread arrests. . . . People picked up under the PTA had no rights whatsoever in those early days. They disappeared. Eventually, we found out that they could be held for seven days. Police denied that they were holding people. Detainees were questioned at all hours, day and night, and solicitors were not allowed in. It was a very anxious time for the families of those detained. . . . It was terrible from 1975 to 1981. That was the worst period; I call it the 'bad time'. Police with dogs, guns and vans swooped on houses in the early hours of the morning, frightening young children, damaging property and making innocent law-abiding citizens the targets of suspicion in their streets and neighbourhoods. If they were any way involved, and when I say 'involved', I mean any way Irish at all, they were raided or taken in.[19]

The way in which the PTA was implemented fueled anti-Irish racism, with the oft-repeated injunctions of the police after various incidents to 'Keep an eye on Irish neighbours and watch out for Irish accents'. In the campaigns in the late 1980s to obtain the release of the Guildford Four and the Birmingham Six, many Irish people in Britain (and critically some British people) who often had very different views on events in Northern Ireland came together to right these self-evident injustices. In such circumstances, a sense of community is fostered out of particular historical experiences and in response to specific social constructions of the Irish in Britain.

Cultural identity, however, also represents hybridity. In this emphasis the diaspora experience necessarily recognises heterogeneity and diversity, because identity lives with and through difference. Compared with the late 1970s and 1980s, in the 1990s there is a greater representation of the Irish 'community' as diverse, if we can take the changes in reportage in the *Irish Post* (the bestselling newspaper for the Irish in Britain) as one gauge of this. In the early 1980s, references to Irish women's groups were at best nervous; nowadays they are routine. The area of sensitivity today, in many Irish arenas, including the *Irish Post*, is much

19 Lennon, *Across the Water*, p. 196.

more likely to be acknowledgment of the existence and campaigns of Irish gay and lesbian groups.

These examples, though, still refer to the 1940s–60s rural emigrants from the Republic of Ireland and their children. They are not, however, the only elements in the Irish population in Britain (nor were they ever the only element), although they still remain the largest grouping. The other major constituent elements are those who have migrated from the Northern Ireland, Protestant and Catholic, and the large flow of migrants from the Republic in the past ten years. Compared with the 19th century, the experience of any Protestant from Northern Ireland coming to Britain, but especially to England, is very different. Anyone with a northern accent is viewed as Irish. There is hardly any research published about them as a group, although some studies are now underway. But the numbers from Northern Ireland have increased substantially in the last twenty years, and they form a significant element in what constitutes being Irish in Britain today.

However, the largest augmentation of the Irish population in Britain has come from the Republic of Ireland since the early 1980s. Much has been made of the fact that these migrants are very different from the 1940s–60s generation who left Ireland. The recent migrants have higher levels of educational qualifications and in the main are more likely to come from urban backgrounds. Some of these differences have been exaggerated, but nevertheless, this migration is significantly different from the previous two main phases in the mid-19th and mid-20th centuries.

For example, it is assumed that attitudes of the new migrants to the Catholic Church are different, and it is expected that this is bound to have an impact on what constitutes 'community' for the Irish in Britain. There have been a number of studies of these new migrants in terms of employment, housing, etc., but only a small number which examine attitudes and perspectives, especially about religion and national identity. One study focused on recent migrants of largely working-class origin from the Republic, in their twenties and thirties who left Ireland without a Leaving Certificate. Contradictory sentiments about Catholicism emerge from their responses. Many of the new migrants from the Republic make a direct link between Catholicism and unhappiness, and bemoan the impact they perceive Catholicism to have on their own lives and on Irish society as a whole.

But for many it would appear that although they have jettisoned their adherence to Catholic beliefs, they recognise that Catholicism has had a part in shaping their Irish identity. These responses prompt the speculation that the respondents have a strong sense of Irish identity as apart from Catholicism, but that Catholicism touches their lives because of its place in Irish society and politics, and the role it has played historically in the Irish community of which they are now a part.[20]

Another study indicates that young Irish middle-class migrants comment, whether from the North or the South, that they find Britain 'shockingly secular'. A sense of spirituality, although not necessarily attachment to organised religion, emerges as an important marker that differentiates the Irish from the English. None of these Irish migrants described themselves as an agnostic or an atheist.[21] This sample was markedly more middle-class than the other, and although both samples are small, they suggest that further research in this area would be fruitful. Research needs to be carried out on the repercussions for the Irish community in Britain of the changing role of religion as a part of Irish national and cultural identities, against a backdrop of the secularisation of Irish society and the changes in Anglo-Irish relations heralded by the current peace process.

Conclusion

I set out at the beginning to indicate a framework for understanding the basis of community and within that context establish what is meant by an Irish community. Broadly, I have situated the discussion within the context of the inevitable problematic that immigrant groups encounter of coming to terms with and making something new of the cultures and economic location they come to inhabit, without simply assimilating. Until the late 1960s, the agenda in Britain was assimilation/incorporation. The strong incorporatist tendencies of British national culture made an indelible mark on the experience of Irish migrants to Britain, and still shape the positioning of the Irish within that national culture.

The agenda, however, is now about plurality; cultural diversity is the hallmark of post-modernity, and it is now more apparent that symbols that represent the differences and boundaries that constitute the Irish

20 Sinead McGlacken, unpublished research dissertation for B.A. Honors Degree, Irish Studies Centre, University of North London, 1992.

21 Mary Kells, "Ethnic Identity Amongst Young Irish Middle Class Migrants in London," in *Irish Studies Centre Occasional Papers Series, No. 7* (London: University of North London Press, 1995).

community in Britain do not necessarily have the same meaning for all Irish people or those of Irish descent. This differentiation is a strength rather than a weakness. The greatest danger surely arises from forms of national and cultural identity that attempt to secure their identity by adopting closed versions of culture and community.

The point is that 'community' is highly symbolised, with the consequence that members of the community can invest it with their often very different selves. Its character is sufficiently malleable that it can accommodate all its members' selves. The imagined community which divides the world between 'us' and 'them' is maintained by a whole system of symbolic 'border guards'. These border guards are used as shared cultural resources with shared collective positioning vis-à-vis other collectivities. They can provide the collectivity members with 'imagined communities', but also with 'communicative communities'. Membership in a people consists in the ability to communicate more effectively, and over a wider range of subjects, with members of one large group than with other outsiders.[22] So although people will have different imaginings of the 'community' in their heads, some symbols or practices will unite larger groups of them, effectively forming alliances on an ethnic basis. Question marks remain over Irish identity in Britain in this respect, but there is no doubt it is a more inclusive notion of community than in the past. The essentialised Irish community which was formed in resistance to anti-Irish racism and in opposition to constructions of English/British identity entailed 'silences' which an emphasis on hybridity allows now to be 'voiced'.

Brent Irish Festival, London, 1987. Photo by Geray Sweeney/Impact

22 Floya Anthias and Nira Yuval-Davis, *Racialised Boundaries* (London: Routledge, 1992).

Hickman

UNAPPROVED ROADS:
POST-COLONIALISM AND IRISH IDENTITY

Luke Gibbons

There might be more to be learned through a careful tracing, along paths not already guarded by the intellectual patrols of neo-imperialism, of the border lines where comparative experiences of imperial victimization and resistance meet and separate. These paths and borders, of course, are not to be found on any Cartesian plane, nor will they stay in the same place as we change our relation to them. . . .

Jonathan Boyarin, *Storm from Paradise* (1992)

In 1948, the Irish humourous journal *Dublin Opinion* published a cartoon depicting the removal of the statue of Queen Victoria from in front of Leinster House, the Irish seat of parliament. "Begob, Eamon", the dejected Queen commiserates with de Valera, who had just lost office in a general election, "there's great changes around here!" This was indeed true, for the removal of the statue was a prologue to the official declaration of an Irish Republic in 1949, an act which formally severed the imperial connection that reached its apotheosis during her reign in the nineteenth century.

Yet the Queen, for all her legendary absence of humour, may have had the last laugh. Early in 1995, a public controversy ensued when

"Begob, Eamon there's great changes around here!" (The Queen Victoria statue was being removed from in front of Leinster House after the first party government had taken office.) *Dublin Opinion*, August 1948

University College, Cork, as part of its 150th anniverary celebrations, decided to exhume a statue of Queen Victoria which had been buried in the grounds of the college since the 1930s, and put it on public display. This, it was argued, was doing no more than setting the historical record straight, a public acknowledgment of the fact

that the university (originally called Queen's College, Cork) was founded under a Victorian administration.

But this is not the way history, or rather memory, operates in a culture with a colonial past; for 1845 was not only the year in which the Queen's Colleges were established, it also marked the beginning of a more painful reminder of Victorian rule, the Great Famine (1845–8).[1] At the opening of the exhibition in which the statue was included, a protestor was arrested for interrupting the proceedings with shouts of "What about the Famine?" Though dismissed by some as a nationalist crank, the protestor was also seeking to register a profound loss of memory, a traumatic episode in Irish history that was no less effectively buried by officialdom, both before and after independence, than Queen Victoria's moving statues.[2]

How is it possible to accommodate these disparate legacies of the Victorian era within the narratives of Irish identity? According to one influential strand in contemporary cultural theory, the answer lies in post-colonial strategies of cultural mixing, that is, embracing notions of 'hybridity' and 'syncretism' rather than obsolete ideas of nation, history or indigenous culture. This, after all, is what is meant by the designation 'post'—colonialism, and all its works and pomps, is deemed to be over and done with (if, indeed, it ever existed in the first place), and the time has come to draw a line over the past. In his highly schematic but instructive overview of the four stages of culture formation mapped out by post-colonial theory, Thomas McEvilley identifies first, the idyllic pre-colonial period, the subject of much subsequent nationalist nostalgia; second, the ordeal of conquest, of alienation, oppression and internal colonisation; third, the nationalist reversal 'which not only denigrates the identity of the coloniser, but also redirects . . . attention to the recovery and reconstitution of [a] once scorned and perhaps abandoned identity';[3] and fourth, the stage ushered in by the generation born after the departure of the colonising forces, which is less concerned with opposition to the colonial legacy—a situation which arose in India and Africa 'about 25 years after the withdrawal of colonialist armies and governments'. It is this latter phase which lends itself to the free play of hybridity and cultural mixing—and also to the distancing project of the diaspora in which immigrants from ex-colonies re-negotiate their ancestral ties in terms of the global demands of their new host culture.

1 See one correspondent's view in a letter to *The Irish Times*: 'As the college must share its special year with events commemorating the Famine, the highlighting of Queen Victoria—who stood almost aloof from the Great Hunger of the people at that time—is an unfortunate choice. Her association with the university could have been adequately recognised in a less dramatic way.' (T. J. Maher, "Queen Victoria's Statue," 30 January, 1995). It is important to point out, however, that the statue was not restored to its former site but was rather 're-framed' behind a glass case in the corner of a display room, as part of a more general exhibition. As I argue below, this changes significantly the 'meaning' of the statue, and certainly calls into question its previous imperious position.

2 The factors which influenced the Irish government's failure to commemorate the centenary of the Famine are discussed in Mary E. Daly, "Why the Great Famine Got Forgotten in the Dark 1940s," *The Sunday Tribune*, 22 January, 1995. For the neglect of the Famine by academic historians, see Cormac O'Grada's valuable introduction to the re-issue of R. Dudley Edwards and T. Desmond Williams, eds., *The Great Famine* (Dublin: The Lilliput Press, 1995), first published in 1956.

3 Thomas McEvilley, "Here Comes Everybody," *Beyond the Pale: Art and Artists on the Edge of Consensus* (Dublin: Irish Museum Of Modern Art, 1994), p. 13.

But whatever about a week being a long time in politics, it is certainly the case that a generation, or even a few generations, is a short time in the centuries-old struggle against western colonisation. The belief that the restoration of Queen Victoria's statue was an inoffensive gesture in the context of an historical arc spanning 1845–1995 could only make sense if the Great Famine in Ireland was a thing of the past, a phase of history that could now be safely consigned to the communal Prozac of the heritage industry. But can the wounds inflicted by a social catastrophe be so easily cauterised? Would anyone seriously suggest that the traumatic lessons of the Holocaust shouldn't be as pertinent in a hundred years' time as they are today? Or—to take an example that touches directly on colonialism and the displacement of the diaspora—that novels such as Toni Morrison's *Beloved* are valuable merely for their re-creation of the ordeal of slavery as it was endured 150 years ago, but have little to do with the *lived experience* of the African American population in the contemporary United States?

What we are dealing with here are different registers of memory, one that is contained and legitimised within the confines of the monument and the museum, and the other having to do with the fugitive traces of collective memory, as transmitted by popular culture, folklore, ballads and so on. In this respect, the contestation of museum space in Philip Napier's *Ballad no. 1* at the "Beyond the Pale" exhibition is remarkable.[4] It features an accordion mounted on a wall, whose intake and expelling of air allows it to double up as an artificial lung attached to the barely decipherable image of the republican hunger striker, Bobby Sands. The blown-up photogravure effect of the image is achieved through small nails, a reminder of the aura of martyrdom which surrounded Sands's death on hunger-strike in 1981. The wheezing moans of the accordion extend beyond the individual body, however, evoking some of the more discordant strains in Irish vernacular culture. Not only do the eerie sounds waft through museum space like the wail of the mythical *banshee* in Irish folklore,[5] but the instrument itself signifies traditional music, more particularly the street singer and the popular ballads that were repeatedly targeted by the authorities as cultural

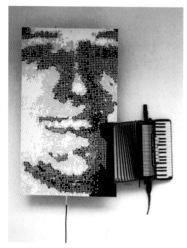

Philip Napier, *Ballad no. 1*, 1992/94. Photo by Michael McDonagh, courtesy of The Arts Council of N. Ireland

58

59

4 At the Irish Museum of Modern Art, 1994–95.

5 The *banshee* (literally, 'female fairy') was a harbinger of death for certain families, and her wail struck terror into all those who heard it.

expressions of insurgency. By linking the famished body with mourning and collective memory, the off-key image becomes, in effect, a living monument for the Famine and the dark shadow which it cast on the lung of the Irish body politic.

The mythic resonances of the *banshee* and vernacular culture are also evident in the figurations of hair and long female tresses central to Alice Maher's recent work. Although the *banshee* is more often heard than seen, sightings of the phantom figure portray her as an old woman, combing her long white hair as she laments. In Maher's *Familiar* series, undulating braids of hair are given an additional historical twist by being recreated though the medium of flax—a material, according to the artist, that is 'interwoven with a thousand meanings and histories'.[6] One of the meanings is the association with women's work and the relative financial independence which cottage industry afforded for women in pre-Famine Ireland. Another historical connection, however, derives from the destruction of the once-thriving Irish wool trade by British colonial policy, and its replacement by a linen industry, based mainly in Northern Ireland. The 'hybridity' of these exhibits is clear from their indeterminate boundaries: between organic and fabricated materials, nature and culture, native and newcomer.

Of course, there are proponents of hybridity who refuse to consider Ireland as a suitable case for post-colonial treatment at all. Though the authors of one 'comprehensive study' find the term 'post-colonial' expansive enough to include not only the literatures of India, Africa and the Caribbean, but also Canada, Australia and even the United States, no place is found for Irish literature. The reason for this becomes apparent later on, when Irish, Welsh and Scottish literatures are discussed 'in relation to the English "mainstream"':

While it is possible to argue that these societies were the first victims of English expansion, their subsequent complicity in the British imperial enterprise makes it difficult for colonized peoples outside Britain to accept their identity as post-colonial.[7]

"The Ballad Singer,"
The London Illustrated News,
29 October, 1881

6 Cecile Bourne, "Interview [with Alice Maher]," in *Familiar: Alice Maher* (Dublin: The Douglas Hyde Gallery, 1995), p. 23.

7 Bill Ashcroft, Gareth Griffiths, and Helen Tiffin, *The Empire Writes Back: Theory and Practice in Post-Colonial Literatures* (London: Methuen, 1989), p. 33.

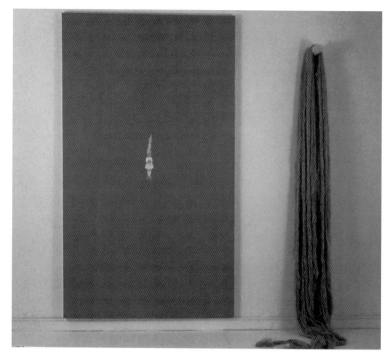

Alice Maher, *Familiar 1*, 1994. Photo by Denis Mortell

8 In one of the few discus-
sions of the Irish contri-
bution to colonialism,
Hiram Morgan points out
that in relation to India,
'those Irish who received
commissions and com-
mands were from the
Protestant elite', and
argues that the same
holds in relation to
Australia: 'In Australia
the Catholic Irish were
numerous but it was the
Anglo-Irish 'imperial
class' who exercised most
influence. . . . The
Catholic Charles Gavan
Duffy did become prime
minister of Victoria in
1871-2 but he was a
rare bird in his day'.
Hiram Morgan,
"Empire-Building: An
Uncomfortable Irish
Heritage," *The Linen
Hall Review* 10, no. 3
(Autumn 1993): 8, 9.

9 As Vijay Mishra and Bob
Hodge point out in their
trenchant review of *The
Empire Writes Back*,
'What an undifferentiat-
ed concept of post-colo-
nialism overlooks are the
very radical differences
in response and the
unbridgeable chasms
that existed between
White and non-White
colonies . . . there is, we
feel, a need to make a
stronger distinction
between the post-colo-
nialism of settler and
non-settler countries'.
Vijay Mishra and Bob
Hodge, "What is Post-
Colonialism?" in Patrick
Williams and Laura
Chrisman, eds., *Colonial
Discourse and Post-
Colonial Theory* (New
York: Columbia
University Press, 1994),
pp. 285, 288. As I argue
below (note 18), there is
also a need in an Irish
context to show the radi-
cal differences within
white societies, and par-
ticularly to question the
assumption which equates
whiteness with the settler
community, or the cul-
ture of the coloniser.

This remarkable statement (which appears to be under the apprehension that Ireland is still part of Britain) only makes sense if one identifies the Irish historically with the settler colony in Ireland, the Anglo-Irish, thus erasing in the process the entire indigenous population—a view closer, in fact, to 'Commonwealth' than post-colonial literature.[8] This indiscriminate application of the term 'post-colonial' is indeed a recurrent feature of *The Empire Writes Back*, with the result that Patrick White and Margaret Atwood are considered post-colonial in the same way as Derek Walcott or Chinua Achebe.[9] This is not to say, of course, that some Catholic or indigenous Irish did not buy into hegemonic forms of racism in the United States and Australia when they themselves managed to throw off the shackles of slavery or subjugation. But it is important to recognise this for what it is, a process of buying into the existing supremacist ideologies, derived mainly from the same legacy of British colonialism from which they were trying to escape. In Charles Gavan Duffy's words, commenting on the upward mobility of some of the Irish Catholic diaspora in Australia:

To strangers at a distance who read of Barrys, MacMahons and Fitzgeralds in high places, it seemed the paradise of the Celts—but they were Celts whose forefathers had broken with the traditions and creed of the island [i.e., Ireland].[10]

This is an important corrective to the essentialist myth that racist attitudes were already present in Irish emigrants— by virtue of their 'whiteness', their backwardness, or 'national character'—before they emigrated to Britain, the United States or Australia.[11] What the immigrant Irish brought with them from the homeland were not the habits of authority fostered by the coloniser but, in fact, a bitter legacy of servitude and ignominy akin to that experienced by native and African Americans. Indeed, from the colonial perspective, the racial labels 'White/non-White' did not follow strict epidermal schemas of visibility or skin colour so that, in an important sense, the Irish historically

Willie Doherty, *Imagined Truths*, 1990

were classified as 'non-White', and treated accordingly. The widespread equation of the 'mere Irish' with the native Americans in the seventeenth century served as a pretext for wholesale confiscations and plantations, and more ominous expressions of genocidal intent as in Edmund Spenser's advice to Queen Elizabeth that 'until Ireland can be famished, it cannot be subdued'.[12] The transportation of the Irish to the New World featured prominently in the 'white slave trade' in the seventeenth century, and

10 Morgan, p. 9. As Mishra and Hodge point out, 'complicit post-colonialism' is that which does not challenge the standards of the imperial centre but rather seeks to emulate them, gaining admittance to the canon (p. 289). That the most considerable achievements in Irish literature derived their impetus from *resisting* the canon is the argument of David Lloyd's *Nationalism and Minor Literature: James Clarence Mangan and the Emergence of Irish Cultural Nationalism* (Berkeley: University of California Press, 1987) —a book, significantly, not included in the extensive reader's guide and bibliography to *The Empire Writes Back.*

11 Considered in this light, there may well be some truth in the observation that the only reason the Irish are not racist at home is that there are not enough non-Europeans in the country to make immigration a social problem. The key question here, however, is why Ireland is in this situation? The answer is clear: because it itself is in the anomalous position of being the only ex-colony in the European Union, and hence is not advanced enough industrially to act as an economic magnet for immigrants from developing countries. This is a radically different proposition from the naive assumption that certain peoples or cultures are inherently bigoted, and only lack the opportunity for their racism to assert itself.

throughout the eighteenth and early nineteenth centuries the Penal code which systematically excluded Catholics from citizenship and political life rendered them, in Edmund Burke's phrase, foreigners in their native land. There was no need to go abroad to experience the 'multiple identities' of the diaspora valourized in post-colonial theory: the uncanny experience of being a stranger to oneself was already a feature of life back home.

As David Roediger remarks of the ambivalence of Irish attitudes to racism in America, 'shared oppression need not generate solidarity but neither must it necessarily breed contempt of one oppressed group for another'.[13] The need to define themselves as white presented itself as an urgent imperative to the degraded Irish who arrived in the United States after the Famine, if they were not to be reduced to servitude once more. This was the political climate in which Ralph Waldo Emerson could write:

I think it cannot be maintained by any candid person that the African race have ever occupied or do promise ever to occupy any very high place in the human family. The Irish cannot; the American Indian cannot; the Chinese cannot. Before the energy of the Caucasian race all the other races have quailed and done obeisance.[14]

It was in these circumstances that many Irish sought to identify with the manifest destiny of whiteness, finding in the anti-abolitionist Democratic party a vehicle for their social and political aspirations. This, in effect, meant an uneasy accommodation with what Reginald Horsman describes as 'American racial Anglo-Saxonism' and, as Roediger ruefully comments, 'under other circumstances, Irish American Catholics might not have accepted so keenly the 'association of nationality with blood—but not ethnicity', which racially conflated them with the otherwise hated English'. But, he continues: 'within the constrained choices and high risks of ante-bellum American politics such a choice was quite logical. The ways in which the Irish competed for work and adjusted to industrial morality in America made it all but certain that they would adopt and extend the politics of white unity offered by the Democratic party'.[15]

The point of drawing attention to the unhealthy intersection of Irish Catholicism with supremacist Anglo-Saxon ideals of whiteness in the United States is to underline the risks inherent in uncritical adulations of 'hybridity' as an empowering strategy for diasporic or post-colonial identity

12 Edmund Spenser, "A Briefe Note on Ireland," (1598), cited in Theodore W. Allen, *The Invention of the White Race*, vol. 1 (London: Verso, 1994), pp. 63, 210. Spenser's advice to the Queen was a follow up to the Lord President's suggestion that 'The Irish should be constrained first to taste some great calamity, so as to render them more assured and dutiful thereafter'. See Pauline Henley, *Spenser in Ireland* (Cork: Cork University Press, 1928), p. 164. It is this histori-cal backdrop which gave such force to accusations of genocidal intent with regard to the nineteenth-century Great Famine.

—particularly when it involves accommodation with the values of powerful expansionist cultures already built on racism. As Ella Shohat and Robert Stam put it, undue haste in deconstructing essentialist notions of identity 'should not obscure the problematic agency of "post-colonial hybridity"':

A celebration of syncreticism and hybridity per se, if not articulated with questions of historical hegemonies, risks sanctifying the fait accompli of colonial violence. For oppressed people, even artistic syncreticism is not a game but a sublimated form of historical pain, which is why Jimi Hendrix played the 'Star Spangled Banner' in a dissonant mode, and why even a politically conservative performer like Ray Charles renders 'America the Beautiful' as a moan and a cry. As a descriptive catch-all term, 'hybridity' fails to discriminate between the diverse modalities of hybridity: colonial imposition, obligatory assimilation, political co-option, cultural mimicry and so forth.[16]

It is in this context that one should consider Willie Doherty's photographic triptychs *Fading Dream* (1989) and *Evergreen Memories* (1989). In *Fading Dreams* we see redolent details of imposing Georgian architecture dating from the period in the eighteenth century when the majority Catholic population were kept in bondage, and then the obsequious 'hybridity' of reclaiming this heritage for a nationalist present by placing a brass harp on a panelled door. The green letters overlaid on the images, however, suggest that nostalgia—the 'fading dreams' and 'hospitable' welcome—for imperial splendour is not restricted to the relics of the old order but is possibly shared by the new 'nationalist' dispensation, notwithstanding its official condemnations (it is not clear, for this reason, to whom 'Depraved' and 'Unknown Depths' refer to). As against this, *Evergreen Memories* shows another neo-classical building which has been more violently reclaimed by nationalist memory, the General Post Office in the centre of Dublin, scene of the 1916 rebellion which declared an Irish republic. On the one hand, this founding site of the state is an object of awe and reverence ('*Evergreen memories*' of '*Resolute*' revolutionaries); but the site is also one of disavowal and rejection (it is not clear whether the overlaid 'Psychopath' and 'Cursed Existence' emanate from the imperial building itself, or from its new custodians, the post-colonial state intent on forgetting its violent origins).[17]

13 David R. Roediger, *The Wages of Whiteness: Race and the Making of the American Working Class* (London: Verso, 1991), p. 134.

14 Cited in McEvilley, "Here Comes Everybody," p. 21.

15 Roediger, p. 144. See also Ronald Horseman, *Race and Manifest Destiny: The Origins of American Racial Anglo-Saxonism* (Cambridge, Mass.: 1981).

16 Ella Shohat and Robert Stam, *Unthinking Eurocentrism: Multiculturalism and the Media* (New York: Routledge, 1994), p. 42.

17 In this connection, the amnesia shown by the Irish state towards the Famine in 1945 was matched by the embarrassing fifteen-minute ceremony which passed for a commemoration of the 75th anniversary of the Rising in 1991.

In a similar vein, John Kindness's satirical panels for the DART (Dublin Area Rapid Transport) trains show the colonial mimicry of the consumerist Irish state as evidenced by the green bottle on the dinner table containing DE sauce (as in *Dail Eireann* [i.e., the Government of Ireland], and perhaps Eamon *de* Valera?). This craven hybridity is an imaginary rip-off of the original HP sauce bottle (as in House of Parliament) which adorns so many British dinner tables. The kind of homely ideology lodged in domestic details is again apparent in Kindness's recent *Belfast Frescoes* which depict, in comic-book fashion, scenes from an upbringing in Protestant Belfast. The affectionate memory of the father's cigarette moving around the room in the dark before breakfast is counterpointed by the imagery on the teapot and cup of the ill-fated Titanic, the pride of the Loyalist shipyards, which was sunk by an iceberg on its maiden voyage in 1912. (In a later picture, a teapot displays the rose and thistle, emblems of the union between England and Scotland, which initially constituted modern Britishness.) The link between the innocent detail of the cigarette and the imperial icon of the ocean liner is forged by the sustained visual pun in the border of the image, in which the smoke of the cigarette is gradually transformed into the fog and mist which concealed the iceberg on the ship's fatal journey. The tigers, elephants and kangeroos in the borders of

John Kindness, *Art on the DART*, 1988. (Dublin Area Rapid Transit)

Early in the morning in our house there was a cigarette that moved around in the dark. it was my father getting ready to go to work.

John Kindness,
Belfast Fresco Series,
1994

subsequent images also harbour imperial fantasies, as when the young boys are shown embarking on safari hunts in their neighbourhood in Belfast. In a later sequence, the closed culture of loyalism is characterised by an image of a Unionist election poster blocking out Labour and Nationalist posters, and the young narrator and his friend being contemptuously labelled as 'Fenian-lovers', not because they were nationalists but merely because, as working-class children, they were not overtly Unionist and supported Labour.

If Ireland does not quite conform to the post-colonial condition, it is not for the reasons outlined by some critics—namely, that because it is 'white' and situated in Europe, therefore it cannot have been subject to colonisation.[18] Anne McClintock is nearer the mark when she advises that: *The term 'post-colonialism' is, in many cases, prematurely celebratory. Ireland may, at a pinch, be 'post-colonial', but for the inhabitants of British-occupied Northern Ireland, not to mention the Palestinian inhabitants of the Israeli Occupied Territories and the West Bank, there may be nothing 'post' about colonialism at all.*[19]

'Post', in this context, signifies a form of historical closure, but it is precisely the *absence* of a sense of an ending which has characterised the national narratives of Irish history. This has less to do with the 'unfinished business'

18 As Theodore Allen argues in the related context of slavery, such judgements betray an assumption that somehow, colonisation is more suitable for 'Third-World' countries: "It is only a 'white' habit of mind that reserves 'slave' for the African-American and boggles at the term 'Irish slave trade'". Theodore Allen, *The Invention of the White Race* (London: Verso, 1994), p. 258.

19 Anne McClintock, "The Angel of Progress: Pitfalls of the Term 'Post-colonialism'," in Williams and Chrisman, eds., *Colonial Discourse and Post-Colonial Theory*, p. 294.

Gibbons

of a united Ireland than with the realisation that there is no possibility of undoing history, of removing all the accretions of conquest—the English language, the inscriptions of the Protestant Ascendency on the landscape and material culture, and so on. For this reason, there is no prospect of restoring a pristine, pre-colonial identity: the lack of historical closure, therefore, is bound up with a similar incompleteness in the culture itself, so that instead of being based on narrow ideals of racial purity and exclusivism, identity is open-ended and heterogeneous. But the important point in all of this is that the retention of the residues of conquest does not necessarily mean subscribing to the values which originally governed them: as Donald Horne has argued, even the sheer survival of cultural artifacts from one era to another may transform their meaning, so that the same building (or, perhaps, even the same statue) 're-located' in a new political era becomes, in a sense, a radically different structure.[20]

From this it follows that openness towards other cultures does not entail accepting them solely on their own terms, all the more so when a minority or subaltern culture is attempting to come out from under the shadow of a major colonial power. As Friedrich Engels remonstrated with those English comrades in the First International who objected to the formation of Irish national branches in England on the grounds that this was betraying the 'universal' ideals of internationalism, this proposal was seeking *not Internationalism, but simply prating submission [on the part of the Irish]. If the promoters of the motion were so brimful of the truly international spirit, let them prove it by removing the seat of the British Federal Council to Dublin and submit to a Council of Irishmen.*[21] What Engels is pointing to here is the hidden *asymmetry* of many calls for internationalism—or its post-colonial counterpart, hybridity—emanating from the heartlands of colonialism. The need to address the other, and the route of the diaspora, is invariably presented as a passage from the margins to the metropolitan centre, but the reverse journey is rarely greeted with much enthusiasm. In fact, those who go in the opposite direction are invariably derided as 'going native', as slumming it when they should really be getting on with the business of persuading the natives to adopt their master's voice.[22] Yet it is only when hybridity becomes truly reciprocal rather than hierarchical that the encounter with the culture of the coloniser

20 Donal Horne, *The Public Culture* (London: Pluto Press, 1986), p. 154.

21 Cited in James M. Blaut, *The National Question: Decolonising the Theory of Nationalism* (London: Zed Books, 1987), p. 144.

22 For some pertinent comments on this, see Shohat and Stam, p. 43.

ceases to be detrimental to one's development.

Another way of negotiating identity through an exchange with the other is to make provision, not just for vertical mobility from the periphery to the centre, but for 'lateral' journeys along the margins which short-circuit the colonial divide. This is the rationale for the present welcome cultural exchange between Irish and Mexican culture. Hybridity need not always take the high road: where there are borders to be crossed, unapproved roads might prove more beneficial in the long run than those patrolled by global powers. So far from rejecting universal values, moreover, this may be the most productive way, as Engels recognised, of taking the Enlightenment to the limit.

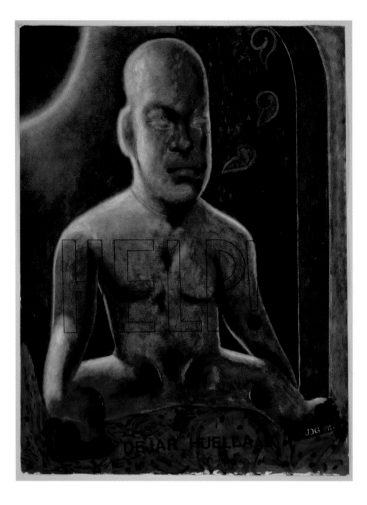

HELP!, 1992, oil on paper mounted on canvas, 78-3/4 x 59" (200 x 150 cm); courtesy of Pedro Torres and Galería OMR, Mexico City

javier de la garza

I conclude this series of paintings with a critical look toward the construction of cultural identity. This study goes from popular culture —from calendars with images from the 30s and 40s, to Mexican film— and to the most ancient symbols we know: pre-Hispanic images.

Using styles taken from advertising, my paintings recycle images that expose a fiction, a search for a lost identity in the symbols that have permeated mass media—to make an impression?

Popular culture appropriates the past; a Chaac Mool advertises package tours in Cancun and life insurance in Mexico City.

¡HELP!

Acapulco, Mexico – January 1995

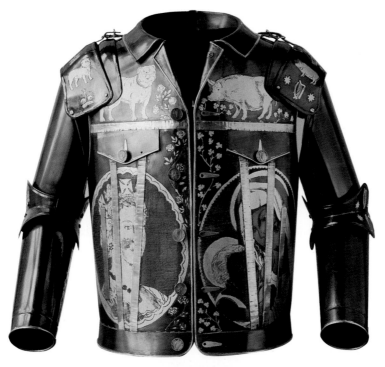

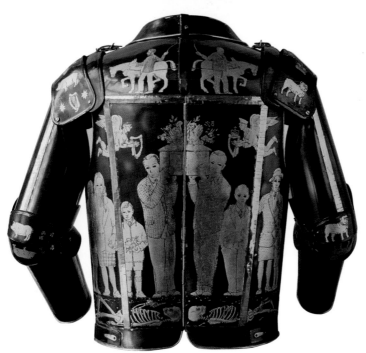

Sectarian Armour,
1995, etched gilded
steel, 23-1/2 x
15-3/4 x 11-7/8"
(60 x 40 x 30 cm);
steel fabrication by
Peter Rooney;
courtesy of the artist

john kindness

Extracts from a personal text . . .

. . . The big problem about wanting to be an artist in Ireland is one of role models. When I eventually found myself on the precipice of my school days and career masters loomed and 'how to write a letter to a prospective employer' lessons were given, all I could see around me were boys who were preparing themselves for apprenticeships in Mackies or the Shipyard. My father had been a 'driller' in the yards but my nearest contact with what he actually did was the mosaic of metal shavings embedded in the soles of his boots, or the rust spots that stained his handkerchiefs. I was well down the slippery slope to my career choice long before I actually met an artist. . . .

. . . I can't say for certain that going to art college was a mistake. Not many people realise this, but you don't actually learn anything at art college anymore; however, you do have to go there to find that out. Self-taught artists often have a sense of inferiority which comes from the feeling that they have missed out on something crucial, and for that reason I am glad that I went, but it was an experience that nearly knocked the art out of me. . . .

. . . The rot didn't begin to set in until I started my diploma course in that big impersonal glass cube beside the cathedral in central Belfast. I had been awarded one of those rare places on the fine art course— ironically, competition was the stiffest for the department with the worst career prospects—and was 'raring to go'. So what went wrong?

. . . Well, for a start, all the staff were from Manchester! Now god knows Belfast needs as much influx of outside ideas as it can get, but this was not healthy. It was 1971, and as if it wasn't enough to have British soldiers on our streets, here was a cultural regiment on tour of duty in the art school. The staff had obviously colonised the place in a sleepier period of history and now found themselves in a city on the verge of civil war that none of them understood and all of them wanted to ignore. . . .

. . . All of this heightened the feeling of being in the hinterland, of always being on the periphery of what was really important; it wasn't until nearly two decades later that I began to shake off that feeling. . . .

. . . By the time I left college, I knew deep down that art couldn't really change things, that painting and sculpture could make no headway in the mayhem that was raging now in the sleepy city I grew up in.

Rapid social changes required a more immediate art form, and some of my contemporaries ended up making film and video productions. I became interested in print media, and with money from a summer job in a bakery and the help of a small community press, I published my first 'work'. . . .

. . . Around about the same time two significant things happened: I got a job as a graphic designer and also became involved with a group of cartoonists in the publication of a satirical magazine — 'The People's Comic'. My contributions to the comic included a story about the formation of a Loyalist Navy, and a strip explaining how to tell the difference between Catholics and Protestants. The now legendary resilience of the Belfast people to adversity was forming itself, along with a wry black humour which was perhaps the only means of survival for the creative spirit during the dark days of the mid-seventies. None of us had any illusions at this stage about putting out material that would make the bigots see the error of their ways; it was simply a matter of staying afloat, and these satires were the weapons that protected our own dignity. . . .

. . . The firm that I worked for was occasionally commissioned to do signage in mosaic, and although we didn't do anything more elaborate than some ornate lettering, I became intrigued by the pictorial possibilities of the medium and began to look into its history. It was like discovering a tomb or a lost city under what you thought were the foundations of your culture. Mosaic, by turning out to be one of the oldest of permanent mediums in our civilisation, helped me to under-stand the importance of creating unique and physically tangible works of art even in this century of change and turmoil. My argument throughout my college years against the fine art object was that it had no relevance to the vast majority of the population. Original art could only be shown in galleries and museums and could only be bought by the wealthy. This, of course, was all true, but here were these incredible pre-Christian images still speaking to us volubly several millennia after their creation, while the average life span of a 20th-century media image was about 48 hours. . . .

Dublin – December 1994

john kindness

john valadez

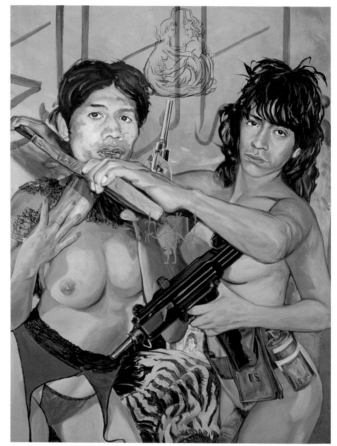

Las Maldosas, 1995, acrylic on canvas, 57 x 78"
(144.7 x 198 cm); courtesy of the artist and Daniel
Saxon Gallery, Los Angeles

I'm doing urban Mexican art

in L.A. it means

don't blink

underclass

clean dishes

cholo logic

you're ignored or a suspect

playing it off

killing your mirror image

twenty dollars a day

fear

ignoring the chill

Los Angeles – November 1994

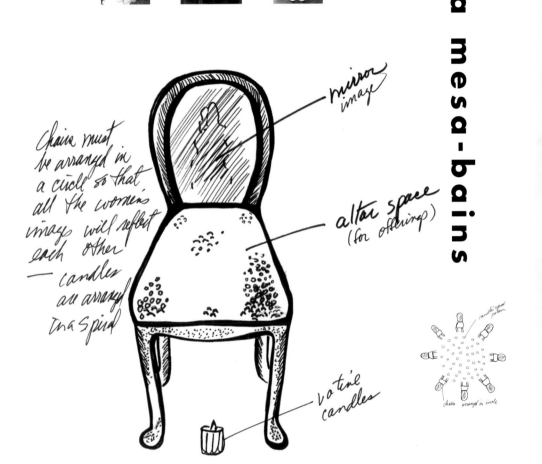

chairs must be arranged in a circle so that all the women's images will reflect each other — candles are arranged in a spiral

mirror image

altar space (for offering)

votive candles

candles spiral pattern

chairs arranged in circle

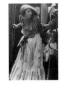 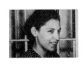 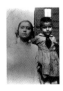

amalia mesa-bains

The development of my work has been rooted in the practice and consciousness of my community. Through the traditions of the home altar and the celebrations of the Day of the Dead, I have created a hybrid form of ephemeral installation. Both of these traditions of popular culture represent aspects of a redemptive and resilient struggle to maintain family history and cultural continuity in the face of colonial domination. My work has been inspired by these popular practices and directed by the Chicano Movement in a persistent process of critical intervention.

A ceremonial aesthetic has grown from this process of critical invention that characterizes my work. Through the use of bricole miniaturization, the use of domestic objects, Catholic imagery, natural and organic ephemera, mirrors, and dispersal, I have pursued a personal and collective narrative of Chicano/Mexicano history. The adoption of this form and process for more than twenty years has produced a politicizing spirituality that has served my community and given meaning to my life.

In my own work, a feminine *Rasquachismo* or *Domesticana*, as I call it, is a driving force in creating a critical space that is simultaneously contestatory and passionately affirming of our histories as women and our situation of struggle.

The series I am presenting in this exhibition extends this *Domesticana* into the importance of women's role in the life of the family, in the history of resistance, and in the tradition of labor connected to the Mexicano/Chicano cultures. The piece titled *The Circle of the Ancestors* narrates through a circle of chairs eight historic moments through eight historic women our cultural genealogy as Chicanas. The circle refers to the arrangement of the eight chairs facing inward around a spiral of candles placed on the floor. The chair, as a metaphor of the body, recalls the suffering and sacrifice present in the lives of these women. At the same time, the circle of chairs is a recalling of the intimacy and collective strength of women's lives in the home, in the fields, even in the Church. The eight figures refer to the ancient, the Mexican Cuatlique and Coyolxauhui; the Virgen de Guadalupe; the colonial paintings, the Castas; the colonial nun and scholar Sor Juana Inez de la Cruz; the revolutionary woman soldier, Adelita and my own *Abuelita* (grandmother); the Chicana farm worker; the *Pachuca/Chola;* and my First Holy Communion. The women represented in the chair altars offer us a circle of time where we remember our future, constructing for ourselves a spiritual and cultural genealogy as Mexicana/Chicana women.

San Francisco – January 1995

The interior of a derelict factory. An overcast day. A scene of total destruction. The roof of the factory has collapsed and the floor is completely covered with twisted metal wreckage and the usual fittings found in a small manufacturing unit.

A small country road flanked on either side by fields and hedges. Dusk. This scene of familiar, rural tranquillity is broken only by the presence of a burnt-out car at the side of the road. All the windows are smashed and the interior is completely gutted. Small pieces of glass and other debris lie close to the vehicle.

These descriptions of two of my photographs suggest the possibility of a narrative. However, the potential for narrative development is resisted. Instead, the viewer is compelled to move beyond the immediate surface of the photograph and to examine the specific details of social and economic experience embedded within the image. This act of resistance is central to the work and creates a point of contact with the marks and the residue of actual incidents and events in particular places.

These photographs owe nothing to the documentary tradition. They do not propose any evidence of truth. Their open-endedness and contingency implicate the present as much as the past. They exist as objects in another reality from their time of production; the reality of a mediated second hand experience, of fictionalised accounts merging with historical and socioeconomic data. Their job is to be there. They occupy space in an uncertain present, a past which is in the process of being denied and a future without history.

Derry, north of Ireland – January 1995

willie doherty

willie doherty

Incident, 1993, cibachrome on aluminum, 48 x 72″ (122 x 183 cm); courtesy of the artist

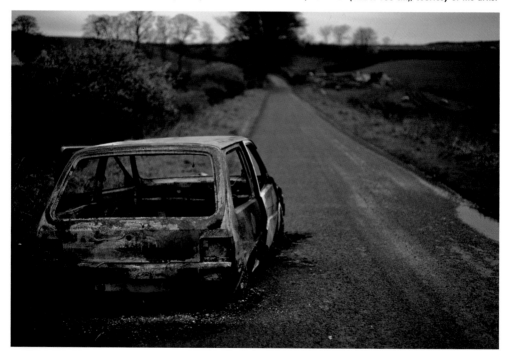

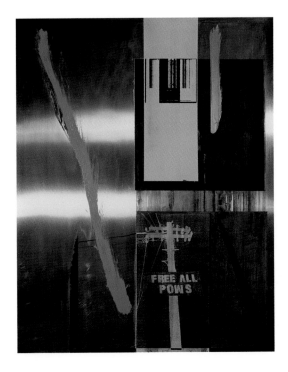

Tricolour 1
(*Free All POW's*), 1995,
mixed media, acrylic,
and silkscreen on zinc,
48 x 36″ (122 x 91.4 cm);
courtesy of the artist.
Photo by Zoran Veljkovic

david fox

JOHN CONSTABLE

Dec. 89, Irishtown, Letterkenny

(You cannot tell what people think by spying through their curtains.)
I read a leaflet about the extradition of Jim Clarke from Portlaoise, so
I go and see his brother. On the wall of his house in Letterkenny is the
most English of paintings, Constable's *Salisbury Cathedral*. Neil Clarke
seems a little distrustful when I ask (as diplomatically as possible) what
it might be doing there, but he goes away and comes back with another
picture. He takes down the Constable, leaving a rectangular dust
shadow. The new work fits precisely into the shadow. The image is of
an IRA firing party engraved in glass with a portrait of a young man; it
is a memorial to Kieran Fleming who drowned crossing the border after
the Great Escape from Long Kesh. Neil tells me that he only puts this
picture up at night when he's alone and has drawn the curtains.

BAKED BEANS

May 88, Killarney

The Great Southern Hotel; I'm at a bosses' conference. Tony O'Reilly
thinks Ireland is a brand that's not selling too well. He says, "working
with such excellent raw materials we have failed miserably and consis-
tently to create awareness", like Gucci for Italy, Dior for France, or the
Royal Family for the UK. . . !

david fox

THE BREEZE BLOCK
Dec. 22, 88

I am travelling the whole length of Ireland and it is dismal. My child, James, has left for home because we slept in a house in Belfast with no roof and it snowed; people live there all the time. I started a week ago at Malin Head, but today my journey was cut short in Co. Monaghan when I fell off a four-inch breeze block at a Garda border post. The cops laughed. I broke my ankle.

THE QUEEN'S ENGLISH
Aug. 12, 89, Belfast

I am taking photographs at a place called the Busy Bee. Six Landrovers, playing soldiers come crashing up on the pavement—Brits running everywhere screaming and shouting. They grab a young woman with a very small child in a pram. There's pretty major resistance as everyone fights back—stones begin to fly, and the girl is pulled from the Brits.

Afterwards RUC men are pushing people into the road while others are pushing people onto the pavement. One of them nudges me in the chest with his rifle—trying to knock the camera out of my hand, "fucking move, fucking move . . . don't you understand the Queen's English?" I don't even understand the question.

MOST DAYS I CHANGE MY MIND
Sept. 27, 94

It's a dirty night in Manhattan, cold and wet. I'm walking down Broadway. Haiti and O.J. flash on the Times Square screen a hundred feet above. Stepping through the traffic a newspaper flaps across the street and wraps itself around my leg. "GER'S GREEN APPLE", it proclaims. Amongst all the signs, perhaps it's a sign. I take it back to my hotel and make a little altar with some of my holy bits and pieces. It quotes someone on the Falls Road: "We support Gerry Adams and hope the fuck he knows what he's doing". It's a bit dismal and hardly an analysis of the situation back home, but I take it up as my slogan. It's going to be the name of my exhibition. I look out of my window at the Empire State Building — and I do believe it's lit up in green.

WET LEVIS
Sept. 29, 94

Heavy rain in New York. Sirens blaring, Gerry's motorcade slips across a wet Times Square. I wave (but with the tinted glass, rather hopefully) and my new Levis are drenched by his limo's stately progress. High

above in lights a giant woman hitches a lift; beneath her is emblazoned: 'Banana Republic'. I get a bad feeling and rush back to work. I make a minor self-criticism—reacting as a shopper is wrong, when the state of nations is being decided.

I'VE BECOME A BIT LIBERTARIAN OVER THE YEARS BUT I'M AGAINST THE FREEDOM TO SHOP
Oct. 94
Back in London I read: "An Indian summer has descended on Ulster and it warmed the faces of the shoppers in Belfast city centre yesterday". The 'Indians' and the 'cowboys' have all put away their guns. The shoppers, Ulster's cavalry, have arrived. I can't believe it. Deep depression sets in. I decide to call the exhibition "White Goods". There are pockets in Ireland yet to see a Shopping City or a Toys R Us, where the hunt for white goods has not become the culture's pinnacle. This is thanks in part to the much-misunderstood Irish Republican Army.

ECOLOGY
Oct. 94
O'Reilly says we have a niche and it is that we are seen as green and unspoilt and more than a thousand miles away from Chernobyl . . . then he laughs.

A PERSISTENTLY PERVERSE ELEMENT
Dec. 94
I know little or nothing about Mexico. I did see an Italian western once, called in English "A Fistful of Dynamite." James Coburn played an IRA bomber helping the revolution in Mexico. I liked it. Did the film have anything to do with either place, Mexico or Ireland? But as this exhibition is supposed to be a collaboration with Mexican, Chicano and Irish artists, here is a contribution to the debate. Sometimes we're proud of the things they say against us:

It would be difficult to deny the existence of a constitutionally criminal class, a persistently perverse element, which is the born foe of all law and order, at war with every form of social and political organisation and whose permanent attitude of mind is that of the Irishman, who on landing in New York, inquired, "Have ye a government here?" and on receiving an affirmative answer, replied, "then I'm agin' it".

This was written by a man called Evans in 1906.

London – January 1995

OVERDUBBING IRELAND

Joan Fowler

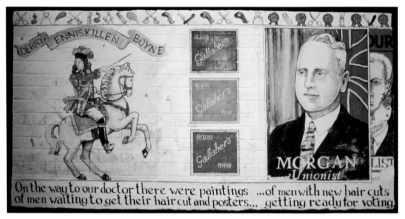

John Kindness, *Belfast Fresco Series*, 1994

Willie Doherty, *The Only Good One is a Dead One*, 1993. Photo by Edward Woodman

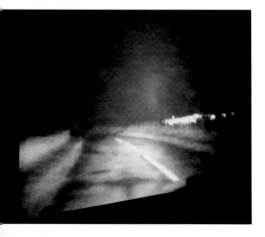

With the 25th Anniversary of British Army involvement in the conflict in Northern Ireland in August 1994, the British Broadcasting Company (BBC) made use of the opportunity to fill some of its summer schedules with documentaries it had made about the province over the period. The schedulers perhaps accomplished a different insight than intended by their retrospective, for, on a general level, that which was most in evidence was not the development of the conflict over twenty-five years, but the development of the representation of the conflict. Inscribed within the often grainy, black and white footage of the late sixties and early seventies was the sense of human tragedy unfolding, with reporters describing injury, death and destruction as these were happening on the screen. By contrast, the images of the late eighties and early nineties showed none of the immediacy of the violence and its effects on human subjects: the cameras were kept at a distance until the site of violence was carefully manicured. Death had been rendered invisible, not just in the interests of

the state but also, apparently, through the strategies and counter-strategies of the Irish Republican Army (IRA) and various other para-military groupings. The scenario after twenty-five years was that the ultimate sign of the conflict, violent death, had been reduced to theatrical funerals specifically stage-managed for the media and its distribution system.

Northern Ireland had come to be maintained and contained as a 'controlled' zone. A status quo was established between the military and para-military forces, and events, or signs of the continuation of conflict, were channelled by the information offices of the state, political parties and para-militaries to the media. Since no side could claim victory, the struggle was played out in the media as either a war for freedom against imperialism, or as a need to defend citizens against terrorism. In global terms, there is nothing particularly unique in this except that the 'controls' imposed are as close to being complete as anywhere in the world, and, as part of the United Kingdom and of the European Union, Northern Ireland is posited by the forces of the state as a free and democratic society, that is to say, as a western society. The former sustains the latter through the application of state-of-the-art electronic surveillance techniques. Containment is not so much a result of overt military activity but of covert intelligence, and the camera is the most pervasive symbol.

One of the issues underpinning this essay is the extent to which Northern Ireland (but also, given the inter-connectedness across the borders, the Republic of Ireland and Britain), has entered a situation where surveillance techniques and the media are covert and overt operations that affect how the individual subject thinks and behaves at conscious and unconscious levels. If so, then a Baudrillardian account of the world seems plausible, and the more traditional concepts of reality, where fiction and representations are merely adjuncts, are inadequate. This is a world where simulation and the 'hyperreal' replace the real, where digital and electronic technology are the basis of the codes of the social system. The signifier and signified are not simply in an unstable relationship to one another but, as the French philosopher Henri Lefebvre put it, we are contemplating 'the decline of the referentials'. Clearly such an extreme view is problematic; for example, not only in terms of Ireland's tenuous relationship with modernity, much less the excessive modernity advanced by Baudrillard—but also in

the implicit reduction of art to social circumstances. An address of these larger issues is beyond the scope of this essay, yet they form part of the considerations involved in a reading of the Irish art in this exhibition. The six artists see their work in terms of a number of practices and with a number of reference points, which together involve contradiction and, as will be indicated, a radical closure of these frameworks and reference points is neither desirable nor possible.

In 1993, artist Willie Doherty made a video-sound installation entitled *The Only Good One Is a Dead One*. On adjacent walls the two video projections show, in one, a street at night in a suburban area with the camera in a fixed position (similar to a surveillance camera), and, in the other, a car being driven down deserted country roads at night from the point of view of a passenger looking ahead at the limited, fleeting sight of what the car's headlights pick up through the darkness. In this sequence, the reflection of the lights of a town or city is occasionally registered in the night sky. The sound tape is a narrative by a male narrator who describes, on the one hand, his experience of surveilling his victim over a period of time as he schemes the best opportunity to kill him and what that will be like, and who, on the other, describes either his own assassination/murder or has assumed the identity of another person who is killed. The narrator is therefore more or less simultaneously in the position of watching and being watched, of killing and being killed. The narrator, far from being an existential or transcendental figure, is decentered and, as in the title of the piece, he talks in terms of clichés; he describes killing or being killed in terms of a Hollywood movie. The installation is not so much about human tragedy as about playing back a tape which simulates human tragedy. If, in one sense, the installation is banal as 'art', with its use of Hollywood-like representations (albeit with multiple story lines), at the same time it raises questions of who is inside or outside the spectre of events, or is everyone implicated; who, if anyone, is witness to what; whether the person(s) in the moving car is (are) outside the known twenty-four-hour surveillance taking place within the urban environment, and for the time being, is (are) outside the limit of the law. On another level, there is the significant question of the extent to which Hollywood movies permeate the social fabric and the individuals therein, and whether this touches on ways in which we represent

the sense of self to ourselves. From time to time we imagine ourselves, in an ideal way, as we might be seen by the camera.

After the IRA cease-fire commenced in September 1994, the British Government was under pressure to relax some of its Emergency Legislation, especially its media ban on the Irish political party, Sinn Fein, which is alleged to have links with the IRA. Since 1988 members of Sinn Fein were prevented from direct speech on television or radio, and the response of the media companies was to use actors to dub the words spoken to microphone. The situation was regarded as a farcical government mistake, and the overdubbing ironically regarded as an artform. On one occasion Gerry Adams is reported to have said, on finding out which of the actors was going to dub his interview, "Dead on. He does it better than me". The lifting of the ban in mid-September 1994 is seen as part of the 'normalisation' process.

Artist David Fox's documentary, *Trouble the Calm* (1988), is not a portrayal of 'normal' society, not in the sense of a community at home with itself. Fox focuses on a number of aspects of society in the Republic of Ireland. The dominant opposition he establishes is that between the

David Fox, *Trouble the Calm* (film still), 1988

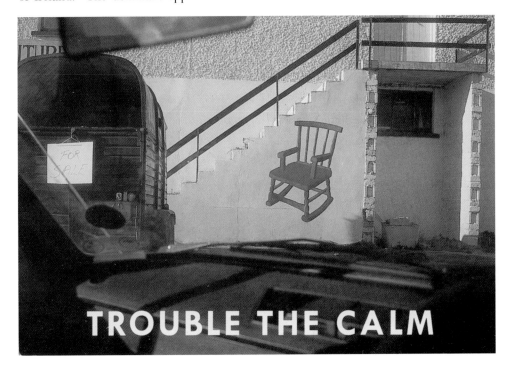

power currently exerted by corporate interests and the multi-nationals over Irish politics and the Irish economy, and the loss of the politics of a new society in the Republic fought for by Sinn Fein in the period between the Easter Rising against British Rule (1916) and the Civil War (1922-23) over the terms of the Anglo-Irish Treaty. Fox suggests that Ireland is a puppet in the global economy, while at the same time it mythologises its Republican legacy and silences its dispossessed through its Emergency Legislation ostensibly aimed against terrorism emanating from Northern Ireland. Fox assumes a position in regard to power relations: power operates through the global communication networks and the economic determinants that sustain them. In this sense, the overdubbing performed by actors on Sinn Fein members is a metaphor for Irish politics. *Trouble the Calm* is an investigation of the public world, or at least a public world as circumscribed by censorship; the private is suggested through the editing techniques as a media bombardment takes effect in the consciousness of the Irish subject. Fox recognises the complexity of the situation, though he does not foreclose the possibility of an alternative social structure.

In a sequence in *Trouble the Calm*, women (outsiders) approach the Taoiseach (Prime Minister) of the day as he attends a reception at a high-powered corporate conference held in a Killarney hotel in the south-west of Ireland. The women are wives of prisoners in the Republic who have been issued with extradition orders to Northern Ireland, where they will face charges connected with alleged IRA activity, pending their appeal against extradition. The women make it clear that there are political, legal and personal issues at stake. One woman asks, "What's going to happen to us? That's what I want to know". The woman is resident in the extreme south of the Republic, and she may be alluding to, among other things, the prospect of a split in the family if her husband is moved North. Women are still expected to assume most of the responsibility for the family unit.

In *Turas* (Journey) (1990, see page 120), video artist Frances Hegarty opens the visual sequences of her video with shots of the estuary of the River Foyle as the former site of mass emigration from Ireland. Since 1921 it represents the furthest north-western point of the border between Northern Ireland and the Republic. In Hegarty's terms, this forms only the starting point for an exploration of the reconciliation of the fact of exile in

the re-tracing of the river back to its source. The English language is used symbolically as that which is to be worked through in order to return to the source, to the mother. The Irish language is identified as a different form of communication, which is part of the process of reclamation. Hegarty's editing is employed in a different way to that of David Fox: here the editing adopts gaps and fissures but most particularly, rhythms. The rhythms of the work, in sight and sound, are constitutive of bodily rhythms. Where Doherty's narrator is without a center, without a body, Hegarty wishes to forefront the materiality of the body of the woman.

In his installation *Apparatus II* (1994, see page 125), installation artist Philip Napier adopts the scroll-like devices used at the front of public buses in Northern Ireland to identify the destination of the route followed. These are lengths of black fabric wrapped around a cardboard tube with the place-names of all possible destinations in the network painted on in white. The place-name is highlighted at a window in front of the bus by manually turning a handle above the driver's seat. Napier has installed the rolls in rows on the floor in a vertical—as opposed to their usual horizontal —position so that the two place-names actually visible on each roll are read on their side. Emanating through each of the tubes in the darkened space is an audio-taped male voice stammering the place names. This is not, however, quite what it might seem. In Ireland, all non-modern place-names pre-date the predominance of the English language, and most place-names derive from English translations of the eighteenth and nineteenth centuries, which were usually mis-translations. The stammering voice in the audio-tape is not naming the places as identified in English on the rolls, but he names the places as retranslated from Irish into English. *Apparatus II* is about disjunction between languages, and between speech, act and thing: the name for a place is a symbol for a loosely defined geographic area. In Ireland, this assumes geo-political significance in both local and national terms. The symbol signifies more than that which it represents.

Napier is interested in manual and mechanised tools, and he views the digitalisation of the destination signs at the front of Northern Ireland's buses as symptomatic of a process which involves the loss of one kind of relationship between humans and their tools, and its replacement with another. Until the early twentieth century, Belfast and its outreach of the

Lagan Valley was the only part of Ireland which could be said to be industrialised. Ireland was largely agrarian, and the majority of its population rarely travelled beyond townlands and the immediate countryside, except to emigrate. Ireland was hardly industrialised before becoming, in many respects, post-industrial during the last three decades.

These factors are crucial to much of John Kindness's practice. In, for example, *Ninja Turtle Harp* (1991, see back cover), the harp, as the official symbol of Ireland and a symbol of traditional Irish music (i.e., 'authentic Irish music'), is painstakingly re-presented in ceramics (a traditional craft), and embellished with decoration depicting the Ninja Turtles, who had their fifteen minutes of fame in recent pulp culture. The work is not so much about a cultural clash between old and new, tradition and modernity, as about an accommodation or even the collapse of one into the other: values are indeed relative as far as the consumer society is concerned. Kindness is not being entirely ironic, because he has a commitment toward revitalising old crafts in his work. In *Belfast Frescoes* (1994, see also page 65), he uses the fresco technique to tell a story in words and images about a boy in Belfast, a Belfast which is pre-1969, still a predominantly industrial city of industrialists, workers and traders, and its economic wealth still determined by its shipyard. *Belfast Frescoes* could be interpreted as nostalgia for a bygone era, but it might be read more accurately as an attempt to represent, from a viewpoint somewhere between fiction and autobiography, specific aspects of life within a culture which has been under-represented because it was marginalised both politically and culturally by both London and Dublin. The more complex, though related point is the fragility of the sense of identity (or identities) in Northern Ireland, which has gone from a position where, pre-1969, it was under-represented in relation to the outside world, to the recent position where it is represented mostly in terms of a tribal conflict.

A common feature of the work under discussion is the relationship between history and modernity, and contingent on this, the possibility of critical intervention in an art context. While the former might be described as a condition of postmodernity, the latter is problematised because of the dominance of the aestheticisation of both past and present in the mass media. In her recent work, Alice Maher examines this condition by, on the

one hand, drawing attention to the work's status as 'art' through the evidence of the process of its making in combinations of drawing, painting and sculpture, and, on the other, paring away at the notion of content with an insistence on radical disjunctions between the signifiers of meaning. This is not, however, the self-referential goal of abstract art. In *Folt* (1993) (translation adopted by the artist: 'abundance, tresses, forest of hair'), Maher creates sets of small paintings on paper to mimic graphical representations of different hairstyles, as well as including human hair within one of the six boxed frames. In these, the woman/model is absent but the sign of the feminine is undeniably present. We recognise the signification going on in these small paintings, not through

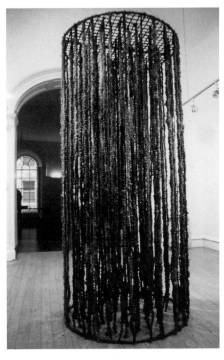

**Alice Maher,
Keep, 1992**

overt means employed by the artist, but precisely through the recall of the ideal models of femininity represented in all aspects of the mass media. When *Folt* was originally exhibited, an extension of the level of meaning was presented through the accompanying catalogue: two illustrations, examples of late nineteenth-century women's hairstyles and examples of the instruments required to construct hairstyles.[1] These belong to an era that not only produced the growth of mass distribution systems for goods and, by extension, mass advertising, but also the theories of commodity fetishism by both Freud and Veblen, and later, a theory of sexual fetishism by Freud. The graphical hairstyle is a sign of both woman and commodity, and woman as commodity, though the opaqueness of these works as paintings also reflect back at the viewer. Maher sees these images as simultaneously repellent and fascinating, negative and positive, because, while they regulate, the hairstyles can also be reinvented.

Maher's recent work pushes the limits of signification between art and the social, not as transcendental categories, but as specific and gendered. The issue is the power of the media to appropriate everything, including—or especially—art into a system where difference is elided

1 *Relocating History: An Exhibition of Work by Seven Irish Women Artists* (Belfast: The Federesky Gallery at Queen's University, and Derry: The Orchard Gallery, 1993).

through the perpetuation of stereotypes. Maher's response has to be one of problematisation, not a withdrawal into an artificial maintenance of high culture, or an ironic play of signifiers which characterises so much post-modernist art, but an attempt to expand the possibilities of language. Something similar occurs with Willie Doherty's recent photographs. In *Border Incident* (1993), for example, a burnt-out car has been left in a ditch at the side of a deserted country road. The artist provides no contex-tualisation beyond the image and the title. The contextualisation already exists; it is provided by the media system. This is further extended in *Incident* (1993, see page 76), which shows another burnt-out car at the side of a deserted country road: the removal of the word 'border' reduces the already minimalist references. It is not, as one commentator put it in another context, that art photography appeals to 'memory, history, cultural convention, and language itself', while the news photograph or the snapshot, 'with its prerequisites of instantaneity, sharpness, and precision, initially inhibits speech'; it is the other way round. This is to suggest that avant-garde concepts about the role of art live on and, while the Baudrillardian scenario of the total system looms large, so too does the optimism about the possibility of meaning and transformation in art.

2 Maurice Berger, "Visual Terrorism," in David J. Brown and Robert Merrill, eds., *Violent Persuasions: The Politics and Imagery of Terrorism* (Seattle: Bay Press, 1993), p. 22.

IRONY, BARBARY, SACRILEGE

Cuauhtémoc Medina

Beloved Modernity, Who Does Not Forgive

What promised to be the "Age of NAFTA" ended up being the new *Burning Plain.*[1] During the eighties and nineties, the Mexican government and its elites invoked, in ever more exalted terms, the idea that Mexico would finally be integrated into that bleached utopia called "modernity." Despite the panegyrics, it was a selfish wish. "Modernity" had a clear meaning in terms of the economic landscape: accelerated privatization, the dismantling of traditional communal land holdings in the countryside, the internationalization of capital . . . that orthodoxy that is triumphant capitalism's rights of conquest.

Hypothetically, becoming "up-to-date" should mean a lifestyle like that found in the United States and Europe, from the mirage of occidental democracy to the abundance of McDonald's. But, as is stubbornly demonstrated in the history of the supposedly "developing" countries, the conduct of "economic liberalization" cannot be carried out except at the expense of our dreams of political modernity and with the increasingly perfect distribution of inequalities. It is not a paradox, but rather a necessary result of the very violence that "modernization" implies that the Mexican state, along with its Chinese and Cuban compadres, had to make use of the apparently unmodern machinery of ideological, military, and political control in order to impose its restructuring—which modernization could only carry out under the sign of despotism and repression.

Thus the collapse of 1994–1995: the intensification of conflicts among religious and economic sectors; the eruption of political violence; the punctual return of the financial crisis at the end of 1994; the Indian rebellion in Chiapas and the zeal for drowning it in blood, even at the cost of consensus. Once more "modernity" showed its true face, appearing as chaos and social breakdown. How, one must ask, was this chaos expressed in the field of arts and culture in Mexico? In the likeness and image of the distorted premise sustaining its government, contemporary culture in

1 A reference to Juan Rulfo's novel *Llano en llamas.*

Mexico can be nothing but divided, fluctuating, pallid, and confused. A grandiloquent mixture of mirages and leaps into the void, swinging between the resuscitation of Aztec mummies of the government's discourse, the cosmopolitan dreams of middle-class intellectuals and artists, and the first stammerings of a possible—but still unrealized—critical culture that is unable to properly define itself due to the tricks of its enemy, a criticism that is not articulated because its adversary is cynical and slippery.

Faced with the impossibility of manufacturing a mythology based on the holocausts of neoliberalism, the country's political and economic elites turned their gaze toward that capital, dilapidated now but always available, which is Mexicanism. The international exhibitions "Mexico: Splendors of Thirty Centuries" and "Europalia," the Mexican Gallery at the British Museum, the collaborationism contained in the sterilized enthronement of the cult of Frida Kahlo, and the transformation of archeological sites into prospectuses for tropical Disneylands, decorated the ephemeral triumphalism of the early nineties that needed to reaffirm the national iconographic apparatus in order to function as a tool of ruthless internationalization. The old prescription was applied: that of historicist pastoralism. The government of the world's oldest revolution attempted to alleviate the absence of an image of the future by trying to reaffirm the thesis of the continuity of the culture's past without conflicts or divisions, since, from the perspective of power, Mexico is an entity where massacre and pillage are hidden behind an image of docility. It is a fruitful association of the new and the old, in which the modernity of the *maquiladoras* and international competition would coincide with the heritage of "Mexico's greatness," before which any opposition, though it came from the idolatrous Indians, was simply an avoidable annoyance. It is an image for export (one that attracts tourism and is sought when Mexico is considered in the galleries and museums) but an image with a clear sense of itself, serving as a source of legitimization, interpreting a monopoly of power in the likeness and image of its monoliths, and defining the terrain wherein the tasks of intellectuals, writers, and artists—the priests of their faith—are supposedly located.

In effect, this structure that is Mexico's national culture—which survives in spite of a domestic television culture inhabited by home-bred Madonnas who don't mention sex, rap groups without ethnic identity,

upper-middle-class punks—is the desiccated child of the intellectual and artistic battles of post-revolutionary Mexico. From Vasconcelos to Octavio Paz, from Diego Rivera to Carlos Fuentes, Mexican intellectuals and artists have constructed a mythology that is precisely that nation that springs to people's lips when they speak of "Mexico." A construct which, due to various causes and political programs, has ended up as an unsalvageable pile of rubble. And, as Roger Bartra said in *La Jaula de la Melancolía* (The Cage of Melancholy), a construct whose main effect is to make it difficult for contemporary Mexicans to define their political and cultural duties:

. . . the national metadiscourse tends to impede or make more difficult Mexicans' relationship with their past and with the history of the world: history is reduced to hieroglyphics, to static symbols destined to glorify the nation's power and to put good sense to sleep; when one wakes from this dream it is difficult to recognize one's own past and even the presence of the world. We have dreamed of a million mythic heroes, but all that remains of the nation is its ruins.[2]

Certainly, the cult of nationalism that the Mexican government revived in recent years had become a moribund religion that nobody but ideologues and the mass media could take seriously. In 1987, Bartra believed that the collapse of the idea of a Mexican national culture would cause an inevitable liberation: the nakedness of *"desmodernidad"*:[3]

Mexicans have been expelled from their national culture: this is why Mexicans pay less and less homage to a metamorphosis thwarted by melancholy, to a progress castrated by backwardness. Mexicans see themselves less and less as that axolote[4] *which the mirror of national culture offers them as a paradigm of unifying nationalist stoicism. They are not enthusiastic about efficient modernity, nor do they want to revive the promise of a proletarian industrial future. Neither do they believe in a return to the Golden Age, to incipient primitivism. Cast out of their native paradise, they have also been expelled from the future. They have lost their identity, but they don't mourn it: their new world is an apple of discord and contradictions. Without having been modern, they are now unmodern; they are no longer like the batrachian, they are other, they are different.*[5]

Still, theory is one thing and ideology is another. In spite of its

2 Roger Bartra, *La Jaula de la Melancolía: Identidad y Metamorfosos del Mexicano* (The Cage of Melancholy: Identity and Metamorphosis of the Mexican) (México: Editorial Grijalbo, 1987), p. 241.

3 Bartra's term alludes both to the literal sense of "un-modernity" and the Mexican slang concept of "desmadre" ("without mother"), which means both chaos and uncontrolled feast, depending on the usage, while implicitly referring to "illegitimacy."

4 *Axolote* is a peculiar batrachian of the salamander family that lives in the lakes of Mexico; it is well-known because it reproduces itself in a larval state, and can stay in that condition until the end of its life without metamorphosis.

5 Bartra, *La Jaula de la Melancolía*, p. 242.

sterility, Mexican identity, like that of the PRI (Mexico's ruling Institutional Revolutionary Party), is a corpse in good health. In spite of its increasingly frequent appearance in sensationalist political headlines around the world, Mexico continues to cash in on its aroma of cultural peculiarity to the degree that, as a metropolis, it often supplants the image of Latin America. It is a mask that conceals, since each idealization of *lo mexicano* must be countered with its sociological nemesis: racism with the Museum of Anthropology, Catholic moralizing with the improbable eroticism of *Like Water for Chocolate*, the PRI dictatorship with the country of surrealism.

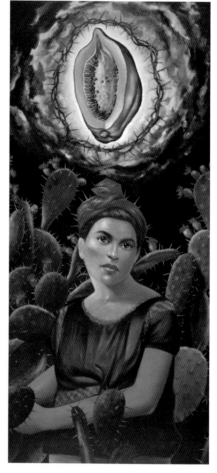

The culture of Mexico is the vision projected in the eyes of Mexican presidents when they decide to "disappear" their opponents, or assassinate them.[6] It is that entity that gives credence to the paranoia of domestic and foreign threats, that validates the authoritarian acts with which our government periodically oils the machinery of those businesses that are its sole true interest.

One could, like many others, act as if artistic and literary work had nothing to do with such constructs of history, and create a "metropolitan" culture in spite of the curse of nationalism and the atrocities committed in the sacrosanct name of Mexico. But acting as if a situation does not exist just tends to perpetuate it; the task of dynamiting the Mexicanist culture of power has barely begun. The reformulation of Mexican culture that would turn it into a living and liberating entity is still a dream. If the national culture that

poisons us is a religion of empty tyrannical images, a subversion is called for that would also be iconographic. At times this would seem to be irony disguised as candidness, at others a revelation of facts contradicting dogma, at still others an amusing sacrilege: as false idolatry, as syncretic dislocation, or as an eschatological profanity.

The Aztec Ghosts

For nine years Javier de la Garza has been painting narratives about the impossibility of Mexico, stories in which the poetry and themes of nationalist mythology are fleshed out as a demonstration of their improbability. These are epiphanies of idolatrous falsehood.

I think nobody could fail to notice that de la Garza's strategies are directly related to those that prevailed in western painting during the eighties: roughly paraphrasing the appropriation of the styles and icons of the first vanguards or stages in the "history of art"; the utilization of ideograms and boxed texts as if to call upon the viewer's skepticism at the ability of painting to transmit its own discourse; the tendency to present more or less central and dominant figures standing out against a background that is not a setting but rather a decorative montage of saturated surfaces, before which the figures clash with their apparent immobility and volume. But, above all, de la Garza's paintings reveal his affiliation with paintings of the eighties in the way in which they are offered as a kind of personal mythology where the paintings seem marked with an excess of oratory accompanied by the impossibility of reading it; this happens either because the painting produces in the viewer an assumption that the artist is keeping some meaning to himself that is displayed as much as it is occluded, or because it combines the stridency of its "messages" with a lack of articulation of its parts.

De la Garza's paintings echo the "postmodern" concern that an opulence of information is a guarantee and expression of the absence of meaning. Thus his work tends to take refuge between mysticism and irony, between the symbolic image and informational indigestion. In this sense, his paintings have meaning only when one considers them in the context that they criticize by reinventing it, the context of the iconography of Mexicanness that Mexican painters and filmmakers developed from the

6 The link between a homogeneous definition of Mexicanist identity and the authoritarian behavior is well proved by the central argument Mexican president Ernesto Zedillo used when he launched the failed military offensive against the Zapatista army on the 9th of February, 1995: ". . . the origin, composition of the leadership, and the goals of the group [of the Zapatista Army] were neither popular, nor indigenous, nor from Chiapas. . . . [and] . . . clearly represent a threat against the Mexican people and public order." (México: Presidencia de la República. Dirección General de Comunicación Social, Press Statement no. 150, February 9, 1995, pp. 3-4). Independently of the question concerning the legitimacy of the government actions, what distinguishes them is the idea of excluding and criminalizing all actions that do not correspond with the public image of the identity of the population. This implicit charge of "anti-Mexican activities" explains a great deal about the vital importance of the cultural narrative for the Mexican regime.

twenties to the fifties, especially those of the sentimental and kitsch branch of melancholy nationality: the films of El Indio Fernández photographed by Gabriel Figueroa, the calendars of Jesús Helguera, María Izquierdo's "metaphysical" paintings and the untouched martyrdom of Frida Kahlo, the cult of the Virgin of Guadalupe and Aztec sculpture.

In fact, Mexican art criticism classified de la Garza as part of a movement, which was called "neo-Mexicanism"—a designation that tends to disguise it as mere revival, so that nostalgia also served to nourish official iconography. This was a current which, as art historian and critic Olivier Debroise observed, began in the eighties as an alternative to the internationalization predominant in Mexican art of previous decades, but that became a kind of mainstream for Mexican painting by mid-decade, with all the risks and contradictions that that involved. Paradoxically, what began as irony became a commercial success, partly because it reinforced an image of Mexican painting recovering its national character, but also because it coincided with North American art's new interest in cultural identity.[7]

Evidently, de la Garza was not trying to pose the reinvigoration of the national myths in his painting, but he cannot deny having participated in this to some degree. Meanwhile, the fact that a taste for his work developed is proof that fossilized Mexican rhetoric is more than capable of assimilating even its heresies. De la Garza has experienced the ambiguities relevant to his points of reference, particularly the difficulty of adequately distinguishing between criticism and homage. His works incorporate that ambiguity, and play on the possibility that the viewer will take them as authentic expressions of the neo-Mexican, while his real intention is to emphasize a paradoxical distance from nationalist myths.

The Border: A Place, Everyplace

One of the paradoxes of Mexicanist culture is the fact of having built its dreams in praise of the *mestizo* while continually feeling threatened by the possibility of new cultural mixtures. Specifically, it always experiences the threat of meltdown when faced with an image of the American way of life. The other side of the illusion of cosmopolitan Mexican culture is the image of its declining folk culture: as long as the Mexican upper classes

7. Olivier Debroise, "Javier de la Garza: fusiones," introduction to the exhibition catalogue *Javier de la Garza* (Mexico City: Galería OMR, 1993), p. 14.

Rubén Ortiz Tórres,
*Graceland
Apparition/El Vez*,
1991; courtesy of
Jan Kesner Gallery,
Los Angeles

define themselves mimetically, they reinforce their dream of the lower class-
es being identical to their original models, as if cultural assimilation were
part of their monopoly on privilege.

Even before going to Los Angeles to study at the California
Institute of the Arts, Rubén Ortiz Tórres had shown a special interest in the
way in which Mexican and Catholic cultural icons have been affected by the
emergence of commercial mass culture in Mexico. However, in recent years
his closeness to the border lifestyles that have developed among Chicanos
and residents of northern Mexico suggested the need to use these images as
a field for the study of cultural misunderstanding.

Rubén Ortiz bases his work on the idea that all cultural identity is
a hard-won construct of abstraction: the cleanness of disturbing aesthetic
elements and the freezing of certain features that are raised to the status
of cultural principles, such as the images of Mexico as a rural reservoir of
popular Catholicism, and of the United States as a theme park of industrial
progress. All identity—and the representation of *lo mexicano* is an
exemplary case—is a political construction. But what is significant in this
construction of identity is that despite its artificiality, it ends up being
assimilated and applied in daily life, creating a constant instability and an
abundance of paradoxes. As Ortiz demonstrates in his video *Como leer al
Macho Mouse* (How to Read Macho Mouse), Emiliano Zapata is caricatured

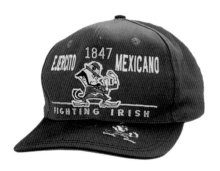

as Speedy González; similarly, Mexican artisans make clay sculptures, in the most traditional style, portraying Donald Duck. Ortiz is particularly interested in those cases that break with cultural taxonomies and generate unexpected dialogues: for example, the way in which the U.S. obsession with the danger of invasions from outer space, provoked in part by immigration, is reflected in Tijuanan paintings on velvet of E.T.

According to Ortiz, the artist's task is not to represent this chaos and put it in order, but to confront the public with the representations that have been made of it, and perhaps to provoke with the disinterested black humor of his own reflections. Thus, Ortiz documents and selects the way in which living culture is practiced in terms of its symbolic abstractions, partly because he is fascinated by that vitality (for example, the opulence of Chicano Low Rider cars) and partly because living culture can only be simultaneously tragic and comic.

His work is a challenge both to the idea (often dreamed of by Mexican artists) of a pure "international" artistic language, and to the utopian notion of representing the identity of a culture through art. In this sense, his work is distinct from Chicano art, which often aspires deliberately to being a symbolic representation of the state of border culture. In contrast, especially in his color photographs, Rubén Ortiz has concentrated on showing that the same evanescence exists in the concept of the Mexico-United States border, whether the moment of the impossibility of recognizing the identifying features of a place is being documented and dramatized in Los Angeles or Mexico City (or many other places). He is interested in those moments when the border is no longer just the Rio Grande dividing line, but becomes a possibility that is latent in any place in North America. Such scenes show the border to be not a place but an aesthetic disturbance.

Recently, Rubén Ortiz has tried to go from the observation of this dislocation to direct intervention. His baseball caps are more than an ironic commentary on the way the emblems of sports teams appropriate cultural

stereotypes; they also construct the possibility of a future Mexican-North American identity—one of the conquest and politicization of mass culture. If these caps were actually fashionable, the cultural industries would circulate not just the stereotypes but the paradoxical and self-critical images of the discourse about identity. Basically, Ortiz tests the possibility of surpassing the reservoir of art. His work looks toward a different audience, one for which representations are more than just something to be enjoyed, an audience for which representations may become political weapons: a purely hypothetical audience, probably improbable, but many times implicit in the multiculturalist standpoints. The baseball caps presented as utopian projects, caged in their vitrines, make even more evident the inconvertible distance between artistic practice and mass culture.

Incest

Let's explore the premise that ideologies are secular religions, that they turn history into a sacred, fossilized, inaccessible narrative, a written theogony. Museums, with their objects displayed out of reach, devoid of all context or contact, manifest that narrow vision of the past and of tradition, consecrating the idea that only that which is no longer available is culture. It is not just that governments rewrite history to justify their political power, but that once they do this they wall history up so it will not propitiate subversive ideas. The education that inoculates us with one version of history tends to present that version as irrevocable fact, in spite of the fact that academic research on the past is constantly being rewritten, and in spite of the fact that popular historical narratives (such as myths) are constantly erased and reconstructed in the plasticity of memory and the spoken word. One of the keys to hegemony is to keep identity and history always present, while maintaining statism at a distance. In this sense, contact with the past takes place under strict control—paternal control.

In her installations, action videos, and objects, Silvia Gruner has been trying to give form to a concern that we might call sacrilege: approaching memory through corporal contact, dislocating the untouched appearance of history and tradition by means of eschatological eroticization. In a way analogous to how Catholic mystical theology periodically disturbs the structure of official Catholicism, Gruner invites the viewer to

have unmediated access to the signs of her culture. Thus, her works frequently emphasize a kind of aura contained in objects: the soul residing in horses or in a bed, the historical presence that phantasmatically inhabits convents and houses, or the iconography of holiness incorporated in a suit. And thus her images, such as the fragrance and color of the soap in one of her installations, are physical emanations and not just visual objects.

Of course, this sacred contact with culture cannot take place without a trace of irony. Silvia Gruner's ceremonies arrive at a certain moment when they bite their tails and metamorphose into jokes and games. Perhaps in this way Silvia tries to ward off the dangers to which a feminist perspective is exposed when it deals with tradition: that is, the temptation to personify it. It is not surprising in the case of Mexico that women such as Frida Kahlo, María Izquierdo, and Tina Modotti are mythicized just when the model of national cultural identity is in crisis; since women tend to be conceptualized with the untouched and irrational essence of nature and culture, for this reason they are summoned when traditional certainties are shaken.

In *Don't Fuck With The Past, You Might Get Pregnant* (1994), Gruner has perfectly joined this theme of the past taken by force with the

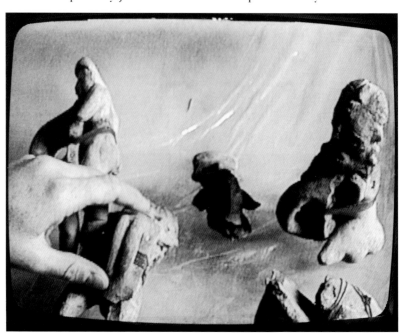

Silvia Gruner, *Don't Fuck With The Past, You Might Get Pregnant* (detail), 1994

need to oppose the myth of femininity as the paradise of identity. The video and stills are presented ambiguously as private ceremony or pornographic archeology. A series of *tepalcates*, broken clay figures from pre-Columbian agrarian religions that are still frequently turned up in tilled fields, are newly fertilized by the artist's hand. That hand draws the idols to a contact denied by historical narrative, while at the same time representing the past as fornicatable material, as the object of violence. The idol is screwed; the woman's hand paradoxically becomes a phallus. (It is not in vain that *patria* —Spanish for country, root of "patriotic"—is a feminine derivative of *pater.*) But as the title of the piece suggests, the escapade is self-rape; it is the artist, and not the past, who might be impregnated by the contact. One would like to see in this "ravishing of the *coatlicues*" the possibility of freeing the past from its dogmas in order to re-link it with new tasks and a new present.

The isolated, anxious gestures of these images are a metaphor for the tentative pursuit one would like to make of identity and history once the official narrative has expired. It is not in vain; the ancient mythologies tear at us subversively as incest.

The United Nations of Art

International exhibitions come and go; they are the thermometer of the nascent culture of the end of the century. It is no coincidence that they take place. While markets are inundated, in an increasingly irreconcilable and expatriate mass of products, with jeans made in Thailand, Japanese tequila, South African wine, and Brazilian PCs, the arts aspire to the formulation of a clarified, self-aware exchange of provenances.

Certainly this cultural representation is problematic. On the one hand, the multiculturalism that apparently dominates the world art scene tries to be the antidote to that inferno of galactic uniformity that was imagined in the metropolis to be the result of international modernism. But, on the other hand, multiculturalism also presents us with the concept of "national cultures" that romanticism formulated for modern states.

Nevertheless, the international exhibitions that we present and observe, contain, like a sin by definition, the assumption that the artists and the works of art represent their countries; the audiences that attend them continue to expect these exhibitions to reveal some truth about, say, for

example, "Mexico and Ireland." This is an illusion; the experience of a society cannot be summarized in an object or image. Yes, a work of art can be involved in the task of giving momentary meaning to a contradictory mass of stimuli—it can, perhaps, aspire to becoming a point of reference or a talisman to help us get through a volatile context—before it falls into the bin of frozen definitions of "cultural patrimony."

But even so, there is a trap, and the trap is set. The fine arts live by the fraud of their transparency. The public walks through the halls of galleries and museums and consumes, *instamatically*, an image that is practically by definition an immediate unit of meaning, which, in spite of being contradictory and bloody, can be viewed in a second and assimilated like a slogan. We visit Babel as tourists and come back with a snapshot.

The Snapshot

No image can be more eloquent than the snapshot, precisely because it is so anti-glamorous. Nothing in it refers to the aesthetics of war, with its close-ups of resplendent activity and its shameless pursuit of suffering with a human face or glory that has not yet been exterminated—all those signs that are precisely what make an image seem documentary, shouting at us about how important it is. Just the opposite: the decomposition of the scene contains much of the simplemindedness of those shots that stuff family albums in the age of the Instamatic. The actors do not play at rhetoric with their gestures, and nothing in their modesty would seem to give away the act they are committing. There is nothing in them of the savage macho mixture of *bandido* and hero that feeds the fears of those who predict the awakening of the so-called "Bronco Mexico." They are nothing like the Ché Guevarian guerrilla fighters of student dreams or middle-class nightmares. Something in them makes myths leap out, as well as demons.

The workers on the Liquidambar ranch in Angel Albino Corzo, in the Mexican state of Chiapas, have taken over the house of the hacienda's owner. It is September, 1994; the photo was taken by Omar Meneses for the newspaper *La Jornada*. On the walls above the lintel hang four silk-screened prints by Andy Warhol.

One of them, the one on the left, hangs crookedly—as crookedly as the portraits of Benito Juárez or the president tend to hang in Mexican

Finca Liquidambar,
Angel Albino Corzo,
Chiapas, 1994.
Photo by
Omar Meneses/
La Jornada

public schools. Marilyn, eternally murdered in her smile, looks dispossessed
and bored in her glass prison—so far from the spotlights of Hollywood, as
far as the peasants are from Diego Rivera's murals. The photo—which I
suppose would be envied by Louise Lawler—shows not only the domesti-
cation of art in this setting of neocolonial furniture and lamps of doubtfully
aristocratic European parentage, it also makes visible the nature of a con-
tradiction experienced as regularly as our daily bread. No, as romantically
and demagogically as we might wish, it is the contradiction of the inability
to decide between the past and the future, between poverty and develop-
ment. Not the halting steps of a transition, but a wound in the social
imagery that opens more and more because the government discourse is
trying to close it.

Here are the revolutionary Indians, in whose name the Mexican
government still governs, and who are the government's worst nightmare.
This is the Mexico that the sanitized, drugged image of our national culture
does not begin to comprehend, and thus eliminates. The Mexico of growing
incomprehension and uncontrollable discontent. What happened to our
surrealist country? What happened to magical realism?

In all this, there is only one real shame. The Mexican culture must
be true to its anger, or it deserves to be no more.

Translated from Spanish by Ellen Calmus

sound works

manuel rocha iturbide

In music, using concepts or ideas that belong to other domains is something that has been realized by composers for a long time. These ideas can be translated directly into music, but they can also be used solely as an inspirational source and therefore be related to the music in an indirect way.

The central element of sound work is language, which is what characterizes a determinate culture. Language is made out of sound and meaning, out of syntax (rhythm) and out of words (signs). The roots of any culture are based on its original language; this is the main emphasis within my work. There is the case where a second language, the language of the conqueror, is imposed onto a culture. In Ireland, English was imposed, and in Mexico it was Spanish. These new languages become part of the "original" culture, but they are spoken in a different way in terms of intonation and pronunciation; new words are also introduced. Because of this, even the sound of the new language becomes a reflection of the original culture. The other sound elements that I use in my work are soundscapes (these are sounds from the country's landscapes, rural and urban, as well as "indigenous" music). I believe these sounds also reflect the essence of culture.

Through my work, I am trying to look into the future by contemplating our roots, which are part of our daily sounds. Since this exhibition addresses issues of culture and identity, I have chosen to comment on possible analogies between Ireland and Mexico. Two years ago, I traveled to Ireland to look for inspiration for this work; I found monolithic stones of our mutual pasts there. To make a comment on Celtic history and mythology is also to talk about the myths and history of Mexico, because both emerge from a collective, archaic archetype.

I am making this commentary through the use of technology and through modernity, two elements that have their origins in the industrialized cultures of our developed neighbors, the United States and Britain. By using computers as a musical tool, I relate in a strong way to these two countries, taking advantage of aspects from one culture to unveil part of another culture, in effect, finding my own roots, which might be sleeping somewhere under an Irish plain. These roots, common to many cultures, are being covered by dust from our First World neighbors.

My visit to the Aran Islands in 1993 left a great impression on me. There were people who did not speak English. They were very tall, and reminded me of the mythical characters from the books of Tolkien. This island is so near to London, so near to Paris, and at the same time so far away. I believe places like this will disappear soon, and that's why I think we have to keep alive our myths and histories. We benefit from much of modernity,

but I hope at the same time we will never let these more powerful nations invade our psychological space through their media bombardment.

My work for this project is titled *Móin Mór*. Its construction is based on an eighth-century Irish poem, and on other contemporary poems in Gaelic written by Derry O'Sullivan. The piece is also made from recordings made during my trip to Ireland in 1993, and includes transformed sounds originally recorded by Italian journalist Antonio Grimaldi from Bloody Sunday (1972) in Derry, when thirteen civil rights demonstrators were killed by the British Army.

Mixing natural sounds, the spoken word, and sounds recorded from daily life, I have created a work that brings together the conflicting realities of contemporary Irish life. The piece begins with the deconstructed voice reciting the poems in Gaelic, using only the consonant sounds of the language, which sound like natural elements (like the wind) representing the spirit of Ireland's ancient culture. The voice then returns in a changed form—with a stone-like resonance, reciting the eighth-century poem:

dar ind adaig I Móin Mór
feraid dertain ní deróil
dorddán dertain ní deróil

géssid ós chaille clithar

cold is the night on Móin Mór
the rain pours down in torrents
a deep roar against the wind which laughs high

sounds from the sheltering woods

As the work gathers momentum the voice returns, and the Gaelic language is more distinct, and the sounds of daily life and granulated fiddle music can be heard. The deconstruction of the voice emphasizes the vowel sounds, and the disintegrated language becomes articulated, sounding like a desperate man attempting to create meaning from something incomprehensible. Suddenly a new voice enters, the sound of a boy speaking English: "you're a bum, a bit of a bum, a bit of a bummy," he laughs. The boy represents a new generation of young people, many of whom neither speak nor value the Irish language, and appear indifferent to the past.

The work ends with the deconstructed words of the poet blended with natural sounds of the ocean. An Aran islander, an old man I met who barely spoke English, recites his own poem, almost singing. For me, this represented hope that the Irish language will not be lost in our modernity.

Paris – February 1995

manuel rocha iturbide

sound works

sound works

roger doyle

Remains of civilisations as old as the Pyramids have been found in Ireland and Mexico. Our knowledge of these civilisations is pieced together from artifacts, burial grounds and calligraphic representations on stone, baked clay and papyrus. Hieroglyphics, cuneiform texts and alphabets so long a mystery up until this century have now been deciphered. We still can only guess as to how religion was practiced and what 'life was really like'. All we can do is examine the dust left behind by the stampede.

As we approach the second millennium and the possibility of space travel, I am inspired by what may lie beyond our world—what civilisations we may yet encounter. Imagine the discovery of an alphabet of a civilisation unknown to us in the future. What would that be like? This looking backwards and forward at the same time, feeling the breadth of the time-space continuum, is unique to our time, and gives us the possibility of being archaeologists of the future.

But what of the here and now? *Here* is Ireland. I am Irish. On becoming a composer, my early pieces sounded so different from each other they might all have been composed by different composers. Instead of finding my *mature* style, this musical schizophrenia has continued unabated. There are 100 composers inside my head living in non-hierarchical happiness, inventing exotic imaginary cultures, poking good humoured fun at known formats, cross-breeding musical species, creating disturbing new worlds, playing with syntax, etc. This inclination was always there—new technology encourages it.

The Irish are offsprings of many cultural and political rapings and love-makings, and have suffered and assimilated much. Who are we? Among the 100 composers in my head, there is not one that thinks of himself as 'Irish'. The multiplicity of language makes this impossible.

In the *Book of Ballymote,* which dates from the seventh century, is a section in old Irish called "Auraicept na n-Eces," the primary textbook of poets, who took twelve years to learn their craft. In it, it states that the Irish language was the *chosen language* because it was culled out of every hyperdark sound in every language . . . it was so large that it was more extensive than any language. Part of the chosen language was the 'Iron Language,' which students had to master in their sixth year. The Iron language was filled with slang words from other languages and words crushed together making new words. Iron language poems employ on the surface an arcane vocabulary that was used in making a second continuous meaning.

I immediately think of James Joyce's *Finnegans Wake,* and at the same time think of the Iron language as something that has slipped into my veins.

Dublin – March 1995

CHICANO MONTAGE: ART AND CULTURAL CRISIS

Max Benavidez

The tradition of the oppressed teaches us that the "state of emergency"
in which we live is not the exception but the rule.[1] —Walter Benjamin

For a Mexican born in the United States, internal exile and displacement are second nature. The late 20th-century U.S. Mexican is often seen by society-at-large as part of a sub-working class with little education, scant economic resources, and no future. Add to this the ironic historical fact that most U.S. Mexicans are born in what is now called the American Southwest but was once a significant part of Mexico proper, and you have a case of spectacular social marginality. Being internally exiled within their former homeland—a place founded and named by Mexicans—has engendered a complex set of external and internal contradictions: resistance and acculturation; pride and self-loathing; denial and flamboyant self-glorification.

These juxtapositions form the basis of the U.S. Mexican's identity: a migrant consciousness that constantly crosses the intersections of opposed cultural fields. It is an identity that simultaneously "speaks" English while holding a perspective at odds with the culture that gave birth to English. There are striking similarities between the conditions of the U.S.-born Mexican and the Irish. James Joyce could just as well have been speaking for a Mexican in the United States as for a Gael in Ireland when he wrote about his alter ego's (Stephen Dedalus) encounter with an Englishman:
The language we are speaking is his before it is mine. . . . His language,
so familiar and so foreign, will always be for me an acquired speech.
I have not made or accepted its words. My voice holds them at bay.
My souls frets in the shadow of his language.[2]

Beyond this, it is also important to recognize the racial roots of the contemporary U.S. Mexican. Like the Mexican national born and bred south of the Mexican-American border, the U.S. Mexican is a *mestizo*—a hybrid racial being who is not Indian, yet of the Indian, not Spanish, yet of Europe. As races go, the half-millenium-old *mestizo* race, sometimes referred to as *la*

1 Walter Benjamin, *Illuminations*, ed. Hannah Arendt (New York: Schocken, 1969).

2 James Joyce, *A Portrait of the Artist as a Young Man* (New York: Viking, 1964).

cosmica raza (the cosmic race), is quite young. This relative newness has an inherent potency that has yet to be harnessed and fully defined.

In addition to a complex racial reality, the U.S. Mexican is not even Mexican in the strictest sense of the term. And, to add yet another layer to an already ambiguous identity, the U.S.-born Mexican is rarely considered American as in the term, "all-American."

As many have noted, history is hysterical. And Mexicans born in the United States have survived more than their share of cultural and racial hysteria. Beginning with the humilation of defeat in the Mexican-American War of 1848, and continuing into the 20th century with forced deportations to Mexico, lynchings, farm labor exploitation, and general social repression, U.S. Mexicans have had to confront a profound level of violence, fear, and loathing from American society.

In spite of nearly 150 years of ongoing oppression, U.S. Mexicans have not remained prone or passive. Although they have not recovered any geographical territory, U.S. Mexicans have created a tradition of cultural resistance that stands in opposition to the economic and social domination imposed by the colonizing Anglo-American culture. Whether it has been *corridos* (Mexican ballads) in the Mexico-Texas region that mythologized folk heroes, or the radical Spanish-language newspapers such as *Regeneracíon* that were published throughout the Southwest in the early decades of this century, or the *pachuco's* (Mexican Zoot suiter) defiant stance during World War II that contradicted the myth of social consensus and frequently led to beatings and jailings, U.S. Mexicans have mapped out a cultural territory marked by an alternative consciousness.

The most successful oppositional movement has been *Chicanismo*. Born out of the civil rights and farmworkers' struggles of the 1960s, this movement was founded on the idea of building a self-created identity, independent of Anglo-American mainstream values. The eruption of the Chicano movement was a step in the long process of decolonization. To identify as a Chicano is to be emphatically political. In addition, by taking the word *Chicano* as its conceptual basis, the movement was appropriating and transposing a term seen by many U.S. Mexicans as vulgar and lower class. In essence, then, terminology dictated form and content.

Beyond the political aspect, there was a powerful accompanying

artistic movement. Most likely, Chicano art was born in 1965 when the late labor leader Cesar Chavez gave budding theater director Luis Valdez permission to mount primitive *actos* on the very picket lines of the Delano fields in central California. In what became a classic example of Chicano ingenuity, incipient artists created a theater out of nothing. As the story is told, Chavez said, "There is no money, no actors. Nothing. Just workers on strike."[3]

To make something out of nothing became the implicit articulation of the *sine qua non* of early Chicano art. In the mid- to late sixties, there were no government or foundation grants, no art degrees, only a burning need for artists to say something about themselves and their situation. That's what Chicano art was then. Now it is displayed in high-priced galleries or prestigious museums, not on street-corner walls. The plays are performed in state-of-the-art theaters, not on dusty roads. But its roots are far less glamorous. They're the smell of the earth itself, scrawled signs exuding generations of pent-up fury, and the naked will to create under any conditions.

For better or worse, today's Chicano artists face a new set of challenges. The aura of the *fin de siecle* hovers over them as does the still-evolving reality of a post–Cold War reality. Artists must cope with neo-Reaganism and its sodomizing of multiculturalism. Over and over again, there is the jarring mixture of contradictory realities: art world success vs. everyday racism; aesthetic maturity vs. rampant indifference; Anglo patrons vs. Chicano content.

The juxtaposition of antithetical facts, images, and realities is simply an extension of the cultural and psychic contradictions noted earlier. This is the strength of the Chicano artist: the ability to take oppositions— whether cultural, personal, or political—and create a new and visionary narrative. It is the ability to transpose the ambiguities of identity into the features of such a vision that, ironically, comes from the often fragmented but revelatory experience of being Chicano.

That is why there is a similarity between the nature of Chicano identity and the technique of montage as formulated by Walter Benjamin: "the ability to capture the infinite, sudden, or subterranean connections of dissimilars."[4]

To live, as the Chicano does, in a constant state of dissimilarity, yet

3 Max Benavidez, "Cesar Chavez Nurtured Seeds of Art," *Los Angeles Times,* 28 April, 1993, sect. F, pp. 1, 4.

4 Benjamin, *Iluminations,* ibid.

to see the "sudden" or "subterranean" connections between specific dissimilars is, in Benjamin's view, the essence of the artistic imagination in the age of technology. By necessity, Chicano artists tap into this realm of hidden or veiled associations for the source of their art.

One artist who delves deeply into the womb of Chicano consciousness is Amalia Mesa-Bains, an artist and intellectual based in San Francisco. In the spirit of the "traditions of the ephemeral" and Mexican devotional art forms, Mesa-Bains has developed a highly refined response to the Chicana conundrum. By drawing on her own life and memories, she has redefined the nature of being a female in an outcast but patriarchal culture.

As a woman, she has taken the Chicano aesthetic, particularly as it has been expounded by Tomás Ybarra-Frausto in his analysis of the *rasquache*[5] (a funky, irreverent sensibility), and created a new critical category: *Chicana Domesticana*.[6] Mesa-Bains recasts "the domestic chamber" from a "space imbued with saliency and isolation" into a metacommentary on the place of woman in the Chicano family, the Catholic Church, and mainstream society. Through on-site installations that use the Mexican home altar tradition—*altares*—as her point of departure, she has brought forth a spiritually restorative vision for the culturally battered Chicana.

In her 1993 altar installation for the Whitney Museum, *Venus Envy, Chapter One (Or the First Holy Communion Moments Before the End)*, Mesa-Bains reclaims not only her own life through the use of mirrors, texts, photographs, personal memorabilia, and items from pop culture, but also charts a new direction in what Whitney curator Thelma Golden calls "the artist's formation of the altar aesthetic." Sensuous visual layerings characterized, as Mesa-Bains notes, "by accumulation, display, and abundance . . . allow a commingling of history, faith and the personal." It is with this ceremonial fusion of spheres that she offers deliverance from the restricted gender roles within Chicano culture, as well as liberation from the narrow, stereotypical image of the Chicana imposed by Anglo-American society.

Mixing the feminine with the religious and tactile—almost palpable physical texture—is something Mesa-Bains has always been drawn to in her life. In noting her childhood memories, one in particular provides a sense of her personal influences:

In the Catholic tradition, the First Holy Communion is the time when you

5 Tomás Ybarra-Frausto, *Rasquache: A Chicano Sensibility* (Phoenix: MARS Artspace, 1988).

6 Amalia Mesa-Bains, "*Domesticana*: The Sensibility of Chicana Rasquache," see p. 156.

officially accept God and it looks a little bit like a big wedding. . . . It was
a time when all the women in the family put all their attention on you.
Shopping for the dress and veil, receiving gifts like your prayerbook and
your rosary from your grandmother made it even more exciting.
Everything was feminine, beautiful, and made of white lace, pearls, little
wax orange blossoms, ribbons, and satin. It felt as though I had become
a bride and was beginning to enter the world of the women of my family.[7]

In *Venus Envy, Chapter Two: The Harem and Other Enclosures*, at
Williams College Museum of Art, Mesa-Bains further refined the idea and
image of evolving Chicana identity. In particular, in the installation *The
Library of Sor Juana Inés de la Cruz*, she takes the Mexican poet-nun's
famous salon space and distills it into three basic elements: the chair, the
mirror, and the book.

As Mesa-Bains writes, "The chair symbolizes the cultural body
and is a historic reference to the colonial trauma of the 1492 invasion.
Wounds to the chair narrate the suffering of that colonial age and reference
the cultural context of Sor Juana's writing." Sor Juana's library/salon
becomes not an enclosure, but a sacred space that sets the spirit free from
the petty orthodoxies of the seventeenth century as well as the bigoted
conventions of our own time. One is reminded here of these lines from the
great poet herself:
Why, for sins you're guilty of
do you, amazed, your blame debate?
Either love what you create
or else create what you can love.[8]

As an intellectual herself, Mesa-Bains can identify with the
feminist struggles of Sor Juana as she fought against the constraints of the
male-dominated Catholic hierarchy. Even more, taking Sor Juana as an
artistic mentor, Mesa-Bains creates in the manner of the famous Mexican
nun. She constructs her works with methodical and meticulous attention
to detail yet weaves in a personal and emotional point of view. By entering
her ceremonial chambers of truth, we enter the zone of illumination; we
enter what Mesa-Bains herself calls the "evanescent intensity of a moment"
that yields life itself.

Recovering sense from the depths also preoccupies Los Angeles

7 Amalia Mesa-Bains,
"Memories of
Childhood," unpublished
manuscript.

8 Octavio Paz, *Sor Juana
Or the Traps of Faith.*
(Cambridge, Mass.:
Harvard University
Press, 1988).

painter and muralist John Valadez. A third-generation native Angeleno, Valadez sees himself as a product of what he calls "schizo-ethnicity." As a Mexican growing up in an Anglo-dominated world, he learned to see everything from "two radically divergent points of view"—as if he were torn between two ways of being.

This deep contradiction within himself, coupled with society's denial of life's inherent duality, bred a deep anger and rage in Valadez. As a survival mechanism, he took a copy of an old volume of the *Encyclopedia Britannica* and reconstructed it through the use of found images.

"I rechanneled the images of the dominant American culture by superimposing my own imagery onto the pages," Valadez explains. "The book is about death, my sexuality, my hostility and self-destructiveness. And it worked. It was a release, a cleansing."[9]

From this experience, Valadez eventually created an authentic expression of the new Mexican reality of downtown Los Angeles with *The Broadway Mural*, an eighty-foot-long wall work that glorifies the Latinization of Broadway Street. The mural, with its giant images of Mexicans and other outcasts in a profusion of exuberant color and energy, is a monumental example of what Umberto Eco calls "semiotic guerrilla warfare." The mural, now housed inside the Victor Clothing store, says more through visual imagery than all the studies and demographic profiles could ever explain.

Perhaps one of Valadez's most revealing paintings is his 1992 pastel, *Immamou*. It is a classic expression of Chicano self-excavation: montage as confession. A headless, naked torso with Kahloesque cuts, bruises, and hieroglyph-like tattoos is submerged under a swirl of murky, troubled water. The sunken torso sits waist-deep in the detritus of our post-modern society. This is the region of the unconscious, a site of desires unspoken, perhaps even unnamable. The word *Immamou* is taken from an old Haitian earth religion and refers to the god of the sea.

"At first, *Immamou* frightened me," Valadez notes. "There are many frightful truths in the world that many of us don't want to deal with. I want to bring these things out into the open.

"In *Immamou*, the markings on the figure are actual ritualistic symbols from the religion," the painter says. "You don't need the head and

9 Max Benavidez, "The Schizo-Ethnic View: John Valadez," *Los Angeles Times*, 18 November, 1992, Sunday Calendar, pp. 6, 80.

face. All you need you need to know about this person is known from the marks on the body and the tattoos. The signs stand for the spirit, and every spirit in this religion has rituals that call forth a particular spirit. I put in the cuts and wounds because it shows the reality of life. We all have marks —physical and otherwise. It about being wounded, and in *Immamou* I'm trying to show that we can transcend the hurt, the trash."[10]

Immamou is the depiction of the wounded survivor, the Chicano who triumphs despite the accumulated weight of twisted history. By invoking imagery from an ancient island religion, Valadez has drawn a connection between urban Mexican experience and the sea of life. This is the inner self proudly displaying its spiritual damage and the markings of its ritual healing. For Valadez, release from the demons of hate and negativity can only come through art, an art that plumbs the bowels of our suffering in an ongoing war between two opposing world views.

The nature of war and military strategems of survival in an information-driven world fascinate artist-provocateur Daniel J. Martinez. Fueled by a remarkably obsessive yet coolly controlled anger, and drawing upon everything from Futurism's aim of integrating life with art to the suprasensorial ideal of the late Brazilian artist Helio Oiticica (who prized only art capable of releasing individuals from their oppressive conditioning) and the often nihilistic, in-your-face aesthetic of urban Chicano art, Martinez has begun to create a hybrid vision of the artist in a postmodern, global society.

Although he now identifies as a Chicano, Martinez is a classic case study of the colonized U.S. Mexican. Growing up in a working-class city near Los Angeles, he never learned to speak Spanish (even though both his parents were fluent). He says it was strictly forbidden by his grammar school teachers, and his parents fell right in line with that repressive ethic. He says he never learned anything positive about his ethnic background. Instead, he was immersed in American pop culture complete with its pervasive stereotypes about Mexicans. So, like many kids of his generation, he just drifted into an unthinking identification with "whiteness." He acted white, talked white. For all intents and purposes, he was white. In other words, he lived a total denial of himself.

Over time, he began to recover and reclaim his heritage. His long journey into ethnic self-awareness makes his notorious buttons for the 1993

10 Ibid.

Whitney Biennial a lesson in high irony. Martinez created exact replicas of the Whitney's standard admission tags but had them read various segments of the sentence, "I can't imagine ever wanting to be white." Of course, Martinez has imagined being white; he has lived it. Ironically, that paradox was completely lost to the critics. Instead, the tags became emblems of the mainstream's disdain for multiculturalism.

In the fall of 1992, Martinez's *I Pissed on the Man Who Called Me a Dog* opened at the New Langton Arts gallery in San Francisco. The installation piece was a claustrophobic labyrinth strewn with old clothes and cardboard boxes that reeked of mildew. All of this was surrounded by a shrieking soundtrack of deranged gospel music compiled by VinZula Kara and video loops of pop violence. At one point, Martinez presented sets of images superimposed with quotes from famous thinkers.

One photograph depicted a grisly atrocity from the Bosnian war. Above it was Aristotle's well-known dictum: "Anyone can become angry—that is easy. But to be angry with the right person, to the right degree, at the right time, for the right purpose and in the right way—that is not easy." Aristotle's words could very well be Martinez's motto.

Indeed, anger and insult are the throughlines of his work. Every installation, each show, becomes another opportunity to agitate. It's another chance to deliver a well-deserved punch into the gut of mainstream

Daniel J. Martinez,
*I Pissed on the Man
Who Called Me a Dog*,
1992; courtesy of
Robert Berman
Gallery, Santa Monica

America. In the process, Martinez joins with other artists whose work only succeeds to the extent that it offends. With them, he must be judged for his ability to incise and incite. It is not enough to belittle or berate. To be successful by the standard he has set for himself, the work must go straight to the heart of the matter and deliver a death blow. Anything less is just flaccid posturing.

Recently, Martinez has also immersed himself in Irish culture. Having spent the summer of 1994 in Ireland has allowed him to absorb the often remarkable similarities between the Irish and U.S.-Mexican experiences with resistance and decolonization. In many respects, he is a quintessential hybrid artist who crosses disciplines, mixes technologies,

applies radical theories, and appropriates disparate elements from the tangled web of postmodern society. He embodies a migrant nomadism, the exilic urge that, as cultural critic Edward Said puts it, comes out of an "elusive oppositional mood" pulsing subversively through our cool, digitized culture. At the same time, Martinez is a construct, a decolonized individual who has made himself over from the fragments of his original culture and the debris of postindustrial society.

Like Mesa-Bains and Valadez, Martinez is an example of Chicano Montage: the ability to capture through art the sometimes fragmentary but always provocative juxtapositions of identity. In their own way, each is

formulating the language and sensibility of a new art, a new approach to the ongoing "state of emergency."

One of the most powerful symbols in Chicano mythology is Aztlán, the ancient mythical Mesoamerican homeland located in the American Southwest. As Chicanos see it, Aztlán is their Promised Land. In Aztlán, Chicanos will be whole again: estrangement will be finally shed like dead skin, and in its place they will find cultural and psychic unity. That is the dream. And, until that day comes, Chicano artists will continue to create an Aztlán of the imagination, a memorable counterpoint to the mass hypnosis of our age.

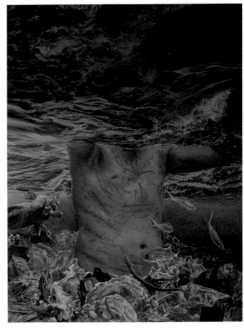

"Don't fuck with the past, you might get pregnant"

We are taught in Mexico to look into the past in a very contrived way, and it's a way that assumes many assumptions, not only about a notion of a "glorious past"—our archeology, our big culture, the treasures of the last thirty centuries, etc.,—but we are also taught to look at all these things in a very conservative way, as if they were outside of ourselves. This was the way I was taught to look at Mexican culture.

This work addresses a parallel, both looking at culture and at what we are taught—what we are allowed to know—and looking at my own past and ideas, where I come from. It has to do with taboo: I am very interested in the notion of the taboo and crossing boundaries, I do it constantly in my work. It has to do with being on both sides of one place. This work is dealing with the feminine but it is also dealing with the masculine — it is a game where I am acting both sides, the masculine and the feminine.

I enter into these images with a disruptive attitude; there is this sense of prohibition, "Don't fuck with the past, you might get pregnant." It's like a joke, something your mother would tell you! The play with the figures becomes an act of violation of the space, a kind of auto-rape.

It is a territory, which might belong to me or not; I am messing with it. It is something that interests me; I want to know more; I want to play games with this place. My work is always a fragmented place; it's a place that basically is filled with *tepalcates*, these little pieces of clay that can be found everywhere and that cannot be reconstructed. I inhabit a space that is an archeological site — it informs my reality.

I seldom think about how my work is going to be read in a different cultural context, because my work is bound up with Mexican culture. Maybe this piece will have an emotional resonance. I think when people first see these figures they don't realize that they are constructed—fictional. But that is only a reflection on our history and ourselves, after all.

Mexico City – December 1994

silvia gruner

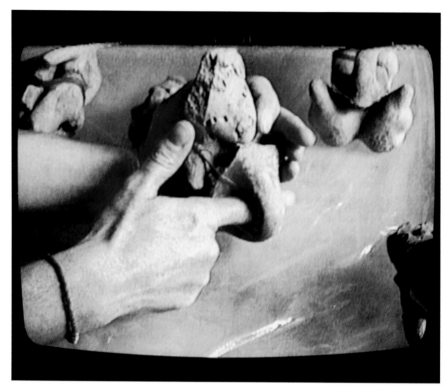

Don't Fuck With The Past, You Might Get Pregnant, 1994,
Ektacolor (chromogenic development) prints;
installation of 16 photographic prints, 20 x 24" each
(51 x 61 cm); overall installation 108 x96" (274 x 244 cm);
courtesy of the artist

silvia gruner

daniel j. martinez

Event for Compression, Hysteria, & the Absence of Zero, 1994. Performance, Belfast, N. of Ireland, two-day duration, August 8-10. Locus+, Newcastle-upon-Tyne; Catalyst Arts, Belfast. Photographs courtesy of Robert Berman Gallery, Santa Monica

daniel j. martinez

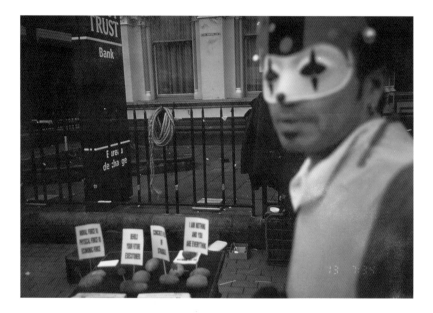

All the visible universe is nothing but a shop of images and signs.
—Baudelaire

In studying this period, so close and yet so distant, I see myself as a surgeon operating with local anesthetic; I work in areas which are numb, dead and yet the patient is alive and can still talk.
—Paul Morand, Paris, 1900

Los Angeles – January 1995

How to Con a Capitalist, 1995. Performance in front of First Trust Bank, Royal Avenue, Belfast City Centre, three-hour duration, 1300-1600 hrs., Monday, March 13. Locus+, Newcastle-upon-Tyne; Catalyst Arts, Belfast. Photograph courtesy of Robert Berman Gallery, Santa Monica

Using visual and discursive forms within video technology, my practice addresses narratives of emigration, examines boundaries between personal and cultural histories, and deals with notions of home, language and other.

Turas is a video work in which linguistic and symbolic ciphers in land-scape are used to trace an eroded Irish language and culture. The central signifier is the river, which extends its epic narrative function by leading not only to its physical source, but also to another, inner location, a formal interior framed in echo of traditions of portraiture.

This interior space is where the Mothervoice offers itself as an alternative, a repository of knowledge and a fund of cultural energy with which to resist the effects of displacement. In *Turas*, the daughter's relationship to the Mothertongue is not only gendered but predicated on a genealogical link with the maternal body. There is also an analogy between the separation from the mother and the emigrant's trauma of lost access to both language and the physical landscape.

"Against the course of the river, against the flow of the river, the Mothertongue reasserts itself."

Sheffield, England – December 1994

frances hegarty

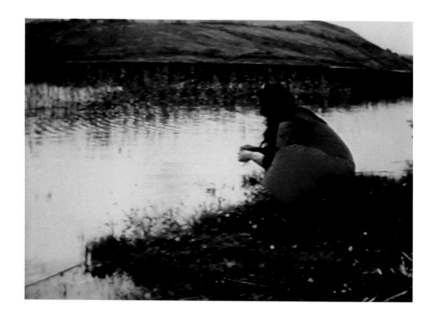

frances hegarty

Turas (Journey) (video stills), 1991, videotape, 10 min.; courtesy of the artist

The Mexicans have truly made their country the second home of the Beatles.

If they had the faces of the Beatles, they would be the Beatles.

The people close their eyes, and they are listening to the Beatles.

Probably Lennon is in one of them.

Rubén Ortiz Tórres and Jesse Lerner, "I Am the Morsa" (from the segment *The Eternal Return* in the feature-length documentary *Frontierland*), 1995, video stills, 16mm film, and paintbox; courtesy of the artist

ruben ortiz tórres

My work describes the confrontation and contradiction of the aesthetics of two opposite cultures. One is a religious, magical world rich in myths and traditions, belonging to an isolated culture. The other, driven by the concept of progress, is based on the ideals of reason and the universal truth professed by the Western world.

Issues of identity have been to varying degrees both rejected and re-invented from formalist schools that disowned "non-artistic values," to political art that promoted visions of historical truth. However, modern, industrialized Mexico forces us to consider both these perspectives. We cannot return to an "unpolluted" notion of a national history as valid content for art, but neither can we, like the internationalists, pretend that art should be reduced to a content-free exploration of purely formal elements.

It is my belief that a purified "art for art's sake" formal exercise must ultimately prove irrelevant; and secondly, that we must accept formal explorations related to content and meaning in a much wider and freer sense than those accepted, for example, by the historically oriented muralists. It seems to me that little scope remains today for the artist interested in a purely formal, aesthetic production. What remains is the possibility of codifying and recodifying reiterable formal elements with given social or aesthetic values within a new semantic system that violates their original contexts.

In my work, these concerns express themselves through the use of representation both historic and contemporary. The dislocation of elements from structured hierarchies of their original systems does not reduce or eliminate their significance. This results in the creation of a personal language that transforms formal and historical perspectives, through a contemporary critical expression.

Los Angeles – December 1989

The image and arrangement of hair plays a role in the formation of gender and cultural identity. The many different meanings ascribed to hair—particularly women's hair—as a culturally significant material are a central part of numerous themes in Western folklore, mythology and consciousness. This multiplicity of theme and meaning is addressed in *Folt*.

Rapunzel of the famous fairy tale let down her hair on request; the hair of the penitent Magdalene grew miraculously to cover her naked-ness; Melisande's hair just wouldn't stop growing until it covered the whole country. What all of these stories have in common is that they represent hair as the downfall of the female, while conversely figuring it as essential to her attractiveness. The images painted here are of hairstyles from many different eras and cultures. They are intended to form a kind of catalogue of identities, values, personae, imaginings and choices that girls and women adopt in order to operate within a world that continually sites them outside of understanding.

The fact that the hairstyles are reduced to very simple, almost diagrammatic forms draws attention to our 'reading' of images and our interpretation of signs. The catalogue of diagrams is broken by the box which contains the detritus of hundreds of human heads, a physical manifestation that breaks into one's ability to 'read'. The hair of people who do not know each other is carefully bound and braided together to make an impossibly long and writhing *folt* which presses up against the glass and into our consciousness.

The use of Irish to title the work also addresses the questions of communication and loss. It is our own language, yet we do not speak it; it is despised and loathed while at the same time elevated to a high cultural plateau. We know its sounds, we recognise its shapes, yet we cannot bring these together to communicate meaning. English strains to denote the nuances that are everywhere in this familiar language that we recognise but cannot speak. It is this strained position that *Folt* occupies. The language of Irish and the language of hair are both embroiled in a dense thicket of history which involves the construction and loss of identity, as well as vast entanglements of shifting meanings.

Folt, an Irish word which can mean abundance, tresses, weeds, forests of hair.

Dublin – December 1994

alice maher

alice maher

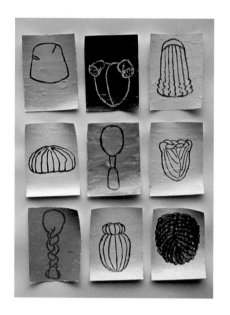

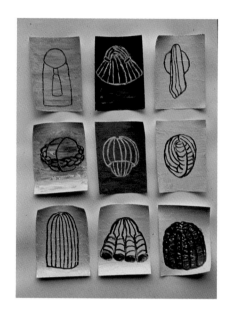

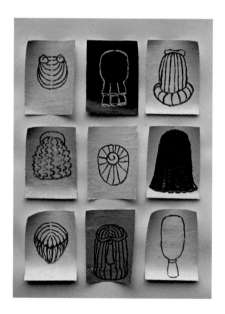

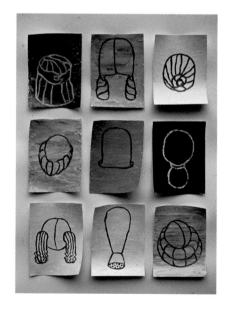

Folt, 1993, oil on paper, sewing pins, braids of human hair, 40-1/2 x 49" (103 x 124.5 cm); courtesy of Orchard Gallery, Derry

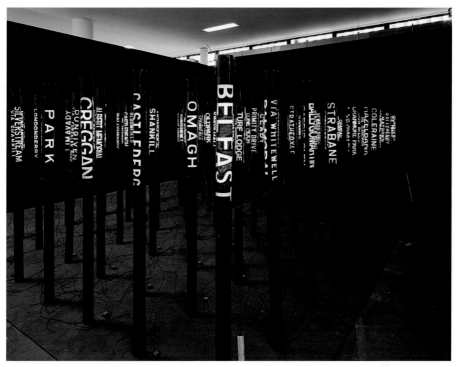

Apparatus II, 1994, mixed media, 9 x 12' (274 x 365 cm); courtesy of the artist. Photo by Eduardo Ortega

The interesting thing about living in Ireland is that nothing is perceived as neutral. This is as much a psychological state as it is a built physical environment.

In part this is a colonial legacy with familiar global characteristics, sharply focused by local specifics.

My recent work deals with the resources available to us in the course of our daily lives. It is a means of coming to terms with the cultural baggage we all carry with us.

Belfast, north of Ireland – January 1995

philip napier

RECOGNISING AND HEALING MALIGNANT SHAME

A Statement about the Urgent Need for Psychological and Spiritual

Recovery from the Effects of Colonialism in Ireland[1]

Garrett O'Connor, M.D.

Introduction

There is widespread support for the view that many contemporary Irish attitudes and behaviours have their origins in colonialism.[2] However, no comprehensive hypothesis exists to explain how this evolutionary process might have taken place. This article attempts to integrate and build on previous contributions to the field by using the trans-generational model of parental child abuse to explicate how subjugated peoples (in this case Irish Catholics) could be damaged psychologically by political oppression (in this case British colonialism).

Children who are subjected to severe and prolonged abuse by parents or other authorities tend to internalise the abuse in the form of a behavioural syndrome characterised by pathological dependency, low self-esteem and suppressed feelings which I have called 'malignant shame'. As adults, shame-based children are likely to abuse *their* children in much the same way as they themselves were abused by their parents, thus transmitting the syndrome of malignant shame to the next generation. And so on down the line.

Could a similar process exist at the *cultural* level whereby prolonged political or governmental abuse of an entire population might be internalised as malignant shame by the institutions of society, and transmitted unwittingly to subsequent generations in the policies and conduct of government, church, school and family?

There is reason to believe that such a cultural process has been endemic in Ireland for many centuries, and that its destructive consequence of malignant shame (low self-esteem, pathological dependency, self-misperceptions of cultural inferiority and suppression of feelings) is a fundamental cause of *contemporary* psychological, social, political and economic distress in the country at this time.

1 This article focuses on the syndrome of malignant shame in Irish Catholics, a post-colonial psychological phenomenon with a major potential to impede personal growth and community development in contemporary Ireland. The oppressive effects of colonialism on Irish Protestants, Jews and other religious adherents, as well as atheists and agnostics, is a complementary topic which will be considered elsewhere.

2. See J. J. Lee, *Ireland 1912-1985: Politics and Society* (Cambridge: Cambridge University Press, 1989); and F. S. L. Lyons, *Culture and Anarchy in Ireland, 1890-1939* (Oxford and New York: Oxford University Press, 1979).

Clinical experience with families suggests that a combination of psychological and spiritual recovery is an effective treatment for malignant shame, and also perhaps the only way to prevent it from being transmitted to the next generation. If malignant shame should prove to be a significant problem for Ireland at a national level, then a similar prescription will undoubtedly be required, but on a much larger scale.

Background

In April of 1967 I was the Director of the Psychiatric Emergency Service of the Johns Hopkins Hospital in Baltimore. The riots following the assassination of Dr. Martin Luther King were in full blast, and the hospital, situated in the centre of a black poverty area, was in a virtual state of siege.

The emergency room was crowded with casualties, some of them physically wounded, others mentally distraught. Among this latter group were several young black men who had been arrested for looting, drinking and 'running amok'. As Psychiatrist-in-Charge, I made a policy decision not to accept these individuals for treatment because I did not consider them to be psychiatrically ill. Instead, I asked the police to bring in the young men who were *not* looting and rioting, but staying at home behind closed doors watching the riots on television.

My policy got me into a lot of trouble with the police and the hospital authorities. They did not concur with my view that socially aggressive behavior by young black men after the murder of Dr. King could be considered a psychologically normal response given the long history of racism, segregation and cultural abuse that blacks had endured in Baltimore and other parts of the American South until that time. I wondered if the young men and women who showed *no* external signs of anger were, in fact, exhibiting signs of post-colonial stress disorder? Split off from their experience of healthy rage by a pathological fear of expressing feelings, were they unconsciously re-enacting the attitudes of passive compliance traditionally expected of slaves and other oppressed peoples?

Post-Colonial Psychological Syndromes

Prominent Third World political writers such as Franz Fanon, Edward Said and Albert Memmi have identified post-colonial dependency

W. Humphrey, *Paddy on Horseback*, 1779

PADDY on HORSE-BACK.

Publish'd March 4 1779 by W.Humphrey.

as a major barrier to progress for de-colonised peoples. The core of the problem for any post-colonial population is a widespread conviction of cultural inferiority generated by prolonged abuse of power in the relationship between coloniser and colonised. Concentration camp survivors,[3] former cult members, liberated hostages and repatriated prisoners of war similarly may be plagued in the aftermath of 'freedom' by a lifetime of irrational emotions, especially shame and guilt.

Whether they know it or not, Irish Catholics all over the world have inherited a history that evokes images of shame, oppression, deprivation and bigotry. In spite of this, they have, as a group, become justly known for their courage, wit, good humour and generosity, not to mention their imagination, sense of higher purpose and legendary capacity to triumph over adversity. These qualities have enabled them to attain unprecedented distinction in business, law, medicine, politics, religion and the arts.[4] And yet many of them, even some of the most successful ones, say that they struggle privately with chronic feelings of shame and a painful sense of personal and cultural inferiority.

This discrepancy of feeling is certainly familiar to me. I grew up as an Irish Catholic in a loving cultured *Fine Gael* family where political discussions seemed to focus on the brutalities of the civil war, which had

3 Yael Danieli, "Diagnostic and Therapeutic Use of the Multigenerational Family Tree in Working with Survivors and Children of Survivors of the Nazi Holocaust," *International Handbook of Traumatic Stress Syndromes*, eds. John P. Wilson and Beverley Raphael (New York: Plenum Press, 1993).

4 Andrew M. Greeley, *The Irish Americans: The Rise to Money and Power* (New York: Harper & Row, 1981).

ended only fourteen years before I was born, and in which my father had served as a medical officer in the Free State Army. Little was said in my hearing about the centuries of colonial history that had caused the war, and my parent's sympathies lay with Britain in her struggle against Hitler. At school, the Irish history I was taught included robbery of our lands by plantations of English colonists, deliberate impoverishment of Irish Catholics through the Penal Laws, and near-elimination of the Irish peasantry by planned neglect and forced emigration during the Famine. Despite this knowledge, I had by the age of eight developed a conviction that England was a source of higher (and better) authority on nearly all matters except Catholicism. In my early teens I came to believe that everything Irish (including myself) was in some way defective or second-rate in comparison to England.

By the time I left Ireland in 1960 to take up voluntary exile as a psychiatrist in North America (where I have remained ever since), this self-misperception of cultural and personal inferiority (which I would later call malignant shame) had become the core of my identity; indeed, it may have been the principal reason for my departure from Ireland, although I wasn't aware of this at the time. Twenty years later, a divorce, re-marriage, recovery from alcoholism and a serious bout with cancer caused me to take stock of my personal situation.

In the mid-1970s I had been invited back to Ireland by Professor Ivor Browne of Dublin to direct a series of Group Relations conferences on unconscious aspects of authority and responsibility sponsored by the Irish Foundation for Human Development. This opportunity brought me into contact with Mr. Paddy Doherty and other Derry leaders working to help their city survive the ravages of military occupation, guerilla warfare and sectarian strife. While attempting to take full responsibility for my personal problems and the damage they had caused me and others, my exposure to the terrible consequences of imperialism in Northern Ireland led me to wonder if the trans-generational dynamics of my family of origin in Dublin and my family of choice in Los Angeles might not also be a micro-cosmic reflection of colonialism. If this were so, then the strengths and weaknesses of my own character could be seen as a psychological legacy of the colonial process manifesting itself at an individual as opposed

to a cultural or community level.

A perusal of 20th-century Irish writing finds support for this view. Many writers and historians have attributed self-misperceptions of personal and cultural inferiority among Irish Catholics to the effects of British colonialism on the national psyche. Professor Joseph Lee refers to the 'elusive but crucial psychological factors that inspired the instinct of inferiority', and has identified self-deception, begrudgery, contempt for authority, lack of self-confidence and poor leadership as post-colonial behavioural constraints on the pursuit of productivity and happiness in contemporary Ireland.

Dr. Anthony Clare, a prominent Irish psychiatrist, while empha- sising the 'extraordinary vigour and vitality of so much of Irish life', also describes the Irish mind as being 'enveloped, and to an extent suffocated, in an English mental embrace'. This development has occurred, he says, in 'a culture [that is] heavily impregnated by an emphasis on physical control, original sin, cultural inferiority and psychological defensiveness'.

The paradoxical and contradictory construction of the 'Irish Catholic Character' is itself a clue to history. Humour, courage, loyalty and tenderness co-exist with pessimism, envy, duplicity and spite. A strong urge to resist authority is tempered by a stronger need to appease it. A constant need for approval is frustrated by a chronic fear of judgment. A deep devotion to suffering for its own sake is supported by a firm belief in tragedy as a virtue.

Freud, Jung and other psychoanalytic theorists believed that indi- viduals are destined to act out apocalyptic themes of ancient history that are handed down from generation to generation through the institutions of society and in the collective unconscious. Thus, Irish Catholics might have a tendency to re-enact in their daily lives the most degrading themes of Irish colonial history, including the double tragedy of triumph through failure or failure through triumph, each option providing a painful, but safe, haven from ambition. In my experience, these destructive re-enactments were most readily observed during struggles for political power within families, and in the relationship between teachers and pupils at school. Shaming strategies such as ridicule, teasing, contempt and public humiliation are clearly rooted in the historical reality of political oppression. Devious

conniving, silence as a form of communication, interpersonal treachery, and secret delight at the misfortunes of others are contemporary reminders of the familial savagery and tribal betrayal to which at least some of our forebears must have turned in order to survive under colonial rule.

Alluding to the psychological impact of foreign and political domination (of Irish Catholics) in Ireland, Clare points to the need for exploration of the Irish penchant 'to say one thing and do another'. Wisely, he warns that investigation of this topic and related issues will require sensitivity and tact if defensiveness and the risk of feeding the Irish tendency to self-denigration is to be avoided.

Nevertheless, the exploration must proceed. The short and long-term effects of potentially destructive post-colonial influences on work performance and human relationships in Ireland should be a matter of national concern. The post-colonial mentality which, according to Lee, impedes ambition and constrains progress by 'shrivel[ling] Irish perspectives on Irish potential' must be identified and harnessed for positive purposes if the current spiritual, cultural and economic renaissance in Ireland is to continue, and the concomitant movement towards peace in Northern Ireland is to be maintained.

Cartoon, 1867 National Library of Ireland

HIS RIVIRINCE. "AH THIN, MISTHER BULL, IF THE BOYS HAD LISTENED TO ME THEY'D BEEN OUT OF THAT ONTIRELY"

Historical Background

This section and the one that follows contain a brief (and highly selective) review of pertinent Irish history, a description of how and why shame-based parents inflict emotional damage on their children, and an introduction to the psychology of malignant shame. An awareness of how these issues are linked will help the reader to identify the connection between family abuse and political oppression. In turn, this awareness will clarify how the oppressive relationship between coloniser and colonised in Ireland has produced self-misperceptions of cultural inferiority (malignant shame) in significant segments of the Irish Catholic population.

At various times since the reign of Elizabeth I, English governments have justified oppression of Catholics in Ireland on the grounds that the Irish were an inferior race and a shameful people.[5] At the end of the 17th century, the Penal Laws were enacted by the colonial government specifically to impoverish and degrade Catholics in Ireland, and to undermine or eliminate the influence of the Irish Catholic Church.

All Irish Catholic institutions which carried traditional values, attitudes and religious beliefs were targeted for destruction. These draconian laws were enforced, more or less, for about eighty years or until 1770, when a process of repeal was initiated only because the repressive legislation had achieved its original objective of 'preventing the further growth of popery', and 'eliminating Catholic landownership'.[6]

An Irish settler in New York, 1850s. Cartoon by Thomas Nast; courtesy of Culver Pictures Inc., New York

Over centuries, the potential for tribal solidarity among Irish Catholics was consistently undermined by

5 Ibid.

6 Kerby A. Miller, *Emigrants and Exiles: Ireland and the Irish Exodus to North America* (New York: Oxford University Press, 1985).

land-rape, poverty, discrimination and the readiness of the Crown to exploit the venality of Irish despair through the purchase of treachery from paid informers. After the Act of Union in 1801, and the failed insurrections of 1798 and 1803, the spirit of Irish Catholicism was further weakened by the systematic elimination of the Irish language as an essential cultural symbol. Even after Catholic Emancipation was achieved in 1829, native Irish experience was increasingly devalued, and preferred styles of dress, behaviour and thought were defined in terms of the dominant British colonial culture.

Then came the Famine in 1845, and with it a real possibility of annihilation or abandonment of Irish Catholics by disease, starvation or neglect by the British government. 1.2 million people died in less than five years, 2 million more emigrated to the U.S. during the next decade, and by 1850 large parts of Ireland (particularly the West and Southwest) must have resembled nothing more than a 600-year-old concentration camp.

Throughout this time and later, English newspapers and journals, most notably *The Times*, *Punch* and *The Illustrated London News* generated powerful denigrating stereotypes designed to promote the view that Irish Catholics were at least partly responsible for the catastrophe that had befallen them. Their laziness, stupidity and superstitious religious beliefs were said to have brought on the Famine, which was conceptualised by some politicians and churchmen as a just punishment from a wrathful God for the sinful and rebellious attitudes of Irish Catholics. 'The great evil with which we have to contend', wrote Charles Trevelyan in 1848, 'is not the physical evil of the famine but the moral evil of the selfish, perverse and turbulent character of the people'. As Treasury Secretary of the British government, Trevelyan was responsible for the funding of Famine relief operations.

IRISH IBERIAN. ANGLO-TEUTONIC. NEGRO

Scientific Racism as depicted in Harper's Weekly, 1898

There is considerable evidence to suggest that Trevelyan's official 'British Government' attitude persists 150 years later as a powerful dynamic of the current war in Northern Ireland. In an interview with the *Belfast Telegraph* on May 10, 1969, Mr. Terence O'Neill made the following statement after resigning as Northern Ireland Prime Minister:

Two Faces (detail), by Sir John Tenniel, 1881, published in *Punch*

It is frightfully hard to explain to Protestants that if you give Roman Catholics a good job and a good house, they will live like Protestants, because they will see neighbours with cars and television sets. They will refuse to have eighteen children, but if a Roman Catholic is jobless and lives in a most ghastly hovel, he will rear eighteen children on National Assistance. If you treat Roman Catholics with due consideration and kindness, they will live like Protestants in spite of the authoritative nature of their Church.

Other pertinent 19th-century literary extracts include the following well-known and widely cited quotations. The first of these was penned by Charles Kingsley, author of *The Water Babies* and other classic English novels, in a letter to his wife after a brief tour of Ireland in 1860:

I am haunted by the human chimpanzees I saw along that hundred miles of horrible country. I believe that there are not only many more of them than of old, but that they are happier, better and more comfortably fed and lodged under our rule than they ever were. But to see white chimpanzees is dreadful; if they were black, one would not feel it so much, but their skins, except where tanned by exposure, are as white as ours.[7]

In an 1862 article entitled 'The Missing Link', *Punch* had this to say about immigrant Irish labourers in England:

7 Charles Kingsley, *His Letters and Memories of His Life*, ed. by his wife (London: 1877), pp. ii, 107.

A creature manifestly between the Gorilla and the Negro is to be met with in some of the lowest districts of London and Liverpool by adventurous explorers. It comes from Ireland, whence it has contrived to migrate: it belongs in fact to a tribe of Irish savages: the lowest species of the Irish Yahoo. When conversing with its kind it talks a sort of gibberish. It is, moreover, a climbing animal and may sometimes be seen ascending a ladder laden with a hod of bricks.

From a historical perspective, however, the British government cannot be held solely responsible for the distress of the Catholic population in Ireland then and now. By a peculiar quirk of historical irony, the 19th-century Irish Catholic Church and its faithful adherents may also have contributed to the process as they struggled together to recover from centuries of persecution and near-annihilation at the hands of the English.

By 1850, substantial numbers of Irish Catholics, separated from their lands, devastated by starvation and disease and apparently deserted by government during the Famine, had come to believe that human misery was all they deserved and all they could expect from their colonial masters. Naturally, they looked to the Catholic Church for succour and salvation. The

American Gold (detail), by F. Opper, 1882

Church's response was immediate, powerful and above all successful, because it stopped a potentially genocidal process from gaining a fatal momentum. But the psychological and spiritual price of survival was high; so high, in fact, that it is still being paid 150 years later by significant numbers of Catholics in Ireland, and by many more on the diaspora, including myself.

Survival of the Church and the Evolution of 19th-Century Catholicism

As part of its survival strategy in the early part of the 19th century, the Irish Catholic Church, having been persecuted, shamed and humiliated by the British government for almost one hundred years, now joined forces with it to suppress the insurgence of militant nationalism in Ireland. This unhappy but efficient alliance led the Church to internalize unconsciously the most abusive aspects of Anglo-Irish history and the Victorian culture, including suppression of feelings, repression of sexuality and the devaluation of women's and children's rights. These negative social values were reinforced by a devotional revolution which emphasised sexist elements of Augustinian and Jansenistic theology imported from France and, ironically, incorporated a strict practicum of religious rituals borrowed from England, including Novenas and the Rosary. In the latter half of the century, the ordinary people of Ireland clung to their religion as a badge of identity and a weapon of defiance. For many, Catholicism became a substitute nationality, and nationalism a form of secular religion.[8]

Emigration

Although emigration by Catholics and Protestants from Ireland to the U.S. and elsewhere had been common since the middle of the 17th century, an enormous exodus of Catholics to North America began in 1847, the peak year of the Famine. Lacking material goods to take on the Atlantic journey, the emigrants brought with them instead the austere, authoritarian survival ideology of 19th-century Irish Catholicism, as well as the usual colonial stigmata of second-class citizenship and low self-esteem. What awaited many of these immigrants in the land of promise was poverty worse than anything they had known in Ireland, and an impenetrable wall of racial prejudice and religious discrimination:

Woman wanted to do general housework—English, Scotch, Welsh, German or any country or color except Irish.[9]

Again, the Catholic Church came to the rescue. Irish clergy, in their traditional role as cultural defenders of a devastated people, used strong infusions of vigourous faith and national pride to counter the racism and bigotry aimed at their immigrant flock.

The parish became more important than the neighbourhood, and

8 Miller, *Emigrants*, ibid.

9 Advertisement in *The Boston Daily*, Sunday, 11 May, 1853.

the priests demanded total obedience to their rule. This clerical strategy helped the immigrants to gain a firm toe-hold in the New World by imbuing them with hope and a strong sense of community. It also positioned them to use their native survival skills to the best advantage in the astonishing ascent that would soon bring Irish Catholics to the pinnacles of material success and political power in the U.S.[10]

Meanwhile, back in Ireland, the 19th-century survival strategy of the Catholic Church to suppress both affect and insurrection was a brilliant success, but at what price? According to Monica McGoldrick, the Church consolidated its control of the people (and thereby ensured its own survival) 'by holding the key to salvation in a land where this life offered so little'.[11] After 1850, the Church may have unwittingly passed on the essentials of its survival plan to subsequent generations of Irish Catholics. Shame, guilt, terror and celibate self-sacrifice were key elements in the Church's campaign to deal with the critical problems of over-population, land shortage and the patronymic system of inheritance. Original sin, sexual repression and eternal damnation were incorporated into a grim theology of fear that led Irish Catholics to believe they had been born bad, were inclined toward evil and deserved punishment for their sins.[11] This bleak spiritual philosophy, which evolved in the harsh climate of famine and colonialism, would later become the foundation for 20th-century Irish Catholicism and has remained so to this day, despite the changes of Vatican II and the many departures from tradition by courageous clergy at every level of Church organisation.

Two Varieties of Shame—Healthy and Malignant

In order to highlight the dynamic similarities between parental abuse of children and political oppression of populations, the foregoing account deliberately juxtaposes the abusive aspects of Irish history with the extraordinary ability of the people to overcome them. Similarly, the coping skills developed by children to survive familial abuse can become the principal tools of their achievement as adults. As we shall see, however, the price that many children of abuse pay for their later material or professional success is to be isolated from their authentic feelings by malignant shame, and therefore to be rendered incapable of achieving intimacy in relationships. The implications of a similar outcome for an

10 Greeley, *The Irish*, ibid.

11 Monica McGoldrick, *Irish Families in Ethnicity and Family Therapy*, ed. Monica McGoldrick, John K. Pearce, and Joseph Giordana (New York: The Guilford Press, 1982).

entire population would be devastating.

Physiological or healthy shame is a critically important motivating factor in the psychology of learning and character development. Healthy shame enables children to grow in two ways. First, it helps them to identify the limit of their ability, and then impels them to exceed it. However, like anxiety and guilt, which, in the 'right amounts' are essential for our psychological well-being, healthy shame can become pathological or malignant under certain circumstances.

Healthy shame becomes malignant when it ceases to motivate behaviour that is consistent with normal growth and development, but instead is used as a weapon by individuals or groups in authority to control or manipulate the actions and attitudes of those under their power. For example, insecure parents may shame and punish their children into submission for the same behaviours or inadequacies that they are unable to tolerate in themselves. Authority figures in schools, prisons, churches and the military can, and do, perpetrate verbal, physical, sexual and religious abuse on their charges in the same manner and for the same reasons. Calculating politicians have used shame in their attempts to break the spirit of entire peoples as they did when subjugating the Native Americans, when murdering the Jews and when neglecting the Irish Catholic peasantry during the Great Famine.

Malignant shame, more than a simple emotion, is an identity: a more or less permanent state of low self-esteem that causes even successful persons to experience themselves as being unworthy, and to view their lives as being empty and unfulfilled. No matter how much good they do, they are never good enough. Shame-based individuals may experience themselves privately as objects of disgust, feel secretly flawed and defective as persons and live in constant fear of being exposed as stupid, ignorant or incompetent.

Malignant shame is a psychological survival mechanism which makes it difficult or impossible for abused persons to express their feelings of anger and rage, because to do so would place them at risk for further damage through retaliation by the perpetrator. Thus, abuse victims often remain passive in the face of punishment because they suspect that the rage and criticism of their perpetrator is both accurate and justified. In extreme

cases, severely abused children or battered wives may come to experience verbal, physical or sexual abuse from their parents or husbands not as a form of assault, but as an expression of love. Malignant shame is an important element of the protective dynamic that causes hostages to revere their captors, prostitutes to love their pimps, revolutionaries to admire their oppressors and 'the Irish to imitate the English in all things, while apparently hating them at the same time!'.[12]

Reduced or absent self-esteem may cause children of abuse to create false personas or caricatures of themselves to divert attention away from what they believe to be the hateful, shameful truth of their 'real' identities. Such children are, quite literally, 'not themselves'. Having lost touch with both their authenticity and their feelings, they may, as adults, become inordinately dependent on the approval and judgment of others for estimations of self-worth.

Discussion

When viewed side by side, the historical evolution of Irish Catholicism and the trans-generational dynamics of parental child abuse would appear to have certain features in common. Oppressed nations and abused children may suffer more than their share of unnecessary pain in the process of growing up. Both will experience problems with authority, dependency, identity and entitlement, and both will be compromised in their ability to integrate thought, feeling, intellect and action in such a way as to promote intimacy and facilitate growth.

Like the child of an abused parent, the 19th-century Irish Catholic Church may have internalised a core identity of malignant shame as a response to generations of persecution by the British Government under the Penal Laws. In keeping with the psychological imperative that seems to mandate the trans-generational transmission of *unacknowledged* shame, the harsh and punitive spiritual pedagogy to which the Church bound its adherents at mid-century may have been as much a vehicle for the unconscious transfer of the Church's malignant shame to the next generation, as it was a pragmatic and effective social strategy to avert the real possibility of abandonment or annihilation of poor Catholics during and after the Famine. In the same way that the caricature or false persona of an abused

12 Douglas Hyde, "The Necessity for De-Anglicizing Ireland," speech for the National Literary Society, Dublin, 25 March, 1982.

child can be regarded as a behavioural adaptation to the threat of parental abuse, the 'Irish Catholic Character' can perhaps best be seen as a caricature of itself, a cultural false *persona* based on massive misperceptions of inferiority which evolved as a survival mechanism in the struggle against prolonged abuse by British governments and their representatives in Ireland.

In 1992 I presented an early version of this paper to a largely Catholic audience in Derry. Some were angry, others were stunned, but many could identify. After the lecture, certain members of the audience challenged my authority to speak on the grounds that I had left Ireland thirty years previously and "no longer had my finger on the pulse of the nation". I had no right, they said, to be "putting the Irish down or accusing them of mental illness" when support and encouragement was what was needed "after all [they] had been through". Protestations by me that I was proud to be Irish, loved my country and still went to Mass and Communion occasionally seemed only to inflame a significant segment of the audience, some of whom adopted a rather threatening stance. At a point when the discussion seemed likely to take a nasty turn, a prominent local physician cried out "Stop! O'Connor is not the problem. The real problem is what do we do with our anger?" "And how about our tenderness?" said a woman quietly in the sudden silence that followed his remark.

Both of them were right. The most crippling feature of post-colonial cultural malignant shame in Ireland is an unconscious collusion between the people, the Church and the government to suppress socially significant expressions of intimacy and rage by obliterating them with shame, trivialising them with ridicule or condemning them with diatribes of moral indignation. The implications of this kind of censorship for personal growth, institutional development and the recovery of indigenous pride in a post-colonial environment are profound because human beings, when isolated from their feelings, are also cut off from their humanity, which, in turn, makes them prone to self-pity and compulsive victimhood. Plantation of this evil partition in the mind of the people was, and is, one of the most destructive consequences of British colonial policy in Ireland, because it fosters the development of pathological dependency, strongly supports a culture of blame and actively impedes the process of emotional liberation which is vital for sustained self-appraisal. "If you don't know

how you feel, you don't know who you are. If you don't know who you are, you are probably leading somebody else's life!".

The split between thought and feeling is evident at every level of Irish life. While we Irish are celebrated for being willing to display our emotions through fictional characters in poetry, drama, literature and song, we are not very skilled at revealing our true feelings in the intimate narrows of face-to-face relationships. At home, many of us are reluctant to speak to each other about our private yearnings for affection because expressions of feeling or physical contact are usually discouraged in families—although compulsive talking to ourselves or others is readily accepted on account of its unique capacity to stifle emotion.

In the absence of formal research which has yet to be conducted, the arguments presented in this paper are based on my clinical observations of malignant shame in hundreds of patients, and my experience of the phenomenon as a self-destructive influence in my own life. The positive response I have received from trusted friends and colleagues with whom I have shared these preliminary ideas has encouraged me to think more about how I internalised my cultural malignant shame through interactions with my family, school, church and government, and how I have passed it on to my children and others dear to me through various abuses of power and authority on my part. A better grasp of the process which facilitated this transmission in my case might prove to be helpful for larger numbers of people struggling with the same issues.

Despite a public record of some small professional accomplishment in my life, I continue to struggle privately with many of the conflicts described in this article, especially those related to authority, identity, entitlement and judgment. Over the years I have come to understand my behaviour in these areas as a disorder of belonging—a post-colonial character syndrome manifested intermittently by procrastination, ambivalence about aggression, magical thinking and difficulty with intimacy in my most cherished relationships. In my case at least, the common denominator of these personality characteristics is an irrational need for approval by others and a simultaneous fear of their negative judgment.

The roots of this syndrome can be traced to my relationships with parents and siblings at home, to my interactions with Holy Ghost fathers

and Jesuit priests at school, to my early but instinctive tendency to delegate higher authority to British values, institutions and objects, and finally to vivid and terrifying childhood images of my personal and public vilification by God on the day of the Last Judgment. Many years of 12-Step work combined with personal psychotherapy have given me a set of psychological tools to deal with these problems. However, the spiritual dimensions of my recovery did not come into focus until I became willing to consider my personal development in terms of my cultural history, and to discern a pattern of connectedness that embraced the diverse and often contradictory elements of my national identity.

The argument has been put to me that conflicts of authority, identity and entitlement can occur independently of culture and should not, therefore, be attributed to the influence of any particular political system. While it is certainly true that such conflicts are universal and ubiquitous in human experience, they appear to be concentrated in post-colonial cultures such as Ireland and Mexico where imperialistic forces have subjected the indigenous populations to appalling excesses of political abuse and *unnecessary* suffering over many generations. I have been told in no uncertain terms that my proclivity as a physician to talk publicly about my personal experience with these conflicts is both inappropriate and embarrassing. Instead, I have been advised to confront my cultural demons by disguising them as fictional characters in a novel, or by having them evaluated in the privacy of a psychiatrist's office for a possible trial of medications. After I mentioned in a public lecture given at Dublin's Peacock Theatre in 1992 that my heroic and marvelous mother was an alcoholic, a member of my family suggested quite seriously that I should cease my cultural researches to pursue other work opportunities. In other words, I should keep quiet.

That is my point. I believe that the post-colonial syndrome of malignant shame has caused many of us in the Irish Catholic community to be ashamed of being ashamed, and therefore to conceal or remain silent about the healthy shame which is our life-line to integrity, ambition, power and success. The real 'hidden Ireland' lies buried in the malignant shame of each individual and each institution in the country, and indeed in every Irish person throughout the world regardless of religious affiliation. But it

is we Catholics who must ultimately take leadership to break the silence about the hidden shame of being Irish, and to bring it, and ourselves, out of personal hiding. It is hard to know how to proceed with this process of externalisation, because factors such as embarrassment and concern for the sensibilities of others must always be considered. But there is no alternative, in my opinion. Finding ways to share our 'experience, strength and hope' is an essential first step in resisting the seduction of false pride which is the emotional hallmark of the true victim. Failure to act will sentence too many of us to a shame-based future as dedicated blamers, whiners and Pollyannas who will surely pass our unresolved social issues and family conflicts onto the children of our next generation.

Even though the current peace process in Northern Ireland may soon result in the departure of British troops from the six counties, the occupation of the Irish mind by psychological relics of colonialism, including malignant shame and the capacity for self-deceit contained in the national tendency to say one thing and do another, will continue indefinitely. Although malignant shame is differentially distributed in the Irish Catholic population (that is, some people and some institutions have more of it than others), the incidence of shame-based conditions such as alcoholism, depression, suicide, child abuse, ruined marriages and unfulfilled dreams is paradoxically elevated in Ireland where loyalty to family, love of children and respect for the dignity of life are also highly valued. Institutional undercurrents of malignant shame are suggested by the contemporary tragedies of the Kerry babies, Miss 'X', Bishop Casey and the pedophiliac scandals in the Irish Catholic Church. Potential candidates for analysis from a historical perspective of cultural inferiority and malignant shame might include the conduct of the plenipotentiaries during the Treaty Talks of 1921 and the role of 'cultural drinking' in the death of Michael Collins.

Perhaps the target of the next guerilla war in Ireland should be the negative attitudes and value judgments *about ourselves* that are rooted in a combination of denigrating colonial stereotypes and anachronistic 19th- century Irish Catholic dogma. Deep rivers of dammed-up anger are waiting to be released at every level of society, and the dishonest practice of condemning revolutionary violence in public while supporting it in private

should be discouraged through promotion of a communications climate in which individuals can feel free to express their authentic feelings and opinions without the risk of being condemned as terrorists.

It is likely that the majority of people reading this article will find its thesis to be neither plausible nor palatable, coming as it does from a person who has lived in exile for thirty-five years. They may argue that 'all that is behind us' and that 'to focus on it now' may endanger the momentum of disengagement from Britain that has begun with Ireland's shift of trade emphasis to the European Community. I contend that 'all that is ahead of us'. We should know that malignant shame is a permanent element of the colonial legacy which will accompany us wherever we go, and which will continue to exert its evil influence on the people and institutions of Ireland unless some formal effort is made to identify and confront it at a national level. There needs to be a clear understanding and acceptance of the fact that *all* institutions and traditions of Irish society have been traumatised by imperialism, and that remedial action must therefore include South as well as North, Protestant as well as Catholic and so on through all the diversities. Our willingness as Catholics and Protestants to abandon our respective roles as living caricatures of a narrow and hostile cultural stereotype would give us the courage to speak to ourselves and to our future as a nation of triumphant mongrels who have proudly integrated the shame and the power and the love of our rich and rare polycultural past.

Formal adoption of a perspective which emphasises the need for individual, family, institutional and community recovery from colonial trauma should include the creation of psychological and cultural institutions to serve as active containers for the outpouring of suppressed and prohibited feelings that will inevitably occur in the process of reconciling political, personal, religious and class differences in Ireland. The availability of such institutions would permit us all to take a part in the process of healing the malignant shame that is tearing us apart because we don't realise, or cannot accept, that it is a part of us. The Centre for Creative Communications, soon to be established by the North West Centre for Learning and Development in Derry, is an example of an institution that has incorporated these vital purposes into its primary task.

In the meantime, perhaps the best prescription for Irish Catholics in Ireland or anywhere else at this particular time would be that given by Nelson Mandela to his own people in his inaugural speech as President of South Africa in May 1994:

Our deepest fear is not that we are inadequate.

Our deepest fear is that we are powerful beyond measure.

It is our light, not our darkness, that most frightens us.

We ask ourselves, who am I to be brilliant, gorgeous,

talented and fabulous?

Actually, who are you not to be?

You are a child of God.

Your playing small doesn't serve the world.

There's nothing enlightened about shrinking so that

other people won't feel insecure around you.

We were born to manifest the glory of God that is

within us.

It's not just in some of us; it's in everyone.

And as we let our own light shine, we unconsciously

give other people permission to do the same.

As we are liberated from our own fear,

our presence automatically liberates others.

THE RECOVERY OF KITSCH

David Lloyd

An irrepressible conundrum mocks national cultures, all the more so when, overshadowed by more powerful neighbors, culture is all the nation has to distinguish it. That conundrum is the apparently inevitable declension of the icons of authentic national culture into kitsch. The images proliferate: round towers and wolfhounds, harps and shamrocks, La Virgen de Guadalupe and pyramids in Yucatán, Aztec masks and feathered serpents. And they have their histories, disinterred and shaped in the projects of cultural nationalism to symbolize the primordial origins of the spirit of the nation, *la raza*. But long before their visible commodification as signals of safe exoticism deployed by our tourist boards, breweries, or airlines, the logic of their standardization and circulation was embedded in the nationalist project.

What does cultural nationalism want? In the first place, to retrieve for the people an authentic tradition that, in its primordiality and continuity, differentiates the nation culturally if not racially from those that surround or occupy it. This act of retrieval seeks to reroot the cultural forms that have survived colonization in the deep history of a people, and to oppose them to the hybrid and grafted forms that have emerged in the forcedmixing of cultures that colonization entails. It is an archeological and genealogical project aimed at purification and refinement, at originality and authenticity. The fact that, as we know only too well, most tradition is invented tradition is less significant than the act of resistant self-differentiation that project involves.

For, in the second place, it is to identify with this difference that cultural nationalism calls its prospective subjects: Rather than masquerading as a well-formed Anglo or Englishman, celebrate our differences even where they are marked as signs of inferiority. Transvalue the values of the colonizer, cease to defer to the dominant culture and its commodities, produce and consume authentic national goods. Above all, cultivate the sentiment of a difference that unifies the people against the colonizing

power, for in that sentiment of difference survives the spirit of the nation. Cultural nationalism seeks accordingly to reform the structures of feeling of individuals, emancipating their affects from dependence and inferiority, and directing them towards an independence founded in cultural integrity. It must do so by deploying artifacts that are the symbols of national culture, parts that represent a whole that has often yet to be constituted: ballads or *corridos*, myths, tales, poetry, music and costumes, murals. Around these, the sentiment of national culture is to be forged in each and every individual.

To achieve these ends, cultural nationalists must deploy, in the name of tradition itself, the most modern techniques of reproduction and dissemination. Benedict Anderson has noted the importance of the press and its commodity forms, the newspaper and the novel, to the emergence of nationalism.[1] We can extend the sweep of nationalism's dependence on the circulation of cultural commodities to include forms from the street ballad, cheaply produced and disseminated by peddlers, to radio, television, and cinema. Nationalist sentiment is borne by commodities whose circulation encompasses the whole national territory. And if every corner of the prospective nation is washed by this circulation, so too each individual must be saturated with the same sentiment without which the uniformity and unity of popular political desire could not be forged. Cultural nationalism requires a certain homogenization of affect, a requirement served not so much by selection as by proliferation, the dissemination of countless ballads, newspaper articles, symbols, and images that are virtually indistinguishable. Indeed, a considerable degree of stylistic uniformity, a simulacrum of the anonymity of "folk" artifacts, is indispensable to the project: stylistic idiosyncrasy would be counterproductive, stylization is of the essence.

Hence the apparent inevitability of the devolution of "authentic national culture" into kitsch. The commodification of certain styles, and the mechanical reproduction of standardized forms of affect that have traditionally been the hallmarks of kitsch have their close counterparts in cultural nationalism. Only here, the reproduction of forms is directed less towards the homogenization of the economic than of the political sphere. This political purpose requires, nonetheless, the production of novelties that are always interchangeable, and the immediate, untroubled evocation of

1 See Benedict Anderson, *Imagined Communities: Reflections on the Origin and Spread of Nationalism* (London: Verso, 1991).

affects that are the sign of each individual's identification with the nation. Rather than the auratic remoteness of the modern artwork, the products of kitsch and of nationalism must, by the very logic of their economic and political *raisons d'être*, appear familiar. Indeed, the sites that they occupy, often to the consternation of both their political and their aesthetic critics, are crucially domestic, those familial spaces in which national desires are safeguarded and reproduced. As Franco Moretti puts it, "kitsch literally 'domesticates' aesthetic experience. It brings it into the home, where most of everyday life takes place."[2] The correspondence with the strategies of nationalism, which seeks to saturate everyday life, are evident, and by no means unrelated to the strategies of religious culture. The Sacred Heart and votary lamp vie for attention with icons of 1916 in not a few Irish kitchens.

This conjunction of nationalist and religious artifacts as domestic objects raises problems for the purely aesthetic judgment. The rigorous castigation of kitsch relies on the assumption of its impurity or authenticity, on its debasement of formerly integral styles into anachronistic stylization, on its tendency to neo-baroque excess. Kitsch is mannerism, sentiment congealed into attitude. Its relation to commodity fetishism in general lies both in its mass-produced standardization of affects and its apparent displacement of authentic social relations. The glossy surfaces and high color tones, the uncannily familiar yet novel melody, appear to condense feeling into sentiment and to furnish fetishistic substitutes in place of aesthetic transubstantiations.

For critics of kitsch, Adolf Loos's functionalist horror of ornamentation is typical, not merely in its castigation of mannered stylization or of impossible conjunctions—Grecian ashtrays or Renaissance hatboxes—but more pointedly in his assumption that consumers of kitsch suffer from an outlived primitivism of affect. Kitsch represents a desire for ornament and surface that belongs with savagery and is deeply antagonistic to aesthetic distance.[3] Unlike, say, Marx and Freud, such a theory of fetishism unironically grasps the destruction of aura in the fakeries of kitsch as an effect of the aesthetic underdevelopment of the populace rather than as an inexorable consequence of the social and economic conditions of modernity. Not underdevelopment but commodity fetishism, which itself dissolves aura into availability and particularity into an advertising slogan, is the

2 See Franco Moretti, *The Way of the World: The* Bildungsroman *in European Culture* (London: Verso, 1987), p. 36.

3 On Loos's writings on kitsch, see Miriam Gusevich, "Decoration and Decorum: Adolf Loos's Critique of Kitsch," in *New German Critique*, no. 43 (Winter 1988): 97-123.

fundamental condition that frames the circulation of kitsch. As Adorno remarks, writing of "commodity music" in the refrain "Especially for you," the swindle "is so transparent that it cynically admits it and transfers the special to realms where it loses all meaning."[4]

The critique of kitsch not only mistakes its relation to modernity, as the critique of nationalism so often mistakes the relation of its apparent traditionalisms to modernity, but equally mistakes in both their relation to distance, aesthetic or historical. Not the stereotype of the savage subject to

immediate impressions that lurks in Loos's scorn, but the tourist is the proper figure for the lover of kitsch. Not for nothing is the object that springs to mind so often a souvenir, a green Connemara marble Celtic cross or an ashtray embossed with a harp: kitsch is congealed memory that expresses simultaneously the impossible desire to realize a relation to a culture available only in the form of recreation, and the failure to transmit the past. Kitsch is the inseparable double of an aesthetic culture that continues to pose as a site of redemption for those who are subject to the economic laws of modernity, even in the spaces of recreation that pretend to emancipate them from labour. It is popular culture's indecorous revenge on aesthetic illusion.

As such, it is no less a vehicle for feeling, even if (as in the case of religious art), what it reveals is, in part, the impossibility of integrating aesthetic affect with modernity's fragmentations. The baroque intensities of wounding and mannered suffering in religious art, and the fascination with ruins and monuments in tourist kitsch signal the at-homeness of such artifacts in the domain of allegory. They point to the impossibility of achieving organic or symbolic integration of a life, or of a life with art, or of religion into the texture of daily life, precisely in their very insistence within the domestic space. In the very gestures it makes towards transcendence, kitsch preserves the melancholy recognition of the insuperable disjunction between desire and its objects. As Adorno puts it, "The positive element of

4 Theodor W. Adorno, "Commodity Music Analysed," in *Quasi Una Fantasia: Essays on Modern Music*, trans. Rodney Livingstone (London: Verso, 1992), p. 44. I have of course been inspired here equally by Walter Benjamin's famous essay, "The Work of Art in the Age of Mechanical Reproduction," and will subsequently draw much from his masterful *Origins of German Tragedy* for my reflections on kitsch, melancholy, and allegory.

kitsch lies in the fact that it sets free for a moment the glimmering realization that you have wasted your life."[5]

But suppose we amend that comment slightly, to read, "it sets free for a moment the glimmering realization that your life has been wasted?" This rewriting brings us closer to what is at stake in the resistance of kitsch to aesthetic judgement, to its parodic relation to the redemptive illusions of high culture, and, more importantly, to what the significance of kitsch is within migrant or colonized cultures. Nowhere are the deracinating and alienating effects of capitalism felt more powerfully than in communities whose histories are determined by domination, displacement, and immigration, for whom ruins are the entirely just and not merely figurative indices of living dislocation. And nowhere is kitsch, from the family snapshot to the religious or national icon, more crucial to the articulation of the simultaneous desire for and impossibility of restoring and maintaining connection. Kitsch becomes, in such spheres, the congealed memory of traumas too intimate and too profound to be lived over without stylization and attitude. In the migrant community especially, kitsch is subject already to the conditions of inauthenticity that trouble cultural nationalist icons, and becomes doubly allegorical of an irredeemable dislocation. The detached fragment that is literally transported is less a memory than the representative of processes of memory which have virtually become unsustainable. It is at once the metonym of transfer and its effects, and a sign of the migrant's ambivalent relation to the new and dominant culture. Verbal, musical, or visual, the icon stands as a refusal of incorporation that simultaneously challenges a rejection that is in any case inevitable. Is it not the experience of virtually every migrant community to be articulated around icons that are despised by the culture from which we come as no longer authentic (as if its own icons ever were!) and by that to which we come as vulgar, sentimental, gaudy—as signs of underdevelopment and inadequate assimilation? Hence, doubtless, the importance and the recurrence of the feeling of shame in relation to such icons on the part of the assimilating migrant of any generation. The emergence of aesthetic judgement, if only as a regulative standard, has always been instrumental in the formation of citizens.

Yet migrant kitsch and the icons of the dominated are marked by a paradoxical discretion, by what they omit to say as a function of their

5 Ibid., p. 50.

allegorical mode, and of their double obligation. Their allegorical function is to gesture towards a trauma that will not and cannot be fully acknowledged—will not, by either the culture from which or the culture to which the migrant migrates. The *emigrant* is the living index of the failure of post-colonial states, and accordingly consigned as rapidly as possible to political oblivion and cultural contempt; the *immigrant* must be seen in the so-called economic good times, not as the return of imperialism's bad conscience, charged with as much resentment as ambition, but as one seeking the betterment offered by a culturally and economically more dynamic society. S/he must be seen in bad times like the present as a parasite seeking to feed off the vitality of the state s/he undermines, rather than as one more actor in the same global circulations of capital and labour as are transforming social relations with renewed and vicious intensity in every sector and in every region of the world.

In turn, the trauma cannot be fully acknowledged any more than it can be forgotten, by the migrant or the dominated, for the disavowal of that trauma has the effect of transforming a collective disaster into an individual or familial affair. In the reconstruction of both community and domestic life, the icon functions to contain memory: it at once serves to preserve cultural continuities in face of their disruption, and to localize, as it were, the poten-

Irish Cultural Center, San Francisco, 1995. Photo by Ed Kashi

tially paralyzing effects of trauma and anomie. Take for example, the strangely moving image above the bar of the Irish Cultural Center in San Francisco, a building in which kitsch thrives at every level, from the architecture to the music. The image, part of a set of sandblasted glass panels that include a round tower and a map of Ireland, appears to represent an emigrant ship. Yet the millions of emigrants who left, and the thousands who died of fever and hunger in the "coffin ships," are represented only in the couple who occupy a deck that resembles a promenade, and whose gaze appears to linger backwards on the homeland, or possibly forwards to the land promised to them by the tourist board. Tourists returning or emigrants leaving, a peculiar sense of dislocation hovers in the midst of the nostalgic glow, while in the bottom

right-hand corner, a lone old man stares out from a promontory. There is no evident connection, and it is impossible to tell whether he represents the next emigrant or a figure for the reduced but persistent peasant society from which, supposedly, the emigrants fled. In such an icon, the unspeakable trauma of the Great Hunger, and of massive emigration over the next century is at once preserved and suppressed.

Yet, even the most traumatic memory is never forgotten. If kitsch preserves, in its congealed and privatized, mostly portable forms, the memories of a community that cannot quite be a people, does it not also represent a repertoire that can, in given political circumstances, be redeployed for collective ends? In such cases, the political possibilities derive precisely from the availability of the icon, its constant circulation prior to any politicizing retrieval, and its accumulation in that circulation of individual meanings and attachments, ranging from a shared sense of affection to a shamed sense of stigmatization. In the contradictory range of feelings that attach to it, often simultaneously, lies the secret of the sudden mobility to which the icon can attain in spite of its debasement and devaluation as mere kitsch. One such instance would be the figure of Mother Ireland, a figure generally decried by the agents of modernity as a residue of atavistic Victorian Celticism, yet whose recirculation in the recent decades of the Troubles has transformed her into a site of profound contestations over the meaning and definition of women's struggles and their relation to republicanism and cultural nationalism. As the superb documentary by the Derry Film Collective, *Mother Ireland*, indicates, it is precisely the contradictoriness of the affects that attach to such icons that permits their transformation from scleroticized to dynamic cultural forms, forms available for contestation and revision. Something similar has been the case with the refiguration of cultural icons like La Malinché and La Virgen de Guadalupe within recent Chicana art and writing.[6]

It is important to emphasize, and by no means in disparagement, this fact that the sources of the icons thus refigured are so often exactly those which have been recirculated, commodified, apparently exhausted in the turns of reproduction and circulation. There is nothing atavistic or regressive in the cultural politics that reappropriates icons long denigrated as vulgar kitsch. On the contrary, what such art often maps is the problematic

6 See, for example, Cherrie Moraga, "A Long Line of Vendidas," in *Loving in the War Years: lo que nunca paso por sus labios* (Boston: South End Press, 1983); Norma Alarcon, "In the Tracks of the Native Woman," *Cultural Critique*, no. 14; and the artwork of Yolanda M. Lopez or Ester Hernandez. I am indebted to Laura Perez's essay "*El desorden*: Nationalism and Chicana/o Aesthetics," forthcoming, for drawing my attention to the work of these artists.

and often ironic interface between the economic and therefore cultural and political force of modernity, and the survival of the alternative spaces of the non-modern. Their political meaning lies in the jarring juxtaposition of motifs that are not so much traditional as they are attenuated by familiarity against motifs derived from the conditions of struggle against postmodern

Mural commemorating 8 IRA volunteers killed in action during ambush of Loughal Barracks, Springhill Estate, Belfast, N. Ireland, 1988. Photo by Laurie Sparham /Network

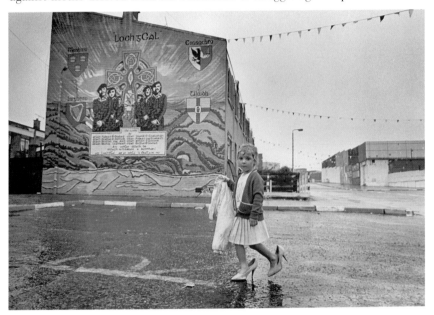

state violence. Some of Gerard Kelly's most powerful murals in West Belfast derive their iconography not from ancient Celtic manuscripts but from Jim Fitzpatrick's post-Marvel Celtic comic, *The Book of Conquests*. As he has remarked, this involved a quite conscious transfer in the art he was initially painting on handkerchiefs while in the H-Blocks, from the permitted kitsch of Ireland's official religious and commodity cultures to the stylization of Celtic mythology:

Prison was supposed to be a breaker's yard for republicans. You were stripped of your dignity, your clothes, anything that showed your identity. You were allowed to paint hankies of the Pope, the Virgin Mary, Mickey Mouse and things like that. They censored everything. [After reading Fitzpatrick] rather than do the Mickey Mouse things, I decided to paint Celtic mythology.[7]

Kelly's repertoire, not unlike that of contemporary Chicano muralists, is drawn from numerous sources, ranging from Sandinista

7 Quoted by Bill Rolston in "The Writing on the Wall: The Murals of Gerry Kelly," *Irish Reporter*, no. 2 (1991): 15.

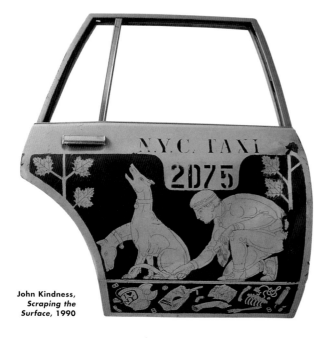

John Kindness,
*Scraping the
Surface*, 1990

murals to newspaper cartoons. At the same time, the mural as a form exists *in situ*, and often gains its exact meanings from its relation not only to a very definite community, but also to the forces of state power against whom the mural speaks in its very vulnerability and relative poverty of material resources. In this sense, it enacts an ironic reversal of the ways in which the state's counterinsurgency apparatuses have tried to produce a simulacrum of the non-modern "knowable community," where so much knowledge passes by intimate channels, in the form of computerized databanks that can access the name of your neighbor's dog, or listening devices that can eavesdrop on every living room or street corner conversation.

The effects of work like Kelly's, or of Mission District muralists, are not remote from those of Rubén Ortiz's video work *Para leer Macho Mouse*, with its extravagant and ironic deployment of Disney and commodified Mexicanisms, nor from his adapted baseball caps, in which a radical juxtaposition of the all-American headgear with the homeboy's appropriation of that dominant icon is spelt out in the adaptations of the very lettering that is supposed to signal legitimate affiliations. But instead they come to bear memories of expropriation, stigma, and resistance: 1492, *Mestizo*, Aztlán. Nor are such murals far from the work of John Kindness's double-edged play with the outrageous convergence of the kitsch of both dominant and unofficial cultures: the *Ninja Turtle Harp*, or the Grecian cab door, *Scraping the Surface*. Kindness's work plays in such images with the horror with which Loos observed Grecian ashtrays or Gothic chandeliers in late-nineteenth-century Vienna, and in doing so liberates from aesthetic judgments the same wit and mobility that allows subordinated cultures to rediscover in "kitsch" a rich repertoire for resistance.

On a West Belfast street named in Irish, a billboard states, "HARP: the Irish lager Mexican's Drink": another, selling cigarettes, reveals an obscure riddle depicting a "Mexican wave." In the fields of the San Joaquin valley of California, a Oaxacan migrant worker, who speaks neither Spanish nor English but his native Mixtec, picks strawberries wearing a faded T-shirt depicting an aggressive leprechaun figure—the logo of the "Fighting Irish" football team. While our cultures remain unique to our histories, they have always converged, interacted, and been reinvented throughout history—only now it is at an extremely rapid pace. The confusion and madness is evident to us all as we try to make sense of this new Babel of our postmodernity.

Trisha Ziff

It could be worse, Jack. Imagine having to drink beer with a lime in it.

PURE GENIUS
The official beer of the Irish World Cup Team.

DOMESTICANA: THE SENSIBILITY OF CHICANA *RASQUACHE*

Amalia Mesa-Bains, Ph.D.

Vernacular, vulgar, inferior, tasteless, and insensible are all terms associated with kitsch. The discourse on kitsch and its relationship to the postmodern avant-garde has been marked by multiple definitions. The work of Gerardo Mosquera[1] in particular has placed kitsch in a recuperative setting, where the Cuban artist who stands outside the everyday embellishments of kitsch can employ the "inferior" to speak of the arbitrary definitions of the "superior." The examination is expanded to make distinctions between mass-produced objects and the intimate expressions of sincere decoration in the domestic space. As Mosquera points out, there is a need for greater classificatory information, and a more specific definition of this phenomenon. Within this process of clarification, meaning and usage become even more crucial. When is kitsch recuperated, by whom, and for what aesthetic intention? Many of these same concerns for meaning and usage can be brought to bear on the *Chicano* phenomenon of "*rasquachismo*," or the view of the downtrodden. Tomás Ybarra-Frausto elaborates:

Very generally, rasquachismo *is an underdog perspective—los de abajo . . . it presupposes a world view of the have not, but it is a quality exemplified in objects and places and social comportment . . . it has evolved as a bicultural sensibility.*[2]

In *rasquachismo,* the irreverent and spontaneous are employed to make the most from the least. In *rasquachismo,* one has a stance that is both defiant and inventive. Aesthetic expression comes from discards, fragments, even recycled everyday materials such as tires, broken plates, plastic containers, which are recombined with elaborate and bold display in yard shrines (*capillas*), domestic decor (*altares*), and even embellishment of the car. In its broadest sense, it is a combination of resistant and resilient attitudes devised to allow the *Chicano* to survive and persevere with a sense of dignity. The capacity to hold life together with bits of string, old coffee cans, and broken mirrors in a dazzling gesture of aesthetic bravado is at

1 Gerardo Mosquera, "Bad Taste in Good Form," in *Halan* (1985).

2 Tomás Ybarra-Frausto, Rasquache: *A Chicano Sensibility* (Phoenix: MARS Artspace, 1988).

the heart of *rasquachismo*.

The political positioning of *Chicanos* emerging from a working-class sensibility called for just such a defiant stance. Raised in *barrios*, many *Chicano* artists have lived through and from a *rasquache* consciousness. Even the term "Chicano," with all its vernacular connotations, is *rasquache*. Consequently, the sensibility of *rasquachismo* is an obvious, and internally defined tool of artist-activists. The intention was to provoke the accepted "superior" norms of the Anglo-American with the everyday reality of *Chicano* cultural practices. Whether through extensions and reinterpretations of the domestic settings, the car, or the personal pose, *rasquachismo* is a world view that provides an oppositional identity. Unlike the Cuban recuperation of kitsch, *rasquachismo* is for the *Chicano* artists a facet of internal exploration that acknowledges the meaning sedimented in popular culture and practices. *Rasquachismo* then becomes for *Chicano* artists and intellectuals a vehicle for both culture and identity. This dual function of resistance and affirmation is essential to the sensibility of *rasquachismo*.

In the counterpoint between kitsch and *rasquachismo* two major differences are apparent. First, kitsch serves as a material or phenomenon of taste through mass-produced objects or style of personal expression in decoration, while *rasquachismo* contains both the material expression but more importantly, a stance or attitudinal position. Consequently, the meaning of each is inherently different. Secondly, its usage reflects a radically opposed instrumentality for the artists. Kitsch as a material expression is recuperated by artists who stand outside the lived reality of its genesis. Conversely, *rasquachismo* for *Chicano* artists is instrumental from within a shared *barrio* sensibility. One can say that kitsch is appropriated while *rasquachismo* is acclaimed or affirmed. *Rasquachismo* is consequently an integral world view that serves as a basis for cultural identity and a socio-political movement. As such, *rasquachismo* has not been limited to the visual arts, but in fact has been used as a major sensibility in theatre, music, and poetry. The tragicomic spirit of *barrio* life, as Ybarra-Frausto details, has been a present form in the early *actos* of Luis Valdez's "Teatro Campesino," in the poetry of José Montoya, in the works of the Royal Chicano Air Force (RCAF, a conceptual artists' collective), in the urban street pageantry of "ASCO" of Los Angeles, and in the border spectacle of

Guillermo Gomez-Peña. *Rasquachismo* can thus be seen as a redemptive sensibility linked to a broadbased cultural movement among *Chicanos*. As the first generation of their community to be educated in universities (after hard-fought battles in the Civil Rights period), these artists employed a bicultural sensibility. Operating as an internally colonized community within the borders of the United States, *Chicanos* forged a new cultural vocabulary composed of sustaining elements of Mexican tradition and lived encounters in a hostile environment. Fragmentation and recombination brought together disparate elements such as *corridos* (Mexican historical ballads), images of Walt Disney, Mexican cinema, and mass media advertising, and even Mexican *calendario* graphics and American Pop art. This encounter of two worlds could only be negotiated through the sensibility of *rasquachismo*, a survivalist irreverence that functioned as a vehicle of cultural continuity. In many respects, the *rasquache* defiance of *Chicano* art production has served as an anecdotal history for a community repudiated and denied in institutional history within the nation as a whole. In so doing, *rasquachismo* provides the anecdote that critical theorist Walter Benjamin refers to: "Anecdote brings things closer to us in space, allows them to enter our lives. Anecdote represents the extreme opposite of History . . . the true method of making things present is to image them in our own space."[3]

Within the visual arts, *rasquachismo* as a sensibility has been a major force. The regional discourse in *Chicano rasquache* has been both rural and urban. For example, the hubcap assemblage of David Avalos has fused the amulets of Catholicism with urban car art into a new icon, the "*Milagro* Hubcap." The rural ethos has been essential to the *rasquache* sculpture series of *Chiles in Traction* by *Chicano* artist Ruben Trejo.

Domesticana

To look within the *rasquache* production of *Chicano* art, and to locate the work of women requires a description of both the *barrio* and family experience and the examination of its representation. This examination necessitates the application of feminist theory to this representation.

The day-to-day experience of working-class *Chicanas* is replete with the practices within the domestic space. The sphere of the domestic

3 Walter Benjamin, *Illuminations*, ed. Hannah Arendt (New York: Schocken, 1969).

includes home embellishments, home altar maintenance, healing traditions, and personal feminine pose or style.

The phenomenon of the home altar is perhaps the most prolific. Established through continuities of spiritual belief, pre-Hispanic in nature, the family altar functions for women as a counterpoint to male-dominated rituals within Catholicism. Often located in bedrooms, the home altar locates family history and cultural belief systems. Arrangements of bric-a-brac, memorabilia, devotional icons, and decorative elements are created by

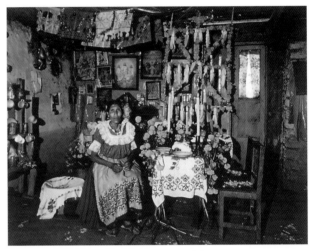

women who exercise a familial aesthetic. Certain formal and continuing elements include saints, flowers (plastic, dried, natural, and synthetic), family photos, mementos, historic objects (military medals, flags, etc.), candles, and offerings. Characterized by accumulation, display, and abundance, the altars allow a commingling of history, faith, and the personal. Formal structures often seen are *nichos*, or niche shelves, *retablo*, or box-like containers highlighting special icons, and innovative uses of Christmas lights, reflective materials, and miniaturization.

Pilar Incarnacion, 1989, Janitzio, Michoacan, Mexico. Photo by Dana Salvo

As an extension of this sacred home space, the frontyard shrine or *capilla* (little chapel) is a larger-scale, more public presentation of the family spiritual aesthetic. *Capilla* elaboration can include cement structures with mosaic mirror decoration, makeshift use of tires, garden statuary, fountain lighting, and plastic flowers. In both the home altar and *capilla*, the transfiguration relies on an almost organic accruing of found objects and differences in scale, which imply lived history over time. For many *Chicanas*, the development of home shrines is the focus for the refinement of domestic skills such as embroidery, crochet, flowermaking, and handpainting.

Related to the creative functioning of the domestic sacred space is the ongoing practice of healing skills. Special herbs, talismans, religious imagery, and photos of historic faithhealers are essential to this cultural

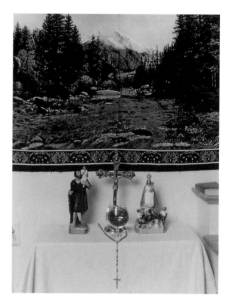

tradition. Young women learn from older women practices such as *limpias* with burned herbs, and the application of homeopathic cures. Regional context contributes to the healing discipline, particularly in the Southwest.

In the larger area of domestic decoration, the use of *artesanias* such as papercutting, carving, and handpainting are prevalent. Added to the use of folk objects is the widespread popularity of *almenaques*, or Mexican calendars and movie posters. The centrality of family life directs the sensibility of "*domesticana*"; *Chicanas* are frequently raised in hierarchical roles of male over female, old over young.

The emphasis on gender stratification creates boundaries within family roles in which women gain responsibility for child rearing, healing and health, home embellishment, and personal glamorization. This traditional picture is enlarged in families within urban centers but nonetheless remains relatively consistent.

Chicana rasquache (domesticana), like its male counterpart, has grown not only out of both resistance to majority culture and affirmation of cultural values, but from women's restrictions within the culture. A defiance of an imposed Anglo-American cultural identity, and the defiance of restrictive gender identity within *Chicano* culture has inspired a female *rasquacheism*. *Domesticana* comes as a spirit of *Chicana* emancipation grounded in advanced education, and to some degree, Anglo-American expectations in a more open society. With new experiences of opportunity, *Chicanas* were able to challenge existing community restrictions regarding the role of women. Techniques of subversion through play with traditional imagery and cultural material are characteristic of *domesticana*. Within this body of work, we can begin to apply critical viewpoints of feminist theory.

Feminist Theory

To understand *domesticana Chicana*, it is necessary to impose a criticality that places art production as more than reflective of ideology, but rather an art production that is constructive of ideology. Art then becomes a social reality through which essential world views and identities, individually lived, are constructed, reproduced, and even redefined. The construction of the feminine through patriarchy relies on a network of psycho-socio relationships that produce meaning. Such meanings are created by the ways in which patriarchy positions us as wives, daughters, sisters, and mothers. Theorist Griselda Pollack elaborates:

The meaning of the term woman is effectively installed in social and economic positions and it is constantly produced in language, in representation made to those people in those social and economic positions—fixing an identity, social place and sexual position and disallowing any other.[4]

In this way, the domestic sphere—with all its social roles and practices—culturally remains fixed in patriarchy unless representation of that world calls into question such practices and thereby contributes to its change. In particular, the feminine is charged with this potential for emancipation. The bedroom and the kitchen convey a centrality but also an imprisonment. With the advent of the modern metropolis, the polarity of public (male) space and private (female) space has taken on a splitting intensified by urbanization. In addition, the rural traditions within the *Chicano* community have encapsulated the private, restricted domain of women in a unique fashion, while strong kinship patterns in extended families have deepened the psycho-socio network of female roles. The domestic chamber then has become a space imbued with both a sense of saliency and isolation. Once again, Pollack's work on feminine space in representation becomes a critical frame:

The spaces of femininity operate not only at the level of what is represented in the drawing room or sewing room. The spaces of femininity are those from which femininity is lived as positionality in discourse and social practice. They are a product of a lived sense of social relatedness, mobility and visibility in the social relation of seeing and being seen. Shaped within sexual politics of looking they demarcate a particular social organization of gaze which itself works back to secure

4 Griselda Pollack, *Visions of Difference: Femininity, Feminism and the History of Art* (Putledge Press, 1988).

a particular ordering of sexual difference. Femininity is both the condition and the effect.[5]

This condition and effect remain in place unless the representation, like language, relocates or repositions the feminine. Spatial ambiguities and metaphors can function to shake the foundational patriarchy in art through challenging works. *Domesticana* begins to reposition the *Chicana* through the working of feminine space.

Chicana Domesticana

The work of *Chicana* artists has long been concerned with the roles of women, questioning of gender relations, and the opening of domestic space. Devices of paradox, irony, and subversion are signs of the conflictual and contradictory nature of the domestic and familial world within the work of the *Chicana* artists. In *domesticana Chicana*, the creation of a familial space serves as a site for personal definition for the artist. For *Chicana* artists using the *rasquache* stance, their work takes on a deeper meaning of domestic tension as the signs of making do are both the affirmation of the domestic life and a challenge to the subjugation of women in the domestic sphere. This domestic tension signifies the contradiction between the supportive aspects of the feminine and the struggle to redefine restrictive roles. Cherished moments stand side by side with examinations of self, culture, and history in visions of a domestic chamber that is both paradise and prison.

Characteristics of *domesticana* include an emphasis on ephemeral site-specific works. This emphasis arises from *Chicano* survivalist responses to the dilemmas of migration and impermanent community celebrations. Much of the work innovates on traditional forms such as the reliquary, *capilla*, domestic memories of bedroom altars, vanity dressers, *ofrendas* (or offerings for the Mexican Day of the Dead), and everyday reflections of femininity and glamour. The extension of these forms through *domesticana* serves as a retrieval of memory, capturing in permanent imagery the remembrance of things past. *Chicanas* make use of assemblage, bricolage, miniaturization and small box works, photography, text, and memorabilia to create a mimetic world view that retells the feminine past from a new position. Narratives of domesticity and ruin are presented in a redemptive enunciation in the language of *domesticana*. Artists use pop

5 Ibid.

culture discards, remnants of party materials, jewelry, kitchenware, toiletries, saints, holy cards, and *milagros* in combined and recombined arrangements that reflect a shattered glamour. *Chicana* artists working in *domesticana* may use hyper-feminization juxtaposed with destruction and loss in a persistent reevaluation of the domestic site.

The works act as devices of intimate storytelling through an aesthetic of accumulation of experience, reference, memory, and trans-

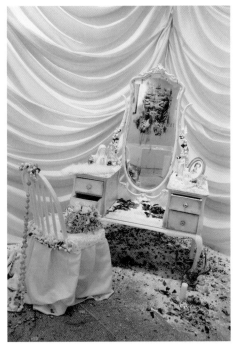

Amalia Mesa-Bains, *Venus Envy, Chapter One (First Holy Communion, Moments Before the End)*, 1991

figuration. Artists whose work embodies *domesticana Chicana* include Santa Barraza, Carmen Lomas Garza, Celia Muñoz, Patricia Rodriguez, and Patssi Valdez.

Summary

The expansion of a feminine *rasquachismo* as *domesticana* has been an attempt to elaborate both intercultural differences between Cuban kitsch and *Chicano rasquache* as well as intracultural differences between *Chicana domesticana*. Like all explorations, terminologies must remain porous, sensibilities never completely named, and categories shattered. As Victor Zamudio-Taylor reminds us, *Chicano* art and *domesticana* "shatters the reified universe and breaks the monopoly of the established discourse to define what is real and true."[6]

The redefining of the feminine must come from the representational vocabularies of women if we are to undo the wounds of patriarchy and colonization. That is the challenge of new views of space, of the new *domesticana* defiance.

6 Victor Zamudio-Taylor, "Contemporary Commentary," in *Ceremony of Memory* (Santa Fe, N.M.: Center for Contemporary Art, 1988), p. 14.

WE ARE ALL RAMONA: ARTISTS, REVOLUTIONARIES, AND ZAPATISTAS WITH PETTICOAT

Ellen Calmus

Fractal Borders

There are borders and there are borders: borders between countries, international borders established by history, geography, language, and law. The borders within borders that emerge through discord or war—internal borders, one could say, though sometimes domestic military checkpoints turn into new international borders—then again, sometimes the old borders melt away or change. East Germany/West Germany, North Vietnam/South Vietnam, Northern Ireland/Southern Ireland, The Union of Soviet Socialist Republics. Since Texas was once part of Mexico, my Mexican friends who forgive me for being a *gringa* say that my having been born in Texas means I'm really a Mexican. (On the other hand, when I visit the country of which I'm a citizen, I get complimented on my English and asked where I learned it; meaning, I suppose, that to firmly rooted *estadounidenses* I've become an articulate foreigner.) People move across borders; borders move across people.

Wars, rebellions, uprisings create complex, shifting borders. The most baroque case I've seen was during the Salvadoran peace talks of 1988, when the office of the papal nuncio in San Salvador was used as neutral territory for talks between Salvadoran government representatives and rebel leaders of the FMLN. The FMLN had armed dozens of guards with sticks, their faces covered with bandannas, in a cordon around the area that stretched into loops and peninsulas to accommodate the hilly terrain and various buildings and streets. The Salvadoran army had guards with machine guns forming a larger cordon around the FMLN guards; the double cordon snaked around a hotel, back and forth over intersections. Journalists who wanted to approach the nuncio had to run a gauntlet of up to seven military checkpoints of alternating allegiance in the space of a couple of blocks, and we would show our different sets of credentials, sizing up the

next group of guards—bandannas and jeans or olive drab?—in order to present the appropriate set of press credentials to avoid getting turned back.

The Zapatista area in the Mexican state of Chiapas has been something like that for over a year, though more chaotic in some ways and less war-hardened in others. (There has, after all, been extremely little armed confrontation: one might ask if this is a war at all, or whether it is more of an extended ritual of bellicose gestures and exhortations.) To get to Zapatista territory you pass army checkpoints, leaving Tuxtla-Gutiérrez, entering San Cristóbal, leaving San Cristóbal, entering Ocosingo, and at various points beyond. Past Ocosingo you may encounter Zapatista check-points as well, depending on the state of the war (if it is a war). And the fractal demarcations of territory are just as complex at the local level; in the Zapatista villages not everyone is Zapatista, and everybody knows who is on which side: "The families at the southern end of town are all Zapatista, the people in the houses by the school are not."

But there are interior borders, too, which also shift: the borders within the individual heart and mind. The Zapatista uprising is only a little more than a year old; the Zapatistas have been organizing and raising support in Chiapas for just ten years. Those combatants were not born Zapatistas. At some point they decided to cross that line, to join a fledgling, ill-equipped guerrilla movement. Why?

Women With a Lot of Petticoat

I asked a group of Chiapanecan Indian women what had made them become "activists"—*activistas*, because in Mexico City, speaking in public, one avoids calling people *Zapatistas*—but we all understood what was meant. They answered, *"Por los golpes"* (because of the blows). At first, I thought they meant the blows of losing their land, their crops, their malnourished children: the blows of fate and economics. But no, they were being entirely literal. It was the blows received, they said, when their husbands beat them.

We were sitting in a circle in one of those old wooden-floored apartments of Mexico City's *Centro Historico*, just a couple of blocks from where thousands of Chiapanecan Indians had occupied the central plaza, the old Zócalo, the plaza in front of the National Palace. These women

were part of that group and had walked all the way from Chiapas, a twenty-day march, protesting the Mexican government's treatment of the Indians. They were tired, amazed at the journey they had just made out of the remote highlands of their native villages all the way to the biggest city in the world, but they carried their astonishment with aplomb.

They were elegantly dressed in the traditional Indigenous clothing: midnight-blue *enaguas*, the long bolts of handwoven cotton skirting folded and wrapped around the hips, cinched at the waist with wide red wrapped *refajas*, red-on-white embroidered *huipiles* (the traditional blouses), and elaborately braided hair. The clothing is not just beautiful, it is layered with meaning. It identifies them with their ethnic group (these women were Tzotziles and Tzeltales) and the village they come from; the craft with which the clothing is made is a sign of their skills at needlework. In fact, they were all artists, sculptors in clay (in Mexico's subtly racist terminology they are called *artesanas*, or "craftswomen" to distinguish them from "real" artists, i.e., those working in the European tradition of the arts).

Artists and revolutionaries, using Spanish like the blunt instrument it is for them as a learned-late second language, they spoke at times in phrases peppered with mistakes; at times, their archaic style of speaking, mixing in vocabulary preserved from centuries past in those isolated highlands, dropping articles, is sheer poetry. They told me that when a woman is very *activista*, they call her *mujer de mucha enagua*: "woman with a lot of petticoat." (A revealing image, and key to understanding the women Zapatistas: unlike the European tradition of women who may assume political and military prowess, but whose doing so is assumed to involve a loss of femininity, these women consider a woman's activism to mean she has "a lot of petticoat": she is a real woman.)

Comandante Ramona on Horseback

I was particularly curious about the women Zapatistas, coming from their ancestral villages in the Chiapas highlands, from the most traditional Indian societies in which women stayed at home and did strictly defined women's work, caring for children, cooking, sewing, remaining even more isolated than Indian men because Indian women are usually limited to their Indigenous languages, rarely speaking the Spanish necessary for access to

the outside world. Suddenly, when the Zapatista National Liberation Army came on the scene with their 1994 New Year's Day march into San Cristóbal, we began to hear that there were Indian women among the *guerrilleros*. The first time the Zapatista leaders appeared before the international press there was a woman among them: Comandante Ramona, a rifle slung across her shoulder, wearing a ski mask with her traditional Chiapanecan Indian dress. I had interviewed women *guerrilleras* from El Salvador, but they had mostly come from the city, with university educations that had included Marxist economics and readings from Lenin and Ché Guevara. The Zapatista women seemed, even more than the Zapatista men, to have sprung from nowhere. How had this happened? How had they come to surmount that barrier of the unknown, to go from their familiar village lives to the violent unknown of guerrilla rebellion?

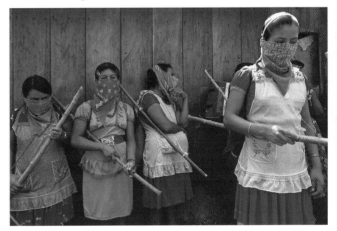

Women Zapatistas at a training camp, Chiapas, Mexico, 1994. Photo by Liliana Nieto del Rio/JB Pictures

If being beaten by one's husband were all it took for a woman to decide to join a revolution, imagine the world-scale insurrection men would have on their hands. However, for better or worse, wife-beating is immensely more common than revolutionary women: it seems that some combination of factors is required to push women across that line. And certainly not all Zapatista women could be victims of overbearing husbands, for many are single (though one of the women who told me about "the blows" said that she was single, it doesn't make much difference whether it is a woman's husband or her parents—the point is that she must break free of her traditional subservient role). Comandante Ramona, for example, is said to have decided many years ago, at the beginning of the Zapatista movement, that she would not get married or have children, choosing instead to fight.

I first began to get an inkling of what Comandante Ramona means to Chiapanecan women while I was walking through a sidewalk market on a little plaza in San Cristóbal. I passed blankets spread with hand-woven

embroidered wool cloths, macrame wristbands, worked-leather bags, carved-wood slingshots, pink and yellow wooden boxes with leather hinges, when I heard a voice calling, "Bracelets! Marcos!" A Chamula Indian girl in her teens had displayed on her blanket some of the most intricate and graceful wristbands I had seen, and Marcos dolls (these are the cloth dolls dressed in Indigenous Chiapanecan clothing that have been sold to tourists for decades, with the simple addition of a ski mask to make them look like the famous Zapatista spokesman and strategist, Subcomandante Marcos) in all sizes. I knelt to get a closer look, and she began to show me her wares: the bracelets in soft colors, the Marcos dolls, and the Ramona dolls. When she saw that I was interested in the Ramonas, her enthusiasm bubbled into a stream of exclamations, reminding me of nothing so much as the way we used to talk about our Barbies in their different outfits: "Here's Ramona on horseback! Here's Ramona with a rifle! Here's Ramona with long hair, see how I did her hair? Here's Ramona with a loop in back to hang her up with. Here's Ramona dressed in her San Andrés *huipil*!" I picked up the dolls and complimented her on her fine work. Eyes sparkling, she told me she had seen Ramona herself: "She was here." The girl was breathless with admiration. The presence of Comandante Ramona in San Cristóbal had made far more of an impression on her than that of the international fantasy-figure of Subcomandante Marcos. Seeing Ramona had changed her perception of herself, charging her doll-making with thrillingly sub-versive significance.

So, who is Comandante Ramona, and what is it about her that so inspired that Chamula girl? Few facts are available: Ramona is a Tzotzil Indian from the town of San Andrés (as any Chiapanecan can tell from a glance at her *huipil*). Before she joined the Zapatistas she worked as an embroiderer. She is a *comandante* in the Zapatista National Liberation Army and a member of its governing Clandestine Revolutionary Indigenous Committee; she is thus of higher rank than Subcomandante Marcos, and is accorded great respect by the Zapatistas. During the peace talks of early 1994, she always appeared before the press standing next to the mediator, Samuel Ruiz, Bishop of San Cristóbal. Later, Ramona was said to be ill, perhaps of cancer; there were rumors around the end of 1994 that she had died. The Zapatistas released a video of Ramona in February

1995, showing a blurry figure in a ski mask sitting behind a table saying, "I am sick, perhaps I will die soon," adding that most Chiapanecan Indians suffer from malnutrition and illness. She urges Mexican women to organize, because "you can't build a free and just Mexico with your arms crossed." On the tape, there is a sort of intimate catch in her voice, as if she were speaking with great restrained emotion; distorted though it may be by the poor quality of the video, in Tzotzil-accented Spanish, her voice is unusually compelling.

But to the Chiapanecans, Ramona is much more than a Zapatista *comandante*; she has become a legend, endowed with almost mystical powers. Indian peasants, complaining about an abuse of power by local officials, will say: "Just wait till Ramona comes, *then* they'll see." When I asked the Chiapanecan women visiting Mexico City what they thought of Ramona, some of their answers surprised me. There was the expected, "She is brave and has dared to defend our rights," but when I asked for specifics, one said, "The light shone from her voice, she shows us the way" and they all nodded, as if they had now given me the facts of the matter. They didn't actually know her, they said (though one of them admitted to me later that she had only denied knowing Ramona because she couldn't admit she knew her in front of the others), but that was beside the point: "Ramona is a *structure*, like Mary. She is a symbol of our struggle. When we hear those words of Ramona's, it gives us a little feeling, we even cry."

It was a European woman, a university professor from Mexico City, who described Comandante Ramona in terms that gave me, with my admittedly occidental understanding, a sense of Ramona as a person: "She is a small woman: she comes only to my shoulder" (the professor is no taller than me—and I'm only 5' 2"—so Ramona must be very small indeed), "and she is very sweet, such a gentle person. But she's *strong*. It's all I can do to keep up with her, walking through the jungle. And she is a *comandante*; if she needs to give an order she's capable of saying, 'Do it!' to a squadron of men. And the men do it." The European professor was just as enthusiastic about Ramona as the Chiapanecan Indian women, and kept ending her sentences with "in fact—oh, I can't tell you that," giving the most tantalizing impression of the *comandante's* fascinating but undivulgable story. Even the exact nature of Ramona's illness has been kept secret

by the Zapatistas, on the grounds, I believe, that if this were known to the Mexican army it might be more difficult to get her medicines to her without their being traced. This may explain why the professor looked so grim when I asked her opinion a couple of weeks later about a women's campaign to guarantee safe conduct for Ramona to come out of the jungle for medical treatment ("They're just creating more problems," she said). Or could the reason she was grim be that Ramona had already died? She said it wouldn't matter if Ramona did die: "Her importance is as a symbol."

So is it Comandante Ramona as a symbol that has inspired Indian women to join the Zapatistas? Perhaps, in part—though I don't think her image would be sufficient in itself to inspire women to cross that line, no matter how charismatic she may be, if there were not also concrete incentives for them to make that choice. Elena Poniatowska says that for Indian women *Zapatismo* represents "the best life option," and she describes the contrast between the lives of Indian women who are not Zapatistas (underpaid for work that is not respected, made to marry a man chosen by their parents), and the lives of the Zapatista women (protected against rapists, respected, their health a community concern, given access to birth control, able to choose their husbands).

I believe there are, in addition to these very important improvements in living conditions for Zapatista women, other factors that are equally or more important to Indian women's decision to become Zapatistas. These considerations have to do with what Mexicans call *voz y voto*, "voice and vote": having a say. Or, to put it another way: power. Perhaps the most important innovation I have heard of in Zapatista Indian communities (and one that began to be instituted years before the 1994 uprising) is women's having full rights to attend and speak in the village assemblies. Previously, women's participation had been very limited: they might enter the assembly hall only after the men had finished their discussion, making it difficult for the women to speak on issues that concerned them. But now women were not only on the agenda, they were setting the agenda. This was when things really began to change for them. I suspect that the fact that Zapatista women feel they themselves are the ones who instigated those subsequent changes makes the women that much more dedicated as Zapatistas; empowerment is more motivating than gratitude.

Marcos wrote in one of his letters (published regularly in Mexican newspapers, translated on the Internet and collected in volumes. Marcos's letters are considered by some to be one of the Zapatistas' principal weapons) that the first Zapatista revolution was not on January 1, 1994, but in March of 1993, when the Zapatista women "imposed" their "Revolutionary Law on Women." The law's ten articles include women's rights to participate in the revolution and earn military rank, to work and receive a fair salary, to decide how many children they want to have, to participate in community affairs and be elected to positions of responsibility, to have priority rights to health care and nutrition, to receive an education, to choose their husband, and to be safe from rape and domestic abuse.

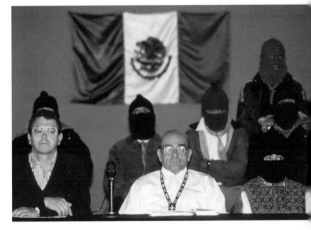

Comandante Ramona with Manuel Camacho and Bishop Samuel Ruiz during the Peace Treaty talks, San Cristóbal de las Casas, Chiapas, Mexico, 1994. Photo by Wesley Bocxe/JB Pictures

By allowing women to set their own agenda, the Zapatistas created a major incentive for women to participate. Women who were beaten by their husbands and girls who were kept from going to school and fed only after their brothers had eaten perceived the Zapatista revolution as specifically addressing their most severe problems. This aspect of *Zapatismo* seems made-to-order to appeal to Indian women. At the same time, there is shared concern that the cultural changes in women's roles not be so radical as to lose those things they value of their Indigenous traditions. There was a recent statewide meeting in which Chiapanecan Indian women discussed which things they want to preserve in their traditions, as well as the things they want to change. A document from the meeting lists women's wearing of Indigenous clothing and raising sheep for their wool as traditions they want to keep. My conversations with Zapatista women lead me to include another incentive for their becoming Zapatista: excitement. Rural poverty is not only miserable, it's boring. Joining the Zapatistas means that women get to travel to other communities, meet new people, and learn Spanish, as well as receive training in weaponry and guerrilla tactics. And Comandante Ramona is a very exciting role model for a young Indigenous girl.

Fuzzy Borders Favor the Disenfranchised

The other side of the question of why Indian women become Zapatistas is the question of why the Zapatista organizers have made such concerted efforts to recruit women. Was it a miraculous freedom from machismo that made them want to have an equal opportunity uprising? Forgive me, Marcos, but I don't think so. It is more likely that they perceived the strategic advantages of including women in their ranks, and once they started there was no turning back.

In fact, women are proving to be particularly adept at this new kind of un-war, in which public relations are everything and having an international audience that is sensitive to human rights means that if either side resorts to military attacks or violence of any kind, it loses points. Violence against women draws a double penalty, while a group of unarmed women defying an all-male army convoy (as was reported to have happened in March 1995 in the Zapatista town of La Realidad) constitutes a no-casualties victory for the Zapatistas, while making the soldiers look pretty foolish: extra points. And does it really matter whether they are apolitical citizens, Zapatista supporters, or trained members of the Zapatista Army for National Liberation? In fact, though they might be Zapatistas, their not appearing to be so makes their victory that much more striking in press reports—and in this war, press coverage is the principal battlefield.

The Zapatistas have demonstrated their skills at making broad use of something that can be a real advantage in guerrilla warfare: amorphous identities and "fuzzy" borders. Marcos's mask allows people to project their fantasies: his amorphous image is a large part of his popularity. The Zapatistas' wide, inclusive platforms do not draw sharp lines; they seem to offer something for everybody (except for Chiapanecan landowners and the nation's rich and powerful). In marked contrast to the modernizing revolutions of Cuba, Nicaragua, and El Salvador, which pitted such concepts as "scientific socialism" against religion and tradition, thus inviting opposition from adherents of many traditional belief systems, *Zapatismo* incorporates a multitude of ideologies and political movements, and draws support from them in the name of radical democracy: Indigenous (and other minority) rights groups from all over the world, Chicanos, ecologists, feminists, liberation theologians, leftists of all stripes, students, human rights activists,

anarchists, performance artists, musicians, and actors. The Zapatistas are like a country that offers tax-free investment opportunities to citizens of all nations. Their use of Internet communications has allowed them to tap into support from people who have never set foot in Mexico. Alma Guillermoprieto writes about Marcos's answer to her challenge of his claim that the Zapatistas would take Mexico City: "Weren't we there already by January 2nd?" asked Marcos. "We were everywhere, on the lips of everyone—in the subway, on the radio. And our flag was in the Zócalo."

Sharply defined borders favor the status quo and thus find proponents among the rich: it is the hacienda owners who set bottle shards into the orchard walls, not the hungry peasants outside. It is the United States that patrols its border with Mexico, not the Mexican government (which, as I write, is considering border-weakening legislation that would allow Mexicans to have dual citizenship). Conversely, fuzzy borders favor the disenfranchised. If the Zapatistas had tried to hold their lines and fight, they would have been defeated long ago. Their advantage lies in fluidity and lack of definition.

The Zapatista women I spoke with also demonstrated a lack of borders within their individual lives, which seems to be a trait common to many Indigenous cultures; for them, the personal is political, though it would never occur to them to say so. Their conversation reveals a perspective that does not divide and never has divided their lives into distinct spheres. Their personal lives, their political activism, their identities as artists, are integrated because they've never been separated: we are artists who joined the revolution because of the blows.

Women activists have the advantage of the particularly amorphous identities assigned them by a machista culture with a very limited conception of women's abilities; not being taken seriously by the authorities, women can be more radical and state their opinions more openly with less risk of being penalized. Women in Mexico City have staged public "acts" that are reminiscent of the public demonstrations of the Argentine "Mothers of the Plaza de Mayo" (who, by the way, support the Zapatista women), incorporating street theater to make a strong public criticism of the government: after the government's rather inept search-and-seizure of a supposed Zapatista "arsenal" consisting of little more than a few small

handguns (the "arsenal" was presented to the press with great fanfare, as justification for the February 9th army incursions into Zapatista territory), a group of women went to the Ministry of the Interior and deposited a collection of water pistols, plastic machine-guns, and toy bows and arrows, saying they were afraid they might be accused of having arsenals in their homes. In marches and demonstrations, the first banners I saw expressing open support for the Zapatistas were being carried by women's groups, as if women in this society can afford to be more publicly radical than men, incurring a lesser risk of reprisal.

Comandante Ramona is another example of the advantages of an amorphous identity. Little as is known about her, hidden as she is from public awareness, she is an ambiguous symbol that seems to appeal to an even broader spectrum of people than Marcos. In a February 1995 march in Mexico City, when the men in the march chanted *"Todos somos Marcos"* ("We are all Marcos"), the women started to chant *"Todos somos Ramona"* ("We are all Ramona"—a chant that was taken up by the march in general, men and women, and the two chants became de rigueur in subsequent marches). A lesbian contingent of the march chanted *"Todos somos Ramona"* as well as *"Lesbianas feministas también somos Zapatistas"* ("Lesbian feminists are also Zapatistas"). A male filmmaker who has spent some time with the Zapatistas is critical of Marcos, but intrigued by Ramona. At a church-sponsored International Women's Day event where the video of Ramona was shown, a young nun sitting next to me wept. I confess that, for reasons I don't fully understand, my eyes filled, too.

But what does Ramona symbolize? She wears a mask: we are sure she must be beautiful. She speaks little Spanish: we can only imagine the eloquence behind that voice. She is a tiny woman, mortally ill, yet she is a *comandante* in a guerrilla uprising that has shaken the whole Mexican political system. She carries a rifle, but I've never heard of her using it. A woman and an Indian in a Third World country, she is one of the most oppressed of the oppressed—yet she has somehow turned that to advantage, refusing to be a victim. She symbolizes the power of authenticity: borders don't cross Ramona, Ramona crosses them. *Con sus enaguas muy bien puestas*, petticoats and all.

THE TENSE EMBRACE OF THE "OTHER": MEXICO & THE U.S.

Rubén Martínez

I was born and raised in Los Angeles, but I've had a series of second homes in my life. For a time, it was the beaches of Venice, California, where I prowled for sex, drugs and rock 'n' roll. Later, I searched for the Revolution in my mother's home country, El Salvador. There were a few pilgrimages looking for God in the endless skies and atop the mesas and buttes of the Southwestern United States, and. . . .

I still haven't settled down. Today, my second home is Mexico City, where my father and his father lived off and on in the 1940s and '50s. I shuttle back and forth between Los Angeles and this, the smoggiest, most populous, and, for me, the most beautiful city on earth. I move back and forth because I don't feel completely at home anywhere—I miss a bit of Los Angeles when I'm in Mexico City, and vice versa.

The distance between L.A. and "el D.F.," as the capital of Mexico is known, is growing shorter by the day. Perhaps in some as yet only dimly imaginable future, it won't matter if I'm in the North or the South. Perhaps one day "south" and "north" and "east" and "west" will be archaic references to a primitive, bordered world where nationalism and economic tension pitched the planet into chaos.

The world over, distances are growing shorter between our cardinal points because of the global forces of high technology, free trade, and immigration. Information moves. Commerce moves. People move. The world appears to be spinning faster everyday; analyzing the dizzying pace of the movement is an ever more daunting task. Indian rebellion in Chiapas, President Mandela in South Africa, race riots in Los Angeles, a holocaust in Bosnia, Communist Hong Kong. . . . It is an appropriate way to end the second millenium. Ends of centuries always bring out the apocalyptic—and the idealistic—in human beings. For our end-of-century, the apocalyptic can be seen in the religious and ethnic conflicts, in the growing intolerance of "otherness." The idealistic is the impulse towards

"one world" that embraces its diverse "others." The collision of these visions has brought us to the brink of a global civil war.

"Distant Relations" features artists from two regions that epitomize the global crisis, and that also point towards the kind of cultural and political negotiations necessary to achieve a peaceful resolution of our conflicts. Like most Americans, I know few particulars of the Irish conflict. I know that until recently we only heard a British perspective of what was happening, and because I'm Catholic, I naturally sympathize with my spiritual brethren. Perhaps romantically, I see in the IRA a European corollary of the revolutionary movements on my continent: the FMLN (Frente Farabundo Martí de Liberación) in El Salvador, the Indian rebels of Chiapas. While I abhor violence, I intimately know histories of peoples who arrived at armed struggle because all other avenues of negotiation had failed. Such was the case in El Salvador. Such is the case today in Chiapas. I suspect that such has been the case in Ireland. The tragedy of conflict on the military level is that all sides ultimately lose their humanity. Each side assumes that the "other" must be destroyed, when the truth is that the moment a settlement is reached, we'll probably have to learn to live with the "other" all over again. . . .

But back to Mexico City. I told you that I am here because I didn't feel completely at home in my first city, Los Angeles. I'm also here because I want to join the people who cross frontiers in the Americas—the immigrants from the south, the new pilgrims. Since I grew up between Latin America and the U.S., between English and Spanish, between the Catholicism of the South and the Protestantism of the North, I feel it's my birthright to be part of that frenetic movement. Everything and everyone is crossing the line that stretches for 2,000 miles between Mexico and the United States. AT&T and the Indian teenager from Oaxaca, Mexican-produced automobile parts and MTV *en español*.

The issues of free trade and immigration have sparked one of the biggest political and cultural debates in the history of the United States. There are only two sides to this conflict. There are those—mostly older, white Americans—who would seal off the border with Mexico and the rest of Latin America, because they fear being overwhelmed by the immigrants. And there are those—the immigrants themselves and a few

visionary Americans—who see in the future a borderless world, a continental identity.

It is an old dream. There've been hints of it in great thinkers of both the U.S. and Latin America. Simón Bolívar, the "liberator" of the independence movements of the 19th century, dreamed of a unified Latin republic stretching from the Southwestern United States to Tierra del Fuego. And one of the Americas' greatest bards, Walt Whitman, poeticized a cosmic, international vision of the continent.

At this point, it is the nativists of the U.S. who are winning the debate, as they have on so many

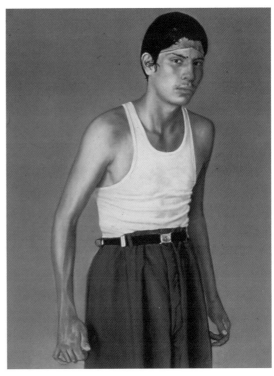

John Valadez, *Clavo*, 1983; courtesy of Daniel Saxon Gallery, Los Angeles

occasions in the last 150 years. Catholic immigrants were suspect from the mid-19th century onward. Asians were barred from entering the country at the turn of the century. And Mexicans have been deported *en masse* on two occasions in the last seventy-five years, during the Great Depression of the 1930s, and in the postwar economic decline of the 1950s. We are on the verge of yet another such tragic chapter today.

In California last November, voters passed Proposition 187, a measure that will bar "illegal aliens" from receiving most forms of public assistance (including education and health care), should it ever be approved by the courts currently reviewing the law's glaring constitutional contradictions. Many otherwise reasonable people, mostly white, but also black and Asian and even a smattering of Latino U.S. citizens, voted in favor of Proposition 187. Most of them would deny that they are racists. And yet they voted for a measure that clearly targets one ethnic group, and that sets in motion forces that have already begun to affect not only those "illegals" that the law singles out, but anyone with brown skin or with a slightly accented English. Since the election, there have been hundreds of

reports across the state of zealots attempting to enforce the law in vigilante fashion. At a restaurant in Santa Paula, a customer asked the Mexican-looking cook for his "green card" (the identification that legal residents carry). At a Palm Springs pharmacy, the mother of a sick child was asked to show her daughter's proof of citizenship. In these and countless other cases, the people targeted were U.S. citizens.

The California middle class has come to view immigration, free trade, and the failure of the old aerospace and automobile industries (the state's economic backbone up until the mid-1980s) as, at the least, interrelated, and, at worst, cause and effect. Californians voted through the distorted prism of their fears last November, fears born out of economic uncertainty that were expertly exploited by the tiny minority of full-fledged racists that promoted Prop. 187. Wherever we look these days—in the former Soviet Union, in Europe, in the Americas—voters seem to be sending desperate messages. The pendulum swings back and forth rapidly, a sure sign that fear is moving people, rather than visionary thinking or even just plain common sense.

Mexicans also voted their fears. In last year's presidential election, they voted the status quo; in Mexico, the status quo, the ruling PRI party (Institutional Revolutionary Party), is synonymous with the forces of reaction. I spent the summer months of 1994 in Mexico, writing about the dramatic changes occurring in my second home. Long viewed by the rest of the world as a colorful culture trapped in a folkloric past of mariachis, macho heroes, and lascivious *señoritas*, I found a Mexico on the move. Seventy years of authoritarian rule are giving way to a more open, democratic society. Mexican teenagers are experimenting with cultural influences from their northern neighbor and creating hybrids—*rocanrol*—that, far from being a sign of cultural death, show the country to be on the cutting edge of urban popular culture. Meanwhile, the rebellion in Chiapas finally brought to the forefront the condition of the Indian and the responsibility of the mixed-race, or *mestizo*, castes.

It was a year of living dangerously in Mexico. Political assassinations shook the country's sense of security, and Chiapas raised the specter of all-out civil war. Above all, 1994 revealed the true Mexico: a country rent by class and ethnic tension. Last year's events told us that Mexico is

not one, but many; that the benefit of economic liberalization (under former president Carlos Salinas de Gortari, nearly all of the government's state-owned companies were sold off to private interests) has so far been for the elites, and not for the tiny middle class or the vast, impoverished masses, such as the Indians of the south. Mexico will either learn to live with its new, heterogeneous self, by bringing social and economic justice to all its regions and ethnic communities, or it will crumble into chaos.

I opt for the optimistic view of Mexico. After nearly a century of government-controlled, ultranationalist rhetoric that stifled critical thinking, independent artists and intellectuals, Indian guerrillas, and growing legions of urban activists are now powerful protagonists in the country's intense debate over its future. Seen in the best light, Mexico is embracing the otherness that it had rejected for so long, both the other of the North (the United States, with its culture of individualism and tradition of democratic debate) and the other of the South (the Indian's mystical and communitarian millenary culture).

Yes, Mexicans voted for the PRI last August. But they didn't vote for the party's infamous corruption and anti-democratic traditions. Mexicans appeared to be saying one thing in the voting booth but quite another in their everyday lives. They voted for the PRI, but they are participating in protest marches more than ever before. They voted for the PRI, but most Mexicans are sympathetic to the rebellion in Chiapas—long as it doesn't cause an all-out civil war. The message is: we are changing, we want to continue changing, but we don't want change so radical that we spin out of control.

California's vote for Prop. 187 is more problematic, because it calls for change, but in a clearly reactionary direction. It seeks to turn back the clock of the continent's movement toward cultural and economic integration: keep those dirty Mexicans out of the States. The only hope that I can glean from the electoral results is that the majority who voted for this vicious legislation are rapidly becoming the minority in California. Even if 187 is fully implemented one day and massive deportations begin, everything the law seeks to detain has already, in effect, occurred. The vast majority of Latino immigrants in California are legal residents, and they will become citizens shortly. Mexican political theorist Jorge Castañeda has

said that an "electoral apartheid" exists today in California, where a minority of white voters dictate the conditions that the Latino working-class majority lives under. The revolution that will overturn this system will be a demographic one.

The minority-becoming-the-majority could be seen on the streets of Los Angeles during the days leading up to the November elections. In the biggest political demonstration in the city's history, some 150,000 activists turned out to protest Prop. 187. Spontaneous walk-outs at dozens of middle and high schools in the Los Angeles area peaked a few weeks before the election when 20,000 students left classes and took to the streets waving Mexican, Salvadoran, Guatemalan, and Nicaraguan flags as a sign of pride in a culture the students felt was being denigrated by the pro-187 campaign.

The flag-waving was quickly denounced by the nativist forces, who outrageously alleged that the immigrant students were proclaiming allegiance to foreign powers. While the flags may indeed have been a polit-ical wash for the students, they were also a sign that Latinos were coming together as never before in California. For in the October Movement, as the anti-187 campaign came to be called, the recently arrived Mexican joined the third-generation Chicano, and the Central American immigrant was recognized by those of Mexican origin as an obvious ally rather than as competition in the job market.

The real test of the October Movement, however, was in taking this newfound Latino unity and creating a viable coalition with other ethnic groups. If the ultimate lesson of the rebellion in Chiapas is that Indian and *mestizo* must work together to achieve social justice (as black and white did during the U.S. Civil Rights movement), the battle over 187 in California once again showed that multiethnic coalitions based on mutual self-interest are the only way progressive forces can achieve their goals. On this count, the October Movement failed. Nearly 80 percent of Latinos voted against Prop. 187, about two-thirds of whites voted for it, while Asians and African Americans each voted about fifty-fifty. Had the Latino student vanguard been able to sway significant numbers beyond its ethnic borders, the outcome of the election would have been far different.

Yet, like the rebels in Chiapas, the student movement in California

—the most significant political mobilization in the United States since the anti-nuclear demonstrations of the early 1980s—remains a powerful political and moral sign. If the greatness of the U.S. Civil Rights movement of the 1960s was the way in which African Americans convinced a plurality of white Americans that equality in a democracy must indeed be for all, the October Movement has the possibility of doing the same in the 90s. The Chicano activist must not only defend the Mexican immigrant, he or she must also decry the erosion of civil rights for African Americans and the sinister, latent anti-Asian sentiment in California. The Chicano in California can serve as the same moral example as the Indian in Mexico.

In the weeks following the electoral debacle of November, I sat in on a number of student movement meetings. Besides the understandable frustration and depression over the results, a battle for the soul of the movement was taking place. Fervent Chicano nationalists espousing separatist ideals clashed with their "internationalist" counterparts who pleaded for a broad-based coalition. The latter emerged as the leading ideology. One powerful contingent of the original October Movement rechristened itself the "Four Winds Student Movement," a name that refers as much to Native American mythology as to the concept of multiethnic organizing.

I write this from Mexico City, a few days before I return to Los Angeles. After a month back in my first home, I will return again to Mexico. This is my future: to endlessly cross the false frontiers that separate us politically and that keep us from seeing the continent as it truly is. Personally, I can no longer see the struggles in Mexico and California as politically or even contextually different. Rather, I see the continent as one in its many-ness. The rebellion in Chiapas is the Student Movement in California.

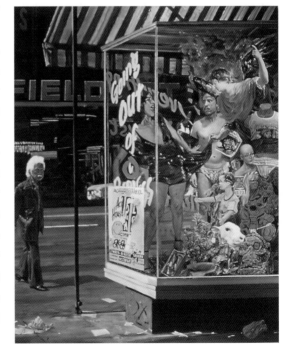

John Valadez, *Going Out of Business*, 1991; courtesy of Daniel Saxon Gallery, Los Angeles

Through its year of living dangerously, Mexico has begun, however tentatively, however painfully, to embrace its northern and southern othernesses. Chicanos, African Americans, white Americans, and Asian Americans in the U.S. must do the same. There are only two futures possible for the Americas as we approach the millenium. There is a Mexico coming to understand its Indian-ness and regional complexity, a U.S. learning to embrace, once again, its immigrant self. Or a Mexico that turns its back on both Chiapas and democracy, and a U.S. that denies its multiracial soul. We can embrace or avoid this truth: that the Mexican conflict is the "multicultural" struggle in the U.S., that the Indian in Mexico is the native person or the immigrant in the U.S., that the racist in the U.S. is the one who delivered the Indian into near-slavery in Mexico.

We catch glimpses of our possible futures. One day, the Latin American presidents and Bill Clinton announce the formation of the biggest free trade zone in the world; the next, we hear that the proponents of Prop. 187 in California are now poised to make theirs a national campaign against the immigrant. In one moment, we hear Mexican president Ernesto Zedillo proclaiming that there will be no more armed conflict in Chiapas; the next, we are told that some 60,000 federal troops have surrounded the Indian communities in the jungles.

These are the contradictions and lies that artists and intellectuals the world over must grapple with as we near the millenium. We must overcome the distortion of the politics of separateness, which is the politics of the old order. We must be the visionaries, the ones who dare to compare the Irish situation to the Mexican and Chicano contexts, the ones who dare to recognize ourselves in the "other."

MEXAMERICA: OUTLAWS' BORDERS LITERATURE AND THE BORDER

Juan Villoro

Mexico's northern border is one of the most closely watched strips of land on the planet. By night, helicopter spotlights sweep the desert's barbed-wire fences; underground, the police shine flashlights over the sewage (the drainage pipes have been fitted with gratings but there are still a large number of Mexicans who manage to reach the United States along the rats' highway). A climate of segregation hangs over California. East L.A. is the second largest Mexican city, and guacamole is the second favorite snack for Superbowl Sunday, but undocumented workers are named for the terror-inspiring beast from outer space: they are aliens.

Governor Pete Wilson's Proposition 187, which takes away the rights of California residents who don't have their papers in order, reveals the function of border controls in the age of free trade and apartheid: contraband merchandise is no longer of interest, what is important is to hold back *la raza*.

For decades, the border was a land of freedom for the American imagination. In Raymond Chandler's novels and in road movies, fugitives with enough charisma to be able to save themselves went to Mexico, that refuge of orange sunsets and melancholy guitars.

Writers planning escapes tend to believe in a zone of salvation. For Adolfo Bioy Casares, the country where the boats go, the place where the escape tunnels lead, is Uruguay; across the river is the beach, that precarious paradise where heroes recover from their adventures. This is, without a doubt, the highest honor a neighboring country can receive. In the Mexican moviehouses of my childhood, I felt proud to belong to the country that offered the fugitives asylum. When the FBI or the county sheriff chased a protagonist who lived by his own code of honor—more human yet more severe than the laws he broke—the scriptwriters turned to their favorite solution: the border.

In *The Electric Kool-Aid Acid Test* Tom Wolfe adapts this saga of

escape to psychedelics: Timothy Leary runs away to found a kind of Club Med of the mind on the beaches of Zihuatanejo. From the far west to trips on LSD, Mexico was seen as a permissive duty-free zone. Vietnam War deserters arrived with the canonical peace sign around their necks and a button on their shirts saying "God is alive and well and living in Mexico."

Still, when the Chevy or the horse disappeared in a cloud of dust, a notice in Spanish appeared on the screen saying, "A few days later the criminals were captured by the Mexican police." The Ministry of the Interior never faltered in its task of vigilance: outlaws' dreams could not triumph, not even in the dark confines of the popcorn-eaters. Hollywood's last refuge looked to the citizens of the eagle and serpent like the dreams of Governor Pete Wilson: a desert with no exit.

If fugitives from the American Dream sought in Mexico a country that was genuine—a rustic utopia, a picturesque territory where, according to Kerouac, even the police are polite—fugitives from the Mexican Dream, in contrast, saw a gateway to liberation in the literature and the American counterculture. These reciprocal fantasies reveal the best temptations of the border: the desire to cross, to explore the other, to trespass.

From Quetzalcóatl to Pepsicóatl

It is not surprising that the Mexican end-of-the-century narrative favors the northern end of our territory for discussing both the influence of culture, which seems always to arrive late, and the construction of a new identity. Does the local spirit remain sound when it works twelve hours in a *maquiladora* and spends weekends at a shopping mall? To what degree does the frequenting of what is foreign erase historic wrongs and oblige one to exclaim in Spanglish, like a character from Luis Humberto Crosthwaite: "Do you recuerda Juan Escutia?"

In the episode "From Quetzalcóatl to Pepsicóatl" in *Tiempo Méxicano* (Mexican Time), Carlos Fuentes makes use of the legend of the Plumed Serpent to plumb Mexico's national identity. Quetzalcóatl, the wisest and most beneficent of the pre-Hispanic gods (known as Kukulkán in the Mayan territories) waged an intense struggle against his fellow gods in the Aztec sky. Tezcatlipoca, Lord of Destiny, found a mechanism to overcome the illustrious Quetzalcóatl: he forced him to look at himself in a mirror. Quetzalcóatl didn't recognize his image as a plumed serpent; horrified at himself, he decided to abandon his people. For Fuentes, this image is the basis of the challenge of our identity. As long as we don't accept our face in the mirror, we will have to continue our flight.

Quetzalcóatl promised that he would return from the east, and the bearded bald men wearing armor and slippers who disembarked in Veracruz in 1521 looked exotic enough to have been sent by the fugitive god. One of the great paradoxes of the Spanish Conquest is that it began with a battle of the indigenous Mexicans against a rejected part of their own culture. Octavio Paz has said that the isolation of the pre-Hispanic cultures was so extreme that they did not have the idea of the "other," of the foreigner with absolute social and religious otherness. It was simpler for them to assimilate the idea of an adverse part of their own culture: Quetzalcóatl in search of his second act.

From Martín Luis Guzmán's *La Querella de México* (Mexico's Dispute) to Octavio Paz's *Labyrinth of Solitude*, the Mexican essay attempted to construct a national identity and studied the signs that were still fresh in the sagas of our origins (Independence from Spain, the Mexican Revolution). Like Turkish coffee, reading the dregs served an oracular purpose: what remained became prophecy. The past as an explanation of the future. The searches for atavistic symbols, for an *Ur-Zeit*, have a common denominator: beneath the successive masks of the Aztecs, the Spanish, and Modernity lies the true face. The premise of this exploration is that there is a univocal distinguishable identity that separates us from others, the equivalent of the "Russian soul" that transmigrates from Dostoyevsky's characters to Solzhenitsyn's. In *Posdata* (Postscript), Paz was one of the first to give nuance to the explorations of the national identity. There is no "one" national ontology, just as there is no Mexican

ideal that can in itself be characteristic.

In contemporary Mexican literature there predominates a pulverized, dispersed, multiple, hybrid conception of identity. It is useless to look for the original and immutable countenance. Quite the contrary: the varied masks—from Tenochtitlán to Chiapas, from the Eagle Warriors' feathered masks to Subcomandante Marcos's ski mask—are identity.

At this century's end, Quetzalcóatl has ceased to be an archetype and now acts like the replicants in *Blade Runner*. He can be any one of us. His many faces no longer fit in the smoking mirror of Tezcatlipoca. They are reflected in the computer screens and holograms of virtual reality. Their aspect depends on the circumstances that inform it.

The god-replicant confronts a territory in which fifty-seven Indigenous languages are spoken, in which the Catholic Church is increasingly active (in its double expression through the repressive clergy and the rebel clergy), and where Mexican yuppies thought the Free Trade Agreement was a Frequent Flier plan to the First World. This multiplicity produces numerous identities, all of them Mexican and all of them provisional.

As demonstrated by any Mexican married couple in their dispute over custody of the television remote control, the foreign culture most present in Mexican homes comes from the United States. Luis Humberto Crosthwaite was able to see the true "meeting of two worlds" that took place in 1992. While dusty academics recorded five centuries of Conquest, Crosthwaite wrote a novel, *La luna siempre ser un amor difícil* (The Moon Will Always Be a Difficult Lover), in which a sixteenth-century Spaniard comes to Mexico during the North American Free Trade Agreement and ends up working in a Tijuana *maquiladora*. The metaphor is brilliant; the radical encounter of two worlds took place not only in distant history, but also yesterday, and the encounter takes place on a primordial stage: the border.

In 1995, Quetzalcóatl would find a country where North American ideas and passions dominate the electronic skies, the advertisements, and computer screens. Welcome to the Kingdom of Pepsicóatl!

What passports does literature issue to the split and disperse identities of the new Mexican nation, and what visas will it accept for those coming from across the border? In an unusual story, *Marcela y el rey* (Marcela and the King), Crosthwaite recycles an American myth and sends

it back as contraband to the United States. The legend that Elvis Presley is alive has brought about all manner of excesses, from "King of Rock & Roll" doubles contests to radio station callers who believe they've seen Elvis in a 7-Eleven at three in the morning. In Crosthwaite's story, the King's ghost appears in Tijuana. Elvis is going through a melancholy period because, among other things, nobody recognizes him (though they tell him he does look something like the singer of "Love Me Tender"). When he meets Marcela, who sings rock 'n' roll with intense authenticity, he cheers up and decides to go back to the United States. But ghosts don't carry passports, and he has to cross the border illegally, like a wetback. In the story's spectacular ending, the King is pursued by Immigration and Naturalization Service (INS) helicopters, and under the spotlights, thinks he's in a Las Vegas concert. The tragic isolation of celebrities acquires an even more dramatic twist: a myth becomes an illegal alien.

As a zone for redefining signs of identity, the border is also the setting for a book of short stories entitled *Embotellado de origin* (Bottled at Point of Origin) by Rosina Condé. The title is an ironic interpretation of life beside the Rio Grande. In a region characterized by mixtures and the most baroque syncretism, Rosina Condé finds a rare proof of authenticity: "They called Tijuana the City of Perfumes, and many people came to Tijuana not just to party but to buy perfume. Because there were perfumes from all over the world, and they were cheaper, and, in addition, they were bottled at point of origin. Because they get them in San Diego but they're bottled in New York." The paradox of a place of transit, where all things come from far away, is that what you get there is genuine. Borders delimit the country they belong to, norms are exhausted before coming to this margin where there is always some *other way* to do things.

Ports have a common logic; they are constructed outward, facing what arrives and what disappears. Something similar happens with land-locked borders; stations of nomadism, they live by what passes along their streets. It would be grotesque to ask, "What is produced in Tijuana?" The perfumes there are better because they have found a route by which to arrive intact from their point of origin. The scenario — a tangle of neon, dust, eternally transient locals — may seem unauthentic, but what is traded is genuine, not subject to the conventions of "stationary" cities.

Border landscape is so mutable that it rarely determines the identity of its inhabitants. If Mexico City oppresses with its weight of centuries, imposing codes as intricate as the directionality of its one-way streets, Tijuana has the lightness of an encampment, a space where everything points to the transitory, and customs are improvised from one hour to the next. Nevertheless, the margin of freedom granted by a border can reach disturbing extremes: a loss of horizon. Federico Campbell explores this disorientation in a story entitled "Los Brothers" (included in *Tijuanenses*). Ever since his novel *Everything about Seals*, Campbell has been interested in amphibious animals who communicate two realities. In appearance, the plot of "Los Brothers" has nothing to do with the border; two people from Tijuana meet in Mexico City and visit the ruins at Tula. The story alludes to diverse methods of orientation (the "clock" method of Japanese pilots, a boat on its inevitable collision course, patrols on their change of route), and derives its internal tension from its many levels of movement. It begins with a tourist excursion, but the "interior" country suggests another journey; after buying a souvenir (a miniature caryatid), the narrator gets lost in a poverty-stricken town where he runs over a man who seems to come out of a cave. He then continues his behavior, which has not varied since the beginning of the story: he flees, he wants to conquer space through movement. In vain, the history he didn't reach in the bastion of the Toltecs, he reaches in the present. What does the plot have to do with the origin of the characters? Campbell's achievement is that the border ceases to be a geographic category; in every situation his narrator is in a border situation, he wanders through a Tijuana of the mind, without compass, condemned to never know which way is north.

Like Campbell, Daniel Sada knows that borders are portable. The amazement provoked by his scenarios is due, in good part, to the fact that the cultural hybrid occurs in the middle of nowhere. Far from any paeans to nature, Sada transforms the desert into an improbable scenario of modernity. Its vast reaches presume cities, trails coming from far away; radio signals are picked up in a hollow, lost voices of Mexican or American radio announcers. Heir to both the Spanish romance and the Mexican *corrido*, Sada writes in meter and doesn't skimp on octosyllabic lines in Spanglish: "*Batazos* everywhere you look . . . lines of heats and home runs

. . . tricky *flaibols* against the sun." The cross of cultures appears in places where usually nobody is to be found; the story of *"Cualquier altinajo"* ("Any Good Times or Bad") from the book *Registro de causantes* (Taxpayers Registry), presents an original variety of baseball: the desert becomes a baseball diamond and the game is a curiously agrarian performance. The mythology of the American baseball player is manifested in players who "instead of spikes wore cowboy boots, for better slide." At the end of the story, the ball gets lost among the cacti, and the catcher decides just to keep going toward another field, the land of *huzaches* where his *compadre* is waiting with a bottle of *sotol*. Halfway between rural tale and pop culture, Daniel Sada transforms the desert into a symbolic reality, a territory of extreme narrative freedom.

But the border also moves through time. One of the most radical maps of the territory to come is *Christopher Unborn* by Carlos Fuentes. Once again the author of *Tiempo Méxicano* returns to the theme of identity, only in this case it is virtual identity. In 1992, the year of the Fifth Centenary is conceived as a distant future in which for the first time the opposition rules (the conservative National Action Party), and where the boundaries of the nation have been redefined. The unpayable foreign debt obliges the country to give away the Gulf to the Seven Sisters Oil Company and to give the Yucatán Peninsula to Club Med. And as if this weren't enough, the north of Mexico and the south of the United States have become an independent third country: Mexamérica. In the novel, Anglatl, Espanglish, and Angloñol are spoken; comedy signs a pact with the Apocalypse, the carnival with the tragedy. In this outlandish "future past" a contest is held; the first child to be born on October 12th, 1992, five hundred years after the discovery of America, will receive the keys to the city. The new Christopher rests in his mother's womb on his way to his historic birth, but he finds out about the world around him: the placenta is as well-informed a bubble as a CNN studio. In *Christopher Unborn* the fusion and confusion of cultures has a simultaneous hue of the birth and the end of the world. According to Adolfo Castañón, this is "a prophecy about the destruction of Mexican spirituality and its intrahistoric values. A desperate prophecy runs through this novel—nourished by a pulse of death, war, violence, subversion, threat, and catastrophe—where one of Carlos

Fuentes's old obsessions is reiterated: 'Mexico's Americanization as the Vietnamization of Mexico'."

The narrative has offered multiple responses to the challenges of Mexico's northern border (our southern border seems to dissolve into similarity); aside from all documentary or anthropological claims, the narrative allows for the invention of lines that reach the farthest corners—and once the demarcations are drawn, the narrative finds ways to violate them. In the narrative, a fence also exists in order for a ball to fly over it.

As long as there is a fortress mentality in those territories that fear the barbarians, there can be few stimuli as evocative as the mixing of genres and cultures. The border has endowed literature with the same ambiguous identity that road movies conferred on Mexico: a place to escape to, the desert where the outlaws got their chance.

Translated from Spanish by Ellen Calmus

CULTURE, CONFLICT AND MURALS: THE IRISH CASE

Bill Rolston

Ireland, Colonisation and Politics

Although much less well-known, the mural tradition in the north of Ireland is as old as that in Mexico. However, the range of themes and styles in the Irish context is much more restricted than in Mexico. For a long time the murals that were painted reflected only one political point of view —unionism. To understand the mural movement in the north of Ireland, it is necessary to look historically at both the political and social context.

The colonial expansion of the British state took place over a number of centuries, and from an early stage affected Ireland. By the 17th century the part of Ireland least under British control was the north. As a result, a policy of 'plantation' was employed as the key strategy of pacification of the north. Colonists from England and Scotland were given the best land and built fortified towns. To compound matters, at the end of the 17th century a series of battles took place in Ireland between two contenders for the English crown, King James IV, the reigning monarch, and his opponent (and son-in-law) Prince William of Orange (in Holland), later King William III. Although not the most decisive of these battles, the one which became eventually the most celebrated was the Battle of the Boyne, which occurred in July, 1690.

Agitation for political independence from Britain was common from the time of the plantation on, and led to numerous attempts, military and political, by the British to contain insurgence. Thus, after the unsuccessful United Irishmen rebellion of 1798, the Act of Union was passed, creating the United Kingdom of Britain and Ireland in 1801. This served to fashion political allegiances which exist to this day; thus unionists are those who wish to preserve the political link between Northern Ireland and Britain, and nationalists are those who wish to sever that link in favour of a united Ireland.[1]

The struggle for political independence reached a crescendo in the final years of the 19th century and first two decades of the 20th century.

1 In addition, loyalists are militant unionists, while republicans are militant nationalists. The bulk of unionists are Protestant, while the majority of nationalists are Catholic.

Key events in this struggle were the nationalist rebellion of 1916, the Easter Rising and the subsequent War of Independence. The British partitioned Ireland in 1921, creating two new states. In the south, the 'Irish Free State' had a semblance of independence, while in the north, 'Northern Ireland', power was in the hands of one party only, the unionists.

Nationalists were in many ways—socially, politically and culturally —relegated to the margins of society. Eventually, nationalist demands for equality led to the Civil Rights campaign of the late 1960s. The failure of the unionist government to concede any reforms spurred the British government to send in troops to restore order in 1969. It also led to the re-emergence of the Irish Republican Army (IRA), political descendants of those who had fought the British in 1916. It was only a short time before the IRA and British Army were involved in a low-intensity war. The loyalists were not to be left out; the Ulster Volunteer Force (UVF) and Ulster Defense Association (UDA) both engaged in military action aimed in the main at terrorising the entire nationalist community. For a quarter of a century the activities of these three sets of armies constituted what was euphemistically referred to as 'the Northern Ireland troubles'.

Murals in the North of Ireland

In the midst of the political turmoil which led to the establishment of the Northern Ireland state, working-class loyalists began to paint murals: the first was in East Belfast in 1908, and depicted the Battle of the Boyne. With the emergence and consolidation of the Northern Ireland state, murals became an integral part of the annual celebrations of this event on July 12 (known as 'the Twelfth'). King Billy, as he is affectionately referred to, riding his white horse across the River Boyne, was the most common icon, although other historical events of loyalist relevance were sometimes painted. Flags, shields and other heraldic imagery were also common.

The Twelfth represented the 'imagined community' of unionism in its purest form; what if unionist workers were at loggerheads with unionist bosses at other times of the year, at least once a year they were able to celebrate as one big unionist family. Murals were a key element in celebrating and indeed creating that unity. In that sense they were more like medieval murals than those of Mexico which had emerged at around the

same time.[2] In fact, it is likely that loyalist murals are unique in this century, emanating as they do from a political ideology committed to conservatism and the maintenance of the status quo rather than liberation, anti-imperialism and socialism.

In the late 1960s and early 1970s, the penetration of transnational capital, which weakened the base of local, unionist capital, British moves to reform the Northern Ireland state, and finally the military campaign of the IRA called unionist identity into question. This became evident on the walls. The number of murals declined, in particular those depicting King Billy. The heraldic murals continued, but eventually a new form of murals emerged, which is now the most common form of loyalist imagery: the militaristic mural. Men wearing balaclavas and brandishing AK47s, rocket launchers, etc. abound, and the accompanying slogans are frequently chilling. Loyalism under siege has produced the narrowest possible set of symbols and messages in its political art.

For most of the existence of the Northern Ireland state, republicans did not paint murals. The state was founded on unionist privilege and dominance, and the streets were policed by the unionist police force. Although nationalists and republicans frequently protested their second-class citizenship and discrimination, they did not have access to the walls, even those of their own ghettos.

The republican hunger strike of 1981 changed all that. The strike was conducted by republican prisoners seeking prisoner of war status, and it led eventually to the deaths of ten prisoners. Countless nationalists and republicans took to the streets in support of the prison protest, and part of that expropriation of public space was the painting of murals in support of the prisoners.[3] The early republican murals related to the hunger strike and to the armed struggle of the IRA. With the ending of the hunger strike, republican muralists turned to other themes: state repression, popular resistance, republican election campaigns and international solidarity being the most common. Throughout these developments there was the fluctuating but regular appearance of militaristic symbols in the murals. Like the loyalists, republicans paraded their hooded men and weapons. The difference, however, was that, given the greater range of themes in republican murals, the militaristic images have never dominated republican imagery to the

2 Unlike the murals of the Italian Renaissance which expressed the commonly held beliefs of both rulers and masses, the Mexican murals portrayed the ideology of a worker, peasant and middle class revolution against the former ruling class: capitalists, clergy and foreign interests. Since that time, in the eyes of many, the contemporary muralist has been identified with poor people, revolution and communism. "Introduction," in Eva Sperling Cockcroft and Holly Barnet-Sanchez, eds., *Signs from the Heart: California Chicano Murals* (Venice, Calif.: SPARC and Albuquerque: University of New Mexico Press, 1990), p. 6.

3 See Bill Rolston, *Drawing Support: Murals in the North of Ireland* (Belfast: Beyond the Pale Publications, 1992).

same extent as they have on the loyalist side.

The existence of such murals revealed the centrality of 'armed struggle' in the republican strategy. But it is important to note that the anti-imperialist message was also articulated in the international solidarity murals. Republican muralists have found echoes of their own struggle in those of the Palestine Liberation Organisation, the African National Congress (ANC), the Southwest African People's Organisation and the Sandinistas. Nelson Mandela, Ché Guevara, Zapata and Lenin have all been seen on the walls of West Belfast and Derry. It is in this regard that republican murals differ most from those of loyalists. Loyalism has few international references; some of those (such as white rule in South Africa) are no longer in the ascendant, and none of them are noted for their political art.

Political Art, Political Transition

In February 1990, as the end of apartheid drew near in South Africa, Albie Sachs, political activist and victim of a state terrorist murder attempt, addressed some provocative thoughts on culture to his fellow members of the ANC. He argued for a moratorium on the use of the metaphor of 'culture as a weapon', a metaphor which he admitted he had himself used frequently in the past. 'A gun is a gun, and if it were full of contradictions, it would fire in all sorts of directions and be useless for its purpose', he argued. Art and literature, on the other hand, deal in ambiguity and complexity. Artists need to explore the world around them in all its complexity, and this includes artists who are members of the liberation movement. However, such a subtle task is not one to which they are accustomed.

'Instead of getting real criticism, we get solidarity criticism. Our artists are not pushed to improve the quality of their work; it is enough that it be politically correct. The more fists and spears and guns, the better'.[4]

Coming from anyone less respected, such criticisms could have been tantamount to disloyalty. But Sachs's purpose was to challenge the liberation movement, and specifically its artists, to see a new role for themselves in the transition to a new South Africa.

Four years after this speech, Nelson Mandela was in office as the first democratically elected President of South Africa. And in the same year the Irish Republican Army called a cease-fire in a political move to facilitate

4 Albie Sachs, "Preparing Ourselves for Freedom: The ANC and Cultural Policy," *Red Letters*, no. 29 (1991): 8.

inclusive negotiations which would, in their view, lead to a British withdrawal and the establishment of new structures in Ireland which were agreed by all Irish people. Loyalist armed groups later called a cease-fire also. Like South Africa at the time of Sachs's article, Ireland seemed to have entered a new phase, a phase of transition.

Ireland has its cultural critics too, perhaps not of the same stature as Sachs, but making similar criticisms from within the anti-imperialist movement. Gathered around organisations such as Derry Frontline and 2020 Vision (also in Derry), a group of community activists, artists and young people discussed the role of culture in the liberation struggle in April 1991.

. . . republican culture might provide a minority with a sense of solidarity and history. But while it defines itself merely as Brits Out, it remains purely oppositional, contradictory, and offers no vision of the future. As such, it cannot claim the status of a liberation culture. But at the same time, we shouldn't undervalue our culture of resistance. . . . it has the potential to become the motivation that will develop and sustain a culture of liberation.[5]

Similar political situations, similar criticisms. The question is: what, if any, is the role of political artists in the new climate in Ireland?

The Tension between Propaganda and Complexity

The first point to make is that such criticisms need not lead to a rejection of the previous period and its cultural products. In the heat of struggle, especially when there is armed insurrection and state repression, the atmosphere is not particularly conducive to artistic subtlety. While the war rages, political art is indeed a weapon. The current war in Ireland has lasted a quarter of a century, and there is, as of the time of writing, no guarantee that the British government will be imaginative enough or enthusiastic enough to facilitate rapid political change, despite the unique opportunity they have been presented with as a result of the republican and loyalist cease-fires. There is thus some debate about whether the war is in fact over, or, as slogans on militaristic republican murals in south Armagh state, merely 'on hold'. Given that, there are limits to the possibility of political artists breaking out of the more narrowly propagandistic view that 'art is a weapon' and moving on to more subtle and complex considerations of what

5 *The 2020 Papers* (Derry, N. Ireland: Derry Frontline, 1994), p. 12.

the vision of the future might be. There may be no urgency to cease painting the guns, uniforms and hooded men which, in the South African context, Sachs judges to be passé, and which have been prominent in Irish murals.

There is a further constraint on the possibilities of moving from simple messages to complex investigations in the Irish case. Most of the muralists on both sides in the north of Ireland are untrained. Yet they have, in the pursuit of political education and agitation, espoused an art form which requires certain levels of skill, namely figurative and narrative painting. Moreover, it is often difficult for untrained muralists to transfer their articulate and well-rehearsed political views into visual form without opting for over-used clichés. Despite these limitations, it must be said that the criticism of the political muralists comes most often from those who have a political axe to grind, either in the form of representing a competing political party or ideology, or voicing the opinions of the art establishment. The latter will often dismiss muralists because they know nothing about the intricacies of contemporary art nor have a formal training, failing to recognise that there is often great skill in the art works that the muralists produce.[6]

A third point follows, that often those who reject the murals fail to take the time to look closely at them, and thus miss their complexity. Like advertisements which appear brash, blunt and unsubtle, political murals are viewed as bludgeoning the unsympathetic viewer; but, also similar to advertisements, which have perfected the art of telling complex stories in deceptively simple ways, political murals often can make very profound points simply. The complexity is thus often in the eye of the beholder. For example, it is possible to look at a mural commemorating the death of a plastic bullet victim and see only soldiers, guns and innocent children, an apparent collection of simplistic clichés. But if the victim was a friend, neighbour or relative of the viewer, then its apparently simple message can conjure up a myriad of emotions and considerations about life, death, the state, justice, etc. The complex message of a mural is evident in situ;[7] it is those who do not share the aspirations, grief and living conditions of the people who live in the neighbourhoods where murals are painted who can most easily dismiss them as lacking in subtlety.

6 On the almost total failure of established artists to 'do their bit' for political insurgents on either side in the North of Ireland (unlike in the case of Mexico in the 1920s or Nicaragua in the 1980s), see Bill Rolston, *Politics of Painting: Murals and Conflict in Northern Ireland* (Cranberry, N.J.: Associated University Presses, 1991), pp. 51-54.

Murals in a Time of Transition

As well as being the year of the cease-fire, 1994 was the 25th anniversary of the deployment of British troops on the streets of Belfast and Derry. Even before the cease-fire, there was an upsurge of republican murals, most of which referred in one way or other to this anniversary (such as the reproduction of a black-and-white photograph from 1969, which showed a young Derry boy with gas mask and petrol bomb). Republican muralists also used the occasion to point out that twenty-five years was long enough and that it was time for the British to go home; in Gaelic, 'slán abhaile' means in effect 'goodbye'.

This trend continued after the cease-fire, with variations of the 'slán abhaile' mural appearing in Belfast, Derry and south of Newry, on the border. To first appearances this might seem to be an obsession with the past. But it must be stressed that it is a case of looking back in order to look forward. As human rights activists in former dictator-

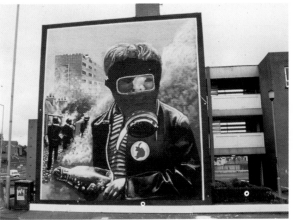

Boy with petrol bomb and gas mask, painted for the 25th Anniversary of the Battle of the Bogside, Bogside, Derry, 1994

Photographs of murals by Bill Rolston

ships in Latin America examine the brutality of the past in order to proclaim 'nunca más', so republican muralists are stating that the future must be different from the past—no more troops, repressive laws, censorship and prisons full of political activists.

Of course, this is not quite the same as painting a detailed vision of the future, but there are limits to articulating that vision at the moment. As pointed out earlier, there is no guarantee that the war is in fact over and that there is a different future to be both articulated and painted. Moreover, the task ahead is not an easy one for republicans. They have acquired great skills of expression and persuasion while in opposition, but they have to go further, to turn slogans into policies, and general aspirations into programmatic statements that can hold up in the heat of political debate. They will have to hold on to their beliefs and principles, and forge alliances with others north and south, socialist, feminist, nationalist and unionist, who agree with them. To the extent that they can do this, there

7 Although it is not necessary to conclude that "(T)aken out of context it would be difficult to find any real merit in these works," it is undoubtedly true that "(T)heir strength lies primarily in their location and their relationship to it." Philip Pocock and Gregory Battcock, *The Obvious Illusion: Murals from the Lower East Side* (New York: George Braziller, 1980), p. 12.

"Slán Abhaile," 25th anniversary of the deployment of British troops in Northern Ireland, Ardoyne, Belfast, 1994

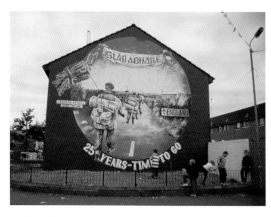

will be many themes for republican muralists.

The prospects seem more limited for unionists. While the British guarantee of the Union remains, they can continue to stay true to traditional form, in effect saying 'no' to any political progress. Conversely, if political developments lead to the removal of that guarantee, the effect will be to fragment unionism. This

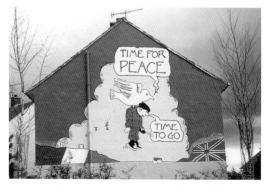

"Time for Peace, Time to Go," 25th anniversary of deployment of British troops in Northern Ireland, Ballymurphy, Belfast, 1994

198
199

is a scary prospect for most unionists. But in the long run, the break-up of unionism must be good for unionists. For too many years union-ism has been portrayed as a monolith with a very narrow range of voices. The nuances have been lost. There are a thousand unionist voices to be heard, and they will not be heard until unionists are forced to say what they want, not what they don't want. If and when that day comes, there will be many themes for loyalist muralists too.

The reaction of loyalist muralists to the peace process is not yet inspiring. They continue to paint militaristic murals, often with the accompanying message that the war against the IRA will go on. Some see in such reactions proof that unionism is virtually incapable of culture in any broad sense of the word.[8] The question is whether what has been true of the past must necessarily be true of the future. Such narrowness of artistic imagination and expression is indicative of the siege mentality of unionism. There is a wide range of issues in unionist communities which theoretically could find expression in murals, but while the siege mentality persists, there is merely silence.

8 'Unsurprisingly, most artists and writers who have emerged from Ulster Protestantism have tended to move away—physically and mentally—from the world that bred them. . . . To remain is to be enclosed in a world where "culture" is restricted to little more than flute bands, Orange marches and the chanting of sectarian slogans at football matches.' Ronan Bennett, "An Irish Answer," *The Guardian Weekend*, 16 July 1994, p. 55.

One telling indication of the contrast between confident republicanism and besieged loyalism comes from Derry. In 1993, an education officer attached to Orchard Gallery had the idea of persuading republican muralists to paint a mural on boards which could be hung—and could sur-

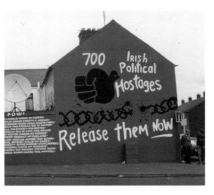

"Release Republican Political Prisoners," Bogside, Derry, 1994

vive!—in a loyalist area, in return for loyalist muralists painting a mural to be hung in a republican area. While he got the agreement of republican muralists, who had even proceeded to the point of discussing a possible theme for the mural, loyalist muralists could not agree to cooperate. Interestingly, the plan was resurrected after the cease-fires of 1994, although, as of the time of writing, no definite agreement on schedule or theme has been reached.

What could the theme of such murals be? The example of California shows what is possible where muralists who are rooted in their communities ('organic intellectuals', to use Gramsci's phrase) tackle issues of importance to those communities. Unemployment, women's rights, drugs, ethnic history and pride, international issues—these and other themes have been to the fore. It is not totally unrealistic to hope that such themes could emerge in the north of Ireland. Some have already been treated by republican muralists, and loyalist muralists have a long history of mural painting which might blossom if released from the narrow confines of the past.

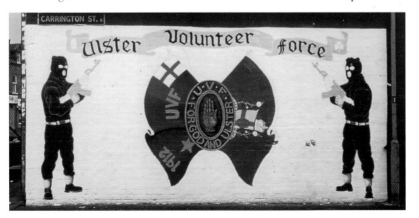

Armed members of the Ulster Volunteer Force, East Belfast, 1994

CONTRADICTION OR PROGRESSION: THE MAINSTREAMING OF A MURAL MOVEMENT

Eva Sperling Cockcroft

Murals are the art form that reflect most clearly any changes in the sociopolitical environment. From the time of the Renaissance, murals have laid out in visual form the ideology of their sponsors, be it the Church, the government, a powerful opposition, or simply private patrons. After the Mexican Revolution of 1917, when the new government desired to promulgate its revised version of Mexican history, muralism was revived as a means of visually representing the point of view of "the revolution." Artists were commissioned to adorn public buildings with heroic images of the newly victorious underclass and its cultural history, pre-conquest civilization. In its new role as a tool of historical revisionism and cultural reclamation, murals have accompanied 20th-century anti-colonialist and anti-bourgeois revolutionary movements around the world, though never again with the kind of massive government support that existed in Mexico in the 1920s.

Muralism was revived in the United States by the example of three great Mexican muralists: Diego Rivera, José Clemente Orozco, and David Alfaro Siqueiros.[1] These three renowned artists came to the United States in the early 1930s when a more conservative government took power in Mexico and reduced its government patronage. During the Depression years, United States artists inspired by the Mexicans persuaded Franklin Delano Roosevelt to begin a mural program as part of the New Deal, but with a few exceptions, the works were unprovocative and unremarkable. Nevertheless, their presence in post offices and public buildings, as well as the Mexican precedent, helped provide the impetus for the community mural movement of the 1960s, which accompanied the strikes, marches, and demonstrations of the Civil Rights and anti-war movements.

Unlike all previous mural movements, which were government sponsored, the community murals of the late 1960s began as an arm of struggle—unfunded and unofficial—a way of claiming urban space for a

1 For an excellent discussion of the influence of the Mexican muralists on United States mural making after the 1930s, see Francis V. O'Connor, "The Influence of Diego Rivera on the Art of the United States During the 1930s and After," in *Diego Rivera* (New York: W. W. Norton & Co., 1986), pp. 156-83; and Laurence P. Hurlburt, *Mexican Muralists in the United States* (Albuquerque, N.M.: University of New Mexico Press, 1989).

particular group or point of view. From the beginning, a large proportion of the artists were professionals, often young art school graduates from African American and Mexican American backgrounds, or European American New Left activists, using their skills to aid political movements. These trained artists worked with neighborhood residents and youth to create murals and to stimulate self-taught artists to join the mural movement.

In the case of Chicano murals, the catalyzing event was the United Farm Workers (UFW) union organizing drive and a corresponding cultural movement toward a politically defined identity. While posters and banners were important elements of new militant art, the use of the mural form was encouraged by the existence of a strong Mexican mural tradition.[2]

In the same way that the Chicano movement itself developed in two overlapping directions, one emphasizing cultural identity and the other political action, the imagery of early murals was drawn from both of these sources. Imagery in cultural murals included copies of Mayan murals, pyramids, Olmec sculptures, Indians (historical, mythical, and Hollywood), the tripartite head (Indian, Spanish, and Mestizo), and religious motifs, particularly the Virgin of Guadalupe. Political murals tended to emphasize Mexican history, oppressed workers, portraits of political leaders like Cesar Chavez and Reies Lopez Tijerina, as well as Emiliano Zapata and "Pancho" Villa—heroes of the Mexican revolution. Solidarity figures from other revolutions, like Ché Guevara and Martin Luther King, Jr., were also frequently depicted. At Chicano demonstrations, the UFW flag and the Virgin of Guadalupe were omnipresent as identifying icons.

These early murals, filled with political and cultural imagery, were similar in origin and themes to the republican murals of the north of Ireland. Chicano mural painters, however, even from the beginning, placed much more emphasis on artistic quality and complex painting. This was due to the large proportion of professionally trained artists involved in mural making, the importance and popularity of the Mexican mural tradition, and its wide dissemination to those with less skill. For example, the film *Walls of Fire*, about the murals of Siqueiros, was widely shown during this period, and many murals borrowed heavily from this source. Also, from the early 1970s, some monies were available to pay muralists (or at least buy supplies) through grass-roots fundraising, small grants, and creative

2 For further discussion of the cultural roots of the Chicano mural movement, see *Signs from the Heart: California Chicano Murals*, Eva Sperling Cockcroft and Holly Barnet-Sanchez, eds. (Albuquerque, N.M.: University of New Mexico Press, 1990).

use of anti-poverty and social service funds.

Another difference between the Irish republican murals and the Chicano walls, even in this early period, was the need of the Chicano movement to address internal problems like gang violence, drugs and other self-destructive behavior attributed to racism and poverty, while at the same time continuing the struggle against external oppressive forces. Muralists approached this issue in several ways. There were impassioned pleas against the constant killings, like "To ace out a home boy from another *barrio* is to kill *La Raza*," as well as murals painted by youth gangs to honor the dead and mark a truce. At the same time, there were works glorifying street culture: *pachuco* and *pachuca* style, low rider cars, graffiti, Spanglish, and "bad taste," like the use of garish color combinations.[3] These works were aimed at raising self-esteem and combating racist stereotypes by glorifying precisely what was condemned by mainstream America.

During this early, nationalist period, 1970–75, monocultural groups predominated. Although Chicano muralists from one city would often help out others in big projects, there was little racial mixing during this period. At Chicano Park in San Diego, for example, land underneath the Coronado Bay Bridge was taken by militants for a people's park in 1970. Part of the plan was to muralize the freeway pillars. During the first few years, several freeway offramps, walls, and pillars were painted by local artists and residents and later by artists from Sacramento. But until 1977, all the artists involved in the San Diego project were Latino.[4] In Los Angeles, mural projects were organized in two housing projects, Ramona Gardens and Estrada Courts. All of these projects were locally controlled and funded during this period with the assistance of the community arts centers (like Centro Cultural de la Raza in San Diego, or the Mechicano Art Center and Goez Gallery in Los Angeles), which organized these activities.

Some of the self-taught artists found the mural medium compatible with their abilities, and felt that their work was of immense value to the local community, which led to their identification as muralists. In 1976, the first national meeting of these self-identified muralists took place in New York City. This sense of identity, of belonging to a larger group, was reinforced by the publication of a newsletter and two books from inside the

3 The highly stylized, defiant, underdog, zoot-suit, gang-influenced attitude evoked by use of the word *pachuco/a* is fully explored by Tomás Ybarra-Frausto in his essay, "*Rasquachismo*: A Chicano Sensibility," in *CARA: Chicano Art, Resistance and Affirmation, 1965-1985* (Los Angeles: UCLA Wight Art Gallery, 1990), pp. 155-62.

4 A second phase of mural activity at Chicano Park beginning in 1977 included European American and Japanese artists.

movement.[5] There are some indications that such an incipient identifica-
tion of wall painters as muralists may also be occurring in Northern Ireland.
In his book *Drawing Support: Murals in the North of Ireland*, Bill Rolston

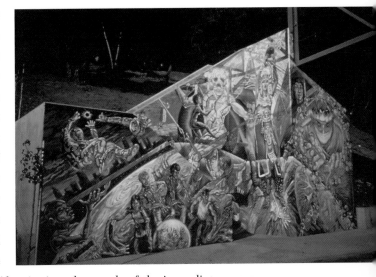

Global Health, Los
Angeles, 1991.
Mural by East Los
Streetscapers

describes the work of one
such artist, Gerard Kelly.
While spending time in
prison as a POW, Kelly
studied art and began to
paint murals on his release
—he is now responsible for
a considerable number of
outstanding murals in his
neighborhood. As Kelly
says, ". . . most people like
art . . . people would stand
and look at a mural before
they would read a paper. Also, it gives the people of the immediate area a
sense of pride."[6] Such artists tend to continue to paint murals beyond the
struggle period and transform a momentary explosion into a continuing
people's art movement. When the heat of the Chicano movement (and the
New Left opposition in general) began to cool in the mid-1970s, many of
the artists who had been involved in militant work began to move towards
more personal expressions and reintegrate into the gallery system. Others
who had identified as muralists felt the power of their work in the commu-
nity in terms not only as a call to struggle, but also as fulfilling a need for
relevant art in ordinary people's lives that spoke to their pride and their
neighborhood. If Irish muralists continue to create community art beyond
the peace, perhaps this pattern will be duplicated in Ireland.

 As muralists moved away from militant imagery (following the
general mood of a post-Vietnam society) toward portrayals of self-pride
and unity, the nationalist phase of the mural movement ended and the
institutional phase began. Murals had become respectable. They were
funded by grants from the new National Endowment for the Arts, which
had a special program to encourage community arts organizations, city
funds, and, briefly but massively, from CETA (Comprehensive

5 *The Mural Manual* by
 Mark Rogovin of
 Chicago's Public Art
 Workshop was self-pub-
 lished in 1973 and re-
 issued by Beacon Press
 in 1975. *Toward A
 People's Art: The
 Contemporary Mural
 Movement* was written
 by Eva Cockcroft of the
 Peoples Painters Group
 of New Jersey, John
 Weber of Chicago Mural
 Group, and political soci-
 ologist James Cockcroft
 in 1977. *Community
 Murals Newsletter* (later
 *Community Murals
 Magazine*, edited by
 Tim Drescher) appeared
 regularly between 1976
 and 1988.

6 Bill Rolston, *Drawing
 Support: Murals in the
 North of Ireland* (Belfast:
 Beyond the Pale
 Publications, 1992),
 p. vii.

Employment Training Act). These latter funds were abruptly terminated with the election of Ronald Reagan in 1980. CETA hired unemployed artists to set up public-service-oriented arts service organizations in cities throughout the country. This general employment program was responsible for a great influx of new artists to the field of community murals. The new mural organizations were multiethnic, and because city funds were often involved, mural content was controlled. More often than not, this was through self-censorship and community requests for noncontroversial subject matter rather than government interference. Positive images of unity, ethnic pride, and history were the most common themes, although whales and other environmental issues formed an important subgroup.

Typical of these new organizations was SPARC (Social and Public Art Resource Center), headed by Chicana muralist Judy Baca, which used public funds along with private grants to finance murals by artists from various ethnic and racial backgrounds. In 1976, Baca and SPARC began a massive project that reflected the new multicultural emphasis. *The Great Wall of Los Angeles* is devoted to the experience of different ethnic groups in the history of California. It covers more than a half mile of the wall along a concrete flood control channel and, under the supervision of Baca, was painted over five summers by large crews of ethnically and culturally diverse artists and teenagers. Since 1989, SPARC has managed a city-funded mural program, *Neighborhood Pride*, which has produced six to ten new murals each year in different ethnic communities of Los Angeles.

Although community murals had become an accepted art form by the mid-1970s, there was still a significant split between minority, mainly Chicano and black artists, and a more art world-oriented group of "public artists" who were working in abstract and photorealist styles that were being incorporated into "urban renewal" and downtown revitalization projects. By the mid-1980s, with the decline of an activist political base and the introduction of significant funds to public art (as more and more cities passed laws mandating that up to one percent of the costs of new city construction and renovation be spent on art), community muralists began to compete for city projects.

This movement out of the neighborhoods and into the mainstream corresponded to the increasing professionalism of muralism, and the desire

of artists to have the opportunity to create major and permanent works. In Los Angeles, this process was more successful than in most other cities, helping to make it the "Mural Capital of the World." During the 1984 Olympic Games, ten of the established community muralists—Chicano, black, and white—were commissioned to paint murals on downtown freeway walls, thereby bringing the murals to the attention of middle-class residents and visitors from around the world—most of whom would never travel into the neighborhoods where the early masterpieces had been painted. Murals became one of the tourist attractions of the city, a source of "neighborhood pride," and a deterrent to graffiti and gang violence. As such, they continued to receive substantial funds and support, even as the recession of the late 1980s forced cutbacks in cultural funds in many other cities.

In the twenty-five years since the heyday of the Chicano movement, the melting pot analogy of American society has given way to a "salad bar-style" celebration of multicultural diversity. Concurrently, the art world has gone from favoring minimalism and hard-edge abstraction to espousing postmodern eclecticism with exhibitions of gender, identity, and politics. The once

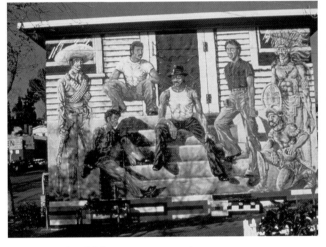

Ghosts of the Barrio, Los Angeles, 1974. Mural by Wayne Healy, East Los Streetscapers

revolutionary idea that community residents should have some say about the art placed in their neighborhood has become incorporated into the selection process of almost all public art programs. Finally, some community artists are receiving a share of the large commissions that make possible really major works and larger audiences.

The trajectory of murals from the *barrio* to the mainstream is exemplified in the career of the East Los Streetscapers, a group that formed in the early years of the mural movement. In 1973, David Botello painted his first mural, *Dreams of Flight*, at Estrada Courts, and a year later Wayne Healy (who happens to be half-Irish and half-Mexican) painted *Ghosts of the Barrio* at Ramona Gardens. The two men joined together in 1975 to

form the Streetscapers group, and they continue their collaboration to this day.[7] Together, they painted *Chicano Time Trip* in East L.A. in 1977. All of the above mentioned murals are considered to be classics of the early Chicano movement, presenting a positive message to young people regarding their cultural heritage. Botello and Healy painted new walls almost every year, both in the *barrio* and in mixed neighborhoods, while holding down other jobs to support their families. In addition to Chicano themes, they created a 500-foot-long space odyssey, *Moonscapes*, for the Culver City branch of the California Bureau of Motor Vehicles building, and an 80-foot-high mural, *El Nuevo Fuego*, on the Victor Clothing Company building in downtown, which debuted during the Olympics. In 1990 they founded the Palmetto Gallery, a work and exhibition space for younger artists as well as for themselves. As experienced and respected muralists from the community, they have been able to win a number of art competitions for public commissions in the 1990s, including one for a Metrorail station and another, ironically, for a police training facility. This is a long way from the politically motivated early walls or the calls to struggle of the Irish militants. Is it a contradiction or a progression?

The situation certainly contradicts the romantic image of a politically motivated mural movement—something that has not existed for some fifteen years. However, success and professionalism by themselves need not be interpreted as a sellout of the movement, as long as commitment to the community continues. Each work must be judged individually by the integrity of its content, not just by the identity of the patron; after all, Rivera painted some of his greatest murals for major capitalists like Ford and Rockefeller. Moreover, only through more accessible and permanent work that demonstrates a complexity of thematic material and a high level of artistry can a mural phenomenon be transformed into a continuing art movement that has influence for more than a few years.

In spite of the mainstreaming of the community mural movement, positive images of ethnic history remain controversial in a changing political climate. The conservative backlash has promoted a growing intolerance for opposing views and multiculturalism, as demonstrated in two recent cases. Recently, objections were raised to a proposed Metrorail station design by Margaret Garcia. The chosen location, near Universal Studios, is

7 Other artists, among them Rudy Calderon and George Yepes, have formed part of the Streetscapers during some periods.

also the historical site of Campo de Cahuenga, where General Pico surrendered California to United States forces in 1847. Using text, Mayan symbols, and images, Garcia's design recounts that history and that of Native American and Mexican residents of early California. Objections come from those who feel that this view of history negatively portrays white Americans. The other case concerns more recent history. A mural honoring the memory of the Black Panther Party, by Noni Olabisi, in a black neighborhood of South Central Los Angeles (and originally funded by city money through the SPARC Neighborhood Pride program) was denied permission by the Cultural Affairs Commission after a series of stormy hearings. This mural was painted, but with private rather than public funds.

As they walk the thin line between banality and censorship, the muralists of the United States continue on a path toward ever more ambitious artistic expressions on the issues facing different communities today. In Ireland, the republican muralists are now at a crossroads. They may stop painting walls now that peace seems to be at hand—or they may change with the times and, like the community muralists of the United States, convert themselves into a continuing voice of the people.

Maestrapeace (detail), San Francisco Women's Building, 18th Street, San Francisco, 1994. Mural painted by Juan Alicia, Miranda Bergman, Edythe Boone, Susan Kelk Cervantes, Meera Desai, Yvonne Littleton, and Irene Perez. Photo by Bill Rolston

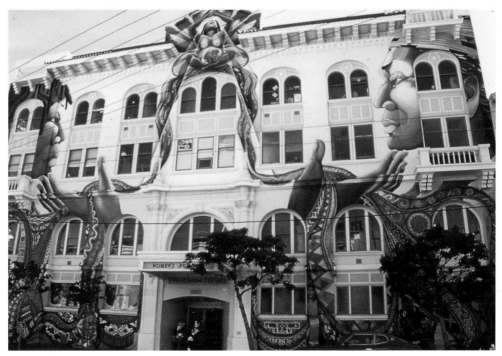

SCEANCHAI RAPPERS: THE WAIT IS OVER

Juan Arturo Brennan

The day I first set foot on Irish soil in the long-ago summer of 1992, yet another bomb had exploded in downtown Belfast, with the usual aftermath of victims, property damage, mutual accusations, funerals, and political maneuvering by both sides. Today, slightly more than two years later, there is talk of laying down arms, implementing a cease-fire, negotiating major issues. The controversial leader Gerry Adams travels throughout the world as a legitimate political figure, presenting Sinn Fein policy before legislatures, parliaments, and political groups of diverse ideologies. More than at any time in the last quarter century, it is possible to glimpse a solution, one that would not involve more deaths, adding to the painful reality of life in Northern Ireland. This crisis, resulting from a brutal occupation, has involved iniquitous legal subterfuges, and has been shrouded in a painfully prolonged campaign of disinformation orchestrated by Downing Street. It has been a long wait.

Political signals seem to mark the end of that wait, but violence—political, military, religious, sectarian violence—has left generations of Irish people so deeply traumatized that the current situation can only be approached with a large dose of skepticism.

Skepticism was precisely what characterized my visit to Ireland in August, 1992, a visit with two main objectives: to get closer to tracing my own family tree with roots in Ireland, and to learn about the political and social situation of that conflictive place.

The first objective was not fulfilled. Where I live I am the only one with my surname; in Ireland Brennans are as abundant as Garcias are in Mexico. Having lost touch with my origins at an early age due to the death of my father in 1960, I never had enough facts to carry out a productive search. In Belfast I found an information center with substantial archives devoted to helping foreign descendants of Irish forebears. With a little luck, one could track down one's ancestors. All I found was the etymological origin of an old surname, O'Braona'in, which means either "sadness" or

"crow," and two different versions of a coat of arms in which lions occupy a prominent place. After my failed search, I was left with the impression that at least my surname would serve as a mantle of protection in Ireland, that being a Brennan in the land of Brennans would give me a solid sense of belonging and identity.

I was disabused of this notion a few days later. In the early hours of the morning after a long night of music, politics, and beer at the Dungloe Pub in the city of Derry, on the way back to the house where I was staying, a British army patrol stopped our car for a routine search. Threatened with an enormous automatic rifle barrel held a few centimeters from my nose, I handed over the identification that the sullen soldier asked for. He opened my passport, shone a powerful flashlight across it and, as he contemptuously threw it back at me, I heard him growl: "What? A fucking Mexican with such a name?"

The second objective of my trip, at least, was more than achieved. During the three weeks I spent in Ireland, I was bombarded with facts, information, points of view, lectures, videos, visits, interviews in what was literally an intensive course in the recent history of Ireland, with special emphasis on the conflict in the North during the last twenty-five years. Over the course of twenty days, my traveling companions—Rubén Ortiz and Manuel Rocha—and I were able to experience the situation, and meet with some of its protagonists. At each point of our journey, we had the good fortune to be able to rely on knowledgeable, committed, passionate friends as our guides in that intense, fascinating, and painful journey: Stephen and Locky in Derry, Liam and Valerie in Dublin, Brid and Paedar in Belfast. Their voices—in fact, the voices of all we met in Ireland—form part of a vast and eloquent chorus that has asked for peace, for justice, for democracy for a long time . . . and it was very evident to me that the Irish are tired of waiting.

In Derry I found a highly politicized community, sharply divided, covered with the scars of a war that is harsh, savage, interminable, marked by many milestones and monuments commemorating endless atrocities. In Dublin I found a timid, conservative city, wrapped in false tranquility, populated by Irish who seem not to want to know anything about what is happening in that other Ireland which, though they deny it, is also theirs.

In Belfast I found the most hardline expression of sectarian violence which, ostensibly or secretly, marks every inhabitant of the city, every day, every hour, everywhere. In Belfast I also found West Belfast. . . .

Enclosed between a highway and a mountain, harassed and surveilled day and night by its own police and the British Army, West Belfast is both a community under siege and one of the most intensely politicized neighborhoods in the world. In West Belfast it is impossible to be apolitical, because here, as in no other part of the country, are reminders of the violence, injustice, and discrimination caused by the artificial division of the island and the unwelcome presence of a force of occupation. If we look more deeply into the history of Northern Ireland in recent years, it becomes difficult to categorically define the conflict as a struggle between Catholics and Protestants; it is more accurate to say that the community is basically divided between the republicans, who demand the unconditional reunification of Ireland and the departure of the English, and the unionists, who do everything possible to maintain their links with England and the obvious advantages that occupation has meant for them.

West Belfast is a republican neighborhood of Northern Ireland's capital, where all the absurd contradictions brought about by the last vestiges of the declining British Empire are concentrated. And though it may be true that many of the manifestations of republican thought are repressed and censored, it is also true that in spite of the unblinking eyes of their Orwellian Big Brother, the inhabitants of West Belfast always find a way to create a channel of expression for their political and social concerns. One of the most interesting forums for republican expression is the West Belfast Community Festival, a variety of artistic and cultural events, all with intensely political content. Each and every one of the festival events is planned and executed with a common goal: to throw into relief for residents and outsiders the terrible situation experienced by people in the North and, at the same time, to make it clear that the republican community is working ceaselessly for the cause of liberty, justice, democracy, and the reunification of their nation.

Music, dance, theater, exhibits, conferences—these are the raw materials of any cultural festival. But, unlike other festivals, each event in the West Belfast Community Festival lends itself to multiple interpretations

going far beyond the mere discussion of its artistic and aesthetic merits. Even the historical explorations have a burning timeliness. Thus, a play about the life of Tom Williams (a patriot of the Irish Revolution) and his execution at the Crumlin Road Jail acts as a contemporary reminder that this prison is still the fate of many current fighters for the republican cause. A photographic exhibition consisting of images of Belfast and Berlin provides an eloquent visual discourse about what it means for the individual to live in a divided country, in a geographic, social, and political area surrounded by artificial borders, fences, stockades, barbed wire, and military and police blockades. A reading of republican poetry gains another dimension when the poems have been written by republican activists during their long imprisonment in English jails, the same jails in which the highly symbolic handicrafts exhibited in various locations as part of the Festival have been laboriously manufactured. Even the West Belfast Community Festival's sports tournaments have a highly political content; they are named after important personalities from the republican cause, such as Mairead Farrell, one of the victims of Gibraltar, or Bobby Sands, the first to sacrifice his own life in a prison hunger strike. These and many other activities were carried out under the common stamp of community participation, collective commitment, and cultural identity. This last aspect was emphasized by the fact that the official language of the West Belfast Community Festival was "Irish," that mysterious, lovely, and euphonious language that we erroneously call Gaelic, and that in the republican community is simply Irish, one of the strongest links with the community's Celtic past and one of the most powerful symbols of Irish republican resistance and identity. While it is true that this fascinating festival took social, political, and cultural cohesion as its main theme, it also had a striking current of multicultural participation. In this aspect, what was most important was the presence of a numerous and combative Basque contingent, which brought to the Festival a solid Euzkadi political, cultural, and artistic dynamic, including intense sessions of exchange of ideas with the Belfast republicans. Less visibly, there were also groups of Corsicans and Catalans present as guests of the Festival. This multinational collage made my friend, the composer Manuel Rocha's ever-sharp humor blossom with the affirmation that all that was lacking in West Belfast was a solid contingent of Yucatecans. . . .

In terms of the multicultural exchange, the principal component of Mexico's presence in the West Belfast Community Festival was the responsibility of Rubén Ortiz, a Mexican visual artist who in recent years has been working closely with Chicano communities in Southern

Gerard Kelly and Rubén Ortiz Torres, *Mural with IRA Volunteer and Zapata*, Belfast, 1993. Photo by Juan Arturo Brennan

California. The task set for Ortiz was, in principle, very simple: to paint a mural in West Belfast, where one of the most common forms of communication is the political mural, with functions analogous to the murals in the border area of Tijuana-San Diego. The creation of the mural, however, was not easy, given the particular conditions of the place. In collaboration with Gerard Kelly, the most outstanding of the West Belfast muralists, Ortiz designed and executed an authentic multicultural mural in which, in addition to other symbols, he combined the images of the revolutionary Mexican leader Emiliano Zapata, James Connolly (a principal figure of the 1916 Irish uprising), a *cholo*, and an IRA volunteer. The combination of rainy weather and police supervision made Ortiz's and Kelly's job difficult, both for them and for those of us who collaborated by mixing paint and painting large areas of the wall based on Ortiz's original designs. I will always remember Rubén and Gerry, each perched on a ladder, painting their mural on a wall in Springhill under the ominous vigilance of a military helicopter and with the periodic presence of the armored vehicles of the police and the British army patrols, both armed to the teeth.

During the intense week of the West Belfast Community Festival, the main headquarters for the artistic and cultural events was Cultu'rlann —an old church located on Falls Road and converted into a culture center—which on a daily basis is the most important social focal point for the Irish republican community. There, in one of the Cultu'rlann areas, one of the most intense political-theatrical-musical sessions I have ever witnessed took place. The show featured an Irish rap group called the Sceanchai Rappers. At first I was skeptical about the presence of this group in the West Belfast Community Festival, mainly due to my conviction that when rap is decontextualized it becomes nothing more than a mere stylistic imitation. What comes to mind as proof of this is the sophisticated and

anodyne rap of people like Hammer and Vanilla Ice, or the ridiculous attempts at rap in Spanish currently performed by the amateurish, spoiled adolescents of commercial Mexican television. And more: since authentic rap is a very specific artistic and social expression of the black communities of the large cities of the United States, how can we conceive of an Irish rap group, and how can we measure the scope of their particular mode of communication? My skepticism vanished immediately on first contact with the four Sceanchai Rappers, who demonstrated a rare intuition for adapting the seed of black rap to their own purposes, in their own context, with their own means of expression. Maighread Medbh, Rick O'Shea, Gerry McGovern, and Marcus Alasdair have formed a group that distinguishes itself more by the individuality of its members than by their work as an ensemble, and this gives their work a very special variety and richness. In that long intense session performed by the Sceanchai Rappers, one thing was clear above all: each of their raps was conceived, written, structured, and performed in terms of the political and social context of the Irish republican struggle in Northern Ireland. That night there was no room for anything but the raw, direct, emotional, powerful expression of the issues important to the cause of a free and united Ireland. As was logical to expect, many of the raps performed that night referred to politics, the military, and the police, but the members of the Sceanchai Rappers were flexible enough to also include in their repertory a series of raps dealing with the more individual and human aspects of Ireland's crisis. Many of these raps turned out to be, in all their rawness and violence, deeply moving.

In "Walk Faster," the Sceanchai Rappers explore the permanent insecurity experienced by Irish women, doubly oppressed in a police state and a society that still has not overcome much of the irrational behavior and atavistic traits of the machista culture of underdevelopment. In the rap entitled "Paddy is a Terrorist," they allude directly to the stereotype created by the English for purposes of propaganda: the false notion that everybody who is Irish is a terrorist, and that the conflict can only be analyzed and finally resolved in military terms. In one of the show's most dramatic moments, the group performed "Nothing but Rain," a rap that paints a desolate portrait of idleness, job discrimination, and hopelessness, all in the context of the oppressive and suffocating Irish climate: humid, overcast, rainy. . . .

Throughout this fascinating and impressive Irish rap session, the members of the Sceanchai Rappers explored some of the specific issues of the Irish republican struggle in particular and of the Irish situation in general, such as the brutal unemployment; the tragedy of emigration; the troubled relations between the communities and the police and paramilitary forces; the absurd laws that London has imposed on Northern Ireland. But they were also able to deal just as lucidly with the universal social problems that assume special significance in the six counties forming the northern part of the island. Thus, with photographic images from newspapers as well as other images created for the occasion, plus a few simple stage props, the Sceanchai Rappers attacked both the British Army and the Irish unionists, the conservative politicians, and the Catholic Church (which has taken the deplorable role of standing in the way of a real peace process and protecting the status quo).

In the context of all these sounds and images, so impressive in their expression of the fundamental aspects of the political and social situation of the six counties, one presence shone with its own intense light: Maighread Medbh, the sole female member of the group. Already known for her poetry and activism for women's rights, Maighread Medbh gave the Sceanchai Rappers' performance a special dynamic that made their raps highly effective in combining the general aspects of the Irish Republican cause and a desire for unification with the specific concerns of women. In fact, it was Maighread Medbh who was responsible for expressing the most intense and powerful moment of the session. At the beginning of the show she delivered a solid, compact poem of her own, a committed and synthesizing vision of what Northern Ireland is today, and of the aspirations of Irish republicans for their unjustly divided nation. The last line of the poem, forceful as a high-caliber bullet, echoed in the dark and cavernous hall of Cultu'rlann on the Falls Road in West Belfast like a warning. That line seemed to sum up not only the larger purpose of the West Belfast Community Festival, but also the challenging attitude of an entire occupied, oppressed, and rebellious people: *I am Ireland, and I'm not waiting any longer.*

Translated from Spanish by Ellen Calmus

COMMUNIQUE: VOICES FROM THE JUNGLE SUBCOMANDANTE MARCOS AND CULTURE

Elena Poniatowska

It is reasonable, just, and necessary in Latin America that suddenly in the hills, among the oaks of the forest, on the mountain, desperate men and women from the deepest reaches of the jungle, from the deepest reaches of abandonment, rifles held high, cry out that Indians and peasants also have the right to live. Latin America is at war, a war of the poor against the rich. It is a muffled, latent, dark, primitive war, the continuing awful struggle of those who have been forgotten, a war interspersed with long years of truce. The poor have a limitless endurance; they helplessly observe the way they are pushed aside, until one day one of them or someone on their side stands up and says, "enough, no more, better to die." It is only when this mass becomes dangerous that its existence is recognized.

In Mexico the past is not past; the past never dies. Every day we experience the Conquest in the flesh. Five hundred years have not elapsed since the arrival of the Conquistadors. In 1995, Indigenous Latin Americans are treated just as they were in 1519; they share the same exact living conditions. Our country is racist, sexist, classist. In *Resistencia y Utopia: 1528-1940* (Resistance and Utopia), Antonio García de León, a historian of Chiapas, writes the same story that was written by the first bishop of Chiapas, Fray Bartolomé de las Casas, in his *Breve Crónica de la Destrucción de las Indias Occidentales* (A Brief Chronicle of the Destruction of the West Indies). Don Samuel Ruiz, the current bishop and worthy successor of Fray Bartolomé, is mocked in Mexico as well as in the Vatican for his defense of the Indians. On the streets of Mexico City and in the larger cities of Chiapas, they put up posters with his photo: "Dangerous Criminal" and "Wanted For Betraying His Country." There have never been such campaigns of harassment against anyone else in the country. He is hated by the rich Chiapanecans, who say that he is the *comandante* of the Zapatista forces, and that Marcos is his subcommander. Since 1960, when he was assigned the diocese of San Cristóbal by Pope

John XXII, Samuel Ruiz has chosen to work on behalf of the poor—and in Latin America to choose to work with the poor is a crime; liberation theology has been demonized. In 1993 Samuel Ruiz was investigated by the Vatican on the initiative of Bishop Bernard Gantin, a black African from Zaire (of all people), head of Latin American Affairs in the Vatican, but it wasn't until 1995 that L'Osservatore Romano admitted that all Bishop Ruiz had done was to concern himself with "the fair demands of the poor exploited masses of his diocese."

Time has not passed in Chiapas. B. Traven, the German writer who lived in Mexico for many years until his death in 1969, could write the same novels today that he wrote in the 1930s, not to mention his *Estudio Antropológico de Chiapas* (An Anthropological Study of Chiapas). His six books about the jungle, *Gobierno* (Government), *La carreta* (The Cart), *Marcha a la montería* (The March to the Hunt), *Trozas* (The Logs), *La rebelión de los colgados* (The Rebellion of the Hanged), *El General* (The General), *Puente en la selva* (A Bridge in the Jungle) are terrifyingly current. Nothing has changed—nothing. Well, something has happened: the rain forests have been nearly annihilated by fortune hunters, timber dealers, cattle ranchers looking for pasture, coffee growers, and landowners, who, unlike the Indians, have no close relationship with nature—they use heavy machinery, they don't know how to grow cacao in the shade of larger trees, they don't know how to live in the jungle without destroying it, they don't take care of the jungle flora and fauna.

Since 1519 Mexico has gone through a long process, a confrontation between two equally great cultures. Yet, one of these cultures did everything in its power to annihilate the other, tear it out by its roots, destroy its temples, break its back. Since then Mexico has not ceased to be a colonized country. The Church of Nuestra Señora de los Remedios, one of the largest churches in the state of Puebla, was constructed on top of a pyramid larger than that of Kofú in Egypt. It measured 488 meters wide by 62 meters tall; its splendor covered an area of 17 hectares. The Spanish church mounted the Aztec temple as Cortez mounted Malinché, but Nature was wise enough to preserve underground the vestiges of our splendid past. The gods still throb under Mexican soil, and Coatlicue and Huitzilopochtli compete with the other saints: but when we want rain we all pray to Tlaloc.

The Zócalo, with its National Palace and Cathedral, was built in the sixteenth century on top of the Templo Mayor, and the latest excavations further confirm (as if further confirmation were possible) the legitimacy and validity of pre-Columbian Mexican society.

Colonization is perhaps the worst thing that can happen to a people, though it is now said that we Mexicans use this as an excuse for not succeeding, for acting like underage children, for lying, cheating, and not being able to solve a single one of our problems. Our huge country, instead of becoming greater, has lost territory. We sold Texas and California to the United States and nothing happened, nobody rose up in arms (in spite of the fact that we lost our best and most fertile land). After two hundred years of independence, we are inferior to our past—not because we lost the land, but due to a condition we share with the rest of Latin America: we are in debt. There is violence behind each Latin American state, ancestral violence and economic violence. We are living on borrowed money, and this gives our life a sense not shared by other lives, the sense of punishment. Our metaphysical insecurity dates from the Conquest and today is transformed into our condition as debtors, as men and women who walk in chains.

For the past sixty-five years, we Mexicans have been guided by our Holy Revolution, our Blessed Revolution, our Enlightened Revolution. Revolutionary rhetoric has permeated not only the predictable, cardboard speeches of the ruling party, it has permeated our entire lives. In our newspapers the term "Mexican Revolution" appears as often as the word "Mexico." It's true, we can't say "Mexico" without saying "Revolution." Nevertheless, the minute there is a revolutionary uprising, official condemnation is unanimous; the Zapatistas turn out to be the cause of all our evils. Among other evils is our punishment by "big money": Mexico began its last presidential administration with two billionaires, it ended up with fourteen. The country of revolution is the land of the big fortunes. The fortunes of Brazil and other Latin American countries pale next to the large Mexican fortunes. Only the Arab oil fortunes are greater.

In response to official history, there were grass-roots uprisings (the student movement of 1968 had a profound influence on the political life of Mexico, giving rise to a number of grass-roots movements), and popular heroes emerged. First it was Zapata, with his cry of "Land and Liberty" in

the revolution of 1910. Emiliano Zapata distributed the land of Morelos in 1910 after building an army out of a bunch of peasants. The land belongs to the farmer, he said to all the poor and to the hacienda owners. Hated by the rich, venerated by the poor, Zapata died without knowing that he had begun one of the most far-reaching movements in Mexico—*Zapatismo*—or that eighty-five years later, in Chiapas, a group made up almost entirely of Indians would show that *Zapatismo* is still alive.

On January 1, 1994, a leader emerged who combined the roots and characteristics of previous leaders—Emiliano Zapata, Rubén Jaramillo, Lucio Cabañas, Genaro Vásquez Rojas—but who took on areas the others never mastered. First, he had a whole series of modern resources the others never dreamed of, such as modern information technology. Insurgent Subcomandante Marcos, he calls himself. The figure of Ché Guevara fertilized the field, and a new *caudillo* has arrived, not mounted on horseback but borne on a great flood of romanticism. The name "Marcos," they say, is made up of the initials of the towns in Chiapas that the Zapatistas took on the 1st of January: Margaritas, Altamirano, La Realidad, Chanal, Ocosingo, and San Cristóbal. One hundred combatants of the Zapatista army stationed themselves in the Plaza de las Armas. They took the National Palace, destroyed its files of land ownership, and finished off its bureaucracy. Unlike Zapata, Marcos has his own news agency. There in the deepest Lacandón Jungle or somewhere in the mountains of the southeast, as he himself describes his location, he knows everything, he reads everything, from T. John Perse to Shakespeare, whose sonnets he quotes in the original English by heart. He has found a way to not only be better informed than his predecessors, but even better informed than city dwellers, and he sends his communiqués by modem to selected newspapers. A ski mask is an essential part of his charisma. It serves less to conceal his face than to reveal his character. His critics say that Ché Guevara always showed his face, but the Subcomandante shows his face through his letters, his famous communiqués, which reveal much more than if we were able to see his nose, which we know is large, his beard, which we know is thick, his eyes, whose loving expression we have all seen, his pipe, and his very recognizable voice. In Mexico the police know everything, and what they don't know they ask the FBI or the CIA, who usually know ahead of time what

will happen in our country. After January 1st Marcos became the most charismatic man in Mexico: nobody can match his ability to convoke an audience for an event. On his own, with his one-man news agency, he uses instruments of communication and persuasion, which in his hands acquire an aspect of the "ideal," becoming instruments at the service of a cause—not because they are owned by Marcos but because they put cybernetics at the service of those who have never had anything, who have never seen a computer in their lives. Computers, thanks to the "Sub," as they call him, turn out to be a democratizing factor. It seems to me that putting modern technology within reach of the poorest people is, in a way, an advancement of the cultural process; with Marcos, the much bandied-about "modernity" sought by Mexico through NAFTA (North American Free Trade Agreement) first began to penetrate the Mexican jungle.

What is Marcos's language? Accused of being sentimental, kitsch, simplistic, a pamphleteer, of writing soap operas, Marcos tells stories in a language everybody can understand. Sometimes he reminds us of Saint-Exupéry. He talks to those around him—the children, old Antonio, the peasants, the men and women who followed him to the mountains to become Zapatistas—and his writing reflects their thoughts. His stories are stories of the soil. Helping the poorest and most downtrodden to be heard is an act of culture, and that is what revolution is about these days. There is an essential book about Chiapas, *Juan Pérez Jolote* by the anthropologist Ricardo Pozas, but we have learned almost nothing since that book—not withstanding Rosario Castellanos's *Balún Canán*, *Oficio de Tinieblas* (Mass for the

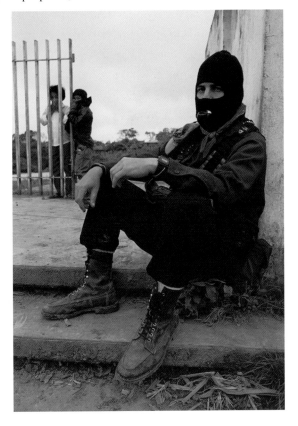

Zapatista leader Subcomandante Marcos, Chiapas, Mexico, 1994. Photo By Wesley Bocxe/JB Pictures

Dying) and *Ciudad Real* (Royal City). For the world to suddenly flood into such a state as abandoned as Chiapas is a cultural revolution.

The Zapatistas are also echoed in the media, mainly in the Mexican newspaper *La Jornada*. Marcos, allowing himself the luxury of censorship (and to the applause of many), has refused access to the most powerful television monopoly of the country: Televisa. It would seem that, thanks to Subcomandante Marcos, a cleansing is taking place of Mexico's often corrupt communications media, and Mexican journalists, inspired by the process, are trying to redeem their media. For a few months romanticism ranged the copy desks of a number of Mexican newspapers, and many reporters returned from Chiapas to Mexico City in an exalted state, saying their vision of the world and of themselves had been turned upside down.

Marcos's language is the language of a man who has survived the jungle and knows it well, a man who has eaten snakes when he could get them, a *mestizo* who gets sick to his stomach and has had an enormously difficult time getting used to the tropics. His language is new in Mexican politics; it is the beginning of a new way of doing politics—which is certainly a cultural phenomenon. Far from resorting to the usual calumnious political rhetoric, nothing in Marcos's speech reminds us of the speech of senators and congressmen. The language of Marcos, a *mestizo*, can clearly be understood by everyone; he shares the language of the men, women, and children of Chiapas. Marcos is familiar with the bites of the *Chechem* fly, or "evil woman," which causes delirium in its feverish victims; he knows about the dangerous *Bac Ne* snake, or "four noses." He knows how to find a path through the jungle in the rain where the branches of the trees form an immense green umbrella; he knows about walking for hours at a stretch carrying a forty-kilo backpack on his shoulder; he knows how to pitch a tent and tighten his belt for days; he knows how to live with other people; and he especially knows how to think. His language is the language of hard daily life, life connected to the soil, the language of survival. The language of politicians, from local representatives to the president of the republic, is the language of bureaucracy. Marcos writes from the soil and constantly speaks of his relationship with the trees, with the sunset, with the cold early morning hours, with the *zacate estrella* (star grass), with old Antonio, with Moi, Tacho, Monarca, Durito, with the inhabitants of Chiapas. He talks

to the mountains and the tall trees, to crickets and beetles, and that is why we feel his words resonate inside us and we hear them to be true.

The Zapatista demands as expressed in their Lacandón Jungle Declaration were cultural: work, land, housing, food, health, education, independence, freedom, democracy, and peace. They asked that all Indigenous languages be declared official Mexican languages, and that the teaching of these be required in primary, secondary, and high schools as well as in the universities; they also asked that their rights and dignity as Indigenous peoples be respected, and that their cultures and traditions be taken into consideration. They want the discrimination and contempt they have suffered for centuries to stop. They demand the right to organize and govern themselves autonomously, because they do not want to be subject to the will of powerful Mexicans and foreigners. They want their justice to be administered by the Indigenous people themselves, according to their customs and traditions, without intervention from illegitimate, corrupt governments.

Can a handful of poorly armed men and women (two thousand, three hundred Zapatistas) change the cultural system of a country, educate that country and make it grow?

In a country hungry for figures worthy of looking up to, the element of ethics in Marcos's identity is definitive. He has not only taken power, he has made our young people grow up, he has raised our society's consciousness, he has made that society participatory. Thanks to him, and I don't blush to say it, I think we are better people. At least Marcos hasn't lied to us, he has not betrayed anybody, and he has lived according to his

Zapatista supporters at the Imperial Palace, San Cristóbal de las Casas, Chiapas, Mexico, 1994. Photo by Wesley Bocxe/JB Pictures

ideas, which seems to be a lot to ask in our country. He stayed in the jungle for eleven years, he has shared and continues to share the Indians' living conditions, he means what he says, and he keeps his word. His war is *sui generis*, as he said himself on March 6th in a letter addressed to Miguel Vásquez, a boy from La Paz, Baja California:

One fine day we decided to become soldiers so that some day soldiers would not be necessary. That is, we chose a profession which is suicidal, since its objective is to disappear: soldiers who are soldiers so that one day nobody would have to be a soldier. Obvious, no?

The Zapatistas chose to start their war on January 1st, 1994, the day the North American Free Trade Agreement took effect. They took over the Plaza de Armas in San Cristóbal de las Casas without frightening the tourists on their Christmas holidays—this was so much the case that Marcos told some tourists who were going to the beach at Cancún that he hoped they would have a good time, and he told some others who planned to go to the archeological site at Palenque that the road was closed and, not without humor, added: "Excuse the inconvenience, but this is a revolution."

The fact that the tourists had not noticed means that the tranquility of San Cristóbal was not disturbed to an alarming degree by armed men in ski masks, wearing crossed bandoliers, and even carrying small machine guns. From the first moment, Subcomandante Marcos's style was not to kill whoever stood in his way. His guerrilla warfare was distinguished as being more political than military.

The government responded to the Zapatista offensive with violence. The war lasted twelve days, the army going so far as to drop bombs; afterward, they razed the land to get rid of any supplies with which civilians might support the Zapatistas. The international press discovered that Mexico was not a First World country but still remained in the Third World. The truth of the Zapatistas penetrated deeply into public opinion. Demonstrations by students, professors, housewives, and poor people were what stopped the army's genocidal attacks against the Zapatista Indians. Responding to public pressure, President Salinas said he would pardon the rebels. Subcomandante Marcos replied with one of the most impressive of his communiques (which have crossed oceans and received answers from Germany, the United States, Canada, Spain, Italy, France, England, El Salvador, Switzerland, Brazil, Holland, Chile, Norway, Japan, Puerto Rico, Panama, South Africa, and Ireland):

Why should we ask for pardon? What are they to pardon us for? For not dying of hunger? For not being quiet about our misery? For not humbly accepting the gigantic historic burden of contempt and abandonment?

For having taken up arms when all other ways were closed to us?
For ignoring the Penal Code of Chiapas, the most absurd and repressive
penal code in living memory? For having demonstrated to the rest of the
country and to the whole world that human dignity is alive and can be
found in its poorest inhabitants? For having prepared ourselves well
and conscientiously before we began? For carrying guns into battle
instead of bows and arrows? For having previously learned how to fight?
For all of us being Mexicans? For most of us being Indians? For calling
on Mexicans to fight in every way possible to defend what is theirs?
For fighting for freedom, democracy and justice? For not following the
patterns of previous guerrilla groups? For not giving up? For not
selling out? For not betraying each other?
Who should ask for pardon, and who is to grant it?
. . . Those who filled their pockets and their souls with declarations
and promises? The dead, our dead, so mortally dead of a "natural"
death—that is, of measles, whooping cough, dengue, cholera, typhoid,
mononucleosis, tetanus, pneumonia, malaria and other gastrointestinal
and pulmonary delights?
. . . Those who treat us like foreigners in our own land and ask us for
our papers and our obedience to a law of whose existence and justice
we know nothing? Those who tortured us, put us in jail, murdered us
or made us disappear for the serious "infraction" of wanting a piece
of land, not a big one, just a piece of land on which we could produce
something to fill our stomachs?
Who should ask pardon, and who is to grant it?

One of Subcomandante Marcos's proposals to Mexican citizens was the creation of a cultural space: a library in the jungle. Marcos and his Zapatistas provided the labor and the raw material, the citizenry supplied the maintenance and continuity.

Through collection drives, young people contributed several thousand books, and a number of university students traveled in caravans to the Lacandón Jungle to work as librarians. Now the library has ceased to exist; it was burned by the Mexican army. What harm was there in a library? Why not leave it for the people of Guadalupe Tepeyac, to whom it belonged? Were they trying to erase a symbol, the symbol of the Zapatistas?

Those who join the Zapatista National Liberation Army have to have finished elementary school. Zapatistas know how to read and write. If they read slowly in public, or if they stumble over certain words when giving a speech or reading a statement to the press, this is due to the fact that their first language is Tzeltal or Tzotzil. Education is a required topic of discussion for them, since one of their main proposals is to achieve literacy among the population—but they want to be the ones who teach the population to read and write. Our book-learned education is characterized by its removal from reality. For example, Mexican children are currently taught that every child should sleep in a room with the window open. Knowing as we do that 40 million Mexicans live (with their families) in two-room dwellings, whose only opening is a door onto the street—who are the children targeted by the official textbook? The last thing to be taught in rural schools is "know-how," and many children drop out of school by the third grade precisely because their schools have no relationship with their reality.

The most important cultural phenomenon brought about by the Zapatistas is their new attitude toward Indian women. For both young Indigenous women and those over thirty-five years old (because at thirty-five they are already old), to become a Zapatista is their best life option. Among the Zapatistas they feel respected. They used to work as maids, weavers, or embroiderers, and they were not paid half what their work was worth. Subcomandante Marcos has said:

We take good care of our women because, since they are malnourished, we don't want them to lose too much blood when they have their periods. Here in the Zapatista Army, the penalty for rape is the death penalty. A man who rapes a woman is sentenced to death by firing squad. Fortunately, we have not yet had to send anyone to be shot.

Zapatista women can choose the man they want to marry. Before, they were the ones chosen. They have the right to control their own bodies, and use a variety of methods of contraception, since they can't have children in the jungle. They can now look their husbands in the eye; they have become true partners.

Rosario Castellanos once told how on one of her journeys to Chiapas she met an Indian returning from the forest with his bundle of

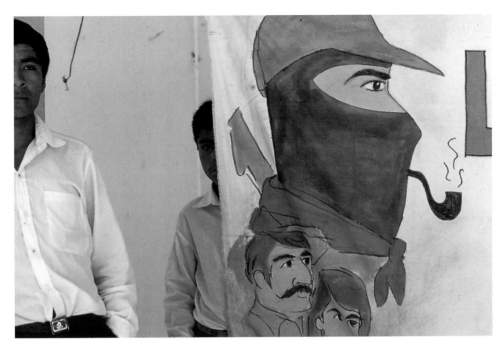

firewood, riding on a burro. Behind him, also with her bundle of firewood, his wife followed on foot. Rosario asked him:

"—So, why do you travel comfortably seated, while your wife follows behind you, on foot?"

Unperturbed, the Chiapanecan answered:

"—Ah, that's because she doesn't have a burro!"

We could say now that, thanks to the Zapatistas, the Indian women of Chiapas finally have a burro.

Translated from Spanish by Ellen Calmus

THE BORDER IS . . . (A MANIFESTO)

Guillermo Gomez-Peña

Border Culture is a polysemantic term.

Stepping outside of one's culture is equivalent to walking outside of the law.

Border culture means boycott, complot, ilegalidad, clandestinidad, contrabando, transgresión, desobediencia binacional; en otras palabras, to smuggle dangerous poetry and utopian visions from one culture to another, desde allá, hasta acá.

But it also means hybrid art forms for new contents-in-gestation: spray mural, techno-altar, poetry-in-tongues, audio graffiti, punkarachi, video corrido, anti-bolero, anti-todo: la migra (border patrol), art world, police, monocultura; en otras palabras y tierras, an art against the monolingües, tapados, nacionalistas, ex-teticistas en extinción, per omnia saecula speculorum. . . .

But it also means to be fluid in English, Spanish, Spanglish, and Ingleñol, 'cause Spanglish is the language of border diplomacy.

But it also means transcultural friendship and collaboration among races, sexes, and generations.

But it also means to practice creative appropriation, expropriation, and subversion of dominant cultural forms.

But it also means a new cartography; a brand-new map to host the new project; the democratization of the East; the socialization of the West; the Third-Worldization of the North, and the First-Worldization of the South.

But it also means a multiplicity of voices away from the center, different geo-cultural relations among more culturally akin regions: Tepito—San Diejuana, San Pancho—Nuyorrico, Miami—Quebec, San Antonio—Berlin, your home town and mine, digamos, a new internationalism ex centris.

But it also means regresar y volver a partir: to return and depart once again, 'cause border culture is a Sisyphean experience and to arrive is just an illusion.

But it also means a new terminology for new hybrid identities and métiers constantly metamorphosing: sudacá, not sudaca; Chicarrican, not Hispanic; mestizaje, not miscegenation; social thinker not bohemian; accionista, not performer; intercultural, not postmodern.

But it also means to develop new models to interpret the world-in-crisis, the only world we know.

But it also means to push the borders of countries and languages or, better said, to find new languages to express the fluctuating borders.

But it also means experimenting with the fringes between art and society, legalidad and illegality, English and español, male and female, North and South, self and other; and subverting these relationships.

But it also means to speak from the crevasse, desde acá, desde el medio. The border is the juncture, not the edge, and monoculturalism has been expelled to the margins.

But it also means glasnost, not government censorship, for censorship is the opposite of border culture.

But it also means to analyze critically all that lies on the current table of debates: multiculturalism, the Latino "boom," "ethnic art," controversial art, even border culture.

But it also means to question and transgress border culture. What today is powerful and necessary, tomorrow is arcane and ridiculous; what today is border culture, tomorrow is institutional art, not vice versa.

But it also means to escape the current co-optation of border culture.

But it also means to look at the past and the future at the same time. 1492 was the beginning of a genocidal era. 1992 will mark the beginning of a new era: America post-Colombina, Arteamérica sin fronteras. Soon, a new internationalism will have to gravitate around the spinal cord of this continent—not Europe, not just the North, not just white, not only you, compañero del otro lado de la frontera, el lenguaje y el océano.

'S É AN RUD É, CULTÚR, NÁ AN MÉID A DHEANANN SÉ (Culture is what culture does)

Gerry Adams

Ní liom é ní leat é, ní le héinne ar leith é. 'S é an rud é, cultúr, ná an méid a dhéanann sé. (Culture is not the preserve of any one set of people or of any one class. Culture is what culture does.)

Tradition and Identity

It is often said that there are two traditions, or two cultures in Ireland. There are not. There are scores of traditions, maybe hundreds, all making up a diverse and rich culture. All equally valid. All part of what we are. Urban and rural. Small town and hill village. Fishing port and island. Inner city and farming community. Gaeltacht[1] and Gallteacht.[2] Labourer and artisan. Visual, literary and oral. Feminist. Song and dance. Orange and green. Hurling and rugby. Football and handball. Pagan and Christian. Protestant and Catholic. North and south. East and west. The midlands. These traditions and all that they represent do not conflict. They are part of the diversity of Irishness.

Culture involves every aspect of our lives, and is not restricted to the artistic expressions which humankind has developed. Culture is the ideas and attitudes of people; it is an indication of how we view things, and it is our response to the environment in which we live. National culture is the reflection of the politics, economics, values, attitudes, aspirations and thoughts of a nation. It is the totality of our response to the world we live in.

Precisely because this is so, cultural colonialism formed and forms a major part of the conquests by some nations over other nations. This is certainly the case in Ireland. I have no doubt that this is true also of other colonised cultures.

Cultural colonialism demands the lowering of national spirit, the revision of history and the destruction of separate identity. It seeks to substitute men and women for mere objects. Objects have no allegiance— they are for sale. As Padraig Pearse, the Irish poet, teacher and leader of

1 Gaeltacht: an Irish-speaking area.

2 Gallteacht: an English-speaking area.

the 1916 Easter Rising wrote of the English education system in Ireland:

The English have established the simulacrum of an educational system but its object is the precise contrary of the object of an educational system. Education should foster; this education is meant to repress. Education should inspire; this education is meant to tame. Education should harden; this education is meant to enervate.[3]

Hundreds of years of such 'education' had its effect. In Ireland today a culture of dependency has been created. This reflects the ethos of survivalism engendered by centuries of British colonialist and imperialist oppression. In other words, it reflects the politics, economics, values, attitudes and thoughts of our rulers.

The Siege of Derry,[4] like the Battle of the Boyne,[5] is as much an influence and a part of Irish history as the Siege of Limerick,[6] the Famine or the Easter Rising of 1916. It reminds us also of the need to stress that 'Brits Out' is not a call, as is often mischievously suggested, for the banishment of Unionists. On the contrary, a peaceful, just and united society in Ireland must offer equal rights to everyone, Loyalist and Nationalist alike.

But this term 'two traditions' or 'two cultures' is a term which is incorrectly and often deliberately misused to describe what are in fact two different and conflicting political allegiances. They conflict because one expresses a notion of allegiance to the union with Britain while the other expresses a notion of allegiance to Ireland, to all the people of the island. There is not a clash of traditions or culture in Ireland. There is a division of allegiance created and sustained by British interference in our affairs.

The civil rights struggle was the beginning of the end of all this. The civil rights demands put the British state to a test. The state failed this test and reacted with terrorism. The demands were both moderate and modest: the right to vote at local government level, an end to discrimination in employment and the scrapping of repressive legislation. Almost thirty years later, Catholics are still twice as likely to be unemployed, and repressive legislation continues to deny citizens their basic democratic rights.

In 1969 the state died. It was revived by the British government, and since then has been kept alive on a life-support unit of British military forces. In the intervening twenty-five years, all of the institutions of Irish life have been affected, none have escaped. While the North has borne the

3 Padraig Pearse, *The Murder Machine*, pamphlet published in February 1916, weeks before the Easter Rising.

4 Siege of Derry, 1689. Apprentice boys (Irish and Protestant) successfully defended Derry against James II (English and Catholic).

5 Battle of Boyne, 1690.

6 Siege of Limerick, 1690-91. Limerick was defended by Patrick Sarsfield, when the city surrendered to the English. Afterwards, Sarsfield left for France with his followers, who became known as "The Wild Geese."

Adams

brunt of the conflict, the impact has been felt all over Ireland, and few of the institutions have risen to the challenge to the need for change which a democratic settlement demands.

As the present situation continues to evolve, and as the old certainties of the past give way, we are all challenged to reassess our relationships with each other, and in turn, the British government is moved to deal with the causes of conflict in Ireland. While there are signs of this happening at a grass roots level, to reach such an accommodation provokes for many an acute crisis of identity.

Community and Resistance

In Belfast now, and throughout the North, many nationalist communities have established their own people's festivals. Thrown back on our own resources (particularly in the most war-ravaged areas), there has been an exciting and myriad range of cultural happenings. The Ardoyne *Fleadh* and the West Belfast Festival, *Feile an Phobail*, are two such events. The *Fleadh* is a musical weekend. The *Feile* is a week-long celebration of song, music, dance, sport, drama, drink, art exhibitions, poetry readings and debate. A winter school, *Eigse an Phobail*, has also been created, not an ivory tower or an elitist junket, but an open-to-all place for the exchange of ideas of hopes and visions.

Young flute player, member of a Republican band, rehearses, Bogside, Derry City, N. of Ireland, 1988. Photo by Laurie Sparham/Network

Feile an Phobail grew out of a particularly vile period of our recent history when the people of West Belfast were attacked as savage subhumans. This reached new depths in 1988 when the community became victim of a particularly vicious campaign, which followed a series of incidents in which two British soldiers were killed at a funeral for one of the victims of a British and Loyalist gun and bomb attack on an earlier funeral. The festival was a response to the British media's attack on our community, and an expression of the people themselves: their creativity, humour, dignity and forgiveness.

A similar parallel would be the development of wall murals[7] over the last fifteen years, which express an equally inclusive assertiveness. They began to appear in Derry and Belfast as part of community resistance during the hunger strikes of 1980-81, reflecting whole communities' solidarity with the prisoners. As an artform, the work of the muralists has continued to evolve. While none of them has received formal art training, their enthusiasm and vision has created a panorama of wondrous gable-high

Dusk over Belfast, day of the funeral of the Gibralter 3; during the funeral three people were killed at Milltown Cemetery, and many more injured during a Loyalist attack by Michael Stone. Belfast, N. of Ireland, 1988. Photo by Mike Abrahams /Network

works of popular and resistance art. These murals are constantly attacked and damaged by British armed forces with paint bombs at night, only to be re-painted and repaired by the young community-artists in daylight.

Culture is our response to the world we live in. So it is with popular expressions like those I touch upon above. All of this tells us, among other things, that culture is not and cannot be the preserve of any one set of people or any one class.

Irish Language v. English Language:

It is to the credit of the Irish people that the Anglicisation process has never been totally successful. Even when the people were dispossessed, the hidden Ireland lived on as the culture of an oppressed people. Its decline can be dated to the modernisation of the relationship between England and Ireland, the Act of Union,[8] after which the emerging middle class strongly rejected the Irish language and customs. They embraced the 'new order' and rejected the 'old values'. To succeed meant speaking English. To be Irish was to be ignorant.

Social and economic advancement became synonymous with the use of English language, mannerisms and culture. This process has been refined in modern Ireland, and successive Dublin governments stand indicted on this score. In the late 1960s, the civil rights struggle provided a broad enough appeal to bring out a substantial proportion of the anti-imperialist population. As the struggle against British dominance has continued, it has been

7 For further reading on the wall murals, see "Culture, Conflict and Murals: The Irish Case," by Bill Rolston, p. 191.

8 The Act of Union, 1801: English parliament imposes the union between Britain and Ireland.

accompanied by an increasing awareness in the ideology of the nationalist people and a re-invigoration of our culture in all its forms. This has been markedly so since the prison hunger-strikes of 1980 and 1981, when the men in the H-Blocks of Long Kesh and the women in Armagh Prison were stripped of all their rights.

In the H-Blocks, with no books, no paper, no pen and no professional teachers, young men lived for almost a decade in filthy conditions. Frequently beaten, stripped naked but unbowed, they taught each other Irish by shouting lessons from one cell to the next. And as one hunger strike was followed by the other, the people outside the prisons learned these lessons also, and they determined to carry on the cultural struggle, each one from where she or he was. The Irish language became a means of resistance, of asserting both their dignity and identity.

There is no such thing as a neutral language, for language is the means by which culture, the totality of our response to the world we live in, is communicated. When a people has spoken a common language for thousands of years, that language reflects their history, sentiments, outlook and philosophy. Culture is filtered through it, and when the language is lost, much of what it represents is also lost. The Irish language has more than 2,000 years of unbroken history. Apart from Greek, Irish has the oldest literature of any living European language. It is the badge of a civilisation whose values were vastly different from the one which seeks to subjugate us. It is a badge of our identity and part of what we are. If the conquest was to be successful, that badge had to be removed, that culture destroyed and that civilisation replaced by an order which accommodated and acquiesced to the interests of our rulers.

There is nothing trivial or 'folksy' in the present interest in the Irish language. These positive attitudes toward the language and culture today extend beyond the occupied areas of the North. In Belfast, there has been a considerable revival in the use of Irish, and the particular significance of this is that it is the first time it has ever happened within a working-class community.

In practice, this revival is expressed in small ways, with language classes in social clubs, with the Gaelicisation of street names and the growth of Irish language schools. The British government continues to outlaw

Irish-language street names and refuses to fund Irish language schools like *Meanscoil Feirste*. The effort to colonise our minds continues on many levels, from censorship within the mass media (television and radio) as well

as in small and trivial ways. Inevitably, the Irish language holds different values and meanings to different people throughout the island, and is spoken for a myriad of different reasons. It is a remarkable, indeed an historic achievement, that the language survives. It can therefore be said with some certainty that the Irish language would prosper in a new Ireland,

Replacing street signs in Irish, 1994. Photo by Sean McKerran/Belfast Exposed

and that in my estimation a bilingual Ireland is an achievable objective.

We must strive to strengthen not weaken our culture and our identity. A language, like any aspect of culture, is not static; it changes and continues constantly to reinvent itself. Without our language, our culture cannot continue to develop its own unique and specific identity.

Irish people who express hostility to the Irish language are denying their own past. The language is the property of all our people. It is our common heritage. Prior to partition, Irish Protestants and Catholics alike played leading roles in Irish music, literature, language and theatre. Those who do not wish to learn or use Irish cannot and should not be compelled to do so, but those who wish to speak the language must be encouraged and empowered to do so. A bilingual Ireland, culturally diverse and reflecting the totality of all our people and all our diversity, must be our aim. What is crucial for progressive forces is an understanding that the Irish language is the reconquest of Ireland, and the reconquest of Ireland is the Irish language. A failure to grasp this, apart from a legitimate patriotic desire to restore our own language and to maintain an Irish cultural identity, means that, if we only function unquestioningly as a dustbin of Anglo-American culture, we will remain morally, psychologically, intellectually and materially worse off. *Beirigi bua/Adalenté*

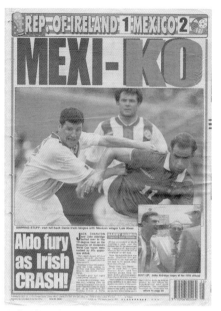

Daily Mirror, 25 June, 1994

"Irlando": Mexico vs. Ireland

Orlando, Florida—World Cup, 1994.
Like most international sporting
events, the 1994 World Cup was the
perfect impetus for clannish and tribal
behavior the world over.

In Ireland and Mexico the streets
were empty—town after town, city
after city—people glued to television
sets. As is often the case in Ireland,
sporting alliances reinforce political
divisions, and this World Cup was no
exception; a sectarian attack occurred,
killing Catholics viewing the game in
a country pub. In Belfast, Loyalist
graffiti mocked the Irish soccer team's

English-born players, labeling them
mercenaries. In Mexico, large crowds
took to the streets to celebrate each
victory, waving national flags and
shouting, Viva Mexico!

As a host of the World Cup, the
United States, the fictional *melting
pot*, became the international *salad
bar*. At each game, immigrant com-
munities from all over the world
displayed caricatures of their own
ethnic identities. For those few
weeks in the summer of 1994, it
was acceptable not to hyphenate
Swedish, Brazilian, Dutch, Irish,
and Mexican with American. People
who had spent their lives investing in
assimilation reveled in their ethnicity.
What emerged from the millions of
spectators was Disneyesque—Swedes
sported yellow-blonde braids, Dutch
wore clogs, Irish donned green paint
and shamrocks, and Mexicans showed
off large sombreros and Zapata
mustaches. At the Ireland vs. Mexico
match in Orlando, it was hard to
distinguish where Disney World
began and ended. The city became a
theme park; Epcot became a reality.
It's a small world after all.

Trisha Ziff

In Brief

Holiday accident woman comatose

A Carrickfergus woman is in a coma after an accident in Majorca.
Josephine Connolly (37) was on holiday with her young son and two work colleagues when the accident happened. It is understood she was injured to fall.
The mother of three, who was flown home at the weekend, is on a life support machine at the Antrim hospital.

Schoolboy pals die in bike tragedy

Two schoolboy pals who were killed when their motorbikes crashed did not have helmets fastened properly and were not using lights, an Aylesbury inquest was told yesterday.
Andy Sharp (16) and Oliver Jutton (14) collided head-on at 38mph as they drove to meet each other along an unlit road between the two farms where they lived with their parents.
Andy died at the scene. Oliver was rushed to hospital but died later.

Major still backs Brittan

PRIME Minister John Major was still firmly backing Sir Leon Brittan last night in the race for the European Commission presidency.
But the former Cabinet minister's candidacy was seen as little more than a distraction alongside the rising fortunes of Belgium's Jean-Luc Dehaene.
The federalist Belgian prime minister has become the new flavourites for Tory Euroscepticists.

Sad parting for principal

LOUGHMACRANE headmaster Ben Ward has retired after 45 years at St Macartan's school. Northern Ireland's longest serving principal has many marvellous years to cherish, but last week's massacre at Loughinisland has cast a shadow over his long career story on P3.

Weather

Dry with sunny spells after a misty start. Max 16C. Sunday's outlook: rain.
Details P4

Inside

Family notices	2,3,4,5,7
News	2-13
Mart	3
Press crossword	4
Editorial	6
Weekend	8,17
Classified	18
Farming	19-22
Sport	9-16
TV, Radio	23,24

We want peace now

● FOOTBALL FAITHFUL...sisters from the Good Shepherd convent in Twinbrook in west Belfast share in the excitement of Ireland's World Cup exploits during last night's game against Mexico. The nuns changed their daily prayer time

Mexican tacos too hot for Jacko

From Mary Carolan
in Dublin

IRELAND went on, oh, oh, oh last night and lived to fight another day after Mexico's victory in the crucial World Cup clash.
Fans were down but not out after the Mexican chilli peppers proved too hot for big Jack Charlton's squad in Orlando.
Despite losing 2-1, the Republic could still qualify for the next round.

Shortly before kick-off yesterday, the fate of six other soccer fans was remembered throughout Ireland.
Pubs and homes fell silent for one minute in tribute to the six men murdered by the UVF in Loughinisland, as they watched the Republic's last World Cup game against Italy.

The gesture was co-ordinated by unions representing publicans and bar workers, sports bodies and the New Consensus group.
Extra detectives were also on duty along the border to help prevent another loyalist atrocity planned to coincide with the World Cup celebrations.

But the additional security failed to dampen spirits – as co-nuts their sale.
The country, north and south, was hotter than a fiery red chili pepper for the crucial match with Mexico.
Pubs had the biggest fiesta since the 1990 World Cup as thousands celebrated the team's performance...

Closing time came early

By Chris Hagan

THE doors of the north's pubs were closed early last night as people stayed away in droves and watched Ireland's march on television at home instead.
Landlords across the whole of Northern Ireland reported a drop in the attendance of bars.
Many said the early Saturday night closure...
The D'I retreat to Mexico last added to the misery for the regulars who did turn out.
In Belfast there was a heightened visible security presence in many of the areas to the west of the city vulnerable to a loyalist attack.
Staff at the Front Page in Belfast's Donegall Street

Chain gang gears up for Maracycle

COOPERATION NORTH'S Maracycle '94 got under way yesterday, with 2,300 enthusiasts making the gruelling journey from Nealy's pub in Dublin to Belfast, where they spent the night.
It started earlier than usual because of the World Cup match between Ireland and Mexico. The Dublin cyclists were due to join the 1,700-strong northern contingent outside the Queen's University PE centre at 2.30 this morning for the 100-mile trip south. And on Sunday, the northern cyclists will return to Belfast.
Cooperation North has asked motorists planning to travel on the main road between Dublin and Belfast for extra caution and reduced speed when cyclists are in view.
The cyclists are expected to cross the border at about lunchtime each day, arriving in Dublin and Belfast during the afternoon.

● Leader: P6

● THIRSTY WORK...Jean McGrory takes a well deserved drink after the 100-mile journey north to Belfast Picture: Hugh Russell

Hotel plan to lure anglers

By Conor Macauley

UP TO 50 new jobs will be created if planning permission is granted for a new £3 million hotel.
Developers want to convert the existing Harday Restaurant complex of Shaws Bridge, south Belfast, into an 80-100 bedroom four star hotel.
If approved, conversion work could be finalised and the premises open for business with a range of conference and a la carte restaurant facilities by August next year.
It would double the existing full-time workforce and provide a further 50 seasonal jobs.
Owner Gerry Diver said its new "fairly com-

...fortive" tax bill would be successful. Permission for a 40 bedroom hotel had already been granted but was not considered financially viable as the second submission was made.
Mr Diver said: "We're hoping to enter the market with a four star standard but at a lower price range. We want to give quality and value for money."
He was confident that, despite a proliferation of hotel developments over the past few years, a ready market exists: "A tourist board report two years ago identified the need for three 80 bedroom hotels in the greater Belfast area.
"We would fulfil the need for one of these. The

...rooms are being designed to be suitable for families. We're aiming at the leisure market and hope to tie up with theatres to offer entertainment packages.
"We're keen to bring business back in as well. We'll have the latest business technology and we're ideally placed all the ring road, close to the motorway."
And in a keen Kilkenny, Mr Diver has an additional lure for potential clients who are members of the angling fraternity: "Now that salmon are being caught in the Lagan again it's great for business because we have a military running along the bottom of the grounds."

Reynolds delivers uncompromising message to IRA

NOTHING less than a complete end to paramilitary violence is acceptable, Taoiseach Albert Reynolds warned yesterday.
"We want it and we want it now. The recent spate of violence is incomprehensible as far as the people are concerned," he said.
Mr Reynolds was speaking after discussing Northern Ireland's future with British Premier John Major on the fringe of the European Union summit in Corfu and before an Anglo-Irish summit.
They said to a determined bid to show that the peace process was still on course despite the continuing bombings and shootings.
Although a firm date for next month's summit has yet to be fixed, Mr Reynolds said the timetable for completing the framework document, which will launch new constitutional talks, was tight.
"We are dealing with very complex matters," he said.
"There are plenty of key problems. But nobody is refusing to move on anything. We are getting officials to define the work and they are continuing now."
Mr Reynolds said he hoped for a response next month from the IRA on the prospects for a ceasefire: "The delay in the cessation of violence and the start of peace is one day too long as far as we are concerned.
"We want a permanent cessation of violence on both sides. That is what the people want and that is what both governments want. The same message must go to paramilitaries on the loyalist side."
British government officials said the talks had restored the state of negotiations in a bid to give a clear "impulse" to further work that still needed to be done in some areas.
Unionists have been told by the British government...
This is a ghost town as the hours to the 5.30 kick-off ticked by. The city centre streets were deserted as all cars were on the Irish team in Orlando.
But as soon as the final whistle was blown the city came to life as fans spilled out to the streets.
The main thoroughfare O' Connell Street was closed to traffic as the garda party got into full swing.
Gardai warned fans not to ride on car bonnets. A spokesman said: "We are not killjoys. We just want people to enjoy themselves without going over the top."
The country is now looking forward to next Tuesday's clash with Norway in New York.
Business leaders have already asked employees to show flexibility for the game, which is due to kick off at 5.30pm Irish time.

...being a request for clarification of the Downing Street declaration.
In a nine-page letter to UDP councillor Gary McMichael, he said it would be wrong to attempt to impose a united Ireland – it could only be achieved with the "freely given agreement and consent" of northern people.
But he spelt out just what unionists did not want to hear: "In the rapidly changing conditions of today's world, the achievement of a united Ireland by agreement and consent would provide the best and most lasting solution."
That did little to ease the fears of unionists, who have attacked him for remarks made during the week.
Mr Reynolds said he would like to see a cross-border authority with power over the north before the Republic would give up its constitutional claim over Northern Ireland.
Ulster Unionist leader James Molyneaux said: "Withdrawal from the common ground in Northern Ireland is not a price which we will pay for an academic commitment to remove an unredeemable territorial claim."
Joint authority that no authority is any part of the world and now a recipe for increased instability and tension, he said.
There was optimism over solving remaining constitutional problems such as the issue in the Republic's claim to the north and the question of new cross-border institutions.
Taoiseach Dick Spring said: "What we want to get is a framework that is acceptable to both communities in Northern Ireland – because ultimately they have the authority, the power to bring agreement, by motion or otherwise."

● SF on peace: P3
● Editorial: P6

● TALKS: Irish Foreign Minister Dick Spring and Prime Minister Albert Reynolds arrive in Corfu for bilateral talks with the British delegation

CULTURE SHOCK

Fionnula Flanagan

The Artist Has the Last Laugh

From a very early age I grew up speaking both Irish and English on a daily basis. Irish was spoken all day at school and English was spoken at home.

My parents were not native Irish speakers and their fluency was scrappy. My mother could sing the national anthem, hold short, polite conversations of a basic nature and was fond of teasing us children with a couple of the aphorisms she knew: *"Aithníonn ciaróg ciaróg eile"* (literally, One spider recognizes another. Or, as we would have it today: "It takes one to know one"). And whenever we fretted about some aspect of our lot in life, measured against the attraction of far-off hills which seemed forever greener, she would trot out: *"Níl aon tintean mar do thintean fún"* (There's no hearth like your home hearth).

My father's vocabulary was minimal, which he would never admit. His usage, usually inaccurate, was nonetheless flamboyant. I overheard a Russian sea captain ask him once if he spoke Irish and my father told him rather grandly he was fluent! As children we delighted in gabbling questions at him, knowing full well that he did not understand, though he always pretended he did. His response was always the same, unhesitating, always monosyllabic. Faking comprehension and intellectual gravity by clearing his throat, he would proclaim, invariably incorrectly, but loudly, and in a tone of great importance—*"TÁ!"* (Is).

My mother rolled her eyes and laughed and said he was incorrigible.

But they believed passionately in the idea of nationhood for Ireland, and in the maxim *"Tír gan teangan, tír gan anam"* (A nation without a language is a nation without a soul), and determined that their children would acquire fluency. They understood that mastery of our native tongue would provide each of us with an essential key, an access code, into an individual and unique ownership of who we were within that concept of Irish nationhood, whether historic, actual or potential.

So when we reached school age, they sent us to an inner-city national school where Irish was both the language of communication and instruction. This was referred to in the Dublin vernacular as "learning through the mejum (medium)," and accorded at that time, by all but Irish enthusiasts, the same mixture of suspicion, scorn and pity commonly reserved for operators of the ouija board.

The school was one of fewer than half a dozen such throughout the country. Irish, like math, was a compulsory subject in all national schools. However, outside the official Gaeltacht areas where it was natively spoken, most all national schools taught Irish as they did the rest of the curriculum, through English, and English was the language used by both the students and teachers on a daily basis.

My mother was frequently challenged, by well-informed neighbours in the housing project where we lived on the north side of Dublin, on the wisdom of daily bussing her young children to the ubiquitous, dangerous inner city, to attend an all-Irish institution, rendered triply suspect for being staffed exclusively by lay teachers and under the direct management of the

My mother's hands, 1995. Photo by Fionnula Flanagan

Department of Education and not of a parish priest. Didn't she know she could have saved the bus fare and had us wimpled into submission right round the corner by the Holy Faith? And what did we need to be fluent for, in a language that was dead and no use to anyone?

"Useful or not," my mother would quietly reply, "it's our language and it's no burden to carry."

"Bloody nuns!" my father would bellow, needlessly.

I am and will be forever grateful to them both.

As I write, my father has been dead for almost five years. My mother, now suffering from senility, lives on in Dublin, where she is compassionately

My mother's hands, 1995. Photo by Fionnula Flanagan

and comfortably cared for. When I go there I visit her daily. Many times she does not recognise me, but is too ashamed to ask me who I am. I always tell her, but my name drifts away from her. She cannot hold onto it. I feed her chocolates and hold her hand and talk to her about simple things and try not to cry.

I ask her if she has heard from her other four children recently. They and their children are scattered on two continents, from New York to Sydney. She doesn't seem to remember. I name them for her. She looks at me accusingly and tells me they were here a minute ago. She has embarked on a journey to a country for which I have no entry visa. I can only stand on the pier and watch her little boat recede. And hope she will look back, see me and wave.

She tells me my father is out in the garden.

I don't know why I suddenly reply in Irish. Perhaps the change of rhythm will dispel the knot in my throat. Hold back the tears. I am not even sure she has heard me.

"An bhfuil sé? Deir tú liom é!" (Is he now?!) She glances at me. Her eyes are suddenly focused, merry with recognition, complicity.

"He's out there now! And wait till I tell you—"

"Is he?"

"Yes, and—" Her voice rises into a giggle.

"Now?"

"He said . . ." She is giggling so much she can hardly speak.

"What is it, mother?"

"He . . ." Tears stream down her face.

"What?"

She struggles, helpless with laughter.

"Tá! . . ." And out it comes. "He said *TÁ!*"

I stare at her. "He said—*TÁ?*"

"Yes! Yes! I'm telling you—" She is off in another gale of laughter, mopping her eyes. Then I remember. And we are both off now, giggling uncontrollably, our laughter echoing from the high ceiling, buffeting the window where the winter garden waits, a silent shade.

"Knock-knock!" beams a nurse face as it tilts around the door. "Are we alright here?" And instantly answers itself. "Grand!" she assesses, cheerfully.

Our laughter abates. "Now!" the nurse face exclaims, in benediction, pleased she has invented us. And vanishes.

I catch my mother's eye. "*TÁ!*" I murmur, and we are off again, our faces awash, my ribcage aching.

It goes on and on until we are both wheezing, breathless, listing in our chairs and the paper hankies are used up, strewn all around us on the floor, primroses in the darkening wood of the room. She taught me to find. On summer evenings long ago. I genuflect to gather them.

"Tha' was," I tell her, in the Dublin vernacular of my childhood, "the bes' laugh!"

With my mother. And my father too, I like to think. I turn and look up at her.

She is fidgeting with a tissue. Her mind has moved on to other concerns that do not include me. She can no longer remember the joke.

She is tired. Her eyes close. Her hands lie like injured birds in her lap, never quite still. And I can see that her boat is moving closer to the open sea.

Now I can leave. She has waved.

A visit with my mother, Dublin, 1995

The Artist in the Empire and Vice Versa

It is a small sign. I spot it as I lift the latch of the iron gate, which is lopsided and swings away from me. Propped discreetly in the left lower

corner of the front bay. I cannot read it from here. I expect it will say 'Please Beware dash Dog!', as many of them do. Or, blank space, 'Pints Today Please', for the milkman, because they're so organized and polite over here. Not like at home where he has to count the empties or be a mind reader if we forget to put them out.

Leave the case here. Too awkward to carry up the path. Prop the gate half shut. But what if a dog comes tearing out when she opens? Onto the road and hit by a car? I'd be responsible. Hardly likely to get lodgings then. Killing the landlady's dog. Have to pay for it too. I shouldn't think, as they are always saying over here. Why, I wonder? A warning. Must believe thinking is bad for them. Perhaps that's a basic tenet of theirs. How-do-you-do I'm your new basic tenet! Maybe she hasn't got one. Didn't say anything about pets on the ad. There, leave it across the open gate. That should stop him. Unless he has a death wish, in which case nothing will. But take the make-up box. Looks good with its worn leather-bound corners. Dark maroon once when the mahogany was new. My father's gift. That he got for a bargain he said from an auctioneer fella that owed him a favour. *Early 19th. Century Mahogany Theatrical Make-up Case; Poss. French*, in spidery faded violet ink on the antique dealer's tag. Which I keep pinned to the satin lining of the smallest compartment. I'll show her that when we get into conversation about it. Because she's bound to ask. And the brass plate with my name and the Abbey's name on the lid that my mother had made for me. I won't say *Thespian* because we in the theatre don't. But if she does I'll smile. At least I'll know she has some savvy. Then I'll ask her do you know that it's less than a hundred years since actors had a price on their heads, in France? That always amazes people. At home they think it's only rebels or priests. The canny French. Knew we were both. Artists, therefore dangerous. Richelieu started it, was it? Well I won't tell her all that. Frighten the life out of her.

See myself approaching in the shine of the letter-box flap. All wobbly. Are my legs fat ? Should wear higher heels. Smell of floor polish. Clean anyway. Hadn't expected to have to pay so much but at least it looks a respectable street. Has a certain decorum, as my mother would say. What does the sign say? Marine blue letters someone has stenciled. Curling script on a white card. Capital N and I trailing tendrils reminiscent of

Gaelic lettering. Must be the right place so. The card veiled by the net curtains. Genteel. Drawing me forward towards the steps. Like the best fishing lures. Now I see it. What? Eyesight! Squinch them tight and open. A joke, is it? What? Or mistake. Must be. A foreign language.

No Coloureds or Irish.

The air is all of a sudden chilled, still. In the eye of that stillness there is no sound. Only the sign. Watching my confusion. To see what I in my Irish foolishness will do. Next. Must tell someone. Who? Panic. Someone. There must be someone to. Why is my heart going so fast? Scalding. Tell them. Can't think of. What? Who? Your credentials girl and be quick about it! My-mother's-sister-served-as-a-nurse-in-the-Royal-Alexandras! My-father's-father-fought-in-India! Don't! Must get away from here before someone. Say it's a wrong address if they. Why are my hands shaking? Back up the path or turn? My life hangs on which. What is the protocol? That can save me. Quick!! Out with it! Subjects must back away from the monarch. Bowing. Yes! Shakespeare! No! Wait! Before that. The comics! *The School Friend.* That my teacher said was British propaganda and trash. Threepence weekly. Good Queen Bess. The Adventures of. Whom I secretly envied. A mere girl, they said. But with plucky chums. Of Yeoman stock. Who won out. Always. Tiny hand in a seed pearled sleeve raised in gracious acknowledgment of all the avid readers of her bubbles. Where Ireland never intruded. Why couldn't she have been ours instead?

No Coloureds or Irish.

God the gate is a hundred miles away! Will the Good Queen save me now? Communist Republican's daughter I? Should I close it after me? Can't move. Mute. I am not what you think I am! Ah! But I am! I am.

A shape moves in the room and a head inclines towards the window. Through the net a child's face peers, blankly curious. No qualms of entitlement there. Our eyes meet. I am released. Red-faced. I whirl and am hurrying too fast back down the path, I've been led up. Quick! Shove

the bloody suitcase through. The gate begins to swing shut. Get out! Get out can't you! Back up through it. The make-up case bangs against the bars. Flies open. Heifer! Jarring pain streaks up the left arm. O Jesus! Lid of the box yawning, hairpins and photographs cascading down to the pavement. Grab at them but they slip through my fingers like lost opportunities. Twenty identical faces of myself stare back from their strewn positions. Serious as a postulant, resume attached. Pitiful, actor's assets. Ha! Hunker down and slam the lid shut. Turn to gather them and a brown hand is stretching towards me from a tweed cuff, proffering a bouquet of my image.

"Here you are Missy."

Soft Indian voice hunkers down to eye level.

Liquid brown eyes and a turban; he reaches for a stray photo.

"Very pretty. May I ask are you an actress?" He makes it sound like temple dancer.

"A model, perhaps?" Soft, teasing voice.

The worm of shame squirms in my chest cavity. Snaking downwards to my hips. I know what models do here. Don't, please! I give no answer. My face is a beet root. Go away.

I grasp the photographs but for a split second he increases his grip, withholding them.

"You are a model?" More insistent now. The brown eyes hard, smiling slightly. Slut, he means. I want to kill.

I snatch the photographs and propel myself upright, make-up box handle grasped tightly in the right hand. Murderous with humiliation. I'll swing it if I have to.

"I don't want your help. Thank you. Just leave me alone."

I am reaching for the suitcase, the photographs forgotten, crushed now between my fist and the suitcase handle.

"I am not one of your slut temple dancers!" I am using my stage authority voice. I crack it like a whip. I hope I sound English.

I see his eyes and catch reflected there the shock of my abuse. But I have not done. I will savage my brown brother into his place as I have been taught.

"My grandfather fought your kind at the Khyber Pass!"

Degraded, I am fast walking down the street away from him,

leaning away from the suitcase weight, the make up case bumping my knees. Jesus! Why did I say that? It isn't even true. Granddad hated the British Army! Crushed photographs tumble like leaves in a trail behind me. I stumble on.

Sweat is pouring down my ribcage. Roaring sound between my ears. Breath thundering. Make for the corner. Round it. Safety! Where am? Out of Terrace and into Parade. Roaring worse now. Sit down for a minute. Area railings. Hold on. Easy does it. Make-up box on the ground between your feet. Something solid. Going to faint. No you're not. Not here, your first day over. Put your elbows on your knees and get your head down between them. Can't. Unknown young actress faints on London street. Just breathe. What if somebody? Pretend you're reading the lid. Concentrate! Breathe! Feel dizzy. Keep breathing! Deep breaths. Read. Can't. Upside down. C-o-n-c-e-n-t-r-a-t-e.



Miss Fionnghuala Flanagan
Abbey Theatre School
Dublin.



Think of the inside. Secret compartment. Thank God it didn't open. See it. Brand new stick of Carmine still in its cellophane and gold wrapper. Keep it from streaking the greasepaint sticks. Like fat fingers they are, lying side by side. Breathe. Count them. Leichner's number two, Leichner's number three. That's good. Breathe. Out loud. Leichner's three and a half. Don't want to do this. Feel sick. Keep the head down. Breathe. Five and nine for a suntanned look. Dot of carmine red in the eye's inner corner. For youth. Keep going. And a Lake liner in case I play a crone. Or a consumptive. They sweat like this. Feel weak. Probably white as a sheet. No colour. Or Irish. O God I'm—

Down in the West End, the black taxis are circling Eros, purring the London audience towards an evening performance. *Perhaps the Shaw? Something about John Bull's Island. Other Island darling. Yes, well, whatever that means. Or the Oscar Wilde one. You know with Lady Whatsit? Bracknell. Yes. So amusing. But we must see the Irish one—O'Casey, I think. Dark, they say. Really? How odd! They're usually so funny.*

Up in NW5, on the pavement where Terrace and Parade collide, on this fine Autumn evening in 1964, I am losing consciousness. As blackness descends it seems that all my young history, and my father's history and my mother's history, and their fathers' and mothers' histories and their fathers' and mothers' before that again come rushing forward to meet this moment.

Half the world away on the far side of the Atlantic, they have not yet marched in Birmingham. Freedom Riders have appeared but not on our horizon. Yet they will. They surely will. Unknown to me, somewhere in the dark hills of Tyrone, a young woman called Devlin is looking westward, listening. A mere girl, they will say. Soon the world will never be the same again.

Everything I've learned in life I learned through Culture Shock.

The Artist's Unwritten Resume

I grew up in gray post-war Ireland of the forties and fifties. Before Television. Before Vatican 2. Before Revisionism. Before the Car Ferry. I was born in Dublin, capital of an ancient, cultured, island people in the Atlantic who have survived more than eight hundred years of systematic, orchestrated attempts by our closest neighbours to annihilate us and steal our land.

To this end, they imposed on us some of the harshest and most unjust laws mankind has ever devised, and when we rebelled they evicted, imprisoned, banished and murdered us. They persecuted and outlawed our religious practices and taxed us cruelly to pay for theirs. They suborned our spiritual leaders who aided and abetted them and joined them in degrading us further. They destroyed our institutions, then proclaimed us dangerous savages for having none.

When, armed with little more than farm implements and outrage, we struck back at them, they deported us by the hundreds of thousands to penal colonies at the ends of the earth where our women became indentured servants and our men became slave labour for their prison industries. We built them the greatest seafaring vessels their navy had ever known. Our women carved out crude homes from the Australian bush and the American prairie, and slaved as cooks and kitchen maids, and yet bore children whose children became teachers and law makers and explorers

and generals and labour leaders and revolutionaries and film stars and secretaries of state and presidents of nations.

When the potato crop failed and we suffered the greatest holocaust of the 19th century, reducing our population by half in the space of twelve years, they seized the opportunity to clear us off the land completely and 1.2 million members of bewildered Irish families who could not, or would not, make the perilous journey to other shores, clung together in holes in the roadside ditches and died in demented wild-eyed terror as starvation and fever wiped them out.

They called us sub-human. Their cartoonists drew pictures to prove it, and they were reproduced as warnings in smart periodicals in the New World where we landed, against all the odds, desperate for any chance to hold onto the slender thread of life.

We lived in stinking hovels in shanty towns in the heart of urban America, and those of us who endured survived poverty we could not have dreamt of, and prejudice that rivaled what we had left behind.

Scornful of our language and ignorant of its beauty and complexity, our masters ridiculed it, taught us to demean it and finally outlawed its usage, imposing their own.

We took that and honed it and produced Shaw and Sheridan and Synge and Wilde and Yeats and Joyce and Beckett and Sean O'Casey and Evan Boland and Brian Friel and Bram Stoker and George Moore and Seamus Heaney and Kate and Edna O'Brien and Scott Fitzgerald and Henry James and Eugene O'Neill and Frank and Flannery O'Connor. And hundreds more of their kind. Brilliant beads on the literary rosary that loops Ireland to the farthest reaches of the Irish diaspora.

For centuries they loosed upon us the might and sophisticated brutality of their empire, and the nations of the world did not intervene. We were not liberated. We invented modern guerrilla warfare to resist them and were called terrorists.

From Skibbereen to Suez we have cleaned their floors and cooked their meals, raised their children and dug their railways, staffed their hospitals and nursed their sick; fought and died under their flag from Belfast to Burma. We do it still.

The Dublin telephone directory is a Who's Who of the outpost

institutions they left us. Hand-me-down titles we tout as symbols of a national identity that continues to elude us.

The Royal Academy of Medicine in Ireland, Royal City of Dublin Hospital, Royal College of General Practitioners, Royal College of Physicians of Ireland, Royal College of Surgeons in Ireland, Royal Dublin Golf Club, Royal Dublin Society, Royal Hibernian Academy of Arts, Royal Horticultural Society of Ireland, Royal Hospital, Royal Institute of the Architects of Ireland, Royal Institution of Chartered Surveyors, Royal Irish Academy, Royal Irish Academy of Music, Royal Irish Automobile Club, Royal Irish Yacht Club, Royal National Lifeboat Institution, Royal Society of Antiquaries of Ireland, Royal St. George Yacht Club, Royal Victoria Eye and Ear Hospital.

They have taught us and we have learned well. Good Queen Bess must be laughing up her seed-pearled sleeve.

They have never apologized, the plucky chums.

We, the savage, the sub-human, from the ruins of our self-esteem, from our grief and treachery and humiliation at their hands have salvaged one entitlement only. The Right to Imagine. We have forged it into an institution. It is possibly the only truly Irish one we have. We use it to tell ourselves who we are.

Culture shock? 'Tis mother's milk to us.

The Artist Goes to the Ends of the Earth

In 1993 my husband and I were invited to take part in an international conference on Social Dreaming in a tiny seaside resort on the wildly beautiful coast of New South Wales.

We took advantage of the trip to Australia to make a detour from Melbourne by air to Hobart, Tasmania. From there we drove for two hours by car through wild bush and picturesque farmland to the farthest tip of the Tasman Peninsula, gateway to Antarctica, to visit the Penal Colony of Port Arthur.

Today Port Arthur is a series of ruined buildings now excellently preserved by the Australian Government, which has courageously documented the shameful history of this institution and designated it a national monument. In the 1840s its name undoubtedly evoked as much

terror as would the names of Nazi labour camps a hundred years later.

With the loss of the Americas in 1776, the British Crown also lost the right to transport convicted felons from their overflowing prison system to states such as Maryland, Virginia, South Carolina and Georgia. Other outlets had to be found, and as far from the stately homes of the British ruling class as possible.

The secession of the Americas also raised the spectre of further losses of Empire should the conflagration of freedom jump the Pacific Ocean and spread to the Orient where Britain had immense holdings. A military toe-hold with accessibility to the Far East and within easy striking distance by their navy would be necessary should such an emergency arise. Rich in timber, Australia and the island of Tasmania—then called Van Diemen's Land—off its southeast coast satisfied both requirements.

The Penal Colony at Port Arthur with its attendant garrison was opened on the southeasterly extreme of the Tasman Peninsula in 1830. It was intended for those transported convicted felons classed as "Incorrigibles."

Within the first three years of operation, the prisoner population under sentence at Port Arthur rose to five hundred men, the number of military personnel guarding them to four hundred. The prisoners, working in chain gangs, were made to carve the site out of the wild bush, build the garrison quarters and then their own stone cells. Each cell measured six by three feet.

Prisoners wore a coarse hessian uniform of yellow, the colour of humiliation, fashioned together with black to resemble the traditional Court Jester or fool in society. They worked in irons, waist deep in icy salt water for the first six months. They had no change of clothing. Once wet, the uniform became heavy and rubbed the flesh raw. Damp ate into the bone. They worked in silence. This hard labour became standard introductory treatment for all new prisoners from then on. In the words of Governor George Arthur, ". . . that within the bounds of humanity the offenders are to be subjected to the last degree of misery."

Houses were built for the officers by the prisoners, who also laid out a Victorian rose garden for the officers' wives and daughters. English oaks and elms were imported, and a chapel with fourteen spires modeled on an English country church was added to make the garrison feel at home.

The Sabbath commenced with punishment time in the yard in the early morning attended by the entire population of the garrison and the prison. For the slightest infraction of the rules prisoners were flogged. Absconders could expect up to a hundred lashes. Standing Orders decreed that those who fainted in mid-flogging be revived in a shallow salt bath so that the punishment might be continued, intensified. The prisoners were then marched to the chapel where attendance at the service was compulsory, irrespective of denomination. They sang hymns.

The prisoners planted a vegetable garden, constructed a mill and a boat yard. From the tall gum trees they built masts for the British Navy. Within a decade their metal and woodworking shops were producing battle ships in excess of 250 tons. Within fifteen years the prison was not only totally self-sustaining, but was exporting tons of carrots, cabbages, potatoes and bread throughout the other penal colonies and the adjacent towns mushrooming around Tasmania and Australia. They were also producing 68,000 hand-made bricks per month, and had expanded into the manufacture of fine furniture, which was exported all over the world.

Port Arthur, with an endless supply of slave labour, many of them skilled craftsmen and artisans condemned to transportation by the British Courts, became one of the most productive and lucrative prison industries in the Empire. A decided asset of the Crown.

In 1849 Port Arthur was designated a Model Prison. Ironically, this would be its downfall. New approaches, modeled on experiments at Pentonville, were introduced. Flogging was abandoned, diet improved and new, modern methods of punishment were introduced. One such was the silent treatment.

From the day of admission to the end of sentence, prisoners were confined to solitary work cells for twenty-three hours a day and no word was spoken to them during that time. They were forbidden to speak, signal to another prisoner or make noise. No bells were rung and the guards wore pampootees as they patrolled the carpeted corridors outside the sound-deadened cells. Total silence and isolation were mandatory. Prisoners were compelled to wear hoods over their heads in the exercise yard so that glancing at a fellow prisoner became impossible. The chapel was redesigned so that prisoners stood in individual partitioned stalls, ensuring that no man

could see the man standing next to him. No contact could be made.

Breaking the silence was punishable by confinement in a cell where the unrelenting darkness ensured that a man could not see the hand in front of his face. Most of the prisoners went mad.

Built in 1867, the last building put on site at Port Arthur was the Lunatic Asylum. Of the prisoner population at that point some 64 percent were considered by the authorities to be mentally insane, and the remainder too feeble to work; therefore "the costs of its construction was borne by the British Government: to serve as some measure of compensation for the reality that these men would never be allowed to return to their native shore" (*Short History Guide to Port Arthur* by Michael Ross and Alex G. Evans).

14,992 Irish men and Irish women were transported to Van Diemen's Land alone, and during its forty-seven years of operation, some 4,000 Irishmen were deported to Port Arthur. Of that number 70 percent were transported there for political offenses. Escapes were rare, and those that managed to do so usually chose America. Few were pardoned home to Ireland. William Smith-O'Brien made it home.

Some 14,900 others did not. Culture shock.

I sit in the airport terminal at Hobart and think of them while I wait for our flight back to Melbourne. 14,992. Of my people.

In a curious twist of serendipity, I notice that satellite television has just flashed on the Irish Taoiseach emerging from an important meeting somewhere. News hounds crowd around him. They are hurling questions and quotes: the Beef Scandal, the Bishop Casey Scandal, the Scandal of the X Case. He ignores these and does not break stride.

Amidst the cacophony, one young jackal pushes to the fore, microphone outthrust as he cites rising levels of unemployment in Ireland, demanding the government's solutions to the current brain drain as thousands make illegally for the U.S. It is not a new issue. I have heard it many times. On both sides of the Atlantic. But I pay attention, leaning forward. I live on the diaspora. I like to listen to the voices from home. One day I hope to hear them grant us the absentee ballot.

It will not be to-day. The Taoiseach is affable but does not wish to linger. Who could blame him?

So I am surprised when he drops an answer to the young reporter.

A spur of the moment decision. I am convinced, as he moves into close-up. Maximum second of impact for an exit line, as any actor knows. He smiles warmly, his tone courteously acknowledging his inquisitor, deftly buttoning the double-breasted Armani with one hand. Almost regretful that it should be necessary to bring to our attention what he is about to point out. He is utterly sincere. He believes every word:

"It's a very small island, you know. We can't all live there."

So saying, the head of the Irish Government exits. Exits frame, as they say in Virtual Reality.

It's a very small island. We can't all live there.

A New Mantra for the Irish Diaspora!

Hardly original of course. Cromwell said it—albeit crudely. So, I fancy, did every tax-strapped landlord who ever pressed American passage into the hands of reluctantly grateful Irish tenant farmers. Perhaps the latter chanted it together for comfort in the stinking bowels of the Coffin Ships or in the rat-infested shanty towns they endured in Boston and New York.

Hey! Perhaps it's chanted there still. Up on Bainbridge Avenue on a Saturday night where the Irish illegals sleep ten to a room. I tell you what, Taoiseach—let's get rid of "*OLÉ! OLÉ! OLÉ!*" which belongs to the Spaniards anyway. Let's put the Irish punt where our mouths are. Let's hear 'em roar out at the next World Cup:

IT'S A VERY SMALL ISLAND. WE CAN'T ALL LIVE THERE!

And sure isn't Charleton the man to make them do it? Yeoman stock.

But I digress. Port Arthur. Van Diemen's Land. 14,992 Irish. What sustained them? What was *their* mantra? A few prayers, perhaps in Irish. A few beloved names, sayings from childhood townlands. *Níl aon tintean mar do thintean féin.* There is no hearth like your home hearth, Taoiseach.

The air is limpid at Port Arthur after the rain. The wind from the South Pole is sharp. The sea a blue green. The quiet of the bush is vast. In summer they have a long twilight. The gray blues and soft greens of the gum trees turn purple as the light changes. Shadows on the low hills play tricks on the eyes. It could be Donegal.

Heartbreak, surely.

Two nights later I am in the deserted members' lounge of the hotel in New South Wales where the Social Dreaming conference is taking place. It is late but I cannot sleep.

I am leafing through the Australian newspaper. Page after page of paid advertisements by the international mining cartel decrying the Australian High Court's recent decision to return ownership of vast tracts of mineral-rich land to the Aboriginals. The advertisements contain dire warnings of national economic ruin. They urge Australians to come to their senses.

I am joined in the lounge by another insomniac, an Australian. We exchange a few words. His name is Brian. His great-grandmother was from Ireland, he says. Came out on a prison transport.

"Incorrigible, was she?" I inquire. I am my father's daughter.

"She must have been right enough." He laughs. "Raised eleven kids and put them all through university."

He'd like to go some day, he says, for a visit.

"Should have happened years ago." and he indicates my newspaper.

"I bet," he says "there's been a few cardiac arrests in the mining company board rooms over the past few days!" And he laughs again.

"Yes, I suppose," I grin.

"The Irish it was made that happen o' course. You knew that?"

"No, I didn't. How do you mean?"

"Simple. There's seven judges on the Court. Five are Irish Catholics!"

He sees my astonishment. And misreads it, thinking he has offended me.

"Well Australian-Irish of course. But it's the same. Well, probably to you it's not. You being the real thing! But we like to think it's the same." And he smiles. "Well, I do, anyway."

Aithníonn ciaróg ciaróg eile.

It takes The Real Thing a few moments to respond. I have come a long way to know the answer. To the ends of the earth.

"It's the same." I assure him, my like-spider, my co-descendant of Incorrigibles, "We are the same."

Balm.

IRISH CATHOLIC

Richard Rodriguez

Discontinuity

There is a crucifix over my bed. I am in bed, my eyes are open. I am waiting for the sound of midnight—a burst of horns, a fire whistle, a woman's scream.

A car passes on the wet pavement outside. My room revolves on a rail of light. And then it is dark. January 1, 1960. The new decade has come to Sacramento, California. It is no longer Christmas. In the morning there will be a cold mass at church, then the Rose Parade on TV. And the long gray afternoon will pass away through a series of black-and-white football games; in a few days I will be back at school.

I am fifteen years old, old enough to be dating. I am not dating. I am brown. I envy my older brother's cool, his way with girls. My brother's bed is empty. My brother is out at a party. I am bookish and witty; though I don't have such maypole words for myself. I write the gossip column ("The Watchful Eye") in the *Gael*, the school paper. I am much more than the class clown; I am the leveler, caustic enough to force my male classmates to a truce. I am bright, a straight line. I am ambitious for college—some school that is hard to get into—a brick castle filled with rich kids where I will clean up, because I want more than they do. I want to be a college professor. I will have run out of things to read. I want to be a journalist on a train far, far away, hurtling toward the present age of my parents. Thirty-six. Thirty-six.

My family has moved three times in Sacramento, each time to a larger house than before. We live in a two-story house. We have two televisions. Two cars. I am not unconscious: I cherish our fabulous mythology: My father makes false teeth. My father received three years of a Mexican grammar school education. My mother has a high school diploma. My mother types eighty words per minute. My mother works in the governor's office where the walls are green. Edmund G. Brown is the governor. Famous people walk by my mother's desk. The other day Chief Justice

Earl Warren said hi to my mother.

Every New Year's Eve my mother cries in front of the TV when Guy Lombardo marks auld lang syne. "It's so sad," my mother says. The crowd in Times Square cheers. This year, however, we have gone to bed early. The back-porch light is on for my brother. I have stayed awake in the dark to feel the difference of a new decade.

There is no difference. It is the unexpected that my life is protected against. Inevitability is what my parents have bought me with their ascent into the American middle class. My ambition will match their desire. I will go to college in the sixties. I will not be the first in my family to attend college, but I will be the first to leave home for college. I will go to Stanford in the sixties. Four years later I will take my first plane trip—TWA's Royal Ambassador Service—to New York. I will go to graduate school at Columbia, then Berkeley.

Ten years from tonight, I will be a graduate student at Berkeley. I will expect to be a college teacher. I will be spending the Christmas break in my apartment on College Way, writing a paper on Henry James's *The American*. I will be composing elaborate opinions about the naive and the worldly, about the Protestant American and the cynical Catholic orders. Over my bed will be a blowup of Marlene Dietrich.

Sacramento, the first minutes of 1960: the ectoplasmic corpus of the crucifix glows with confidence. Awake on my bed, I am inclined forward: I want the years coming to improve me, to make my hand a man's hand and my soul a man's soul.

The sixties will be my sacramental confirmation. The fifties already have defined my life. As 1949 became 1950, we lived in a one-story house on 39th Street, a few blocks closer to Mexico. There were no faces like ours on the block. Nor were there voices like ours on the block. When I began school, my classmates seemed of one blank face and of one emotion, which was cheerful. The majority of the class carried lunchboxes full of snowballs of frosted pastry. It was an American classroom. And yet we were a dominion of Ireland, the Emerald Isle, the darling land. "Our lovely Ireland," the nuns always called her.

The conclusion of my education will be at secular universities where the majority of my teachers will be Jews—many of them only a

generation from working-class memories. But the Sisters of Mercy will remain the most influential. They will claim me for Ireland.

What was my initial resistance? When I came to the classroom unable, unwilling to speak English, the nuns methodically elected me. They picked on me. They would not let me be but I must speak louder, Richard, and louder, Richard. I think of those women now, towers, linen-draped silos, inclining this way and that, and only their faces showing, themselves country lasses, the daughters of immigrants. They served as my link between Mexico and America, between my father's dark Latin skepticism and the Edenic cherry tree of Protestant imagining. Pulling ears, straightening collars, blushing, strong-arming, my nuns ushered their students in straight lines toward an American future none of us could conceive. Years after, the nuns would leave me a skeptical figure within tall library windows, regarding the swirling chaos on the quad below.

From its influence on my life I should have imagined Ireland to be much larger than its picayune place on the map. During the hot Sacramento summers, I'd pass afternoons in the long reading gallery of nineteenth-century English fiction. I gathered a not-accurate picture of London and of the English landscape. Ireland had no comparable place in my literary imagination. As a Catholic schoolboy I had to learnt to put on the brogue in order to tell Catholic jokes, of gravediggers and drunkards and priests. Ireland sprang from the tongue. Ireland set the towering stalks of the litanies of the church to clanging by its inflection. Ireland was the omniscient whisper from a confessional box.

Did your mother come from Ireland? Around March 17th, a Catholic holiday, my mother—that free-floating patriot—my mother would begin to bristle. "If it's so wonderful, why did they all leave?" But it was her joke sometimes too, that we were Irish. My mother's surname is Moran, her father a black Irishman? She laughed. Her father was dark and tall with eyes as green as leaves. There were Irish in nineteenth-century Mexico, my mother said. But there was no family tree to blow one way or the other. The other way would lead to Spain. For Moran is a common enough name in Spain as through Latin America. Could it have been taken, not from Ireland, but to Ireland by the Spanish—Spanish sailors shipwrecked by Elizabeth's navy?

My younger sister asked me to help her with an essay for school. The subject was Ireland. I dictated a mouthful of clover about Dublin's Jewish mayor and some American celebrities and politicians, Ed Sullivan, Dennis Day, Mayor Daley, Carmel Quinn. "Ireland, mother of us all. . . ." The essay won for my sister an award from the local Hibernian Society. I taunted her the night she had to dress up for the awards banquet. My mother, though, returned from the banquet full of humor. They had all trouped into the hall behind the Irish flag—my sister, my mother, my father, an assortment of old ladies, and some white-haired priests.

When Father O'Neil came back from his first trip home to Ireland, I was in third or fourth grade. There was a general assembly at school so we could see his slides, rectangles of an impossible green bisected by the plane's wing. Dublin gray, stone and sky. The relations lined up in front of white houses, waving to us or just standing there. There was something so sad about Father then, behind the cone of light from the projector, in Sacramento, at Sacred Heart School, so far from the faces of home and those faces so sad.

Ireland was where old priests returned to live with their widowed sisters and (one never said it) to die. So it was a big white cake and off you go. Ireland was our heart's home. I imagined the place from St. Patrick's Day cards, a cheerful Catholic place—a cottage, a bell on the breeze, and that breeze at your back, through quilted meadows and over the winding road. Sacramento, my Sacramento, then, must seem to Father O'Neil as flat, as far away as Africa in the Maryknoll missionary movies. Life was the journey far from home, or so I decided as I watched Father O'Neil popping squares of memory upside down into a projector.

Fading Ireland. . . . The American experience of Catholicism as an immigrant faith, a ghetto contest of them against us, was coming to an end in America. In the colored pages of *Life* magazine the old dead Pope with his purple face and his hooked nose was borne aloft through St. Peter's. My generation would be the last to be raised with so powerful a sense of the ghetto church. An American of Irish descent and athletic good looks would soon be elected President, our first Catholic President of the United States. As the old Pope passed through the doors of death, American Catholics were entering the gates of the city. A fat, expressive Italian Pope would

soon call his church to *"aggiornamento,"* a new rapprochement with the non-Catholic world. As the fifties passed, however, the nuns went on neatly dividing the world, as if they remained the Fates they had always been. We were the Catholics and all others, alas, were defined by the fact of their difference from us.

By the time many of us got to college, the temptation would be to turn back, embarrassed by the parochialism of our Catholic schooling. The gothic habits, the very names, Sister Mary Damien, Sister Mary Aquin, the prohibitions, the virtues would seem, from a distance of modernity, funny. There was no other word for it.

But then that was the general tone of the sixties, an irreverent laugh-in—for the theme of the sixties was the theme of discontinuity. As higher education became mass education, a generation of Americans, many the children of parents who did not make it to college, found themselves living a new future. We were not fated to become like our parents; we should not have to submit ourselves to compromise, to memory. We would therefore believe we were freed from history. History was evil because it hadn't, after all, worked. Look at the wars, look at the poverty. We were innocent. We were at the edge of an Aquarian Age, or so the lyrics of the sixties hustled us to believe.

"The sixties were about mommy and daddy, a family affair," says a friend of mine who ran off with a soldier. It has become the fashion appropriate to an age of individualism to date the start and the end of the era according to private calendars. Another friend, a woman who became a nationally known antiwar activist, says the sixties began with her divorce in 1962.

Shall I say the sixties began for me in 1963 when my parents drove me to Stanford University? My sixties began in the 1950s. In the fifties, billboards appeared on the horizons, which beckoned restless Americans toward California. If you asked, people in Sacramento in the fifties said they were from Alabama or from Portugal. Somewhere else. Sacramento of the 1950s was the end of the Middle Ages and Sacramento growing was the beginning of London. In those days people were leaving their villages and their mothers' maiden names to live among strangers in tract houses. Highways swelled into freeways. People didn't need anyone else to tell

them how to behave on K Street. And God spoke to each ambition through the G.I. Bill.

I should say that my sixties began in the sixteenth century with the Protestant Reformation. For the sixties were a Protestant flowering. The famous activists of the decade were secular Jews who heralded a messianic future. But the true fathers of Woodstock, of sit-ins, and of rock pastoral were the dark-robed Puritan fathers.

In the early 1950s, Sacramento, California, was a city of over 100,000 people, a river town, the "Camellia Capital of the World." Sacramento was the great city of the Central Valley, the state capital. As the fifties advanced, people arrived by the hundreds, then thousands, each month. Downtown Sacramento began to skid with the building of Country Club Shopping Center. The city was growing north and south.

A statewide university system was created on an economic paradigm of supply and demand to accommodate middle-class ambition. Dr. Clark Kerr named it a "multiversity." The problem was numbers. Mass education caused the market value of the diploma to decline, and so did the glamour of undergraduate living. It was a dilemma peculiar to American ambition and one Henry James might have understood.

In the fall of 1963, President Kennedy was assassinated in Dallas. *Life* magazine printed a eulogy that said, "When you're Irish, what you know is that life will break your heart." The next year, on a spring afternoon, when windows were open and radios were up, my roommate at Stanford walked in to announce, with the smile he usually reserved for pictures of naked women, that they were busting heads at Berkeley. In the papers the next day students at Berkeley, using insect words, complained of the impersonality of the multiversity, of being reduced to IBM numbers.

The sixties should have been my time. I was the son of Mexican immigrant parents. I was the non-white American who was to be given full access to American life. If it had all gone as planned for me—the radical politics become bureaucratic affirmative action policy—I should have ended up teaching *Hamlet* at some vast Arizona or Ohio state university, liberal, discontent, tenured. But the romanticism of the sixties never took. Blame it on Ireland. I never bought into the idea that I could be free of the past, except in obvious ways. Oh, I had become free of Mexico—no longer

spoke Spanish, no longer cared to or could. People at Stanford thought I was Pakistani. Ireland still clung to my heart in the sixties. The nuns' lessons—of sin, of historical skepticism—were real lessons. They were not offered as metaphor and I never took them as such. And my best friends in high school and college, as today, carried names that came from the trusted Old Sod—Murray, O'Donnell, Keating, Faherty.

Larry Faherty is my best friend in high school. Larry Faherty wears a ducktail sealed with emerald green Stay-Set. He gets kicked out of Brother Michael's English class all the time for having long hair, which is an impertinence. Larry Faherty is rich. His parents have moved to a new house on a new street on the new south side of town. Larry Faherty loves Mexico, he has been there on vacation every summer since his freshman year, and he speaks Spanish to me. Though I answer in English. My mother worries about my association with Larry Faherty. He and I go to San Francisco on the Greyhound and eat French dinners. We'd go anywhere to see Black Orpheus.

Larry Faherty is in New Orleans with his family for Christmas, so we have not spent New Year's Eve together going to the movies. He will send me a postcard written in Spanish.

It must be around two in the morning when my brother's blue Plymouth pulls into the driveway. The car door slams.

He comes in the back door, he opens the refrigerator and the bottles rattle. My mother calls out to him. "Did you turn off the light?" "Yeah." His voice is thick with American disrespect.

His foot is on the stairs. I close my eyes. He turns on the light for a moment, he turns it off. He fumbles around in the dark. He falls into bed. January 1960, at the edge of my adolescence, in the first hours of the new decade, amid the warmth and the smells of all that is now lost to me, I put away my ambitions and fall asleep.

Protestants

One weekday in summer I am riding my bicycle past the Fremont Presbyterian Church. The door is wide open. So I stop to look. Painters on scaffolds are painting the walls white. I walk in. The room glows with daylight drawn through yellow-pebbled glass windows. There are no side

altars, no statues. There is a wooden pulpit and a table on which stands a gold-painted cross. There are no kneelers in the pews. Don't the Protestants pray on their knees? This is only a room—place of assembly— now empty but for its heavy golden light and its painters. Whereas my church is never empty so long as the ruby burns in the sanctuary lamp; my church is filled with all times and all places. All the same, I like this plain room, this empty Protestant shell. I ponder it as I ride away.

It is 1956. It is summer, and already, though it is not yet noon, the dry heat of Sacramento promises to rise above the fat dusty leaves to a hundred degrees. I hate the summer of Sacramento. It is flat and it is dull. And yet something about summer is elemental to me and I move easily through it.

America happens in summer. At school, during the rest of the year, America is an abstraction—an anthem or a concept for the civics class. It is easier to see what is meant by the Soviet Union. At church, at the end of the mass, the priest prays for "the conversion of Russia," for it is Our Lady of Fatima's special request. Russia is not an abstraction, it is evil and has the fat red face of evil or the gummy-eyed stare of people who ladle watery soup from huge cauldrons. Russia bears the weight of history, of people on the move, people forced from their villages. America is unencumbered by history, and rises even as the grasses, even as the heat, even as planes rise. America opens like a sprinkler's fan, or like a book in summer. At the Clunie Library in McKinley Park, the books that please me most are books about boyhood and summer.

My Sacramento becomes America. America is the quiet of a summer morning, the cantaloupe-colored light, the puddles of shade on the street as I bicycle through. There is a scent of lawn. Think of America and you'll think of lawns, force-fed, prickling rectangles of green, our pastures, our playgrounds, our commons, our graves.

On Saturdays I cut the front lawn. On my knees I trim the edges. Afterwards, I take off my shoes to water down the sidewalk. Around noontime as I finish, the old ladies of America who have powdered under their arms and tied on their summer straw hats walk by and congratulate me for "keeping your house so pretty and clean. Whyn't you come over to my house now . . . ?"

I smile because I know it matters in America to keep your lawn trim and green. It matters to me that my lawn is as nice as the other lawns on the block. On those Saturday mornings, Sacramento is busy painting and hammering, washing the car. I feel happy to be part of the activity. I cannot explain it—I am 12 years old—I have no way of discerning a theological aspect to what I sense about Sacramento on Saturday mornings. I do not know that the busyness is Protestantism.

Behind the Protestant facade of our house, the problem is Mexico. The problem is Ireland, the problem is Rome. I love the Latin mass and trust the questions and the answers. I feel the assurance of belonging to an institution that stretches over all time. But at home there is always something to pray for. Somebody's sick or somebody's out of a job. At night the family prays the rosary, five sets of ten Hail Marys. Asking for favors.

Catholicism at home, our Mexican faith, centers on Our Lady of Guadalupe. It is the image of Our Lady of Guadalupe, her downcast girl's face, which hangs over my parents' intimate bed. The Virgin is "ours," my mother says. In the sixteenth century, shortly after the Spaniards had overtaken Mexico and left the Indians demoralized, the Virgin Mary came on a cloud of bird song to a Mexican peasant named Juan Diego. The new thing for the New World was that Christian Mary appeared in the God-joke guise of an Indian princess.

The problem is that Sister Mary Celestine decides to have our sixth-grade class reenact the story of Guadalupe, and she does not choose me to play the part of Juan Diego.

"Why not?" my mother wants to know at dinner. Sister Mary Celestine has assigned the role of Juan Diego to Peter Veglia. "The Veglias aren't Mexican," my mother says, lining up her knife and her spoon, "they are Spanish." Sister Mary Celestine has missed the point. (Peter Veglia is cute. My mother has missed the point.) My mother says she is going to speak to the nuns.

"Don't," I say.

So I play an astounded Indian in a crowd scene. Offstage I listen as the Guadalupe, with spikes of tinfoil stapled onto her cape, speaks tenderness to the upturned face of Peter Veglia. She says that she wants the Indians to come to her in their suffering. She does not promise to end

human pain. She promises that she will share the Indians' suffering, which is our cue to shuffle on stage and fall to our knees. The curtain closes as irresolutely as it has parted.

What had Mexico taught my parents? They had come to America; they had broken with the past. My parents were hardworking. My parents were doing well. We had just bought our secondhand but very beautiful DeSoto. "Nothing lasts a hundred years," my father says, regarding the blue DeSoto. He says it all the time: his counsel. I am sitting fat and comfortable in front of the TV, reading my *Time* magazine. My mother calls for me to take out the garbage. "Now!" My father looks over the edge of the newspaper and he says it: Nothing lasts a hundred years.

I think I might want to be an architect. I sketch the plans for vast amusement parks to make Sacramento beautiful. I am pleased by the new twelve-story El Mirador Hotel downtown. Sacramento meets my optimism. There is a new mall planned over by Sears.

Sacramento is annexing to itself miles of vacant land. United Airlines has announced direct service to New York City. All of it matters to me. I figure that I am at the very center of the world. The United States is the best country. California has just become the most populous state, and Sacramento is its state capital.

It becomes a sort of joke between my father and me. "Life is harder than you think, boy." You're thinking of Mexico, Papa (while I fold the newspapers for my route). "You'll see," he says.

One of my aunts goes back to Mexico to visit, and she returns and tells my mother that the wooden step—the bottom step—of their old house near Guadalajara is still needing a nail. Thirty years later! They laugh. My father is attentive to the way Sacramento repairs itself. The street lights burn out, a pothole opens on the asphalt, a tree limb cracks, and someone comes from "the city" within a day. My father shakes his head. It is as close as he comes to praising America.

Like the Irish nuns, my father is always remembering. He remembers the political turmoil of Mexico. He grumbles about the intrigues of Masonic lodges in Mexico. My father talks about how America stole the Southwest from Mexico. (And how Mexicans could never forget it.) Americans died at the Alamo to make Texas a slave state. And what does

puta history do? She gives Texas to the gringo.

America has a different version, the ballad of Davy Crockett. On television, Walt Disney Mexicans at the battle of the Alamo are dressed in French-style uniforms—white suspenders crossed over their bellies. I watch with my family downstairs. And for the first time I want the Americans—those greasy, buckskin Texans—to lose and die.

At a time when most boys in Sacramento are sporting coonskin caps, my father teaches me the story of the St. Patrick's Brigade. In the nineteenth century, there were Irish immigrants to the United States, most of them teenagers, who enlisted to fight in the Mexican-American War. They ended up in Mexico, and when they saw how the gringos behaved in Catholic churches and when they saw how the gringos treated women, the Irishmen changed their flags, my father said. So the Americans hung them as traitors one afternoon in Mexico City.

Mexico was a place of memory. America was the beginning of the future.

Ireland became the mediating island. I grew up in Ireland. The priest and the nuns seemed to believe in America. Priests were optimists. They were builders and golfers. They bellowed their Latin. They drove fast in dark-colored cars. They wore Hawaiian shirts. They played hard at being regular guys, and they told jokes to cover any embarrassment when they collected money for new hospitals or new high schools.

The nuns made me learn the preamble to the Constitution. The nuns taught me confidence. There was no question about my belonging in America. I mean that literally. There was no question. There was no question about English being my language. The nuns were as unsentimental as the priests were sentimental. But they all assumed my American success.

The only exception to the rule of confidence at school came with religion class. At the start of each school day, after the "Morning Offering," after the Pledge of Allegiance to the flag of the United States of America, our young hearts were plunged in the cold bath of Ireland. For fifty minutes life turned salt, a vale of tears. Our gallery—our history, our geography, our arithmetic—was Ireland. The story of man was the story of sin that could not be overcome with any such thing as a Declaration of Independence. Earth was clocks and bottles and heavy weights. Earth was wheels and

rattles and sighs and death. We all must die. Heaven was bliss eternal, heaven was a reign of grace bursting over the high city and over the mansions of that city. Earth was Ireland and heaven was Ireland. The dagger in Mary's heart was sorrow for man's sins. The bleeding heart of Jesus was sorrow for man's sins. Our consolation alone was Our Redeemer, our precious Lord. Man needed Christ's intervention—His death on the cross. God the Father had given His only begotten son. *That cross you wear isn't a pretty bauble, Patsy, it's like wearing a little electric chair around your neck.* Christ had instituted a church—a priesthood, sacraments, the mass—and man required all the constant intercession of the saints and the church and the special help of Mother Mary to keep the high road. All alone man would wander and err like pagan Caesar or like Henry VIII.

At nine-thirty the subject changed. The class turned to the exercises of worldly ambition—spelling, writing, reading—in preparation for adulthood in comic America. The nuns never reconciled the faces of comedy and tragedy, and they never saw the need.

While I was in high school, the swarming magnetic dots of the television screen began to compose themselves into black faces during the nightly news; the Civil Rights movement was gaining national attention. Black Protestantism had until then seemed to me a puzzling exhibition of perspiring women and wet-voiced men chained to a rhythm that was foreign to me. Suddenly, on the nightly news there appeared Dr. Martin Luther King, Jr., and everything I thought I knew about saints began to change as I contemplated that face, as I listened to that voice. I began to believe in heroes.

By the time I got to Stanford I believed in manmade history. I tutored ghetto children. I paraded through downtown Palo Alto toward my first antiwar rally. I was an English major at Stanford; increasingly, though, I began taking courses in religion, mainly Protestantism. I took on a new hero—a Protestant theologian named Robert McAfree Brown. These were the years of ecumenism, and I had outgrown any caution regarding contact with non-Catholics. I eagerly bit into the Protestant apple the nuns had warned me against, and I admitted its sweetness. When my mother learned that I was taking a course from a Protestant minister, she made me promise that I would ask the Catholic chaplain at Stanford for permission. I didn't, though I told her I did.

So began my Protestant years. I was attracted to the modesty of style, the unencumbered voices of Luther and Calvin, free of the trinketed cynicism of Mexico and the nagging poetry of Ireland. And there was a masculine call to action. One week Dr. McAfee Brown was flying to Rome to serve as an official Protestant delegate to the Vatican Council. All the while he was writing books; he knew more about Catholicism than the nuns could have told me. He would be off the next week to Selma.

I entered a master's program in religious studies at Columbia University; I took most of my courses across the street at Union Theological Seminary. When Columbia was closed by sit-ins and police riots, I sat in the library of Union Seminary reading eighteenth-century Puritan auto-biographies—books of people who had learned to read late in their lives. They spoke from their pine houses and from within the rings of their candles about personal confrontations with God.

Were these the renowned dour Puritans? But here were people who believed in the possibility of change, sudden conversion. One could be born again, sin could be overturned like a wooden table, like a bucket of water. With God's help one could stand on one's own feet. There was no necessary tragedy. Was there a need, then, for angels and priests?

It was thus in the late sixties, in a neogothic library in New York City, that I found a theology to escape my father's skepticism and my mother's famous intimacy with the Virgin Mary.

As I read, I remembered the close-cut lawns of Sacramento, I saw the face of the Puritan. It was an old lady's face I saw; she wore a yellow dress with sunflowers on the pockets, she wore a sun hat. She stopped to congratulate me for keeping my lawn so pretty. She was smiling.

Evil

On my part it is less a decision to get to know Larry Faherty than a fascination I decide not to deny myself.

"Faherty, take off those stupid sunglasses," Brother Michael interjects into the *Iliad*.

Skinny, pale, slouching, yesterday Larry Faherty won the essay contest I had expected and wanted desperately to win.

"Faherty, I'll give you three to take them off. ONE . . ."

Our courtship: Larry and I are sitting at the far end of the football field during the lunch hour, a blurry distance from the schoolyard monitor. Larry saves his milk cartons to use as ashtrays. Larry has been reading a book by James Baldwin about Negroes in Harlem. Larry Faherty has been to New York. Larry Faherty calls Sacramento "Sacramenty." Larry Faherty writes poetry. I have been to Mexico with my parents to visit relatives. Larry went to summer schools in Mexico to learn Spanish. Larry is not afraid of Mexico. Sometimes he makes it sound male. "We all went down to the whorehouse," he says, flicking an ash. Sometimes he tells Mexico as a woman. No one there asks if he is gringo. The Mexicans speak to him only in Spanish, with *cortesia*—it's in the language, he says.

Larry Faherty protests the smallness of our island.

Peter Raderman—of the duckling yellow crew cut and the school sweater—warns me in confidence (and for my own good) that Larry Faherty will ruin me . . . "socially." So Larry is jeopardizing my tenuous ties with circles of athletic glamour and social celebrity at school. My mother worries. My parents are in awe of his parents. Larry's mother is a teacher; his father works for the government. My sister Sylvia says "look at his hair" as Larry rides up on his bicycle.

Larry Faherty's hair: it is long and it is greasy. Every four weeks or so, Larry's hair descends to his collar. There is a ritual confrontation in Brother Michael's English class.

"TWO . . ."

Brother Michael is late in his twenties, passionate, athletic, sarcastic, the stuff of crushes. Not only does he understand the classics, he plays the lead role. All the boys think he is their favorite teacher. But he is mine. I have managed to become his pet. After school. Brother Michael encourages me, he spends time with me, he gets me to write for the school paper. In class I am careful not to act kissy. I told you, I am the class wit. Like Falstaff, I take hits and then I hit back. I am as ready to laugh at your humiliation as you are to laugh at mine.

Larry Faherty sits silent, he judges me when I make the class laugh, even at the expense of Brother Michael, which I figure Larry ought to enjoy.

Larry Faherty is the one kid in class I regard as brighter than me. His essays, done the night before, have big words stuck in like cherries.

When Larry gets kicked out of class, he is not allowed to come back until he has gone to the barber. Because I am the obedient Catholic schoolboy, because I never get in trouble, I am fascinated by Larry Faherty's defiance.

"THREE." A rustle of black serge, the little wind of starch and sweat as Brother Michael rushes past; a furious slap knocks the sunglasses clattering across the floor.

I too laugh when the pneumatic hinge has finally jerked the door shut against Larry. My mother has no reason to fear. I will always be attracted for the same reason that I will never become. Because I am a Catholic.

The Christian Brothers traditionally have been teachers of the poor. There is talk of the Jesuits coming to town to build a rich school in the suburbs. In Sacramento, Christian Brothers High School teaches the middle class. But the governing male ethos is tough. There will be order in the classroom because there is order in the cosmos—marches, genuflections, reverend addresses. I am indebted to my elders, the scholars, the theologians who preceded me. My teacher, by definition, assumes authority.

During a high school religious retreat, the traveling Redemptorist priest with a crucifix slung in his sash like a musket brays counsel to the assembly of five hundred boys. There is the one about the boy who went away to a non-Catholic college and lost his faith because he was encouraged to think he knew all the answers by himself, fool. The sin of pride. Pride is not submitting to authority. Pride is insisting on one's own way. Pride is lonely, men, lonely as hell.

The purpose of Catholic education was not "originality." At Christian Brothers, we read Aquinas and we read Shakespeare. At Christian Brothers, having a mind of one's own was a problem. Like Faherty. We were trained to keep order. From my class at Christian Brothers would come yet another Catholic generation of policemen and FBI agents and firemen, even a White House Secret Serviceman.

An Irish kid named Denny who sat in front of me in French class, and who this morning wears a checkered shirt, will become a cop. He will be driving after midnight down a rainy street, and he will be killed by a rifle shot through the passenger window. In 1961, in Brother Paul's French class, Larry Faherty drums his pencil eraser against his closed French

grammar. Oh God, he is bored with Brother Paul, with French, with Sacramento. It is Mexico Larry loves, not France. Spanish.

Larry Faherty scolds me for not speaking Spanish. He calls me affectionately—the insulting word for the son who pretends to be a gringo —*pocho*. We are the odd couple: Larry is 6 feet tall, fair, Spanish-speaking. I answer in English. We spend a summer working for John F. Kennedy's election. We go to movies. He tells me what I should have known about sex, about girls, letting his line down tenderly, a little at a time, into the clear pool of my imagination. We talk about politics and about Mexico and about the young man Larry saw shot down to a pool of blood on a street in Mexico City. On Friday nights he honks for me in his father's Chrysler, the cigarette dangling from his lip. "Salutti Beulah Mumm," he calls out to the window of Beulah Mumm, the librarian who lives next door to us. "Salutti Cerrutti," he honks at the house of Mrs. Cerrutti. "There's something funny about that kid," my father says. We go to a jazz coffeehouse. We order espressos. I never finish mine. Black musicians with preoccupied red eyes play for dulling hours. It amuses Larry to overtip the waitress—sometimes two or three times the amount of the bill—"to see what she will do." She keeps the money, of course, and with a poker face.

Larry scorns me for not taking chances. I refuse to hitchhike. I refuse to smoke cigarettes. I refuse Spanish. And yet, I think, Larry senses Mexico in me, I am his way of escaping Sacramento. But if I am his Negro, he is mine too. His casual relationship to money, his house with a swimming pool, these I take as ethnic traits. What dooms our friendship is that we stare past one another. What he sees in me is innocence, an inferiority complex, Mexico. He is all casualness about the things I intend to have. I want what he claims to discard. I ingratiate myself to Larry Faherty's parents, and I get invited down to Southern California beach towns where they spend the summers.

And so for two or three years we know each other better than we know anyone else in the world. But then we graduate and I am to go to Stanford—"Stahnnn-ford" Larry says with a plummy cartoon voice, disapproving my choice. Larry goes off to college too. There is some kind of trouble. (Larry is vague on the phone.) He transfers to another college in the Midwest. We exchange letters. We see each other at Christmas. He is

becoming sadder, handsome.

One summer Larry Faherty joins the Peace Corps, a fine young Kennedy cadet. There is a war in Vietnam and Lyndon Johnson is President. Larry writes from Africa. Then there is trouble again. Larry has been kicked out of the Peace Corps—"for not wearing pajamas," Larry is quoted as saying in the Sacramento papers, which headline the story. The Peace Corps official is vague in response.

1968. We are, both of us, deep in the sixties now. But Larry Faherty has nowhere to go when the sixties become the sixties. From Africa he quotes Ayn Rand; he grumbles about the uniform answers of the newly fashionable left. His mood passes. His liberal heart cannot justify America's war in Vietnam, and his next letter says so.

The letters become less frequent. I am living in New York. I hear he is living in Paris. I have no address for him there. In New York, at Columbia, student demonstrations in April close down the university. Politically, I still think of myself as of the left. I write letters to congressmen. I march in antiwar demonstrations up Fifth Avenue. But I cannot follow the decade all the way down the line. Date my defection with the murder of Dr. Martin Luther King, Jr. After his death, the Pauline vision of a society united is undermined by hack radicals like Stokley Carmichael, proclaiming a Protestant separatist line. The virtue of the sixties moves from integration to defiance. The posture of the outsider is perceived as glamorous. Students at Columbia are reading *The Student as Nigger* in order to justify their privilege, a version of noblesse oblige which puts me in mind of the rah-rah twits in a Wodehouse comedy.

I do not believe in sudden Protestant changes, reformations, so much as I believe in fade-outs and soft loosenings. My friendship with Larry Faherty has no denouement.

There is a vacuity, an abeyance, an alignment to the spring afternoon as I walk defiantly toward the library between jeering students and silent policemen. The protest is all about me—about the need for more "minority students" and the "racist" university. Rocks and bottles are thrown and the horses charge in my wake.

For religious as well as for temperamental reasons, it is impossible for me to imagine a propriety that will justify the seizure of an office of

authority. I will never be a hero of the sixties brand. I will go to the library to confront the Protestant Reformation.

A manufactured sign in somebody's dormitory window urges passersby to "Question Authority." Why (me with my Samsonite briefcase) should one simply, as a matter of reflex, question authority?

An august historian of Protestant history lectures on Galileo—the inevitable example—as I sit in the classroom, and I am silent, though I would protest to him that if the church was wrong, it was possibly wrong for a valid reason. For the church sought to protect the communal vision, the Catholic world—a rounded, weighted, lovely thing—against an anarchy implicit in the admission of novelty. Novelty should only come from within the church; a question not of facts but of authority.

America is the fruit of a Northern European idea of freedom. How should I protest? America has justified modernity. How much can America hear from the Catholic schoolboy who defends the medieval Catholic dream? Of what value to America are notions of authority, communality, continuity? Tolerance is the noble Protestant virtue to replace Catholic orthodoxy. But, lacking a Catholic longing for union, what could America's Protestant sixties lend to the Protestant enterprise beyond flea-bitten utopias—reversions to an arcadian world—nomadic trappings, natural religion, mushrooms, sitars, incense?

The sixties offered assurance that middle-class Americans, even Americans among the upper classes who yearned for purity, could disenfranchise themselves, see themselves, by virtue of their era, as orphans of authority and that way achieve ultimate identification with "the people." All you had to do was leave home.

His head bandaged after a student-police riot in the university president's office, a friend at Columbia tells me that only during the sit-in had he come to understand the meaning of "community."

Many of the hundreds of riot policemen on campus at Columbia eat in John Jay Hall. They eat, most of them, on one side of the cafeteria; most of the students eat on the other. I make it a practice, a theatrical point, of sitting on the blue side, among what Catholic intuition teaches me to recognize as the righteous angels.

It was not then nor is it now a matter of divorcing myself from the

opinions of the left. In the contest of politics, I was of the left. But in the overarching debate, I took the Catholic side, even if I saw the Protestant necessity clearly. The era's individualism seemed to me to stray too far from the communal need, an exploration of limits I privately called by its Catholic name: error.

What happened to the boys I grew up with at Christian Brothers? What happened to my teachers? What happened to the church? We were educated in the sixteenth century and then set loose in the modern city.

A mile from where I live now, an ex-cop, an ex-boxer named Dan White was elected to the Board of Supervisors of San Francisco—the city of gays, of drugs, of violence, of rock. Dan White remembered the neighborhoods as villages. He had never really been to the city before. He went mad. He crawled through a window of city hall with a loaded gun in his pocket. He murdered the mayor and the homosexual member of the Board of Supervisors. Newspaper accounts described Dan White's house. There were maps of Ireland on the walls, and there were holy pictures, and there were phonograph records of Irish ballads, sentimental and stirring.

It is possible to recognize the stuff of ballads in the life of Dan White, to recognize in the story of a dishonored man the American Catholic dilemma carried to an impossible conclusion.

In the 1840s, the nativist argument against accepting the Irish in the U.S. was Mexico. The fear was that the Irish would conspire with their fellow papists to overturn Protestant America. The truth of my education was that Catholicism made Irish immigrants, as it made me, into the sort of Americans who upheld the collective idea of America, even more perhaps than did the Puritan fathers for whom this country was an escape.

Something is now clear about Larry, and that is my betrayal of him. The last time I saw Larry Faherty, he was ducking down in the backseat of his father's Chrysler in the parking lot of the Greyhound station. Larry had wanted to see me. Our meeting was rushed, nervous, but lacking the fervor demanded of it. Larry was on the lam, he was sure the cops were looking for him because he was in trouble with the draft board. He wasn't supposed to be in the country.

"Salutti Beulah Mumm . . .?" He hoisted a duffel bag onto his shoulder.

Just go, I thought.

Then the dusty Greyhound carried my blessed hero away. The last I heard he was in Mexico, where I imagine his rebellious soul lapped by corrupt, warm waters.

In 1973, I went to England to pursue a study of puritanism and the rise of the novel. I sat in the darkening library of the Warburg Institute reading *Paradise Lost*. Even as I became fascinated with the glamour of Milton's Satan, I saw the absolute necessity to avert my soul's eye from a logic that would make mere individualism a virtue. The logic of Milton's faith made Satan the hero of man's creation.

Envoi

"Personal essays," the editor writes—not theory, autobiography. He says he is compiling a book of them, points of view. "Describe the odyssey you took through the sixties, how your life was changed. . . ."

The sixties never happened to me. I didn't get a divorce. I never took drugs. I didn't schoon the desert in a VW van. I wasn't packed off to Saigon or chased up into Canada. "I don't even listen to rock music," I answered him.

The sixties were gringo time. White-middle-class crisis! The white middle class decided it no longer wanted the diploma, the seals, the ribbons, and the stole I had cherished from boyhood. The white middle class pretended to be poor. I took the prizes, as many as I could get, but I had no competition.

The man who lives across the hall tells me that he is interested in studying Hinduism. He grew up an Irish-Catholic.

The prescription of the sixties was for cutting loose. But I believe in continuous time, as I believe in God. I believe that the boy of ten relentlessly dogs the man of forty. Four blocks from where I live today, in St. Dominic's Church, my parents were married. I have, in forty years, traveled and lived in several cities and countries, have gone to universities and met people. And I have ended up four blocks from the apartment house where my mother lived when she first came to America.

I would have liked you to believe that I strode through the Protestant sixties purblind as Brideshead. As a Catholic schoolboy, I had been

taught, if I had been taught nothing else, that we lived in a group. Ironically, this lesson implicates me in the sixties. Though I remain a Catholic, I did not evade the sixties, nor did my church evade the sixties.

I live alone. I have no children. I read at night. I jog at noon. I live in an apartment in a four-story Victorian that was designed to house an optimistic nineteenth-century family of many polite children. There are no children in my neighborhood. Most of the people I know best are living lives changed from the lives of our parents.

"Go on back to the safe world of your Irish nunnies who praised you for being so obedient," one friend of mine says. Jewish. He doesn't go to temple, though, he prowls the public toilets of city parks, looking for sex. My friend says he is careful. He says I am sentimental.

St. Dominic's, down the block, is dark and sparsely attended. Most of the people in church who are my age sit alone, hugging their shriveling souls, or else they sit staring through the bland recitation of vulgarized mysteries, and then they stand up and go home.

It is a liturgy meant to assure those of us who live in the city, alone in what we rather hesitate to call our faith. The Catholic Church insists that we are still a community, notwithstanding the evidence of the empty pews. The lector announces the Proclamation of Faith through her microphone: "Letter B. Page 36 in your missalettes. 'When we eat this bread and drink this cup. . . .'" Proclaiming the death of the heart.

Most Sundays I cross town to attend Mass in the Hispanic part of the city at St. Peter's, a nineteenth-century Irish church. It is dark and of an opulent vulgarity, with squeaky floors, a gallery of painted statues susceptible to candlelight and roses. A virile St. Patrick occupies a little gothic pavilion to the right of the main altar. The church is now filled with Spanish, with dark-eyed children and teenaged parents, and with waves of the sound of wailing babies that puts one in mind of the souls in purgatory, and with the off-key, full-throated singing of the women of Mexico.

During the sermon I study the stained glass windows to the blessed memories of Mary Anns and Patricks. The Irish have left the city for suburbs. I expect this Hispanic generation sitting around me to make a similar journey toward the middle class and away from this village church in the heart of the city.

There comes a moment in *Hamlet* that seems to me one of the saddest moments in the world. Hamlet stops, literally: Hamlet steps out of his play to address the audience. Hamlet stands alone and apart; Shakespeare no longer believes with Catholic assurance. The traditional faith of the playwright is that we are social creatures; all that is most essential to know about ourselves and about each other we know in communion, in conversation. The play tells all.

Hamlet becomes a modern man when he speaks his true heart to the void. He leaves the play behind him—a contraption, a booth—his father's Chrysler. Hamlet becomes a novel, which is the genre that Protestantism gave literature.

Four blocks from my house is a gym where men with pale thin legs sit harnessed to bucking Nautilus machines like victims of polio. I pay money to hang upside down on a bar listening to Vivaldi on earphones. My guru, my coach, is a twenty-four-year-old man from Dublin who is training to compete next year in the Mr. Ireland contest.

Another teacher, before she died, sent me a card, a confident florid verse. Sister Mary Regis (she also signs herself in the post–Vatican Council style with her family name—Sister Mary Downey) tells me that she will not be able to come to the lecture I am going to give in Sacramento as she has a "chronic illness." (She is dying of cancer.) "Keep me in your prayers and I do you."

"When the nuns die, they die alone," Father O'Neil (he of the slides of Ireland) says to me a few months later. We are walking in the schoolyard of Sacred Heart; we are followed by a photographer who is shooting a going-home-again for *People* magazine, because my book has just been published. The photographer encourages Father O'Neil to "act normal."

I remember when Father O'Neil arrived from Ireland. His hair was black. He was handsome. He was shy. He apologized for his Irish, then. In this pause I am facing a man with gold teeth and gray hair. But the accent endures as a hint of youth clinging to him.

"None of their students ever come back. . . ." He is talking of Sister Mary Regis. I ask him how many nuns are left teaching at Sacred Heart School. There are two.

Sister Mary Regis writes: "Yes, I have fond memories of you and

your days at Sacred Heart. Do you remember that you carried a notebook and asked millions of questions?"

I want to praise them. They deserve better than the ridicule the sixties heaped at their feet. I did not learn from any other of my teachers, as I learned from my nuns, that teaching is a vocation, a holy life, self-less, complete.

At Berkeley, in 1975, my sixties came to an end. The popular press discovered what it called the "me generation" on campus. No more warm-weather revolutions. I taught Freshman English while the Asian students at the back of my classroom studied biochemistry behind propped-up Shakespeare. I lectured on *Hamlet*.

One yellow day in April, revolution came to me. It was time for me to graduate to a full-time teaching position. I'd had offers. That day— the day I had to make a choice—I decided to turn down all offers by way of rejecting the romantic label the sixties had pinned on me: "Minority Student"—I just didn't want it. I moved across the Bay to San Francisco. I publicly scorned the sixties and became entangled in the memory of the era as a critic.

Which is how you find me now, on a Sunday morning in 1987. Over my desk is an etching by David Hockney from a suite of etchings suggested by the fairy tails of Grimm: a reading chair, empty, by a tall window. Outside, the leafed trees. Titled *The Boy Who Left Home*.

In a few minutes I will be leaving for the church across town, the Mexican church I told you about, where still I search for home.

"Keep me in your prayers," the nun would write to her third-grade student, remembering him as a boy on her deathbed. And I do you. Oh Ireland, Ireland.

SELECTED BIBLIOGRAPHY

Adorno, Theodor W. "Commodity Music Analysed." In *Quasi Una Fantasia: Essays on Modern Music*. Trans. Rodney Livingstone. London: Verso Press, 1992.

Anderson, Benedict. *Imagined Communities: Reflections on the Origin and Spread of Nationalism*. London: Verso Press, 1991.

Ashcroft, Bill, Gareth Griffiths, and Helen Tiffin. *The Empire Writes Back: Theory and Practice in Post-Colonial Literatures*. London: Methuen, 1989.

Benjamin, Walter. *Illuminations*. Ed. Hannah Arendt. New York: Schocken, 1969.

Berger, Maurice. "Visual Terrorism." In *Violent Persuasions: The Politics and Imagery of Terrorism*. Ed. David J. Brown and Robert Merrill. Seattle: Bay Press, 1993.

Brett, Guy. *Through Our Own Eyes: Popular Art and Modern History*. Philadelphia: New Society, 1987.

Camnitzer, Luis. "Access to the Mainstream." *New Art Examiner* (June 1987): 20-23.

Clare, Anthony. "The Mad Irish." In *Mental Health in Ireland*. Ed. Colm Keane. Dublin: Gill and Macmillan, and Radio Telefis Eireann, 1991.

Coleman, Terry. *Going to America*. New York: Pantheon Books, 1972.

Eco, Umberto, Richard Rorty, Jonathan Culler, and Christine Brooke-Rose. *Interpretation and Overinterpretation*. Cambridge: Cambridge University Press, 1992.

Edwards, R. Dudley and T. Desmond Williams, eds. *The Great Famine*. 2nd ed. Dublin: The Lilliput Press, 1995.

Ernst, Robert. *Immigrant Life in New York City: 1825–1863*. New York: King's Crown, 1949.

Fanon, Franz. *Black Skin, White Masks*. London: Grove Press, 1967.

Gadamer, Hans-Georg. *The Relevance of the Beautiful and Other Essays*. Cambridge: Cambridge University Press, 1986.

Goldman, Shifra. "Latin Visions and Revisions." *Art in America* (May 1988): 138-47.

Goldman, Shifra, and Ybarra-Frausto, Tomás. *Arte Chicano: A Comprehensive Annotated Bibliography of Chicano Art, 1965-1981*. Berkeley: Chicano Studies Library Publication Unit, University of California, 1985.

Gibbons, Luke. "Race Against Time: Racial Discourse and Irish History." *The Oxford Literary Review* 13, nos. 1-2 (1991).

Gomez-Peña, Guillermo. "The Multicultural Paradigm: An Open Letter to the National Arts Community." *High Performance* (September 1989): 18-27.

Gusevich, Miriam. "Decoration and Decorum: Adolf Loos's Critique of Kitsch." *New German Critique* 43 (Winter 1988).

Hurlburt, Laurence P. *Mexican Muralists in the United States*. Albuquerque, N.M.: University of New Mexico Press, 1989.

Joyce, James. *A Portrait of the Artist as a Young Man*. 1916. Reprint, New York: Viking, 1964.

Kristeva, Julia. *The Kristeva Reader*. Ed. Toril Moi. New York: Columbia University Press, 1986.

Mayer, Monica. *Translations: An International Dialogue of Women Artists*. Los Angeles: Monica Mayer, Jo Goodwin, and Denise Arfitz, 1980.

McEvilley, Thomas. "Here Comes Everybody." *Beyond the Pale: Art and Artists on the Edge of Consensus*. Dublin: Irish Museum of Modern Art, 1994.

Memmi, Albert. *The Coloniser and the Colonised*. London: Earthscan Publications, 1990.

Mesa-Bains, Amalia. "Meeting the Challenge of Cultural Transformation." *FYI* 5, no. 3 (Fall 1989): 1.

Miller, Robert Ryal. *Shamrock and Sword: The Saint Patrick's Battalion in the U.S–Mexican War*. University of Oklahoma Press, 1989.

Moraga, Cherríe. "A Long Line of Vendidas." In *Loving in the War Years: lo que nunca paso por sus labios*. Boston: South End Press, 1983.

Moretti, Franco. *The Way of the World: The* Bildungsroman *in European Culture*. London: Verso Press, 1987.

Mosquera, Gerardo. "Bad Taste in Good Form." *Social Text*, no. 15 (Fall 1986): 54-63.

O'Connor, Francis V. "The Influence of Diego Rivera on the Art of the United States During the 1930s and After." In *Diego Rivera*. New York: W. W. Norton & Co., 1986.

Paz, Octavio. *Sor Juana Or The Traps of Faith*. Cambridge, Mass.: Harvard University Press, 1988.

Rascón, Armando. *Xicano Progeny, Investigative Agents, Executive Council, and Other Representatives from the Sovereign State of Aztlán*. San Francisco: The Mexican Museum, 1995.

Said, Edward W. *Yeats and Decolonization in Nationalism, Colonialism and Literature*. Minneapolis: University of Minnesota Press, 1990.

———. *Culture and Imperialism*. New York: Knopf, 1993.

———. *The World, the Text, and the Critic*. Cambridge, Mass.: Harvard University Press, 1983.

Sanchez-Tranquilino, Marcos, ed. "Art and Histories Reconsidered." *Journal* (Winter 1987). (A special section including Harry Gamboa, Jr., "The Chicano/a Artist Inside and Outside the Mainstream" [pp. 20-29] and Tranquilino's "Mano a Mano: An Essay on the Representation of the Zoot Suit and Its Misrepresentation by Octavio Paz [pp. 34-42].)

Weisman, Alan. *La Frontera: The United States Border with Mexico*. New York: Harcourt Brace Jovanovich, 1986.

Weiss, Lawrence D. "Industrial Reserve Army of the Southwest: Navajo and Mexican." *Southwest Economy and Society*, no. 3 (Fall 1977).

Williams, Patrick, and Laura Chrisman, eds. *Colonial Discourse and Post-Colonial Theory*. New York: Columbia University Press, 1994.

Ybarra-Frausto, Tomás. *"Rasquachismo*: A Chicano Sensibility." In *CARA: Chicano Art, Resistance and Affirmation, 1965-1985*. Los Angeles: UCLA Wight Art Gallery, 1990.

———. Rasquache: *A Chicano Sensibility*. Phoenix: Mars Artspace, 1988.

———. "The Chicano Movement and the Emergence of a Chicano Poetic Consciousness." *New Scholar* 6 (1977): 81-108.

Selected Books Published by Participating Authors

Adams, Gerry. *Selected Writings: Gerry Adams*. Dingle, Co. Kerry: Brandon Book Publishers Ltd., 1994.

———. *The Street and Other Stories*. Dingle, Co. Kerry: Brandon Book Publishers Ltd., 1992.

———. *Falls Memoirs*. Dingle, Co. Kerry: Brandon Book Publishers Ltd., 1982.

Benavidez, Max. *Prince of Faces: Confessions of a Shadow Warrior.* New York: Pantheon, 1995.

Cockcroft, Eva. *Towards a People's Art: The Contemporary Mural Movement.* 1977. Reprint Albuquerque: N.M.: University of New Mexico Press, forthcoming.

Cockcroft, Eva Sperling, and Holly Barnet-Sanchez, eds. *Signs from the Heart: California Chicano Murals.* Albuquerque, N.M.: University of New Mexico Press, 1990.

Gibbons, Luke. "Challenging the Canon: Revisionism and Cultural Criticism." In *Field Day Anthology of Irish Writing.* New York: W.W. Norton & Co., 1992.

———. *Cinema and Ireland.* New York: Routledge, 1988.

Gomez-Peña, Guillermo. *Warrior for Gringostroika.* St. Paul, Minn.: Graywolf Press, 1993.

Hickman, Mary J.. *Religion, Class and Identity.* Aldershot, England: Avebury Press, forthcoming.

Lippard, Lucy R.. *The Pink Glass Swan: Selected Feminist Essays on Art.* New York: The New Press, 1995.

———. *Mixed Blessings: New Art in Multicultural America.* New York: Pantheon, 1990.

———. "Critical Kindness." In *Treasures of New York.* Dublin, Ireland: Arts Council of Northern Ireland, Kerlin Gallery, 1990.

Lloyd, David. *Nationalism and Minor Literature: James Clarence Mangan and the Emergence of Irish Cultural Nationalism.* Berkeley: University of California Press, 1987.

Martínez, Rubén. *The Other Side: Notes from the New L.A., Mexico City, and Beyond.* London: Verso Press, 1992.

Poniatowska, Elena. "And Here's to You Jesusa." Trans. Gregory Kolovakos and Ronald Christ. In *Lives on the Line: The Testimony of Contemporary Latin American Authors,* ed. Doris Meyer. Berkeley: University of California Press, 1988.

———. *Dear Diego.* Trans. Katharine Silver. New York: Pantheon Books, 1986.

———. *Massacre in Mexico: 1968.* Trans. Helen R. Lane [Prologue by Octavio Paz]. New York: Viking Press, 1975.

Rodriguez, Richard. *Days of Obligation: An Argument with My Mexican Father.* New York: Viking, 1992.

———. *Hunger of Memory: The Education of Richard Rodriguez.* New York: David R. Godine, 1982.

Rolston, Bill. *Drawing Support: Murals in the North of Ireland.* Belfast: Beyond the Pale Publications, 1992.

Villoro, Juan. *El Disparo de Argón.* Madrid: Alfaguara, and New York: Vintage, 1994.

———. *Tiempo Transcurrido.* Mexico City: Fondo de Cultura, 1986.

Ziff, Trisha. *Between Worlds: Contemporary Mexican Photography.* New York: New Amsterdam Press, 1992.

———. *Still War: Images from the North of Ireland.* New York: New Amsterdam Press, 1990.

EXHIBITION CHECKLIST

Willie Doherty

Untitled (At the Border 1), 1995
Cibachrome (silver dye-bleach) print
on aluminum
48 x 72" (122 x 190.5 cm)
Courtesy of the artist and Matt's Gallery,
London

Untitled (At the Border 2), 1995
Cibachrome (silver dye-bleach) print
on aluminum
48 x 72" (122 x 190.5 cm)
Courtesy of the artist and Matt's Gallery,
London

Untitled (At the Border 3), 1995
Cibachrome (silver dye-bleach) print
on aluminum
48 x 72" (122 x 190.5 cm)
Courtesy of the artist and Matt's Gallery,
London

Untitled (At the Border 4), 1995
Cibachrome (silver dye-bleach) print
on aluminum
48 x 72" (122 x 190.5 cm)
Courtesy of the artist and Matt's Gallery,
London

David Fox

Tricolour 1, 1995
Mixed media
24 x 46" (61 x 117 cm)
Collection of the artist

Tricolour 2, 1995
Mixed media
24 x 46" (61 x 117 cm)
Collection of the artist

Tricolour 3, 1995
Mixed media
24 x 46" (61 x 117 cm)
Collection of the artist

Tricolour 4, 1995
Mixed media
24 x 46" (61 x 117 cm)
Collection of the artist

Tricolour 5, 1995
Mixed media
24 x 46" (61 x 117 cm)
Collection of the artist

Tricolour 6, 1995
Mixed media
24 x 46" (61 x 117 cm)
Collection of the artist

Tricolour 7, 1995
Mixed media
24 x 46" (61 x 117 cm)
Collection of the artist

Tricolour 8, 1995
Mixed media
24 x 46" (61 x 117 cm)
Collection of the artist

Javier de la Garza

Help!, 1992
Oil on paper mounted on canvas
78-3/4 x 59" (200 x 150 cm)
Collection of Pedro Torres, Mexico City

In-finito, 1992
Oil on paper mounted on canvas
59 x 78-3/4" (150 x 200 cm)
Collection of Sandra Azcárraga, Mexico City

Identidad, 1992
Oil on paper mounted on canvas
94 x 59" (240 x 150 cm)
Courtesy of the artist and Galería OMR,
Mexico City

Mexicas, 1992
Oil on canvas
75-1/2 x 95-2/3" (192 x 243 cm)
Courtesy of the artist and Galería OMR,
Mexico City

Silvia Gruner

*Don't Fuck With The Past, You Might Get
Pregnant*, 1995
Ektacolor (chromogenic development) prints
Installation of sixteen photographic prints:
20 x 24" each (51 x 61 cm)
Overall installation: 108 x 96" (274 x 244 cm)
Collection of the artist

Frances Hegarty

Turas (Journey), 1991-95
Video installation
Collection of the artist; funded by the Arts
Council of Great Britain

John Kindness

Ninja Turtle Harp, 1991
Ceramic mosaic
24 x 9" (61 x 23 cm)
Collection of the artist

Fast Food Frescoes, 1995
Lime fresco on slate
Three panels: 24 x 24" (61 x 61 cm)
Collection of the artist

Sectarian Armour, 1995
Etched gilded steel
23-1/2 x 15-3/4 x 11-7/8" (60 x 40 x 30 cm)
Steel fabrication by Peter Rooney
Collection of the artist

Alice Maher

Folt, 1993
Oil on paper, sewing pins, and braids
of human hair
40-1/2 x 49" (103 x 124.5 cm)
Collection of the artist

Daniel J. Martinez

*Event for (class) compression or what
defense can one mount against an avalanche*
Installation, mixed media
120 x 120" (305 x 305 cm)
Courtesy of Robert Berman Gallery,
Santa Monica

Amalia Mesa-Bains

The Circle of the Ancestors, 1995
Installation: eight chairs, mixed media
38 x 21 x 18" (96.5 x 53 x 45 cm)
each; overall 240 x 180" (610 x 457 cm)
Courtesy of the artist and Steinbaum
Krauss Gallery, New York

Philip Napier

Ballad no. 1, 1992-94
Mixed media
54 x 36" (137 x 91 cm)
Collection of the artist

Apparatus V, 1995
Installation, mixed media
120 x 120" (305 x 305 cm)
Collection of the artist

Rubén Ortiz Torres

Modified Baseball Series, 1991-93
Twelve baseball caps
7 x 9 x 4" each (17.7 x 22.8 x 10 cm)
Collection of the artist

Frontierland, 1995
Video installation: video and
mixed media
60 x 84" (152 x 84 cm)
Collection of the artist

John Valadez

Immamou, 1992
Pastel on paper
67-1/2 x 57-1/2" (171.5 x 146 cm)
Collection of Susan Hill, Venice, California

Butch, 1993
Pastel on paper
56-1/8 x 50-1/4" (142 x 127.5 cm)
Courtesy of the artist and Daniel Saxon
Gallery, Los Angeles

Juanito, 1993
Pastel on paper
56-1/8 x 50-1/4" (142 x 127.5 cm)
Courtesy of the artist and Daniel Saxon
Gallery, Los Angeles

Perica, 1993
Pastel on paper
56-1/8 x 50-1/4" (142 x 127.5 cm)
Courtesy of the artist and Daniel Saxon
Gallery, Los Angeles

Maria del Mundo, 1995
Oil on canvas
120 x 108" (305 x 175 cm)
Courtesy of the artist and Daniel Saxon
Gallery, Los Angeles

ANTHOLOGY CONTRIBUTORS

Gerry Adams (Belfast): is President of Sinn Fein. He became politically active during the civil rights movement in Ireland in the 1960s. He has been imprisoned for his political beliefs and the victim of an assassination attempt. He is the author of several books, including *Falls Memoirs* (Brandon Books, 1982), *Politics of Irish Freedom* (Brandon Books, 1986), *Pathway to Peace* (Brandon Books, 1988), *The Street and Other Stories* (Brandon Books, 1992), *Selected Writings: Gerry Adams* (Brandon Books, 1994). With John Hume, leader of the SDLP in the north of Ireland, he initiated a peace process that included an IRA cease-fire in August 1994 and a Loyalist cease-fire in October 1994.

Max Benavidez (Los Angeles): is an author and critic with a special focus on Chicano art and culture. His works include *The Stopping of Sorrow* (Momentum, 1986), a collection of prose and poetry; a forthcoming personal memoir, *Prince of Faces: Confessions of a Shadow Warrior* (Pantheon, 1995); and a yet-to-be published collection of critical essays on art and life in the American Southwest, *L.A. Gothic: A Date with Destiny* (Arte Publico Press, 1996). In addition, he is a frequent contributor to the *Los Angeles Times* and *Art Issues* magazine. He is currently a lecturer in the Department of English at UCLA.

Juan Arturo Brennan (Mexico City): is a writer, journalist, filmmaker, and musicologist. Mexican, though of Irish descent, he lives and works in Mexico City. His writings are frequently published in the newspaper *La Jornada* and magazines such as *Pauta* and *Vogue*. In July 1992 he received a British Council Traveling Award for research in Ireland on this project.

Ellen Calmus (Mexico City): is a writer and translator. She has taught in the U.S. at Princeton University, and in Mexico at the University of the Americas. Her research on war began at the Woodrow Wilson School of Public and International Affairs at Princeton University, and has included extensive interviews conducted in El Salvador, Nicaragua, Cuba, Mexico, the U.S., and Australia. She is currently writing a book about El Salvador.

Eva Sperling Cockcroft (Los Angeles): is a leading mural artist and writer. Her books include the groundbreaking *Towards a People's Art: The Contemporary Mural Movement*, first published in 1977, to be reprinted in 1996 by UNM Press, and *Signs from the Heart: California Chicano Murals* (1990). She has contributed essays on socially concerned Latin American and Latino art to the catalogue *The Latin American Spirit* (1988), and has written on Latino art for *Art in America* and other magazines. Her latest public art project is a series of ceramic tile panels for the Metrorail station in the largely black and hispanic Compton section of Los Angeles. She is currently teaching in the studio art department at the University of California at Irvine.

Fionnula Flanagan (Dublin/Los Angeles): is an established actress, producer, and director. Best known for her work on James Joyce, she wrote and adapted *Joyce's Women* for both stage and screen. She has appeared both on and off-Broadway, and in many film and television shows in the United States. She received an Emmy for *Rich Man, Poor Man*, a Jacob's Award for the Irish language play *A Trial*, and both the Los Angeles and San Francisco critics award for her film, *Joyce's Women*.

Joan Fowler (Dublin): is an art historian, writer, and lecturer in art history at the National College of Art and Design in Dublin. She is a prolific writer on Irish art and culture, addressing in particular issues of national identity and gender.

Luke Gibbons (Dublin): is a leading Irish intellectual and writer on visual aesthetics from 18th-century Irish painting to contemporary Irish cinema. He lectures in the School of Communication Studies at Dublin City University. A member of Field Day, he participated in the recently published *Field Day Anthology of Irish Writing*, editing the chapter titled "Challenging the Canon: Revisionism and Cultural Criticism" (Norton, 1992). He was also a coauthor of *Cinema and Ireland* (Routledge, 1988). He is currently working on a book about 18th-century visual aesthetics in Ireland.

Guillermo Gomez-Peña (Los Angeles): is a writer and experimental artist who was born in Mexico City and came to the United States in 1978. Since that time, he has been exploring border issues, crosscultural identity, and U.S./Latino cultural relations with the use of multiple media. From 1984 to 1990, he was a founding member of the Border Arts Workshop/Taller de Arte Fronterizo. He has received the Prix de la Parole at the International Theater Festival of the Americas (1989), the New York Bessie Award (1989), and a MacArthur Foundation Fellowship (1991).

Mary J. Hickman (London): is the director of the Irish Studies Centre (ISC) at the University of North London. She is second-generation Irish. A book based on her doctoral thesis, *Religion, Class and Identity*, will be published by Avebury Press in 1995. Presently she is directing a major research project for the Commission for Racial Equality on discrimination of the Irish community in Britain.

Lucy R. Lippard (New Mexico): is the author of seventeen books, including *Mixed Blessings: New Art in a Multicultural America* and *Partial Recall: Photographs of Native North Americans* (New Press, 1992). She has curated and organized over forty exhibitions in the United States, Europe, and Latin America. She is a contributing editor to *Art in America* and writes a column on art and politics for *Z* magazine. Lippard is one of the most prolific curators in her field, with an in-depth knowledge of art and multiculturalism. In 1986 she curated an exhibition of contemporary Irish art, "Divisions, Crossroads, Turns of Mind: Some New Irish Art," which traveled to Ireland, Canada, and the USA.

David Lloyd (Berkeley): is an associate professor of English at the University of California at Berkeley. His book on James Clarence Mangan is the first sustained attempt to apply modern critical theory in a rigorous fashion to the study of Irish cultural nationalism. Lloyd's chief writings include *Nationalism and Minor Literature: James Clarence Mangan and the Emergence of Irish Cultural Nationalism* (University of California Press, 1987). His forthcoming publication *Anomalous States: Irish Writing in the Post-Colonial Moment* will be published by Duke University Press in 1995.

Rubén Martínez (Los Angeles): is a poet, performer, and journalist. He is the Los Angeles Bureau Chief for Pacific News Service, a lecturer of journalism at Claremont McKenna College, and a contributor to National Public Radio. He is a co-host of PBS-affiliate KCET's public affairs program, *Life and Times*. Martínez is the author of *The Other Side: Notes from the New L.A., Mexico City, and Beyond* (Verso, 1992), a collection of essays and poetry. He writes for the *Los Angeles Times*, *La Opinión*, *The Nation*, *Mother Jones*, and *Rolling Stone*.

Cuauhtémoc Medina (Mexico City): is an art historian, writer, and a member of CURARE. He contributes to various Mexican periodicals and magazines, including *Poliester* and *Luna Cornea*. He writes on fine art and photography, and is currently studying for his doctorate at the University of East Anglia, England.

Amalia Mesa-Bains (San Francisco): is a well-known Chicana cultural activist. She has written extensively on Chicano/a art and culture, and has curated many international shows of Chicano/a art. Mesa-Bains also works as an artist in her own right, and has contributed to this project as a practicing artist and writer.

Garrett O'Connor (Dublin/Los Angeles): received an M.D. from the Royal College of Surgeons, Dublin, and did his residency in psychiatry in Baltimore, Maryland, where he spent eight years on the faculty of Johns Hopkins Hospital. He is currently Associate Clinical Professor of Psychiatry at UCLA. In the specialty of Addiction Medicine, he is a consultant and lecturer of international repute. He is also an author, actor, musician, and producer for both theater and film. He is the director of the Institute for Innocence, a California nonprofit organization that conducts workshops for adults with Irish Catholic backgrounds. He lives in Los Angeles, and is currently writing a book based on his work for the Institute of Innocence.

Elena Poniatowska (Mexico City): is one of Mexico's most respected contemporary authors. Since 1953 she has published numerous articles, essays, and books that have been translated into several languages. Her works includes *Massacre in Mexico: 1968*, *Dear Diego*, *Here's to You Kid Jesusa*, and *You Come by Night*. She is known for her active participation in political and cultural events. Poniatowska has recently published, in the newspaper *La Jornada*, a series of letters in correspondence with Subcomandante Marcos.

Richard Rodriguez (San Francisco): is the author of *Hunger of Memory* and *Days of Obligation: An Argument with My Mexican Father*. He works as an editor at Pacific News Service, San Francisco, and is a contributing editor for *Harper's* and the Sunday Opinion Section of the *Los Angeles Times*. He appears on the MacNeil/Lehrer NewsHour as an essayist.

Bill Rolston (Belfast): was born and raised in West Belfast. He lived for six years in the United States, where he studied on the East Coast, and later taught high school for one year near Los Angeles. He returned to Belfast in 1970 and completed a doctorate at Queen's University, Belfast, and began lecturing in Sociology at the University of Ulster (UU). He is currently a Senior Lecturer at UU. He has written widely on politics and society in the North of Ireland, including *Drawing Support: Murals in the North of Ireland*, and *The Media and Northern Ireland: Covering the Troubles* (MacMillan, 1991).

Juan Villoro (Mexico City): is professor of Literature at the National University in Mexico, and a visiting professor in Mexican literature at Yale. He has published several books, including a novel, *El Disparo de Argón*, and two collections of short stories, *La Noche Navegable* (Joaquin Mortiz, 1980) and *Albercas* (Joaquin Mortiz, 1980), as well as children's books. He has also translated Truman Capote and Graham Greene into Spanish.

Trisha Ziff (Los Angeles/Mexico City): is a curator, author, and filmmaker. Born in England, she lived in Ireland in the 1980s, establishing community arts, film, and photography projects in Derry. She now makes her home in Los Angeles and Mexico City. She is the editor of two books, *Still War: Images from the North of Ireland* (New Amsterdam, 1990), and *Between Worlds: Contemporary Mexican Photography* (New Amsterdam, 1992). She recently completed her first documentary film project, *Oaxacalifornia*. She is the curator of the exhibition "Distant Relations" and the editor of this anthology.

ARTISTS

Willie Doherty lives and works in his native city of Derry, north of Ireland. He has exhibited extensively in Europe and the United States over the last fifteen years. His work has been shown at the Tate Gallery, London; The Metropolitan Museum of Art, Tokyo; and Museo Nacional de Arte Reina Sofia, Madrid. In 1993, Doherty was one of the first Irish artists to represent his country at the Venice Biennale. Magazines that have reviewed his work include *Artforum*, *Camera Austria*, and *Perspektief*.

David Fox was born in Dublin, Ireland, and presently lives and works in London. He studied at the Slade School of Art, London. Fox was a member of the Poster Film Collective in London from 1977–82, and is a director at Faction Films, London. He is a painter, installation artist, and filmmaker. He directed *Trouble the Calm* (1988), *Vootrekker Ruck* (1994), and co-directed *Irish News—British Stories* (1984), and *Picturing Derry* (1985).

Javier de la Garza was born in Tampico, Tamaulipas, Mexico. He lives and works in Morelos on the outskirts of Mexico City. His work has bee exhibited in Mexico, Spain, Belgium, and the United States, and was included in the 1993 ARCO Spanish Festival as well as the 1994 Havana Bienial. In addition to working as a painter, de la Garza has designed sets for film and theater in Paris, including the set and costumes for *Codice Borgia*, performed by the National Ballet of Mexico.

Silvia Gruner was born in Mexico City where she continues to live and work. She studied at the Massachusetts College of Art and at the Bezel Academy of Art and Design, Jerusalem, Israel. She works primarily with video and mixed media to create installation works as well as performance art. She has exhibited, performed, and screened her films in Latin America and North America. She is currently working on a three-part international installation project in Sweden, Guatemala, and Mexico.

Frances Hegarty was born in Teelin, County Donegal, Ireland, and currently lives and works in Sheffield, England. She works primarily as a video and installation artist. Hegarty's work has been seen in museums and film festivals in the United States, Europe, and Australia. She is a lecturer of Fine Art at the School of Cultural Studies, Hallam University, Sheffield. She is currently working on a video installation, *The Diaspora Project*, in Sydney and Melbourne, Australia.

John Kindness was born in Belfast, north of Ireland, and currently lives and works in Dublin. He works with mixed media, including ceramics, etchings on steel, and traditional fresco painting. His works have been exhibited in Europe and North America. In 1991, Kindness received a fellowship from PS1's International Studies Program, New York, to produce his first solo exhibition, "Treasures in New York." His recent exhibition, "Belfast Frescoes," was purchased by the Ulster Museum for their permanent collection. His work is included in the permanent collections of the Victoria and Albert Museum, London; the Boston Museum of Fine Art; the British Council; and the Irish Museum of Modern Art, Dublin.

Alice Maher was born in Tipperary, Ireland. She lives and works in Dublin. She studied Fine Art in Cork, Ireland, at the University of Ulster, Belfast, and at the San Francisco Art Institute. She has exhibited internationally in Europe, North America, Brazil, and Japan. Maher works as both a painter and mixed-media artist, creating installations that use natural organic elements of hair, bees, and nettles. She has received various awards in Ireland and was a Fulbright scholar in California. A publication on her work was produced in 1995 in association with her recent solo exhibition,"Familiar," at the Douglas Hyde Gallery, Dublin, Ireland, and the Orchard Gallery, Derry, N. of Ireland.

Daniel J. Martinez lives and works in his hometown of Los Angeles, California. He is an Assistant Professor at the University of California, Irvine, teaching interdisciplinary installation and telecommunications in the Studio Art Department. He participated in the La Biennale di Venezia, Venice, Italy in 1993. In the same year he was also part of the Whitney Museum of American Art's Biennial. Martinez has performed and exhibited extensively in the United States, Europe, Mexico, and Brazil. His public art projects include an El Segundo Metrorail Station in Los Angeles (1991). Magazines and newspapers that have reviewed his work include the *New York Times*, *Newsweek*, *Artforum*, *Flash Art*, and *Art in America*.

Amalia Mesa-Bains was born in Santa Clara, California, and lives and works in San Francisco. She earned a Ph.D. from the University of California at Berkeley in Clinical Psychology, and is a former MacArthur Fellow. Mesa-Bains is an established author, and has exhibited extensively in the United States, Europe, and Mexico. Her installation, *Venus Envy, Chapter One*, was exhibited at the Whitney Museum of American Art in 1993. She has curated many exhibitions of Chicano art, including "Ceremony of Spirit" (1992-93), and "Other Mexico: Sources and Meaning" (1993-94).

Philip Napier was born in Belfast, North of Ireland, where he continues to live and work. He is a mixed-media installation artist who has exhibited in Ireland, England, Italy, and the United States. In 1994, with artist Alice Maher, Napier represented Ireland in São Paulo at the Brazil Biennial. He is currently working on a commission for the terminal serving the Republic of Ireland at Heathrow Airport, London, and will participate in the exhibition "L'Imaginaire Irlandais" at the École Nationale Superieure des Beaux Arts, Paris (1995).

Rubén Ortiz Torres was born in Mexico City, and lives and works in Los Angeles and Mexico City. He studied fine arts at the Escuela Nacional de Artes Plásticas, Mexico City, and Harvard University. He was a Fulbright Scholar at the California Institute for the Arts in Valencia. Ortiz is cross-border artist who works in a variety of media, including painting, photography, mixed media, and film. He has exhibited extensively in Mexico, the United States, Europe, Australia, and Brazil. His films include *How to Read Macho Mouse* (1993), and *Frontierland* (1995), a collaboration with Jesse Lerner.

John Valadez was born in Los Angeles, where he continues to live and work. He is a painter and muralist who has exhibited in the United States, Europe, and Mexico. His public commissions include the Federal Building in El Paso, Texas (1991-94) and the Los Angeles County Metro Transit Memorial Park Station, Pasadena (1994). He is currently working on a public commission for the Santa Ana Federal Court House, which will take three years to complete.

COMPOSERS

Roger Doyle lives and works in his native Dublin, Ireland, where he specializes in electro-acoustic music. He studied at the Royal Irish Academy of Music and at the University of Utrecht's Institute of Sonology. Doyle has been a visiting scholar at the University of Washington, Seattle, and the Banff Centre for the Arts in Canada. He has worked with numerous music and theatre groups. His music for the Dublin's Gate Theatre production of Wilde's *Salomé* was produced at the Edinburgh Festival, and later seen in London and at the Spoleto Festival in the USA. He has composed the soundtracks for Irish films, and has recordings published on compact discs and cassettes. His compositions are available at the Centre of Contemporary Music in Dublin. Since 1991 he has been working on the *Babel Project*.

Manuel Rocha Iturbide was born in Mexico City, and lives and works in Paris. He studied composition at the University of Mexico, and did postgraduate studies at Mills College, San Francisco, where he obtained an MFA in electronic music and composition. He is currently completing his doctorate at the University of Paris on granular synthesis techniques. His music has been performed in Mexico, the United States, Canada, France, and Spain. Rocha recently received an award from Mexico's Consejo Nacional para Las Artes y La Cultura to produce three electronic compositions.

Editor: Trisha Ziff
Production coordinator: Pilar Perez
Copyeditor: Sherri Schottlaender
Design: Michele Perez

Ikon Gallery
58 – 72 John Bright Street, Birmingham B1 1BN, England
telephone 44 1 21 643 0708
facsimile 44 1 21 643 2254

Camden Arts Centre
Arkwright Road, London NW3 6DG, England
telephone 44 1 71 435 2643 / 435 5224
facsimile 44 1 71 794 3371

Irish Museum of Modern Art
Royal Hospital Kilmainham, Dublin 8, Ireland
telephone 353 1 671 8666
facsimile 353 1 671 8695

Santa Monica Museum of Art
2437 Main Street, Santa Monica, California 90405, USA
telephone 310 399 0433
facsimile 310 399 6954

Museo Arte de Contemporáneo de Carrillo Gil
Av Revolución no. 1608, CP 0100 México DF, México
telephone 525 550 1254 / 550 3983
facsimile 525 550 4232
email: macinb@servidor.unam.mex

This publication has been funded in part by the Fideicomiso para La Cultura Mexico/USA,
Fundación Rockefeller, Fundación Cultural Bancomer, and Fondo Nacional para La Cultura y
Las Artes, and has been organized by the Santa Monica Museum of Art, California, and Pilar
Perez and Associates.

Paper: Matrix Matte
Printed in the USA by Typecraft Inc., Pasadena, California

This anthology is published by Smart Art Press, 2525 Michigan Avenue, C-1 Santa Monica, CA 90404 on the
occasion of the exhibition "Distant Relations/Cercanías Distantes/Clann I gCéin: A Dialogue Among Chicano, Irish
and Mexican Artists."

SMART READER:

Once in a while, we at Smart Art Press are asked to participate in a project that makes us look even smarter than we really are. Such is *Distant Relations: Chicano, Irish, and Mexican Art and Critical Writing*. This 288-page book not only documents an exhibition of contemporary art selected to travel to at least six international venues, but also contains twenty-one critical essays by Chicano, Irish, and Mexican writers. Conceived by Trisha Ziff and beautifully designed by Michele Perez, we simply said "yes" when asked to help publish *Distant Relations*. Smart indeed. And now you own Vol. 2, No. 11 of the SAP Library, entering its second year and second tier of publications. Thank you Trisha Ziff and Pilar Perez.

A SPECIAL OFFER:
Subscribe to SMART ART PRESS and receive the next nine publications for just $99 (Vol. 2, Nos. 12–20)
Upcoming publications include:
•*A Decade of Protest: Political Art from Cuba, the United States and Vietnam*
•*Man Ray: Paris–L. A.*
•*The Things You See When You Don't Have a Grenade* by Daniel J. Martinez

Plus 6 others, and various and intermittent SAP announcement cards, pamphlets, and other material we geneate on a continuing basis. We want you to have every shred of SAP Ephemera, as it is important to the collectible nature of the Library.

Available at $130: The extensive and valuable first tier of the SAP Library (Vol. 1, Nos. 1–10 plus accompanying ephemera):

#1. *Burt Payne 3: Access* (now scarce)
#2. *Wheels*
#3. *Jim Butler: Paintings*
#4. Murder (also scarce)
#5. *The Short Story of the Long History of Bergamot Station*
#6. *Joe Zucker: A Decade of Paintings*
#7. *Fool's Paradise*
#8. *Jim Shaw: Dreams* (sold out 1st printing, but you get one anyway)
#9. *Alan Rath: Plants, Animals, People, Machines* (another best seller)
#10. *EATS: An American Obsession*

☐ I want Vol. 1, Nos. 1–10 for $130

☐ I want Vol. 2, Nos. 12–20 for $99

☐ I want another *Distant Relations* catalogue for $25

NAME _____

ADDRESS _____

PHONE _____
CREDIT CARD _____
SIGNATURE _____ EXP. DATE _____

SMART ART PRESS
2525 MICHIGAN AVE BUILDING C SANTA MONICA, CA 90404
PHONE 310-264-4678 FAX 310-264-4682

MUSIC NOTES

Móin Mór
composed by Manuel Rocha Iturbide © 1995
Duration: 9:50

Gaelic poems written and recited by
Derry O'Sullivan.
Anonymous Irish poem from eighth century
A.D. read by Derry O'Sullivan.
Poems recorded in Paris, France, 1995.

Sounds were recorded by the composer in
Ireland in 1993, with the exception of an
excerpt from a field recording of the events
of Bloody Sunday, Derry, 1972 by Antonio
Grimaldi.

This piece was made and mixed down digitally
at the personal studio of the composer. Sound
was also transformed on the granular synthesis
system of Barry Traux at Simon Fraser
University, Vancouver, Canada, and on the
GIST granular synthesis Toolkit for IRCAM
ISPW, designed by Gherard Eckel and Manuel
Rocha Iturbide.

Special thanks to: Jean Baptiste Barriere,
Gherard Eckel, Brid Keenan and Paeder
Whelan, Derry O'Sullivan, Barry Traux,
Trisha Ziff.

Funded by the British Council, Mexico.

Under the Green Time
composed by Roger Doyle © PRS 1995
Duration: 18:36

Uilleann pipes and low D whistle:
Brian O'Huiginn (first and last sections)
Flute: Viviana Guzman (second section)
Shrieks: Elena Lopez (third section)
Keyboards, programming, and electronics:
Roger Doyle

Recorded at the Wellington Booth and
Studio L'inster, Dublin, Ireland.
Engineered and produced by Doyler.

"Under the Green Time" is taken from the
poem "The Room of Rhetoric" by Irish writer
Sebastian Barry.

Funded by The Arts Council, Ireland (An
Chomhairie Eaiaíon).